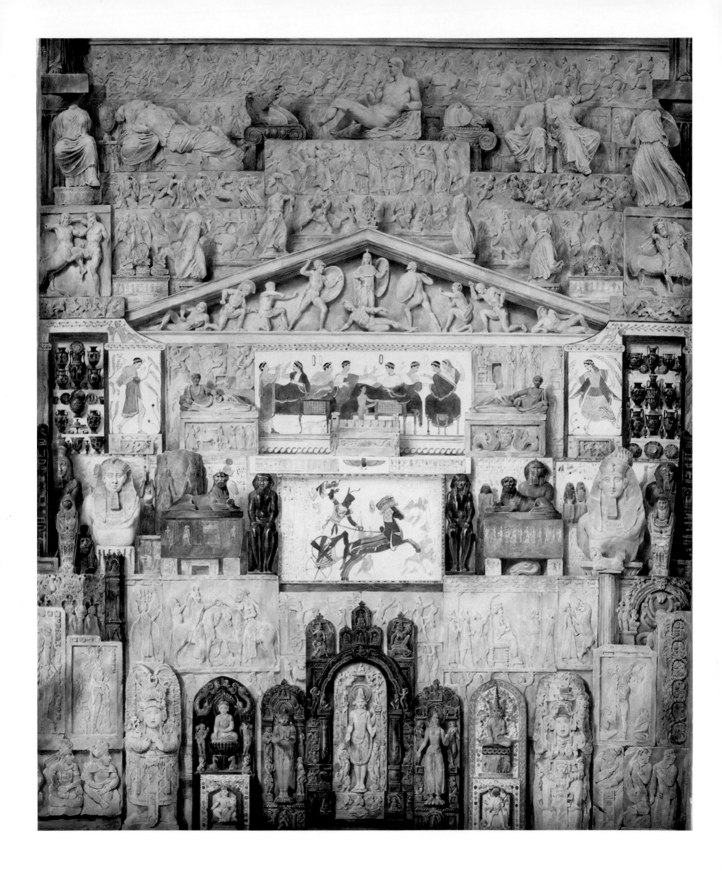

THE WORLD OF
ANCIENT ART

John Boardman

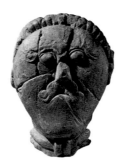

Thames & Hudson

Frontispiece: James Stephanoff, An Assemblage of Works of Art in Sculpture and Painting, exhibited in 1845. This watercolour is a composition of examples of the sculptural arts of different cultures – Greek, Etruscan, Egyptian, Assyrian, Persian, Indian, Maya – a demonstration of the collections of antiquities that were made for public museums in the later 18th and 19th centuries, as sources of instruction for the public. London, British Museum PD 1994.12-10.6.

The author and publishers are deeply indebted to the many archives and institutions which have supplied illustrations for this book, and to individuals (named in captions) for a similar service.

Archivio Alinari 424, 427, 432, 435; Professor M. Andronicos 311; Ferdinand Anton 548; Agora Excavations, American School of Classical Studies, Athens 355; Deutsches Archaeologisches Institut, Athens 291; Professor Sir John Boardman 212, 338, 340, 341; G.H.S. Bushnell 469; Courtesy of the Oriental Institute, University of Chicago 19; Michael D. Coe 471; F. Delaporte 466; English Heritage Photographic Library 15;

Photography © Eskenazi Ltd. 92; Fototeca Unione 423; Alison Frantz 296; John Freeman 157; Griffith Institute, Ashmolean Museum, Oxford 269; Irmgard Groth-Kimball 33, 456, 460, 492; Abraham Guillem 539, 541; Fotoarchiv Hirmer 24, 166, 170, 171, 218, 228, 230, 238, 240, 253, 268, 452; Archaeological Survey of India 27, 131; India Office Library and Records 117, 130; Israel Department of Antiquities 321; Deutsche Archaeologisches Institut, Istanbul 10; © Justin Kerr 458, 487, 489; Kerkenes Dag Excavation, Middle East Technical University, Ankara 224; William MacQuitty 279; © Colin McEwan 464; Professor Amaedeo Mainri 430; H.Mann 551; Bildarchiv Foto Marburg 28; © Simon Nicholls 462; Semitour Périgord 2; Josephine Powell 30, 37, 47, 114, 196, 207, 229, 235; Princeton University Press and the University of Cincinnati 239; Photo © RMN 6a&b; Ministère de la culture et de la communication, Direction régionale des affaires culturelles de Rhône-Alpes, service regional de l'archéologie 4; Deutsches Archaeologisches Institut, Rome 425; John Ross 32; Nicholas J. Saunders 480; J.A. Sabloff 470; The Studio/Michael and Menachem 31; Antonio Tejada 483; Rheinisches Landesmuseum, Trier 408; Jean Vertut 5; Grahame L. Walsch 644; J. Ward-Perkins 407; R.B. Welsch 528; Werner Forman Archive 273; Roger Wood 49.

First published in 2006 in hardcover in the United States of America by Thames & Hudson Inc., 500 Fifth Avenue, New York, New York 10110

thamesandhudsonusa.com

Library of Congress Catalog Card Number 2005906277

ISBN-13: 978-0-500-23827-1
ISBN-10: 0-500-23827-8

Printed and bound in China by C&C Offset Printing Co Ltd

for

SHEILA (d. 2005)

JULIA AND MARK

MIMA AND DAN

CONTENTS

I
EARLY DAYS AND THE PRIMITIVE 16

II
THE ARTS OF URBAN LIFE 30

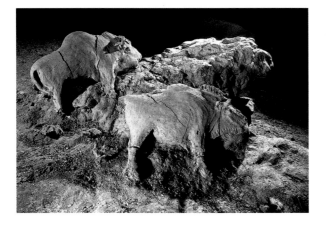

III

THE NORTHERN AND NOMADIC, AND INTERFACES 316

IV

THE TROPICAL ARTS 365

PREFACE

The arts of man in antiquity had a clear function, determined by his needs and aspirations; and these in turn were determined by his environment. This book deals with the solutions and responses of man the maker and artist at a time when he was beginning to control much of his environment – its animal and vegetable life, through domestication and irrigation – and before artisans began to think that they might or even should have a function beyond answering human needs; before they consciously became 'artists' in the modern sense, answerable only to their own inspiration or sponsors.

We can never quite view works of ancient art through the eyes of antiquity, even when they are in their original contexts, even often when they are still *in situ*. They were not designed for a museum or gallery, or to be viewed as isolated monuments; and they were used by societies very unlike our own. We may sometimes then find it easier to share the intention of the artists than the response of the intended viewers, although intention and response should have been more closely interdependent than they have proved in many later periods, to the present day, because ancient arts were more consciously designed to serve the societies for which they were created.

This book tries to offer an account of ancient art worldwide, for any reader who has an interest both in art and in the history and achievements of mankind, on as comprehensive a scale as space allows. There is also a general message, reflected in the layout of the book and the way in which some subjects are presented. It is not a 'theory of ancient art', but rather a way of looking at it that is complementary to other, historical, aesthetic, social, evolutionary or psychological approaches. Briefly: there can be little doubt that the arts and architecture of early man and early civilizations were ultimately, if indirectly, dictated by the problems and opportunities that their environment offered for the development of human life and the pursuit of at least security, at best happiness. Human choice enters into the matter, especially in the details, but also in the fact that man has sometimes been led to settle in uncompromising environments, rather than simply stay in the tropical/temperate areas of Earth. In earliest days climate and

the environment completely dictated the development of human culture and what man was able to create. They determined the shaping of his societies, including their arts, quite apart from determining availability of materials and the discovery of techniques to handle them. It will come as no surprise, therefore, that there is more in common between the arts of people sharing roughly comparable climates, resources and environments worldwide, than there is between those whose way of life is made totally disparate by the conditions in which they were obliged to live. This is 'way of life', as opposed to 'lifestyle', a word which deserves to be rescued from its status as a cliché, for its value in describing a mode of living that is chosen (like 'hairstyle'), rather than determined by other people or factors.

Very broadly, and this is perforce a study of very broad generalizations, three areas of comparability in environment worldwide are here distinguished, and each of them awarded a Chapter:

1. The northern steppes, forests and deserts of Asia, Europe and North America, which are the homes of hunters and gatherers, then pastoralists and nomads, eventually even farmers, surveyed in Chapter Three.

2. The mainly northern temperate zones with the great valley civilizations and the rapid development there of major urban societies dependent largely on flocks, farming and control of water, on developing technology, especially with metals, and on large and controllable working populations. These run from China, through the Near East and Egypt, to Central and South America, discussed in the longest chapter (Two), with some preliminary consideration of their common features (the 'Common Record').

3. The tropical, in South America, Africa and Oceania, where the living is, superficially at least, easy; but the dating is problematic, virtually to the present day, and so treated in rather less detail, in Chapter Four.

This is the programme and the phenomena are seen to be worldwide, including both Old and New Worlds. Finer tuning is possible and there are overlaps and interesting interfaces to observe between the three geographical zones, where the arts of very different societies may interact, just as there are environments which are not geographically much related – deserts,

for example. Thus, it is arguable that the south Sahara reproduces just north of the Equator many of the conditions of the northern zone, with desert and grassland; while south of the Equator, in South America, there are roughly comparable conditions. But I have attempted to make the demonstration manageable and intelligible in a single book without cutting too many corners. To put it baldly, I want to remind the reader that there is more in common between the arts of North America, early Europe and the steppes of Asia, than there is between them and the arts of the urban civilizations to their south, from Mexico to China, which are themselves closely related to each other in their general aspirations and so their artistic products, despite superficial differences of 'style', which are perhaps no more nor less significant than differences in language; and than there is between these mainly temperate urban arts and the remarkably coherent arts of the tropics, especially in the Old World.

Diffusion of ideas and arts through proximity or migration is important, and in the Old World at least some similarities can be explained by copying or the movement of peoples. But all had to be determined by a perceived need and man's response to it. Diffusion seldom did much seriously to alter already established patterns and attitudes in the arts, even in periods of close contact and easy communication between peoples. Where there is no stimulus or threat from outside there is commonly no change, unless the environment dictates it. In Central America there is little overall change for centuries – until the arrival of a devastating new culture from the Old World as late as the end of the 15th century AD. Yet some innovation may be seen to be not necessarily the result of migration or borrowing from neighbours rather than independent invention or response to a newly perceived need. This is most apparent when comparisons are drawn between the Old and New Worlds, where, after the very earliest phase, human societies developed in total isolation each from the other for millennia – a point which will be worth dwelling upon (in Chapter Two, E). Models to explain diffusion of ideas and practices as against indigenous invention have been proposed, mainly by

prehistorians seeking explanations and patterns for phenomena for which there is nothing but the physical record, but each case is best judged on its merits, and we have much to learn from the historic period where there are other sources available which enable us to understand why certain choices were made.

I should explain the 'ancient' of the title. In the Old World I have taken the story down to the time when Christianity and Buddhism began to spread, when old arts had been either abandoned or (except in China and India) replaced by new; in the New World, down to the arrival of Europeans, when the record first ceases to be strictly comparable with that of the ancient Old World; for the northerners, roughly the same time scale as their southern neighbours; but, for the southern tropical, the nature of the evidence may bring us close even to the present day.

World Histories are more common these days than World Histories of Art, although there have been some noble attempts at the latter in encyclopaedias and books; in French, from Reinach to Bazin; and in English, from Ernst Gombrich's classic *The Story of Art*, most of which was written before 1950 but has been regularly updated and enlarged since, to the more recent and excellent *A World History of Art*, by Hugh Honour and John Fleming, first published in 1982 and regularly updated. Some of these study the arts of man from a social as well as a technical and narrowly art-historical viewpoint, but without offering broader geographical comparisons. In many the ancient arts seem merely tacked on to the serious business of Western Art. Other studies which are more consciously based on anthropological or archaeological theory sometimes take a broader view; not often, and they tend to be restricted in time (usually prehistory) or place, while global comparative studies are almost confined to the very earliest times, the Palaeolithic. Studies of local ancient arts – Chinese, Egyptian, Aztec, etc – do not often venture into consideration of craft history in terms of place, date, studios, imagery and development except in purely local terms. In this book I try to make a virtue of a degree of superficiality, in the interests of telling what I believe to be as true a story as any, and one which often transcends centuries and frontiers.

Of the World Histories written in the last century I know of the work of only one scholar who seems to have been capable of embracing all the potential of the subject – Arnold Toynbee. His work is now somewhat unfashionable, and often dismissed as out-of-date, hopelessly Western-world-oriented, even racist, or at best 'half full of wisdom'. At the time, the completion of his work was both hailed as a superhuman effort of scholarship and reviled by some of narrower intellectual compass. His views on prehistory have certainly been overtaken by new discoveries, but even now Toynbee is not easily challenged in later periods. His background as a classicist certainly helped him to appreciate what 'the West' achieved or could be held responsible for. But you have to have read very little of his work to believe that he undervalued other civilizations: his knowledge of them remains unrivalled, being based on a very long and busy academic life, and enlightened by very extensive travelling and discourse with foreign scholars. His basic message was that the geneses and development of civilizations were determined by the challenge of their environment and man's response; and their breakdown to, among other things, a loss of command over the environment, plus simple greed. As a basic idea this is not easily gainsaid, and he was ingenious and observant in tracing what the very varied challenges may have been. That the environment was an important one is shown especially in Toynbee's last book, *Mankind and Mother Earth* (1976), which seems to have escaped much attention. It deals with the history of the world, from life in the cave to the first Moon landing. His aim was to provide 'a readable chronological narrative relating the story of man's interaction with his environment and with his fellow man from the earliest beginnings of human life until the 1970s'. He explains that: 'There were moments ... at which large parts of man's habitat were linked together, and I have taken such moments as opportunities for trying to present a panoramic view However, for most of the time between *c.* 3000 BC and AD 1500, each of the regions into which mankind's habitat was divided went its own way. Insulation and differentiation prevailed over intercourse and assimilation. The regional civilizations co-existed

without coalescing.' The persistent factors were the challenges offered by the environment and increasingly by other people. Toynbee only notes the arts and architecture en route; we shall place them at centre stage, but they cannot be said to prove or disprove his central thesis, simply to illustrate the approach and offer a key to viewing such evidence.

Not that all modern histories ignore the environment – far from it. It is often prominent in works devoted to special areas and periods. Fernand Braudel's epic study of the Mediterranean world is strong on the subject. More recently Felipe Fernández-Armesto's *Civilizations* (2000) surveys Toynbee's field by environment rather than theme, drawing historical and social parallels. It is comprehensive, but discursive, and dwells on many minor environmental types rather than the broader divisions into which my book necessarily falls. Fernández-Armesto's present title as Professor of Global Environment History is an indication of the new trend in studies, which my book tries to complement. None of these historians dwells much on art and architecture, except in passing.

We are spared discussion of 'what is a civilization?' in this book since my main subject areas are defined by what we can observe to have been a common visual experience rather than religious, social or political order. I set great store by the term 'visual experience' since it takes us away from the arts as museum exhibits, and places them back in the settings in and for which they were made and viewed. It takes more than knowledge of the appearance of things to understand what they might have meant, although relatively few of the peoples whose arts we survey here have left us written records of their own views on the matter, or indeed any views at all. We have to think of palaces in the terms of the minority who lived in them and of the many who had to visit them for various reasons; and for the rest of the population in terms of what was visible in temples, towns and homes.

My definition of a civilization is therefore simplistic, and it makes little difference whether you wish to count twenty of them in world history, or fewer, or more, or insist on various regroupings. Mine are dictated by the need to make the book of reasonable length, and to demonstrate a certain visual coherence in the arts of each, even when practised by peoples of different race, language and religion; even, very occasionally, in different places and over very long periods of time. It recognizes that most of us who are used to looking at art and architecture, old and new, can broadly distinguish between what we call Celtic or Chinese or Indian or Mayan or Egyptian arts, without becoming over-involved in problems of development and source or even date.

Almost the only thing we can hope to share with antiquity is this visual experience of its members, although ours is incomplete and calls for imagination and wide knowledge. The act of empathy is difficult since we cannot allow fully for all the impermanent elements which help to create such an experience – dress, food, speech, religion. But at least we know a great deal about what was consciously created by artisans and architects to satisfy the societies they served, even if some guesswork is required when it comes to perishable materials. Generally, however, contemporary representations or even texts can help us to a fuller view of the physical world in which people lived, and even if we cannot share their inner thoughts with any confidence, we can have a very good idea of how these were formed by their experience. Modern analogies are fashionable and can be highly misleading, but I would judge that even with the overwhelming presence of international corporate identities in the shape of manufactured goods, such as motor cars or McDonald's architecture, it would not take a present-day observer long to determine whether he was standing in the American Mid-West, Paris, Harare, Delhi or Hong Kong. He would be guided by identification of visual clues that reveal the cultural and 'stylistic' milieu into which these have intruded, without reading notices or hearing speech.

All this requires a certain sense of style which it would be difficult to define, but which most readers will find familiar and intelligible. There is nothing mystical about this. One of my self-imposed exercises for early experiment with this theme was to go through the many pictures of a standard textbook (G. Kubler's Pelican, *The Art and Architecture of Ancient America*) to see whether there was anything which in style or form

I could have mistaken for a product of the Old World of any period. Among those of the developed New World civilizations (Maya, Aztec, Andean) there was virtually nothing, except for occasional traces of realism, where the common factor was the artist's perception not geography, and some glimpses of high stylization which recalled some early Chinese bronzes – an observation which later study showed to be not altogether pointless. These were all, however, 'superior' arts, not the more pedestrian domestic ones, where comparable techniques and materials tend to produce more closely comparable results. But in the major arts the differences and likenesses in terms of techniques were illuminating, as was exploration beyond them into the social and religious structures they illustrated and for which they are often the only evidence, while the broad differences between north, temperate and tropical were not unlike those in the Old World. This is, in a word, a matter of trying to observe the similarities as well as those differences which have generally dictated other accounts of the arts of antiquity.

There is, however, one constant worldwide, the effect of which on the arts is immediately apparent, sometimes in content, sometimes in style. This is religion – 'an intrinsic and distinctive trait of human nature. It is a human being's necessary response to the challenge of the mysteriousness of the phenomena that he encounters in virtue of his uniquely human faculty of consciousness' (Toynbee). From the earliest times this is expressed in what is popularly now called shamanism, borrowing from Central Asia the term for a man (usually, rather than a woman) who is the intermediary between the real and the spirit world, with which he is in touch and which he may even visit. The mediation is effected through ritual and dance, often frenzied, and may be enhanced by drugs. There is always a close rapport with the animal world, sometimes the vegetable. In urban societies such responses are tamed or subordinated to organized religion of a more political structure, but they are still generally detectable, though with some difficulty in élite societies which prefer to have to deal with a hierarchy of gods, deemed to behave as a human family, rather than with some more mystical communion with the natural world. It has never wholly disappeared, but one of the things which marks the end of what passes for 'ancient' in this book is its recession before various manifestations of religions less wholly dependent on either the ruling classes or magic.

Several of the major civilizations of the Old World enjoyed a special spiritual and social extension to the shamanistic. It is generally associated with the teaching of an individual: Confucius in China (Taoism had more of the shaman), the Buddha in India, Zoroaster in Persia and Central Asia, Greek enlightenment (Socrates, if it needs a name), Jesus Christ in the Roman Empire. We are at a loss to know whether there was any such development in the New World; stories of the priest-king Quetzalcoatl suggest the possibility, there is nothing in the arts there to support it directly, but everything to demonstrate the importance of the natural/spiritual. All this raises questions which this book cannot begin to answer, although the relevant phenomena in the arts can be observed along the way. More important is the proposition that man the artisan or artist is as vital an element in the history of humankind as man the shaman or priest or thinker or reformer; or, for that matter, as man the soldier or politician.

It has not been easy to decide how to lay out this book. It could have been arranged geographically, picking out points to compare along the way. Such a study might have served many readers conveniently as a guide to early art but would have been less efficient in drawing the comparisons and contrasts which illuminate the general message. So I have chosen to proceed by the three major geographical zones already indicated, preceding each with a summary account of common factors in their environments and arts. These summaries need to be kept in mind by the reader as we go on to explore them geographically. This will involve no little century-jumping. It is not a study in which the question 'which came first?' is of much importance, and although diffusion by peoples or trade will play a major role, no less important are the observations of independent solutions found for similar problems, often at great distances of time and space.

The only useful comparisons with pre-Columbian art in America, mainly AD, is with Old World societies,

sometimes at least two millennia older. Special consideration has therefore to be given to comparisons between the Old and New Worlds; special consideration too, inescapably, to Greece of the days before Alexander the Great (4th century BC), when it was in no way on the same plane of social structure as other civilizations considered here, but was nonetheless creating an artistic and architectural 'Classicism' which was to become pervasive worldwide. I should make clear that in this book 'Classical' refers to the realistic style of art, its conventions, figures and ornament, that was devised in 5th-century BC Greece, and that the term includes its later life in and beyond the Roman Empire. So these two subjects, the Classical and the Old/New Worlds, are given separate treatment within the main urban chapter (Chapter Two, C and E). It will also be revealing to study the interfaces between the three major zones and the degree to which they were or were not (generally, not) permeable by their neighbours. This means taking the non-urban zones and the interfaces after the urban, since the latter is usually the main actor in the confrontation.

Our attention is inevitably caught foremost by the élite arts which reflect the exercise of power and possession of wealth, and which, for their individuality, set their stamp on the styles of individual cultures. It would be possible to concentrate exclusively on the humbler expressions of art in the lives of the ordinary people – farmers, soldiers, slaves, the women of the household. Often these would be found to reflect as best they could the taste of their masters, yet there may also be in them a greater unity of expression worldwide than is looked for even in this book. The simpler crafts, being less ambitious, are bound more closely to what their media and techniques allowed, and express more directly many more basic human responses to nature, materials and everyday life. In these respects at least the Old and New Worlds appear more at one.

Viewing art in books is less than ideal. Appreciation of ancient art, more than most, comes best after some experience of the places where it was made, especially where whole sites and major monuments are involved, and with some knowledge of the history of the peoples involved. Apart from what time has already taken away from objects – colour, completeness,

context – Museums further remove us from an authentic view of them by isolating them in a false world of showcases, while attempts at reconstructed tableaux of ancient man in his environment tend to look too artificial, whether they are 'real' or 'virtual'. A single museum that can cover with some substance the whole range of the art objects considered in this book is hard to find – I know only the British Museum, the Metropolitan Museum in New York and the Museum of Fine Arts in Boston. In Paris, Rome, Berlin, St Petersburg, Los Angeles, the same range may be achieved but not under one roof. Some anthropological museums (such as the Pitt-Rivers in Oxford) that still display their wares by subject rather than geography may be at least as rewarding for comparative study. Much of the message of this book and a great part of the detail is contained in the captions to the pictures.

My qualifications as author of this account may not be the very best, but are based on years of work on the material culture and art of what has been described as the first modern civilization – Greece – and as much on archaeological as art-historical matters. I do not regard this as a handicap, since it requires close scrutiny of both objects and of the many other sources of evidence for the society which made and used them, and does not kowtow to any universal theory of art. I had an early interest in interaction between Greeks and their neighbours. Some travel and study well beyond the Mediterranean world, west and east, has broadened the mind and sharpened the eye. An archaeological and museum training has proved at least as important as any with texts (Greek and Latin), as well as the stimulus of teaching, often non-Britons. This remains a very personal account and I have not shrunk from using the first person singular on occasion, where otherwise I might be thought to be engaging with some accepted truth. I had mooted this general approach in a lecture in London on the occasion of the 1994 exhibition of George Ortiz's collection at the Royal Academy, where the objects ranged from Mesopotamian to Polynesian, and in a lecture helping to launch the Macmillan *History of Art* in Melbourne. That various people have recalled to me the points made has encouraged me to develop it, but

even this would probably never have been achieved without also the active encouragement of my publisher, Thomas Neurath.

Dates here are BC and AD, not BCE and CE (Common or Christian Era), which are too readily confused, nor BP (before present) which is unhelpful for anything in the last ten thousand years. The English-reading public, and all archaeologists with most art historians, are by now used to metric sizes of objects and some distances – so km, m, cm, and mm, but no hectares. Dates in the very early periods depend on science and can be vague (or wrong) but at least I hope things are in the right order, where this is important. The spelling of place names follows the practice in most recent books and is not exclusively either ancient or modern. The maps are multi-period, giving names mentioned in the text and some others for orientation. I have pestered many scholars and friends with questions on various topics (I single out Norman Hammond for vetting my sections on the Americas, Jaromir Malek on the Egyptian and Mary Tregear on the Chinese), but relied most on the written word and object or image; the errors are my own. The illustrations are from a wide variety of sources, including other books; this is not meant to be in itself a 'picture book' so much as an illustrated history.

I

EARLY DAYS AND
THE PRIMITIVE

It is hardly surprising that *homo sapiens*' first major essays in figurative art, long before there could have been any aspiration to architectural sophistication – still at best a cave or shelter of branches – should have been devoted to subjects intimately related to those means of his survival provided by the natural world, and the threats offered by or to it. What needed to be acquired physically, mainly food, could also be captured in image. Art served to create a physical and spiritual relationship with those aspects of the physical world which determined life and survival, and to express relationships to other humans. The phenomenon is well charted although detailed explanations for individual instances will always elude us.

Diffusion of human life was from a single centre, Africa, but the eventual creations of man the artist (or woman: I use 'man' for the species) were very probably independently devised in different places and at different times, and they had begun as soon as man became a tool-using creature. Indeed, in appearance, his art can also readily be paralleled in the arts of far more recent societies, for which the conditions of life have been virtually those of the Old Stone Age.

From this Palaeolithic, starting nearly three million years ago, to the transition to the Neolithic, the New Stone Age, which occurred at different times for different peoples between nine to seven thousand years ago, and much later in some places, is a very long time on any reckoning. Man the artist is alleged

to have been at work already over seventy thousand years ago, in Africa, scratching a geometric pattern on a piece of soft rock (ochre) which he may have used for colouring himself or other things, and piercing shells as beads. The earliest objects for decoration are of course natural – pebbles, bones, horn – and we can be sure that some sort of personal adornment and similar idle indulgence in the creation of pleasing pattern became commonplace, but even simple patterns have to be inspired by observation of something and may have a purpose. We have to be impatient, and look for something to which we can more readily attribute positive and explicable human intentions.

We are more than usually restricted here by the accident of what has survived. The earliest are objects

which had been decorated or manufactured in periods of very sparse population, and whose survival has depended on the constraints of discovery and observation; also with the proviso that they are not in perishable materials, which must have accounted for most – wood, unfired clay, painted human flesh. Most surviving cave paintings come much later, and they depend on quite exceptional conditions of burial and climate. A hundred years ago the record was a patchy one. Most early objects and paintings seemed western European and close dating was impossible. We can now see that the phenomenon of Palaeolithic man as artist was worldwide.

The animal world, human and non-human, is the dominant subject for the figurative arts. But natural forces of the climate, and the observed diurnal and annual phenomena of day/night and the seasons, were of paramount importance, and were probably the incentive for some of the first attempts at explanation, by identifying the other-worldy, in divinities or spirits to be appeased or encouraged by image as well as ritual. Later we find evocative studies in art of the effects on man's world of sun, wind and waves, and attempts to personify them in figure or symbol, and generally in pattern on other objects rather than on cave walls. I imagine that the most impressive inexplicable visual factors for early man, apart from the animal and vegetable kingdoms in which he lived and upon which he depended, were the elements – wind, rain, thunder, lightning, fire. To these we should add the material of dreams, the content of which was determined and limited by his conscious experience, but which might include images of the dead as in life (intimations of immortality), of the threats and promises of the real world, even of what could be construed as a heaven and a hell – all potent images for an artist of any period. Both we and our arts are such stuff as dreams are made on. And to all this was added those common experiences which could be shared through the increasing sophistication of speech and image.

Life was that of the gatherer (nuts, fruit, vegetables), then of the hunter-gatherer (adding game and fish). The early images certainly have much to do with recognition of the importance of animals, as threats and as sources of food – and which needed to multiply to provide for man's security and future. But what of the 'gathering'? Where in early art are the trees, roots, fruit, which must have been no less a source for survival? Perhaps they were regarded as more secure, not needing renewal like the animal kingdom, but judged to be reliable in reappearing without human aid and taken for granted, rather like fish. An animal can be killed and eaten only once; the life must be renewed, its source therefore must be appeased and commemorated, whence no doubt the depictions and the continuing role of animal sacrifice in human society. But it is clear that there is far more to early art than commemoration of hunting or propitiation of the threatening, and there may be a rich repertory of symbolism which we may never succeed in understanding. The better-understood later arts of 'civilized' man offer little guidance here, and it may be too easy for modern scholars to exaggerate the complexity of pre-civilized life, much of which was still quite akin to the life of animals. While ritual was surely a major factor in the promotion of images in art, their creation was a conscious act, often of skilled artisans. The notion that they could have been made in a trance-like 'shamanistic' state seems hardly credible, whatever and however inspired were the rituals the artists may have witnessed and served. At any rate, we can only speculate about such behaviour.

The earliest of the figurative arts are small images in stone, horn or bone, commonly of animal or human subjects, as well as incised decoration on natural objects 3. We cannot know their function but can be sure that they were more than the product of idle moments, and some appear on or as utensils 6. Status may have had some part to play. There has never been a classless society in the animal kingdom; there has always been a pecking order, an élite which might perpetuate itself through family or command of power. Some men or animals always emerge as leaders, for their strength and, with age, their practical wisdom. Art can express and define status, and possession of objects which might have been deemed to hold magic powers would help establish and identify that status. So too would body-painting and clothing, which seems to have had, and continues to have, no less a role as an indicator of rank than as a protection against the elements. The human body is robust.

The Upper Palaeolithic (Ice Age) painted and incised

figures on cave walls appear from perhaps as early as the 40th millennium BC, and continue far later wherever caves remained significant shelters for human life. They are best known to us from western Europe, where they are among the earliest, but they are found worldwide, often in deep recesses of complicated cave systems, remote even from the areas which were occupied for eating and sleeping. Comparable are the incised figures found on rock faces, also worldwide, but more difficult to date 8, 9. The subjects are dominantly of the animal kingdom, with man subordinate and not even often portrayed as hunter; indeed, painted representations of humans are conspicuously less realistic than those of animals 2. Yet some of the animals in the earliest paintings are not those commonly caught and eaten, and the record is thus of observation of life beyond the immediately useful, including much that might threaten.

The ability to conceptualize and stylize – in the robust or fleet animals of the paintings and the well-endowed women in the round or relief 3 – appears alongside an ability to hold in the mind's eye, from experience, accurate observation of live forms and action well enough to reproduce them far from their models. It is not surprising that some of the animal paintings have been suspected as forgeries, so well do they anticipate the attempts at rendering life and movement through line and colour in far later periods. On individual sites, over time, some of the figures show a progressive abstraction of forms, possibly through practice and teaching of the craft: this might be man beginning to reveal himself as a conscious artist and able to learn from others or from observation. Their role is as individual studies, with the creatures seldom composed even in herds or as narrative groups, and with their bodies often readily superimposed on each other without diminishing their function: the concentration of images presumably enhanced their power. In the earliest of the European cave complexes (Chauvet 4, apparently far earlier than Lascaux 2) outline drawing precedes 'solid' drawing by millennia, which answers the way our eyes and brains recognize objects by their outlines rather than their mass. The basic profile view dominates, but there is the rare frontal or three-quarter figure, composed instinctively, with colour and occasional shading lending an impression of relief.

'X-ray' views 8 are an exceptional combination of the conceptual and experience.

There are no landscape details, and scale varies enormously, from the minute to the Lascaux painted bulls, over 5m long. Besides the paintings, the cave walls were also sometimes carved to render relief figures, or were decorated with modelled clay 5. Sometimes a natural configuration of the rock face may have suggested the place for decoration: the forms offered by the natural world would long prove as vital a stimulus to the artist's imagination as the animal. In this way, representations could be three-dimensional, like the real world, and not reduced to two dimensions. The latter is a convention which we readily accept since most of our art is 'flat', forgetting that this is itself a sophisticated variation on the creation of images in the round, and presents special problems which have always challenged artists.

The quality of much of this work is staggering. Not the least revealing trait is the way in which practical objects, a stone knife or bone spear-thrower 6, 7, were treated by their makers in ways which we might be tempted to explain as showing the Artist at work. A readiness to spend time and skill beyond what the immediate task required is an indication of a certain positive appreciation of excellence, itself deemed likely to enhance the function of the artefact. This accounts for the exquisite flint implements from various cultures, where what we might take for an Artist's regard for the purest symmetry and balance of whole and part is probably just as much an important and essential element in making the tool the more effective, physically as well as symbolically 7. The added quality might seem to us simply decorative; but adding an animal or vegetable form to an object for regular use also energizes it, makes it more efficient. This is a practice which has never been forgotten, and to dismiss such additives as mere decoration misses their message, even today. It does not need to be taught, and the overall homogeneity of subject, style and standards of workmanship in the first millennia of man as artisan or Artist offers a clear message for the theme of this book. 'It is not too much to say that the search for beauty lies near the source of the highest cerebral capacities.' These are the words of a biologist (J.Z. Young), not an art historian.

The tempo of human exploration and innovation quickened markedly towards the end of this long period, a symptom of technological progress. When pastoralism and agriculture began to develop, and with them a notable growth of population and the creation of sizeable settlements of several families, there was a significant advance in conscious artistry. This was a result of the new conditions rather than some sudden evolutionary change in man's brain. He and his art adapted to the new circumstances, just as, earlier, his habitat and way of life had guided his first steps as an artist.

Identification of the earliest pastoralism and domestication of animals, and then of agriculture and an accompanying form of urbanism, is no easy matter. Bold claims have been made about 'priority' of the different ways of life in different places, but it is a question that only becomes an important one if there is clear indication of diffusion of people and ideas from one or very few centres. Otherwise, when independent development remains an option, given the right circumstances, it is a matter for academic curiosity only. So much of relevance has been discovered only in the last fifty years, and will be in the next fifty, that 'firsts' become rather meaningless. There are early pre-imperial-urban sites, however, in the Near East, that have something to tell us of man the artist, both as hunter-gatherer and enjoying a very early pastoral or agricultural way of life.

Mesopotamia (roughly modern Iraq) as a cradle of civilization seemed an acceptable concept to both early archaeology and Biblical scholarship of the 19th century: the home of both the Garden of Eden and the Tower of Babel. Exploration and better means of dating finds soon modified such a view in favour of other possible sources of diffusion, yet the latest discoveries bring us inexorably back to the land between the two great rivers. In northernmost Mesopotamia (now within Turkey) the site at Göbekli Tepe shows by 9000 BC a sizeable cult complex on a hilltop, with various buildings including a stone temple, some 14m sq and others circular, containing massive T-shaped stone pillars decorated with animals 10, while from the same culture and area are stone images of human heads and animals, in the round. Here we have a startling precursor of sculpture-decorated urban temples, laid out with an architect's eye, but for hunter-gatherers who have left their caves. Nearly 600km to the west, at Çatal Hüyük 11, 13, lies a township of the 7th to 6th millennia BC whose houses are decorated with painting and painted relief, recording hunting, pastoral activity, even townscapes and landscapes: an isolated phenomenon to archaeology so far, but surely not so in antiquity, and a notable advance on the familiar cave paintings. So already we have regular planning for stone architecture, with figure-decorated elements, and interior decoration for houses in painting and relief, with the expected animal subjects but without the realism of the early caves.

Moving south, even earlier, still before 9000 BC at Jericho (near Jerusalem), and still in the phase before pottery-making, there are great circular buildings and a massive fortification, implying a perceived need to guard people and resources, accompanied by art practised on the remains of the dead (skulls), using plaster and cowry shells to restore the live appearance 12. The practice has been discovered now also in nearby Jordan, along with painted plaster figures at half-lifesize 14, and it is recorded elsewhere in the world at later dates, when art is recruited to restore a lifelike appearance to the dead. For the pre-literate period down to around 3500 BC there is much more in Mesopotamia too to indicate some sophistication in the working of stone and, with the discovery of the property of fired clay, the decoration of pottery with geometricized forms, including human figures. We find whole vases treated as human figures by modelling and painting the 'neck' as a head. This anthropomorphizing of natural or practical forms has a long history; man himself becomes the model for his arts.

I shall not dwell on the New Stone Age (Neolithic) here; it is the earlier period that offers most by way of illustration of a common human artistic response to the environment. Nor should we perhaps attach too much importance to the development of agriculture, man attempting to control the vegetable as well as the animal world, since this seems to have happened sporadically and at a small scale from an early date, even among pastoral nomads, without inevitably and everywhere creating radically different societies or arts, such as can be seen to develop soon with startling speed. What has

been called the 'Neolithic revolution' was indeed as real a phenomenon as the later 'urban revolution'. It has to be judged and explained differently in different places at different times: not a subject for this book. The definition of these revolutions was the achievement of the great archaeologist Gordon Childe, and no little dependent in detail on his broader, Marxist world-view.

Among the Neolithic arts the most conspicuous novelties are in the handling and firing of clay, and the advent of 'ceramic' cultures was as important as the later appearance of metalworking cultures in the Copper or Bronze Ages. With the clay figures we can already discern the inherent difference between modelled figures, built up in clay by hand, and carved figures, produced by whittling down stone, bone or wood – a difference perceptible for centuries to come in the history of art. The Neolithic vases were often decorated with close attention to the suitability of decoration to shape, and dwelling on stylized patterns inspired by the world around – trees, water, clouds – and less often on the animal and human subjects of earlier and later art. The decoration is painted with a narrow range of colours, or incised, and in places we already find impressed decoration from stamps (like seals). Some examples of these products are shown in the introductions to the various local urban arts in the next Chapter, if only in places to demonstrate discontinuity rather than continuity with what follows **75, 76, 159, 161, 250, 584–85**.

The Neolithic is the bridge to ways of life that it has proved possible to study in greater detail, and to societies whose responses are easier by now to judge and compare. There are some remarkable regional phenomena. Among them are the Megalithic 'big-stone' aspirations of peoples in western Europe which answered complicated religious needs in a way unique to the area and which have nothing to do with the big-stone monuments of civilizations far to the east, which are sophisticated in far different ways which we shall observe. The western megaliths start in the 4th millennium BC, and range from the north of Britain, through Stonehenge **15**, 'passage graves' inspired by wooden longhouses, beneath long mounds, the standing stones of France (Carnac and the Grand Menhir, a granite splinter 20m high – if it ever stood), to Spain and as far as Malta (the island of Gozo).

The one thing they may have in common is their dependence on observation of the heavens and the calendar of seasons, which we shall also find to have been a common feature in various incipient, ambitious civilizations, from China to Mexico. As much as anything the monuments are a declaration of man's ability to control and shape even the most challenging features of his environment. This preoccupation with big stone affected religious architecture more than figurative art, in which the record is more modest **16**. On many of the megaliths there was widespread patterning of circles, spirals and maeanders, formal translations of features of the natural world, or of patterns dictated by techniques with wicker or textiles. The monuments imply that the many who were required to erect them recognized the necessity for them, but this does not necessarily imply coercion, or even the existence of any highly organized society approaching the truly urban, except in their latest phases. Religious needs were a more cogent driving force than political. There were early 'megalithic' cultures elsewhere, from south India to Polynesia – none so ambitious.

Our terminology shows that the Stone Age becoming the Bronze Age is a transition determined by technological discovery. This happened in different places at different dates, really never in pre-Columbian America, and usually not without some positive diffusion of knowledge passed by people, although independent discovery of how to extract metals from the earth and how to harden copper by adding other metals seems certainly to have happened in different parts of the Old World. One thing that the Americas demonstrate is that a metal technology, with iron and bronze, is not a prerequisite for the development of a sophisticated urban society and the arts and monuments which it generates. A Bronze Age need not define a new beginning, although the wealth, craft specialization and new technologies which it involved inevitably worked notable changes at all levels of life, and this was reflected in the arts.

Artists are both inspired and constrained by available materials and what they can do with them. But it was not just the experience of iron, bronze or agriculture that both diversified and created new focuses for major cultures in the Old World, and led them to adopt

distinctive ways of life and art. Greater possibilities for the sharing of knowledge through observation, travel, even the beginnings of writing, and far larger populations which we can better understand because they left more for us to find, make the study of man and his arts suddenly a more challenging prospect. We launch into the three main areas of our study with a world order not all that unlike our own down to about a century and a half ago, since the transition to the truly modern world was also mainly technological, especially in so far as it is related to ease of travel by land or sea. To put it baldly, access to and understanding of materials – stone, clay, metal – lead to the development of technologies to exploit them; these, and by preference agriculture and a non-mobile way of life, generate growth and what we call 'progress'. Without the more advanced technologies, whether in the service of power or agriculture, there is little or no 'progress'. This can be observed in the history and arts of the north, south and the Americas (before the arrival of Europeans) when compared with the temperate urban societies of the Old World.

The purpose of early art is of course fundamental to its execution and determines form and decoration. It takes us away from the strictly practical into man's concern to understand the world he lives in, how to preserve or even improve it, by a form of magic which can be expressed in decoration and form, as readily as in song, act or ritual; indeed, all go together. It concerns the living world of animals and plants, and what we prosaically call the environment; it concerns life and death, the acknowledgement of the rule of nature, and then the assertion of man's dominance over both nature and his fellow men. The mystery of death might be regarded as simply a different existence requiring equal attention from the living. Which is why so much of the history of ancient art is about advertisement and security for both the quick and the dead, and about the mediation of exceptional humans between the everyday and the spirit world – the realm of priests, doctors, shamans, who access the spiritual through the frenzy of dance, drugs, or some inborn psychological imbalance which had marked them out from their fellows. This access was one of the functions also of man the artist.

In this chapter I have so far avoided use of the word 'primitive'. It has too many connotations which are either pejorative or complimentary rather than purely descriptive. It is commonly used nowadays to refer either to arts of very early people, or to arts of innocence, which are mainly tropical, and in truth very far from being innocent; these arts were highly influential among European artists a hundred years ago. I take the utterly primitive to be an art which may indeed be attempting to serve a purpose, but which in execution evinces no sensitivity or thought promoted by either medium or subject – at best an entertaining doodle. It is commonly a display of stick-figures such as may appear on cave walls in the early period, but almost anywhere subsequently, and is usually the product of people whose requirements are casual, although the subjects may be informative and serious, and only the technique naive.

The 'primitive' that might be a subject for a world history of art of all periods can be very sophisticated, whatever the simplicity of its appearance. It may be a response to much the same stimuli as promoted other arts, sometimes totally conditioned by medium (notably weaving or wickerwork) but not otherwise much determined by technique or direct visual inspiration. It is totally conceptual but not casual, and often intrudes into areas where more sophisticated arts, both in early days and far later, were practised; but most often where they were not. It is timeless and as likely to be met today as in the remains of remote antiquity. I deliberately avoid consideration of any of this in terms of child art, though this is done by many scholars, mainly because child art begs too many questions – of vision, intent and ability, rather than environment, even parental environment. Therefore, while a few words on the matter are required, 'primitive' in these terms is avoided here. And although many early and later arts, such as the African and Polynesian, may seem to qualify as 'primitive' in the view of art historians seeking their influence on later, modern artists, this seems to me a convenient rather than accurate use of the term, and another reason for avoiding it. For much the same reasons 'folk art' is also shunned as a serious descriptive term.

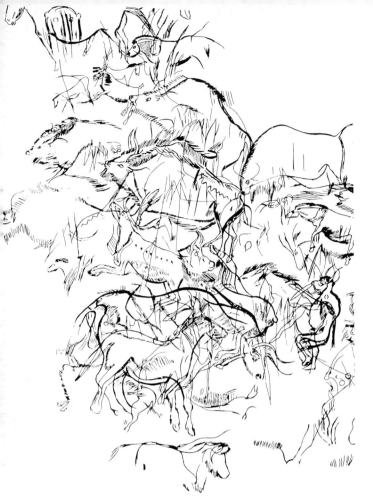

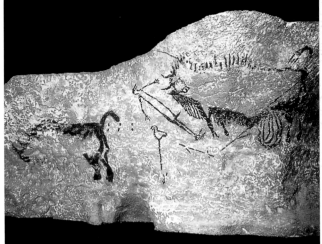

1 Engraved scene of overlapping figures of bison and a bison-man on cave walls at Ariège, France. About 15,000 BC.

2 Cave painting at Lascaux (Dordogne, France): a horse, cattle and stags on the ceiling of a gallery in the cave; several of the figures are painted at considerably more than life-size. The paint is a very realistic yellowish ochre; a wounded bison (a spear in its side) attacking a man. About 15,000 BC.

3 (a) The 'Willendorf Venus', from near the Danube, NE Austria. A figurine of fine limestone which emphasizes the important elements of female anatomy, but ignores facial features in favour of a mass of curly hair. Height 11cm. Before 10,000 BC. Vienna, Naturhistorisches Museum. A yet earlier (about 30,000 BC) Venus found recently near by (Galgenberg) has a more lively pose. (b) The 'Venus of Laussel' (Dordogne). Carved on a fragment from a rock face. Height 43cm. Before 10,000 BC. Bordeaux, Musée d'Aquitaine.

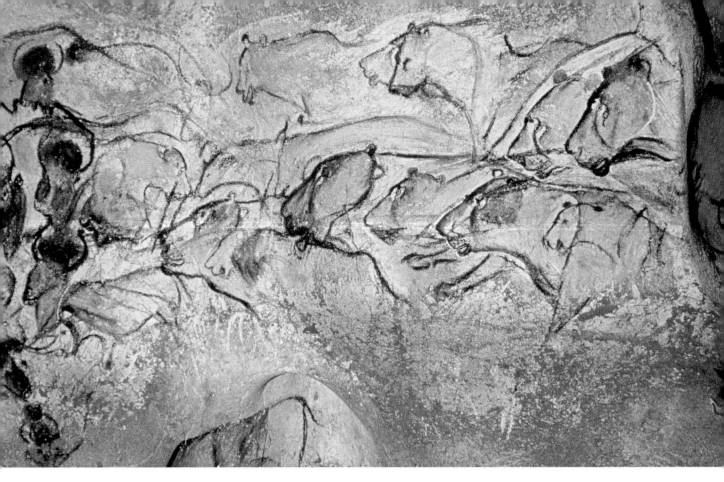

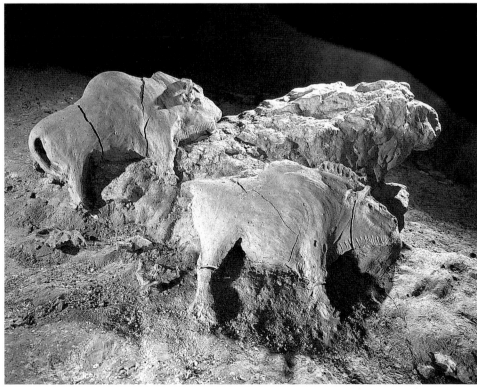

4 This is apparently the earliest of the known cave paintings, in the Chauvet Cave (Ardèche, France). The animals include a rhinoceros, drawn in outline, bears, big cats and mammoths. About 30,000 BC.

5 Modelled clay reliefs of bison mating, on a cave wall at Tuc d'Andoubert (SW France). Each is a little over 60cm long. About 15–10,000 BC.

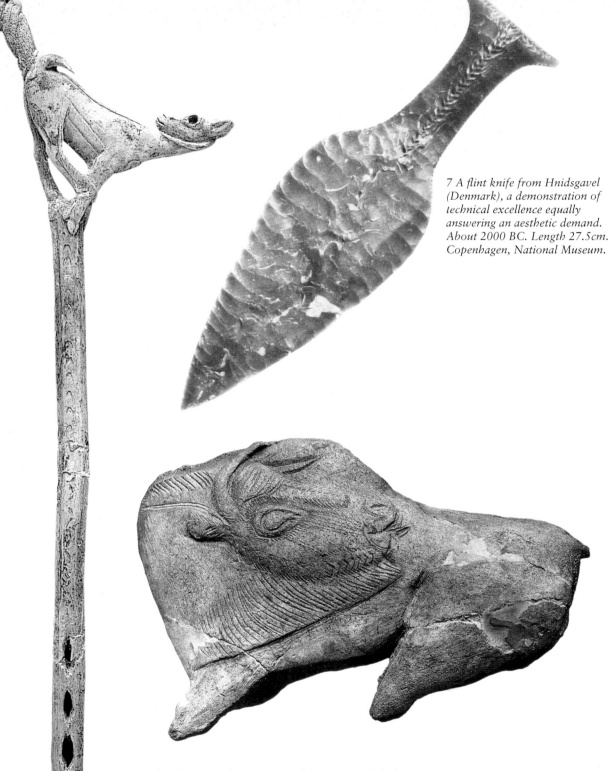

7 A flint knife from Hnidsgavel (Denmark), a demonstration of technical excellence equally answering an aesthetic demand. About 2000 BC. Length 27.5cm. Copenhagen, National Museum.

6 Carved antler spear-throwers (Magdalenian period; before 10,000 BC): (a) with the figure of a young deer, from the Pyrenees; (b) with a bison, from La Madeleine. Length 10.2cm. Both St-Germain-en-Laye, Museum des Antiquités Nationales.

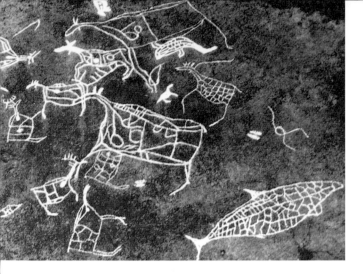

8 Arctic art. Rock engraving of animals and a whale from Buskerud, Norway. This X-ray treatment, indicating skeleton and organs, is met worldwide (notably also in Aboriginal Australian art), but especially in the north, and indicates a desire to render both form and structure in the drawing. The whale is 1.4m long. Before 2000 BC.

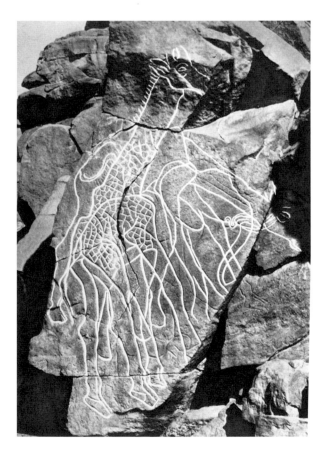

9 Giraffe and elephants incised on a rock face in the Fezzan (south Libya). Early Neolithic? Height 2.55m.

10 Stone T-shaped pillars with incised and relief decoration were set around the interior of a temple at Göbekli Tepe in northern Mesopotamia (E Turkey), a cult place for Early Neolithic hunter-gatherers. The pillars are some 2.5m high, and an unfinished one was found over 6m high weighing some 50 tons – truly a megalith. On the one shown there are ducks on the capital, water birds on the shaft, while the side of the shaft shows fish, an insect and snakes. 10th mill. BC.

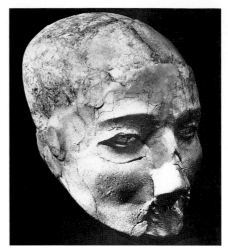

11 Wall painting in a 'shrine' at Çatal Hüyük in south Turkey. It appears to show terraces of houses and a distant view of volcanoes. Other shrine walls were decorated with plaster bull heads, like trophies, incorporating actual horns of wild bulls. The houses of this farming and pastoral community were semi-dugout. Neolithic, 7th mill. BC. Ankara Museum.

12 A human skull made up in plaster, with cowrie-shell eyes, from Jericho, a practice attested elsewhere in the region. Compare the bull heads at Çatal Hüyük mentioned under [11]; and in early Egypt (but much later than Jericho) there were attempts at restored portraiture on skulls or 'making up' of figures. 7th mill. BC. Amman, Jordan Archaeological Museum.

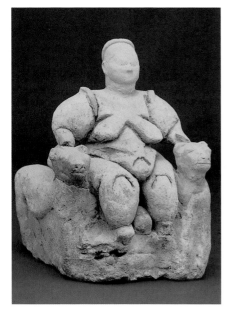

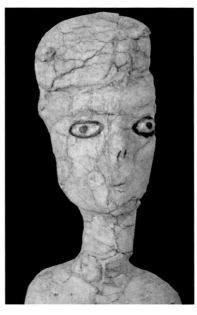

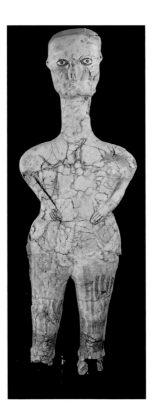

13 Clay goddess seated on an animal throne, from Çatal Hüyük. The body forms are as those of many Neolithic figures elsewhere, but here she is given furniture – a type repeated long after for the royal or divine in the Levant and Egypt, on lion or sphinx thrones. Neolithic, 7th/6th mill. BC. Height 20cm (head restored). Ankara Museum.

14 Painted plaster figures, half-life-size, from 'Ain Ghazal (Jordan). The eyes are outlined with bitumen, with orange, green and black paint indicating dress or tattooing. Sexual characteristics are conspicuously absent. 7th mill. BC. (a) London, British Museum ANE. (b) Amman, Department of Antiquities.

16 Major figural work is not a characteristic of the Megalithic, apart from some upright stone markers ('statue-menhirs'), in southern Europe, Corsica and Sardinia, not much shaped to the body forms which are marked upon them. Their purpose is not clear but they do not feature much in settlements rather than in remoter places; there are male and female – most have no mouths marked, which may be significant. The general type is seen across Europe, to the Ukraine, where they resemble the very few stone figure-markers made by eastern nomads (kamennaya baba – 'stone women'). This is one of the more complicated from the west, from Saint-Sernin-sur-Rance (Aveyron, France). 3rd mill. BC. Height 1.2m. Rodez Museum.

15 Stonehenge stands splendidly in Salisbury Plain, southern England, well viewed by modern travellers from a main road. It had 30 uprights, 7m tall, joined by lintels, enclosing further circles with uprights, some of local stone, some of bluestone from Wales, 200km away. Built around 2000 BC, it is one of the latest of the west European megalithic structures. Alignment to celestial events – risings of sun and moon – indicates that seasonal rituals were among the purposes for such monuments, which take the form of circles or avenues, or simply standing stones. Such ambitious architecture is not matched by any very notable exercise of other arts in other materials.

II

THE ARTS OF
URBAN LIFE

This is, inevitably, the core of this book, offering more detailed consideration of the achievements and arts of the major urban civilizations of antiquity, from China to Egypt to the Roman Empire, from Mexico to Peru. It is mainly descriptive but it also seeks out similarities rather than differences, and so the first part attempts to define what many of these similarities may be, generically – the Common Record (A) – before going on to a survey, area by area, which will also demonstrate but not dwell on the differences. Most of these are 'stylistic' and are the sort of thing that helps us easily to distinguish, say, Egyptian from Chinese. Two interludes introduce the special problems of the genesis of Classical art (C), and of drawing comparisons between the Old and New Worlds (E).

A. THE COMMON RECORD

PLACE AND STYLE

The one common factor here is the environment: mainly temperate (in the Old World), or capable of admitting physical adjustment by man, so that the advantages of a temperate climate for the creation of any urban civilization based on agricultural wealth could be exploited. The adjustments were mainly a problem for the New World and any near-desert regions. Another common feature is the focus provided by a major river, offering possibilities of developed agriculture with irrigation (the Yangtze and Yellow Rivers, the Indus, the Oxus, the Tigris and Euphrates making Mesopotamia, the Nile, rivers on the Mexican plateau and the Peruvian coast); and the availability, of increasing importance in the Old World, of mineral resources. Geography combined with exploitation of the indigenous animal world for riding and transport (in the Old World the horse, camel, oxen, with sledges, then the invention of the wheel), plus a measure of ingenuity and daring in sea-going (although this was mainly coastwise and not cross-seas and proved less important than in later years), ensured knowledge of other peoples and access to their resources, both material and conceptual. In the north the European rivers (Danube, Rhine, Rhone) and the Russian (Bug, Dniepr, Don, Volga) seem to have been more important as routes than as focuses, except at their mouths, and much the same applied to the rivers far to the south, sometimes in rain forests (Amazon, Niger, Congo). These are subjects for Chapters Three and Four.

The advantages offered by the environment, and the requirement of organized labour for large-scale agriculture and public works, went hand in hand with concentrations of wealth, and encouraged the development of centralized power, kingdoms and empires. Efficient agriculture produced a surplus to maintain labourers and soldiers, and the luxury of encouraging specialized crafts in the service of both the ruling classes and the ruled. Power was expressed architecturally by the design of cities and palaces, realized on a grandiose scale through the availability of mass labour, hired or servile. Manners in the higher arts, not only architecture, were set by the rulers, and it was in their interests generally that these manners should be conservative, reflecting on the stability of their dynastic power. Artisans are essentially creatures of habit, only occasionally innovative, but conservatism can also in places lead to deliberate archaism and even stagnation. There is little incentive for change, once acceptable modes have been devised. It is probably true to say that the more absolute the authority, the more stereotyped the arts.

In a discourse intended to look for similarities rather than differences, the latter will always be apparent – the difference in 'style' between Chinese and Egyptian arts, for instance – and they deserve a moment's thought. Is Egyptian style inevitably one of a desert people dependent on one river, and the Chinese one of a people living beside rivers and hills? In the early period, as surveyed in much of the last chapter, very strong regional differences did not emerge; some account of these pre-urban arts will appear in this chapter too, as a reminder or for contrast. But the differences do become apparent in the major urban societies to which we now turn, where the developing local styles do not obviously emerge from what went before except in a very general way, dictated by environment and materials. The overall styles are as different as the languages. Is there a connection? Differentiation in language certainly occurred long before the creation of distinctive local styles in the arts of the urban cultures. Both language and art are means of communication; are they more closely related? Might a highly inflected and structured language, like the Indo-European, predispose the artist to a more architectonic attitude to his craft; or vice versa? Does this explain the superficial differences between Greek and Chinese art? Having posed the problem, I back hurriedly away from the question: our understanding of art and language do not yet, I believe, allow us to answer it with any conviction for the early period; at any rate it must lie also in the hands of scholars other than art historians. There are many more questions than answers here.

A geographical unit, like China or India, does not of course guarantee a cultural or political unit, but it certainly helps to promote one, just as it tends to promote a common language, arising from and contributing to easy communication of ideas and images. People who share the same language do not always share the same views about art and life, but commonly they do, and, at a more restricted level, even a common dialect can be found to correspond with a common view of the arts, promoted no little by propinquity. A common language and common views about the arts do not, however, guarantee also a common ethnic origin. This becomes apparent where arts and language are both well enough defined, as in the Classical world.

CITIES, ARCHITECTURE AND CEMETERIES

Security and display were two major factors in building cities 17-22. Planning had to answer the demands of defence and of easy internal communication, but was no less an expression of power. The rectilinear was commonest, with a grid of streets, except in the earliest towns which followed the more haphazard pattern of most agglutinative settlements around a central meeting place where the chief lived; but often, for his own security, a chief would remove himself from too great proximity to his subjects. Such settlements seldom survived into the period in which they might qualify as a city. Regular circular plans generally derived from the scheme of simple encampments. Major buildings occupied eye-catching positions, on high ground if possible or on an artificial terrace. Where town defence was not a concern the habitation spread loosely around the better-defined areas of the cult or administrative buildings. Earthquake areas tended to avoid unstable tall structures (China, Anatolia, Central America) but could build massively.

A kingdom might have more than one major city, each with a palace, and rulers could be peripatetic. There were also subsidiary cities, for princes or garrisons, generally modelled on the capitals, and sometimes with subsidiary palaces. The Minoan 'villas' of Crete are but one example of princely private houses with palatial aspirations; this must also explain many of the smaller but well-appointed Central American sites. Sites built for the practice of cult only were not always embraced in city walls but could be quite separately located at what appeared to be holy places, and then might need their own defences. The cult of the rulers was generally in or near their palaces, and in some places the god might seem more important than the ruler, but then the ruler was very commonly assimilated to the god.

The practice of the élite arts depended on what materials were available and often took the form of a monumental expression of what had been achieved in the arts at a lower level, even the urban domestic. If we look at architecture, one result was the creation of 'orders', well-defined and predictable decorative and constructional forms, like the Classical Doric or Ionic, Egyptian *cavetti* and capitals, spreading Chinese eaves with decorative brackets 24-27, 77. Some of these are best displayed in columns and doors, and many copy forms natural in materials other than stone – tree-trunks, bound reeds, etc – while the notion of using a carved human figure as a support was as widely used in architecture in the Old and New Worlds (Caryatids, Atlantes; 28-30) as in minor arts (hilts, mirror handles). The orders tended also to determine plans for major building types, which changed slowly over centuries, and the importance of the column itself may derive from its role in tentage, especially covering large areas where a forest of tent-poles/columns was required – whence the 'hypostyle hall' with its forest of columns which is found in the more ambitious early architecture of many parts of the world.

This regularity in architectural manners is apparent in most places but most codified in the Classical world, India and Egypt. A certain resistance to change was not inhibiting, although change could be slow. Concentration of artistic or artisanal interest in centres of power or population meant that change obeyed a certain logic of development, which the archaeologist and art historian can trace and date more easily than they can in the areas to north or south, where the

architecture is evanescent. There are patterns of change, not universally shared and often dependent on techniques and materials as much as taste. They are apparent in every area, least perhaps in Egypt and America, and most in China, Mesopotamia and the Classical (Greek and Roman) world. I would be reluctant, however, to accept the proposition of any universal model of development and decay in the architectural or other arts; too much depended on the patterns of political power, which we should not expect always to be mirrored in the arts, though they can sometimes help to explain change, for better or worse. What would have happened to American art if the first contacts with another urban culture had been with Buddhists not Spaniards?

Size was important both *per se* and as an expression of power. Structural height might acknowledge the possibility of access, through ritual, to and from the presumed homes of divinity, most obviously the heavens, or it might acknowledge the importance and possible divine occupation of mountains. Pyramids, *ziggurats*, stupas, pagodas and the American stepped mounds are the obvious examples, and can even be called 'mountains' **31–34**. Major buildings may follow regular patterns but are customized for their occupants, divine or mortal – a new king needs a new palace, a god needs thanking for a victory or reminded of his obligations by a new temple. For both temple and palace, control of entry was important. And display is important – processional ways, and plazas for assemblies, generally undemocratic in origin and usage (compare Red Square in Moscow or the Horse Guards Parade in London).

The major and most visible monuments of any community were designed for its rulers, its gods or the dead, and permanence was sought through choice of materials – best was stone, then fired brick, and *faute de mieux* wood. Yet size often had to be determined by what width could be spanned by a wooden beam. Stone vaults could be achieved by corbelling (letting the stone courses overlap gradually to meet at the apex), which was the only method in the New World **40, 45b** and widely practised in the Old **36–37, 39**. But in the Old World the true arch, with a keystone, was also eventually understood, and thence the vault and dome **38**. There is even a premature instance of it in 3rd-millennium BC Mesopotamia for a mudbrick vault **35**, such as are regular there for tombs at Nimrud in the 8th century BC. It reminds us that things can be independently invented and sometimes have to be reinvented. Wealth promotes greed, which creates problems of security, and the arts of defence for cities and palaces could require consideration of more than mere size and weight in their design. Monumental gateways, by their size and symbolic decoration **195, 213, 238, 337, 409, 541**, were meant both to reassure and to terrify.

When it came to size the natural landscape offered infinite possibilities. Conspicuous features could be deemed holy, and views of them exploited in the layout of temples and towns. Some city plans involved a form of landscaping in the creation of terraces **354**. Taking the broader view, one might interpret the overall appearance of a city as being, consciously or not, a statement of contrast or collusion with its setting, challenging it where the environment is flat and featureless (Central Asia, Egypt, much of Mesopotamia), and imitating it where there is more articulation of landscape (China, Greece, South America). Any alteration of the natural landscape was unusual, but attempts on a colossal scale came in the form of rock-cut sculptured façades for tombs and the like **49, 212, 220, 339**. Fortunately nothing came of a plan to carve Mount Athos into an image of the seated Alexander the Great, anticipating Mount Rushmore with its colossal American Presidential heads. But it was not only the fully urban cultures that harboured comparable ambitions. Think of the White Horse cut in the turf of the chalk hill at Uffington in Oxfordshire (about 800 BC), the Serpent Mound of Ohio **612**, the Nazca lines of Peru **533** and the 'geo-glyphs' of Chile, where dark stones were assembled in the silhouette shapes of animals, even of a human figure 105m in extent. More generally, man the artist has not been slow to alter the natural world for purposes of display, and in earliest days it was natural unaltered objects – pebbles, horn, bone – on which his imagination played.

To return to the practical: road building became a major concern once surfaces for rapid travel by horse, cart or chariot could be prepared. The Achaemenid Persians were among the first to concern themselves about this, and over vast distances (Persia to the Aegean), but there are paved Minoan roads, and the Romans were the prime practitioners, with military needs probably outbidding commercial ones, while the Incas in Peru had to deal with even more difficult terrain for their extensive road network. At their best the aqueducts **41** and viaducts, even drains, of the Roman world are high architectural art, and everywhere the fountain-house or bath, as a focus for civic life, was also a field for architectural decoration.

Only the Greeks, followed by the Romans, made major architectural provision for the theatre **310, 407, 408** or sport, in the form of a stadium or gymnasium. The Central American ball-game courts **470** hardly count as sportsfields, given their apparent religious purpose and the dire outcome for the defeated **477**, but it is often said that the Minoan courtyards in Crete were for the bull-leaping 'games'. The military training that was the reason for early 'sport' everywhere did not involve a public spectacle, except where funeral games were mounted to honour the military prowess of the dead, and these needed no permanent structure.

Formal private, usually royal parks, from China, through Anatolia to the Aztecs, were at various times important civic features. For the Assyrian and Achaemenid Persian nobility large areas could be laid out and stocked with wild animals for the hunt – literally *paradeisoi*, paradises. The Hanging Gardens of Babylon, terraces of trees, were justly renowned, not least for the feats of irrigation required **168**. The creation of formal gardens, usually with water features and pavilions, was as constant a preoccupation of many rulers and nobles, from Egypt **23** to China, as provision of palaces, perhaps from nostalgia for a farming life, but often for the practical purpose of growing fruit or vines. Walled gardens, with their waterways and groves, in Persia, Central Asia and India, can still be enjoyed as civilized oases in desert regions. The creation of special buildings for commercial and administrative

purposes was a peculiarity of the Classical world – stoa colonnades for offices and shops **355**, lawcourts, council halls. Palaces were important for dynasts, to dominate as well as protect. Temples had to accommodate the deity, usually in the form of a statue in the Classical world – the temple's main function – but also with provision for ritual and display of offerings. Since the exercise of power was deemed the gift of the gods, their temples reflected as much or more on civic or dynastic strength as on piety.

Public cemetery areas were generally not architecturally defined, as modern ones are, but royal burials were given appropriate settings everywhere, and they could be conspicuous, like the pyramids of Egypt, or carefully hidden, like the royal tombs at Egyptian Thebes, largely to protect the wealth of their contents. The largest manmade mounds of antiquity covered graves. The tombs of one's ancestors embodied power, so they were not only guarded but often placed where that power might be most effective, under the tallest monuments (pyramids in Egypt, mounds in America), but also under houses, even palaces (Assyria), or in a conspicuous place in a city (the Mausoleum **309**, and in Rome). Few cemeteries spoke to the living as directly as the Classical, with their sculptured monuments showing the dead as in domestic life **308**, and figural decoration applied to tombs was generally more devoted to expressions of power and status.

Understanding, and some assumed control, of the seasons was essential worldwide, and this generated advanced study of astronomy. In the settled communities this is expressed regularly in architecture by the orientation of buildings, and the creation of calendrical or time-keeping monuments that recorded and even predicted celestial events. These can be highly sophisticated and can be traced long before cities. Star-maps of varying degrees of accuracy and often in religious contexts are ubiquitous. A formal and codified rationale or even written prescription for the laying out of cities can even be found in China, India, America and the Classical world.

Continuity was a major concern, contributing to conservatism in the arts and to care for ancestors and their tombs, combined in places with provision for the

assumed or desired immortality of those buried. So tomb construction and furnishing were major considerations and engaged artists who had to demonstrate the immortality of people and families, often linked explicitly with the immortality of their gods. This was a lesser concern, or at least less elaborately managed, in the lower echelons of society – most of the arts of this chapter are élitist and not so conspicuously public as were the Classical. So artists were everywhere employed to create and stock satisfactory environments for the powerful in their afterlife, often hidden from view. China and Egypt provide the most spectacular examples. In many places attempts were made to restore the body itself, from the very early plastered skulls of Jericho **12** and Egypt, to embalming (Egypt) or other forms of body restoration (South America, Central Asia). Some peoples resorted to the provision of gold masks or jade suits, gold and jade being symbolic of eternity, or at the least an application of red paint or ochre which seemed to restore the blood to bones. The artist abets society's attempt to preserve the dead for the benefit of both the dead themselves and for their surviving family. He has no role only where the body is purged of mortality by fire or flesh-eaters, but in a formal cemetery ashes can be lavishly accommodated too. Tomb finds are often our major resource for ancient arts, since those that escaped early looting can be more readily and effectively sought out by the excavator than objects from houses. Ancient Greece has again proved an exception by taking more care for what went conspicuously on a tomb than for what was hidden within it; this has proved a continuing trait, encouraged later and elsewhere by Christian and Buddhist attitudes.

FUNCTIONS AND APPLICATIONS

Before art was ever 'for art's sake' its function, that is, the need to employ a specialist artisan or artist to produce or decorate an object or structure, was definable in terms of any society's needs. Our last section anticipated this one, with some account of the artist in the service of both the living and the dead. Incentives can range from the political to personal adornment. I select here some of the obvious, with some less obvious but no less evocative, essential and universal examples.

The range of artefacts which afforded the artist opportunities for invention or even individual expression was determined by social requirements, which were much the same everywhere. The skilled artist was often challenged to reproduce the commonplace, such as clay pottery, in extravagant forms or with scarce and therefore valuable materials, precious metals and the hardest stones. A gold dagger may not be much use in battle but it makes a brave piece of equipment for a king, and his real sword may also have extravagant fittings and decoration. Dedications to the gods which were generally on view had to impress fellow men as much as the divinity. Objects commonly made from humble materials – clay, leather, wood, horn – were everywhere reproduced in more valuable, even if less efficient, equivalents (technically 'skeuomorphs'). In the same way, many precious objects could themselves be downgraded in copies in poorer materials to be more widely employed and admired as decoration of modest gifts to the gods. There are many points of contact between the élite and the humbler arts.

In a world where nationality and loyalty began to be matters of importance, yet easy communication and trade exposed all to the ideas and arts of others, it proved possible and perhaps necessary to identify or create visual corporate identities – in blazons, dress, recognizable figures of kings, gods or heroes – commonly based on religion. Deliberately or not, these might keep at bay the ideas and images of others which, where they were pervasive, might always be countered by reinterpreting them for local needs. The fortunes of a state may be bound up in the survival and protection of an image of its god – in Homeric story, Troy will fall once its *palladion* statue of Athena is stolen **443**. We shall see much of this at the interfaces between cultures, where peoples seek to steal or annul their neighbours' sources of strength. Art can be used to define nationality just as it was and is used to define class, sometimes very precisely, but 'ethnicity' was not the same sort of problem in antiquity as it is made to seem today. Art can by the same token be used as propaganda, to encourage or reassure one's own people, to persuade or frighten outsiders. This becomes more subtle in the Classical world than in most of the other areas studied in this Chapter. But the placing of visual statements of power at entrances to towns or palaces is normal, and trade in decorated objects or with coinage can be a successfully insidious form of propaganda, introducing significant and attractive foreign images.

Dress is an important marker of status and an art form in itself as well as a significant factor in representations; the naked figure was seldom depicted for its own sake, except to indicate the very young, the impoverished, servile, dead or despised. This reflects life, where clothing reveals status; here again, Greece proved an exception. Uniformity requires uniforms; these were not exclusively military, but also for religious personnel, senior administrative staff and certainly royalty. Hence the value of head-dresses, crowns, sceptres, conspicuous jewellery and raiment, even hairstyle. Tattooing of large areas of the body was not for the truly urban man about town, but not unknown.

The desire for display explains much of the energy spent on acquiring precious metals and the most recalcitrant of hard stones – obsidian, jade, the harder gemstones – and the incentive for devising techniques for handling them. Gold can be managed in various different ways – cast, as wire, in foil, as granules, soldered – and advanced ways of manipulating it for these effects were devised independently in Old and New Worlds. In the absence of gold other metals or stones acquire the same status. Prestige and value are added if you coat something with gold, jade, lacquer or enamel, or inset it with precious stones. Colour can convey much the same effect and it is sad that so much of ancient art has come down to us without its original colour; but pigments were as sought after as metals, and colours had significant connotations – lucky green, virile red, etc. Jewellery of precious metals and stones, for men or women, everywhere concentrates on those objects which are most conspicuously worn – earrings, finger-rings, attachments to clothing and equipment. Big jewellery spools to be fitted into stretched ear lobes are found in Old and New Worlds. Where the material is precious it signifies wealth and status, sometimes indicating office and authority, as with signet rings, which may also indicate personal identity. In poorer materials, stone or wooden beads, it helps satisfy the desire for ornament, but we should never assume it was without some other message. Durability is a major factor in all this – the way the stones never wear, the untarnished inviolability of gold, the pure reflecting white of silver. These too are the materials in which best to express the power of the supernatural, at a more sophisticated level than the commonplace magical.

With the less-than-monumental arts serving everyday life, we are perhaps brought closer to the people than to their gods and rulers. These are certainly often the only media in which we may detect humour and compassion. Clay is the ubiquitous, cheapest and most versatile material, and the invention of moulds, everywhere, facilitated mass production of significant and influential figure types as well as answering the demands of conservatism. Clay figurines often mimic the more grandiose images in harder or more precious materials, but sometimes they offer images peculiar to their scale

and medium, and to their lower social environment. Pottery decoration allows a field for significant pattern, and for portrayal of less ambitious themes, even narrative, but is seldom so used except in the Classical world and parts of America (notably the Maya and Moche). Where the pots themselves have a more than domestic function, as offerings or for ceremonial, their shapes and decoration may reflect this.

In such complex and interacting societies the ability to write, either in order to communicate or record, becomes a more pressing need than to the north or south; writing can become an art form in itself and even influence other arts, as with Chinese calligraphy. Writing in the Old World starts with pictures, for things which are also described in sounds as speech. Speech expresses more than pictures can, including things and ideas that cannot be drawn. But the picture of an object recalls the sound of the word that describes it. Other words can thus be expressed by series of pictures which convey those sounds, regardless of what is being described, whether an object or an idea. The pictograph lies behind all early writing in the Old World 42–50. In the New World it was much the same for the Aztecs and Mixtecs of Mexico, but the Maya script 52 had a more complex origin, combining the phonetic with the semantic, sound and meaning. Where the written characters start as pictures they call for skills in rendering natural forms in miniature, forms which become more stylized with time, some ultimately becoming our alphabets 51, 69. They long remained in their original form in Egyptian hieroglyphs, however, which create exquisite 'writing' 43, and the pictograph remains the ultimate inspiration for most later Old World scripts. But they become so stylized at a very early date in the cuneiform of Mesopotamia (the signs deconstructed into groups of wedge marks) that their origins are totally obscured 44; yet a cuneiform document can remain still jewel-like in appearance 48. In China, a relatively late starter, the translation of the pictograph takes a quite different turn, to fluent calligraphy with brush and ink, and writing emerges as an art form as nowhere else 42. In Central America the 'glyphs' long remained broadly intelligible in terms of their origins and they changed but little over

centuries **52**. The Classical world made a virtue of stone-cut lettering **51, 69**.

For the important written messages to be effective they relied greatly on the way they were presented. This is especially apparent when texts are used as propaganda or for instruction – the decrees and self-congratulatory annals of Mesopotamian and Egyptian kings were prominently displayed although to a mainly illiterate public, the Buddhist King Asoka's columns carried his edicts, Maya staircases could be covered with annals, while at Bisitun in Persia the great trilingual inscription of Darius I is as much a work of art as the relief it accompanies **49**. Classical Athens was smothered with regulations and lawcodes whose effect depended more on their sheer presence than on their ready legibility. Statues may themselves be covered with inscriptions, not just on their bases but on flesh or dress, in Old and New Worlds **214, 344, 481**, so close is the association of image and text. We shall see many narrative arts mixing images and texts freely, especially in painting and relief sculpture, and regardless of scale, but the picture takes the lead and there is nothing like an 'illustrated book' except in Egypt, the late Classical and the latest Maya/Aztec **459, 521, 522**. Writing itself is a form of magic.

Administrative needs created the practice of sealing, for property and documents, and everywhere in the Old World seal-engraving becomes a major, miniaturist art, usually with figure subjects except in China where most are inscribed with names, like rubber stamps **111**. All the major cultures used seals in this way except the Americans. Simpler patterned stamps (*pintaderas*) had been used in early periods (back to 6000 BC in Anatolia) for decorating material or flesh, not for business purposes. In the New World there were intaglio cylinders and stamps of clay, usually patterned and rarely figural, for decorating objects, textiles or flesh, but not for use as administrative seals. In much of the Old World, notably the Classical where it comes close to jewellery, seal-engraving was a major art form **116, 121, 204, 215, 232, 233, 243, 284, 313, 334, 345, 346, 374, 397, 441–43**.

Weight standards were derived either from weights of basic materials used for exchange, or from association with volume (a potful or handful). Natural objects serving as money were counted not weighed – cowry shells, cacao beans – and inspired the earliest forms of coinage in other materials, in China. Coinage as we know it, as round or square stamped or cast metal, was an area in which the artist came to be most active, following Anatolian and Greek example, and the arts of providing devices for coinage were closely allied to those for the creation of personal seals. Coinage also offered the commonest form of widely disseminated display of corporate identity in images (such as the 'Athenian owls' carrying the city goddess' familiar **316**), as well as a field for propaganda in the Roman world **411**.

We come now to the representational arts, both applied and as independent monuments. The secular and divine went hand in hand, and the stories and therefore the images of gods depended no little on the recorded or observed behaviour of the ruling classes or of their imagined divine or heroic ancestors. This removed them no little from their origins in the earliest religions, which were inspired by the needs of survival and the more direct acknowledgement of natural and animal forces; this was more apparent to a late date in the arts of the northerners, although gods of the weather and countryside were always important, everywhere.

With the power of a mortal ruler so closely linked to the patronage of the immortal, images of divinity were humanoid, with rare recollections or admissions of the power of the animal world, notably in Egypt, India and America, harking back to more basic views about the function of religion and of man's dependence on the animal kingdom. This emerges in the images of the daemonic or monstrous which were devised to express natural forces, either benign (the Chinese dragon and phoenix) or, more often, malignant, and thus requiring the attention of gods, heroes and kings, and thereby a means of demonstrating their power. Many images of monsters are simply distorted predator forms, but it is notable how many have an essentially anthropoid base with animal additions, generally of predators (lion, tiger, jaguar, eagle, snake, scorpion), or they simply bear animal heads or limbs. There are very few totally imaginary monster creations, except in literature; exceptions may be the Chinese dragon who develops from predator to reptile with a variety of additive features (e.g., **99, 104**), or the Greek sea-monster/*ketos* **449**, and various Indian Hindu attempts to render impossible literary monsters and activities in art **157**. Combining animals to represent monsters is commonplace, and often disturbingly realistic. Leonardo da Vinci remarked that you can make an imaginary animal appear natural by 'having its limbs such that each bears some resemblance to that of some one of the other animals'.

The natural world of vegetation played a role in art determined by the importance of plant life, from maize to the vine, for survival, as well as by its ubiquity in the real world. What we might define as decorative pattern can often be seen to be a stylization of the real – a wreath, flowers, animal skin – or to derive from crafts which have survived less well and where the patterns were largely determined by materials and techniques, most obviously in weaving or wickerwork and carpentry, resulting in a worldwide commonality of pattern ('technomorphs'), wherever the same materials and so the same techniques were current. This is made most clear in those very rare anthropological museums, such as the Pitt-Rivers in Oxford, where objects from all around the world are grouped by function and technique, not geography.

Figurative arts are important. They are a means of communication and recollection, essential in a community whose rulers depended on recognition of their power by their mainly illiterate subjects, and whose priests had to justify their authority. They are important also as a record of history and myth, no less so than oral or written traditions. Scenes of action were largely devoted to commemorating the behaviour of gods and of rulers as victors. These might then range from depiction of court life, often dwelling on the ceremonial which expressed power, or dangerous élitist sports like hunting, to the defeat of enemies, real or surrogate (monsters), as well as sheer displays of wealth

and high living. Scenes invoking divinity might equally range from depiction of worship to the defeat of challenging supernatural powers, sometimes of the family of gods which mirrored the dynastic hierarchies of mortal rulers. Conservatism and the desire for continuity meant that there was sometimes almost an obsession with the past and its stories, which became a major theme for the artist. In many respects a detailed awareness of the past might promote concepts of progress, and of the necessity to plan for the future, not strongly apparent on any lengthy time scale outside these urban cultures. In some places deliberate non-portrayal of the divine was practised, to avoid sacrilege; thus in early Buddhism, some Semitic and, later, Islam; or the divinity is replaced by a symbol or attribute.

A by-product of this historical viewpoint is the mortal acting of narrative of the past. At its simplest this is the re-enactment of a hunt to ensure repeated success, using masks and animal skins. More sophisticated is the spoken theatre, which goes beyond the enactment of successes achieved or desired in the hunt or war, and could permit precise identification with gods or men verbally and with masks and dress. But this is also a popular activity in all periods and places, and, except for religious acts, was possibly not as popularly enjoyed in a formal way in the main urban cultures as it was to be in the Classical world, where it not only inspired major literature but also major architecture for performances. Not all cultures have left any visual record of these performances but they must often lie behind the narrative schemes adopted in art, introducing an element of staginess in presentation and contributing to the artists' expression of the spectacular, whether on stage or in procession and pageant.

For the viewer, identification of individuals, human or divine, depended on inscriptions, or familiar attributes and dress, or the context in which they were placed. This can amount to a form of portraiture, but not realistic portraiture except in a very generalized form, as for the Amarna royalty in Egypt **261-63**. True portraiture was another Classical aberration, as we shall see. Depictions of the events and activities of everyday life – domestic, rustic, artisanal – are for the less imperial arts, or can dwell on the sources of corporate wealth – generally flocks and fertility. A detailed treatment in art of or for the everyday, as well as for dignity in the afterlife, is a feature mainly of Egypt and China, but implicit elsewhere in many objects made expressly for burial, or chosen for burial. On the whole male activities are chosen rather than female. Overall, female figures are commonly goddesses, especially of fertility, or heroines involved in hero stories, but there were woman rulers, often depicted rather as honorary men (and given a false beard in Egypt), even women warriors (Central Asia). Egypt was generous in portrayal of the mortal feminine, the Classical world extremely generous; Achaemenid Persia ignored them totally in monumental arts and they are not very conspicuous in the New World.

Visual messages often need to tell stories, and not always to those already familiar with the narrative. Modes in the depiction of events were essentially timeless, even when of historical events. That is to say, figures and groups express primarily their identity and generic function in a story, which were more important than exact description of any moment of action as in a snapshot, even when a specific event is the subject. Absolute simultaneity of action in multi-figure scenes was never a determinant, rather than expression of the function and presence of the participants; nor in fact was it to be in major arts until the camera was invented. This can lead to repetition of the same figure in large compositions, and only very rarely any expression of the passage of time in events such as battles. It was groups and figures of maximum or most characteristic action that determined their depiction. Artists of each culture developed formulae for figures (thus sometimes also identifying them), groups and events, as well as observing or imaging in detail specific live action, and the formulae of written or even recited narrative did not necessarily influence the creation of the visual formulae.

There are broadly three main schemes for visual narrative, all practised in the cultures surveyed in this Chapter but generally not all at once, and not to north or south, where narrative was exceptional. The first and the commonest is mono-scenic, where a significant active episode or often the result of action is chosen, and where attendant figures may serve to allude to other aspects of

the event, before or after the action. The second is sequential, with repetition of figures in separate fields like a strip cartoon (as **428**). The third does the same, but in a single field, and here the same figure may appear more than once, or it may be possible for the prime figure (e.g., the Buddha) to be shown only once while a sequence of events is depicted by repeated figures around him. In these any unity of time is quite irrelevant (as **136, 188, 423**). Different cultures favour one scheme over another, and there are numerous hybrids which have encouraged various scholarly classifications which do not conceal the fact that the basic schemes are universal. Only the mono-scenic relate in any way to the 'snapshot' image of complicated action, which becomes familiar in western art only in the 19th century.

Everywhere differing sizes for figures indicated differing status and importance (as **179, 269, 489**), often even where the figures were realistic. But equally, the shape of the field to be decorated may dictate size, and in simpler narrative arts the desirability of having heads at the same level (isocephaly) influenced both scale and composition. Except in Classical art, the viewer did not worry that a standing and a seated figure each had head and feet at upper and lower borders and so were 'really' of different heights. The artist's conventions had to be intelligible to the viewer, and it seems that in this matter his solutions were the same everywhere in the formal arts in this Chapter. They may occasionally be prompted by imitation of a dominant foreign style (often, it seems, the Classical in the later Old World), and always open to special preferences at some times in some places, often dictated by the type of object to be decorated.

Our subject here is visual not verbal invention, and the content of major texts – epic or ritual – does not for the most part affect the way the figures, or the events that may be narrated by them, are depicted. The epics of Homer and Gilgamesh, the Maharabata, the Bible, the Tao-te Ching, are not especially good guides to iconography in ancient art until the latest period. They have acquired more value since antiquity, wherever the original visual tradition had been broken and a new one had to be created, as happened commonly in the Middle Ages or by Renaissance or neo-Classical artists.

Visual tradition can be at least as free in invention as oral tradition, except that detailed visual records may remain influential longer than a poem might be accurately remembered. But unnatural figures like monsters often have names before they have images, and observation of the processes of invention of their images can be instructive. This can make for ambiguity and bafflement in the eyes of a modern observer who is used to more coherence and individual identification in narrative scenes.

The intention of narrative scenes was to record, glorify and, through recollection, instruct. Mortal impersonation of divine and other figures makes for the creation of masks and costumes, for stage or ritual, another source of survival for images. Representations of sexual activity are generally related to cult; deliberate eroticism in art was a sophistication that antiquity rarely indulged (some in Egypt and the later Classical). The commonest form of humour in art was expressed by letting animals perform human functions **53, 55, 177**, precursors of the 'beast epics' still written today, or by attempts at visual puns, such as decorating a pot as though it were a human body or head **57**. These appear everywhere, and the Classical world became most subtle in such matters. Other types of visual pun or ambiguity occur occasionally. At its simplest this was a matter of embellishing part of a figure with the head of another: commonly this is just a matter of adding a snake or bird head to a tail, wing or any other sinuous member, and is at its most sophisticated in the Animal Style art of the steppes, but appears more prosaically in urban arts, such as those of the Near East and the Classical, where an animal could even be partly absorbed into the floral border of a scene **349**. The combination of two profile views of heads to create an image which can pass equally as a frontal view of one head lies at the basis of many early Chinese *taotie* masks **87** but is a scheme that lingers into the Medieval period. Related is the use of a single head for two bodies, a common device for motifs at corners of objects or buildings, mainly in China **92**, the Near East and the Classical world. Composition of a figure or part of a figure by use of other figures was no latter-day invention of the Renaissance painter Arcimbaldo, but in antiquity was employed less

completely. There is much of it in the Animal Style art of the steppes, and in Greek and Near Eastern heads where, for example, an ear and beard may be replaced by the figure of a waterbird **58**. In later Classical arts such combinations of parts of figures are miscalled *grylli*. The simple 'funniness' of some figures is surely not merely a modern perception **54–56**.

The role of the artist was to interpret the world around him, not to reproduce it. He was abetted by various forms of allusion and illusion, and a symbol could be as evocative and specific as an image. Figures are semi-realistic; it is rare to detect an artist who simply looked at life and rendered it, as one might be expected to in a modern life class, for instance. There are individual exceptions, inevitably, but they never generated a widespread fashion for exact realism, as they did in Greece, nor do they seem to depend totally on deliberate and close observation of life. Emotion is normally displayed by gesture not expression, except for the most obvious (horror, grief, pain). Stylistic distortions and simplifications are minimal, but there are times when great stylization and even abstraction of figures is indulged – as in early China and Central America – a mode more familiar to the north and south, and generally associated with ritual which seems deliberately to try to disguise the commonplace or exalt the otherworldy. Otherwise parts of figures may well be rendered in terms of geometrical pattern – a natural shorthand which can be quite effective whether executed quickly with a brush or laboriously in carved stone. Most cultures go through an early period in which stick-figures satisfy any need to indicate human or animal forms, and they revert to the 'primitive' mode often in popular arts, but these can achieve considerable sophistication, just as they did in the Palaeolithic.

Looking at realistic pictures today we have been schooled by later European artists with their mathematics and lenses, and by the camera, which has a single vanishing point, not the multiple points we create as we scan a scene by moving our heads. This is not the only or necessarily the best way to present the world, although it is the easiest. In most ancient art the non-observance of life, other than conceptually, means no expression of perspective for objects or scenes, except accidentally, and without the single vanishing point for a whole scene rather than, almost casually, for an individual object within it. Architectural complexes, such as towns or gardens, were commonly represented in a simple combination of plan and elevation **23, 63**. Eventually the Chinese and the Classical world were producing perspective views that look modern **77, 431, 432**. Non-figure, landscape or furniture elements are usually minimal or are used to help define a place or assist depiction of an action. Two-dimensional figures also generally combine profile (head and legs) and frontality (torso). True three-quarter views are achieved eventually in Han China, and earlier in 5th-century BC Greece, along with true foreshortening of limbs (rather than just obscuring limbs one behind another, such as thigh and shin for a kneeler). This was decidedly a 'modern' trend and remained a problem (or rather, was not recognized as one) until Renaissance artists took as much care to render natural forms and poses as had 5th-century Greeks.

Symmetry in composition often determines groups, even where the action is not itself strictly symmetrical. Effective exercise of political power depends on a degree of orderliness which is reflected in the arts and is structurally desirable in architecture. Rhythmic repetition of figures or patterns also reflects major elements of everyday life – music, marching, poetry – and can be visually effective since the message may thereby be made more emphatic. This architectonic quality is not universal but it seems to satisfy an innate liking for pattern and regularity, encouraged by inspection of the natural world, and it can prove to be a major determinant: it is not conspicuous to the north and south but it is dominant in the Mediterranean and Mesopotamian world. It came to be supported by geometrical theory and observation of proportion (see below). Action scenes tend to be shown developing from left to right, which is how the human brain reads them, but there are many exceptions, not necessarily influenced by the direction in which writing is read.

We are approaching the point at which we have to address the life and functions of the individual artist, but this cannot be broached until the basic questions of materials and techniques have been briefly explored. At the simplest, materials may, of course, influence style – one thinks of plastic clay, abraded stone, grained wood, whatever in metal must be hammered or cast, whatever in fibre must be knotted or interwoven. But the latter-day addiction to 'Truth to Material', promoted by the ideas of the 19th-century artist and historian John Ruskin, is meaningless in antiquity, where the practitioners of the higher arts often display a 'determination to transcend the limitations, or even disguise the identity, of the material employed' (Penny). Classical artists were particularly adept at this, removing tool marks, covering raw materials with paint or plaster, painting false ashlar blocks on a stuccoed façade – gold is almost the only material that is everywhere allowed to speak for itself.

Stone for architecture or sculpture was available almost universally, and where it was scarce or intractable there was always clay for bricks, fired or not, or forests for timber. The quarrying techniques – splitting, or use of wooden wedges driven home or swollen with water – were familiar worldwide. Abrasion is the simplest way to work stone, if laborious, and served most areas, notably even Egypt where metal tools were almost ignored, and the Americas where they were not available. Copper chisels (for Egypt) needed constant sharpening; bronze was better, or iron, sometimes of steely hardness for the Classical world. The techniques and implements for stone resembled those for wood. Egypt invented the claw chisel (with a cutting edge like gappy teeth) to remove thin layers of stone, but this was more effectively employed by Greeks from the 6th century on, made of steel-hard iron and used on hard stone (marble). Drilling can cut out stone as well as decorate it; the drill was revolved in the palms of the hand, or worked with a bow in the Old World (the 'string' wrapped round the drill shaft) for everything from major architecture to gemstones, where something like a bow-driven lathe could be used. Tubular drills – reed or bone used with abrasive powder like emery or chips of obsidian, even diamond – could remove larger areas, the 'cores' being broken away, and they were used in Old and New Worlds.

Clay objects could be fired in open fires, but best in kiln ovens of fairly uniform structure everywhere. Multiple firing was not unknown for decorative effects, but the most familiar Greek pots depended for their appearance on careful control of a single firing in two different atmospheres, reducing (smoky), which turned all black, and oxidizing, which returned the red to red but kept the glossy black. Moulds could facilitate virtual mass-production of common artefacts, from pots to figurines. The heat achieved would determine what pigments might be applied, and the value of lead in this (plumbate wares and glazes) was observed in the Old World and, without true glazes, in the New, while Egypt had perfected enamelling, then widely copied in the Near East and Europe.

The potter's wheel came to be used everywhere except the Americas (where, at best, turntables are found), but the early basic techniques of building up pot walls in coils or strips of clay were not forgotten, especially for the larger vessels. The observation of nuggets of raw metals which could be hammered or melted led to

techniques of extraction by fire from ores. Hammering could prove the simplest technique to create metal objects for use, but eventually some form of soldering was learned and the value of casting in moulds prepared from clay or wax. Old and New Worlds invented the use of wax models for preparing moulds, where the wax could be melted out and replaced by molten metal (the 'lost-wax' or *cire perdue* technique) for anything from a solid earring to a hollow statue, usually assembled from separately cast parts for the life-size or colossal in the Old World.

Wood was a universal medium, but commonly painted or covered with plaster (gesso) before painting. Bone-like materials depended on local fauna – mammoth ivory, elephant tusks (the creature was wild in Syria and north Africa into the early historic period), hippopotamus teeth, walrus tusks, rhinoceros horn, antlers. In the same way textiles depended on availability, usually of animal hair or fur (for felt), and the development of suitable crops like cotton. Precious stones were small and mobile and were farthest carried – lapis lazuli was brought from Afghanistan to the Mediterranean even in the Bronze Age, and the many hardstones of India and Ceylon were well known in the West before Alexander's conquests. The Baltic was a major source of amber for the Mediterranean even in prehistoric times. Jade and turquoise were shared interests of the Americas and Central/Eastern Asia. Pigments were derived from at first mineral, then vegetable sources, and not always applied with hair brushes but by cloth or fingers or even sprayed by mouth or tube. Water-based, they could be used on dry or wet plaster, and a plaster ground was often applied over other materials to be painted, especially wood or stone.

Many mainly practical skills were also at the service of the artist. The human body itself was a field and resource for artists. Painting, tattooing or scarification of the body have been worldwide practices, to the present day. In rock art, hand-prints (positive, or negative – from spraying paint over the hand) are common everywhere from earliest times. Later, casts from life could inspire (Egypt **264**) or be incorporated in (Greece) statuary. Corpses or skeletons could be restored with plaster **12**, or the bones at least coated with a blood-restoring red pigment. These practices are not confined to the less-developed societies.

Standards for linear measurement were usually determined by human body parts (hand, foot, etc.); the human body has been the module, down through the Roman architect Vitruvius' prescription for the human body in art, to Le Corbusier's 20th-century view of man as the measure of his architecture. Chinese and Greek vase profiles may be definable mathematically, but this does not mean that they were devised mathematically. The Golden/Ideal Line/Section, much exploited in Renaissance art and theory, has been detected here and there, as in the pyramids. It is probably also no more than a matter of our eye approving what numbers can describe (it is a matter of the division of a line AB at C, so that CB is longer, and the proportion AC:CB is as CB:AB).

Measurement for distance was in terms of time taken to travel, by land or sea. Geometry in the service of art is prominent everywhere. Agreed modules for building bricks, tiles and even masonry are detectable in most cultures, notably Mesopotamia, Egypt and the Classical world, and were often displayed publicly to encourage conformity. For sculpture the Egyptians used a grid system of squares for laying out figures **61**, but this did not prescribe accurately the place of every joint, and was of no less use for copying drawings at a larger scale for carving, or ensuring uniformity. The Greeks observed proportion, measuring by head heights, with sculptors even writing books about it (Polyclitus' *Canon* **301**); but they applied it also to all parts of major architecture from mouldings to overall plans. Even the modern Sri Lankan provider of wooden Buddhas for tourists works from a simple grid of squares **62**. Modules for human figures in the arts have been observed in many cultures, but the human body is a fairly uniform structure without being the design of an obsessive mathematician; place and date have determined different real human proportions, and systems deduced by scholars based on their observation of the products without other evidence of original laying-out techniques may be too imaginative.

There were various simple aids to production. The compass helped compose complicated spiral patterns,

from Greek Ionic capitals to Celtic ornament **59, 60**. Moulds, combs, multiple brushes and templates can make for time-saving and uniformity in decoration, especially on pottery and architecture. Plans and elevations were drawn out, with varying degrees of precision, as guides to the architect or records of work done, and they are found in most cultures **63, 64, 67, 69**. For the most part, however, 'rule of thumb' determined procedures. Models of architectural members were carved for copying; both Greek and Egyptian model stone capitals have been found. Copying in sculpture could be managed from reuse of original models for casting new moulds. In stone in the Classical world (5th century BC on) it was a matter of working from clay or plaster models, and accurate 'pointing off' from them of significant points on or in the stone being carved, by measurement or simple triangulation, employing methods used throughout the history of Western sculpture. There seems no trace of this elsewhere.

The great Maya façades must have been carefully laid out geometrically **466, 468**. Where no such care was taken, it shows in awkward asymmetry or excessive variations in scale. Significant variations in scale could be exploited, as in the enlargement of furniture or utensil forms for major architecture, and the compliment was returned in the common use of architectural detail on minor objects. There are early military maps from China **65**, Mesopotamian maps showing parts of towns and designating properties **66**, Mexican town plans and narrative scenes with an engaging formula for showing paths by rows of footprints **521**. These indicate that the draughtsman was able to envisage the relationship of features on the ground as seen from above. The Classical world was relatively slow to develop such skills, which do not appear until after the 4th century BC and the scientific interests of Aristotle, and in the Roman period when maps of the empire were a major contribution to keeping control: for instance, the 3rd/4th-century AD original copied in the Peutinger Table road map (now in Vienna), from Britain to the Ganges.

Almost all the techniques here described were practised worldwide and often independently invented.

THE ARTISTS

'There is no such thing as art, only artists.' This truism is of little help for our study since in early days the individual artist is so often elusive. Yet we would do wrong to imagine that significant innovation was sometimes due not so much to new challenges or requirements as to the imagination of an individual.

Where the material is plentiful it has proved possible to apply 19th-century techniques of attribution, devised by Giovanni Morelli for Flemish and early Italian painting, to ancient drawing and painting (though less easily to sculpture). These depend on observation of details which are drawn unconsciously, without dependence on a model – ears, hands, dress folds – and seem as distinctive as handwriting. The techniques have been most successfully applied, and proved, in the Classical world **302, 303** and for the pottery of the Moche in Peru **534, 535**.

In antiquity the artist's status seemed to stand for little, except sometimes in the case of the architect (as in Egypt) because his work was most closely associated with the aspirations of the ruling class, or may have been prized in the very few places and periods in which artists seem to have been valued, such as Greece rather than Rome. In the Classical world, too, the sculptor and painter (not of vases) enjoyed prestige and moderate wealth, although mass production always proved profitable for the simpler painted wares and eventually for the mould-made, in clay or metal.

Generally the artist/artisan appears to have received no special recompense for the value added by his art and was paid at the upper range for any manual worker. But this is not easy to judge except in the Classical world, from the contracts for work on some architectural sculpture of the Greek period (almost a cottage industry) to Diocletian's Edict fixing maximum wages in AD 301. For the more significant arts everywhere it is clear that palace workshops are involved, and craft specialization becomes apparent in even the earliest of the developing societies, while it can be discerned often also in far smaller communities where the demand was sufficient to sustain specialists.

This reflects the stratification of society into distinct classes or castes, each with a prescribed function in the community, and in the later periods in the West the establishment of regular guilds or trade unions such as become common from the Middle Ages on.

Specialization and official or rich patronage meant that there was time to spend ensuring perfection of detail and finish, to a degree that is rare today. Some ancient artists were more interested in perfection than any more pedestrian view of their role as purveyors of decoration might suggest. This is an aspect that ought perhaps to be considered more carefully in the context of the ancient artist than of the modern, and it touches on the philosophy of the artist and his own conscious or unconscious attitude to his work. In the terms of Chinese Taoism, 'Perfect activity leaves no track behind it; perfect speech is like a jade worker whose tool leaves no mark.' Deletion of all traces of technique is a feature of many of the greatest ancient arts, and I have remarked on the ancient artist's general indifference to Truth to Material already. One result of pride in achievement was the interest among the finer artists everywhere in creating virtuoso pieces, usually miniaturist miracles, occasionally gigantic ones, and not in any spirit of personal display since most remained anonymous or redounded to the glory of their sponsors. I think of much jewellery, or the use of difficult techniques with recalcitrant material like jade, or awkward material like glass. Ancient art provokes many such thoughts about the role of art in later periods, about what we should and perhaps not expect of artists – and what they should themselves be seeking as servants, whether of society or of collectors.

We find very few signatures of individual artists in antiquity, a reflection both of their own view of their

work, and of society's valuation of it. There are some among the Maya on fine pottery **489**, and far more on Classical Greek pottery; they then become rarer or amount to no more than workshop-stamps as the artefacts become more mass-produced. Among the higher arts, Classical sculptors and gem-engravers sometimes sign their work **51**, **443**, more rarely metalsmiths and mosaicists. The team of artisans involved in production of the finer Chinese bronzes and lacquer may be named in inscriptions on the objects, and there is the implication at least of named ivory-workers who carved early Indian stone sculpture. There are no artists' signatures in early Mesopotamia. Masons in Persia learned from Lydia to use personal signs ('masons' marks') to label work done in the quarry, and also carving of relief figures and architectural mouldings. There was a similar practice among the Moche in Peru in patterned brick stamps. This is probably not so much a signature as a claim for payment. The marks involved – not true pictographs – may derive in Eurasia from horse brands, where they generate signs which are used as family blazons (*tamga*). The record about artists in literature is fuller, especially for the major arts, for architecture and sculpture in Egypt, and in the Classical world where there were even real 'Art Histories'. That by Pliny the Elder (1st century AD) was scientifically rather than historically determined, organized by materials, rather than artists, style or date. Artists may be moved to show themselves at work, usually in humbler or subsidiary settings **70–73**; the creation of major architecture is a matter for imperial display of authority and control of manpower **74**.

Of women as artists we find virtually no evidence; it may be suspected, from cave to palace, but not easily proved, yet our expectations should not be determined by the record of later periods. In early societies it was normal for women to be the potters and certainly the weavers. Some Classical women panel-painters (as there were poetesses) are named. Yet their domestic role as weavers and possibly potters meant that women may have created many of the basic patterns which were reproduced in other media, even if only in a subsidiary role, and where scenes of narrative were involved we may not assume that they were simply copyists of the designs of others. In a play by the Greek dramatist Euripides, Athenian women can recognize the subjects of their weaving in the myth scenes on temples at Delphi, and the common border-pattern of squares on Athenian 5th/4th-century vases derives from woven patterns. But the Classical potters and vase-painters were men and there were some male weavers. As customers for many of the less prestigious products, women could have influenced the subjects chosen for decoration by an artisan with an eye to the market, but it is hard to prove, even in Classical Athens. Their most senior role outside the house was probably as priestesses, where they might influence artists of religious ornament and equipment. But there were woman Pharaohs in Egypt, influential mistresses and empresses in the Classical world, even warrior queens in Central Asia. It is not easy to determine whether their sex much affected the artists who worked for them.

Finally, what was it all for? Sometimes we find objects of exquisite finish placed where only the gods might admire them. These probably indicate no more than an artist's instinctive desire for perfection, a matter already considered. The furnishing of tombs, notably in Egypt, China and the New World, involved the deliberate creation for deposition of prime objects or paintings, usually set far from mortal sight, but their function in an afterlife is explicit, and their purpose therefore broadly magical. It might not seem easy for an artist to express visually what was a common understanding of religious or philosophical truths, but they made the attempt, abetted by antiquity's readiness to interpret such matters in terms of images of myth and action. It is certainly more difficult for us to share the emotional impact of ancient art on the ancient viewer. We may recognize the imposing and terrifying but miss the significance provided by original context. Not all cultures also offered reassuring images to their folk – mainly the Chinese and Classical, which are the most humanist, and some Egyptian. The comforting becomes more prominent in the arts of new religions – Christianity and Buddhism.

In the Hellenistic and Roman period we find real art collectors creating something like galleries and museums in their homes or gardens. These displayed the products and styles of earlier periods but also attempted to express what they believed to be their role. Major temple

sanctuaries in which votives had accumulated over many years served as galleries which could offer continuing inspiration for later artists. In the Near East statues of gods could embody that god's power, and so would be carried off by victors and placed in virtual museums of antique art, as at Babylon and Susa. The Chinese would seek out and reuse in cult and even copy old jades and ritual bronze vessels and bells. The Maya and Aztecs kept and sometimes 'improved' relics of their own or neighbouring cultures with inscriptions and refurbishing. The practice can be a source of deliberate archaism in the arts. The power of the image and inscription was such that later disapproval could be expressed not just by destroying them, but by cancelling or defacing them, or, in Egypt and the Classical world, giving them new identities **425**. Overthrowing the works of one's enemies, including 'works of art', was both a demonstration of success and an acknowledgement of the power and status of the artists' creations.

It is no doubt the case that in creating monumental works which were designed to commemorate the achievements of a dynasty or people the artists were conscious that they might also be communicating with generations to come, just as they were building on the achievements and dreams of their ancestors. The care and collection of older monuments would have contributed to the same view – practices that are evident almost everywhere in urban societies. It all helped to nourish that awareness of both past and future, which was expressed as forcefully in visual arts as in literature and social traditions. It created a sense of 'progress'. This is far less apparent to north and south.

For the most part the artist was working for a mortal viewer who could be expected to share his vision and expectations and be able to interpret his formulae, and so to understand how the art enhanced function as well as appearance, as well as to take in any more profound message, political or religious. The artist exercised a profession which both shaped and preserved a form of permanence which was shared with writing, but denied to the spoken word or human memory. He could arouse passion, compassion, fear, desire, as well as any writer, dancer or musician; the combination of these skills in performance, as on a stage, can be devastating. This is

power, even magical power, and the artist as magician is acknowledged in myth worldwide, his skills often attributed to gods or to divine inspiration. What man the artist contributed, be it to a flint axe-head or a ceremonial shield, lent an indefinable added value of a sophistication far beyond that achieved in the rest of the animal kingdom, even by the most assiduous bower bird. It should not be impossible for us, also *homines sapientes*, to share the appreciation sought and achieved by ancient artists, to understand their motivation and the response of their customers, but it is sometimes very difficult.

I cannot pick out these common themes in every one of the following accounts of the main chosen urban areas without seeming repetitive or totally biased in favour of making a point and therefore being highly selective of examples. Nonetheless, readers will find most of them here. They will, I hope, anticipate them and recognize the common features, and find in this as much a coherent narrative account of ancient arts as a discourse on similarities and differences. Readers may find their own questions to reflect upon, prompted by this attempt to explore the common record in a broadly historical manner.

Interfaces with cultures to north and south are considered in the following two Chapters, but there are interfaces of a sort within this Chapter too: matters of diffusion, and not only of Classical art. There is a give-and-take of styles and ideas to be observed, as when Greece learns from the east and later returns the lesson, with Classically adjusted styles, while China and India do much the same with Central Asia.

Since what follows is more narrative than argument, it may be healthy to start with China and end with the Americas, where the records are more distinctive than in most other areas, in which the expected parallels may seem more conspicuous. The arrangement of the following sections is not determined only by date or geography, but by the convenience of keeping together those that are roughly similar or related in time or place, and there will be call for two interludes (C, E) to introduce the Classical Greek and the New World. The clusters of illustrations are arranged so that like is with like in terms of material or date, and so not always in the order in which they may be discussed in the text; the captions may be read through as readily as the main text.

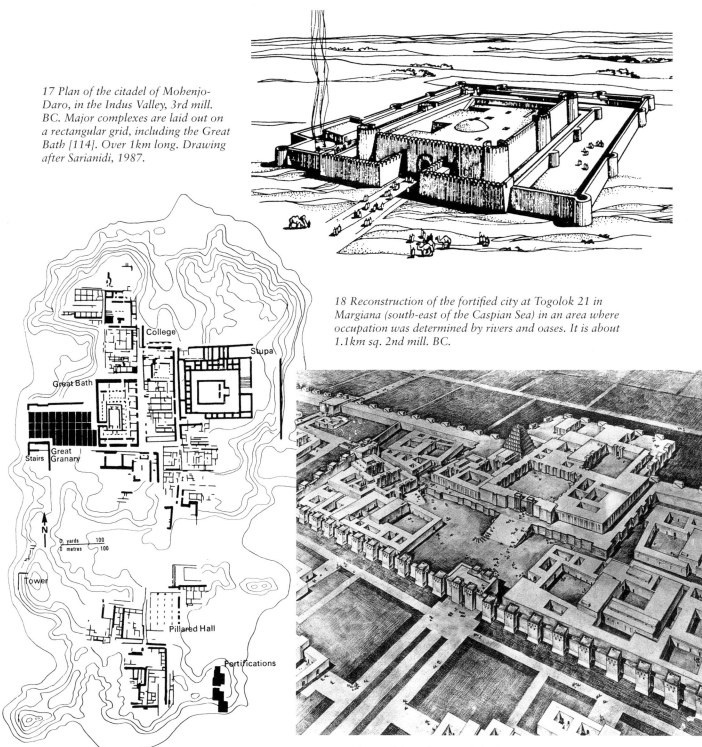

17 Plan of the citadel of Mohenjo-Daro, in the Indus Valley, 3rd mill. BC. Major complexes are laid out on a rectangular grid, including the Great Bath [114]. Over 1km long. Drawing after Sarianidi, 1987.

18 Reconstruction of the fortified city at Togolok 21 in Margiana (south-east of the Caspian Sea) in an area where occupation was determined by rivers and oases. It is about 1.1km sq. 2nd mill. BC.

19 The citadel at Khorsabad, built by the Assyrian King Sargon II, in a reconstruction by Charles Altman. The pyramidal ziggurat (top centre) had a 'spiral' ramp of seven levels to its top. The dominant theme is defence. 8th cent. BC.

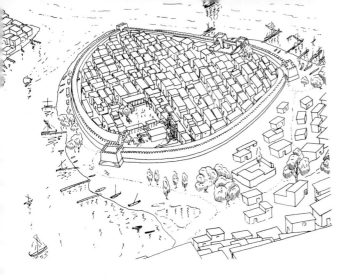

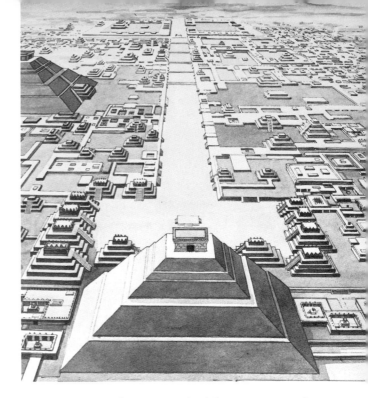

20 Greeks had started to settle on the east coast of the Aegean (W Turkey) in the Bronze Age. A major city, Old Smyrna (Bayrakli, just north of Izmir), flourished through to about 600 BC, when it was destroyed by the Lydians, who captured it by means of a siege mound which overtopped its walls. This is a reconstruction (by R.V. Nicholls) of its appearance at that time, a plan which had begun to take form in the 8th cent. – a sheltered port with stout walls, a grid-pattern of streets within, a raised temple area within the near gate, and a very substantial extra-mural suburb in the foreground. This was very much the pattern also for new Greek colonial foundations in Italy and Sicily in the 8th to 6th cent. BC.

22 Reconstruction (by D. Barnard) of the Mexican city of Teotihuacan, laid out in a strict grid, incorporating the 'pyramid' mounds for cult. It covered over 20km sq and perhaps housed some 200,000 people. 6th cent. AD.

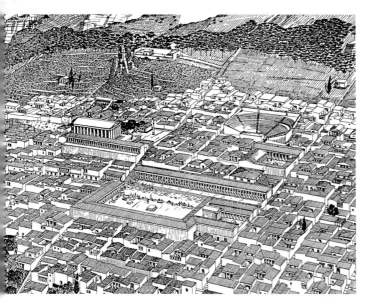

21 Reconstruction (by A. Zippelius) of the Greek city of Priene on the east shore of the Aegean between Miletus and Ephesus. The acropolis rises at the back, with the town theatre set into it. The grid of streets incorporates rectangular areas devoted to cult and administrative buildings. Late 4th cent. BC.

23 Gardens and waterworks were common features in imperial palace grounds and, in some places, as in Egypt, India and Persia, for private persons. A pleasure boat is here being towed along on a lake in an ornamental private garden in Egypt. A painting in the tomb of Rekh-mi-Re at Thebes, 15th cent. BC. The scale is adjusted to the importance of each element, with plan and elevation views combined.

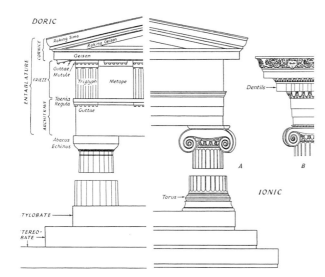

24 A view of the temple of Amun at Luxor in Egypt showing different patterns for columns in each building. This is the Great Hall of Rameses II, late 2nd mill. BC.

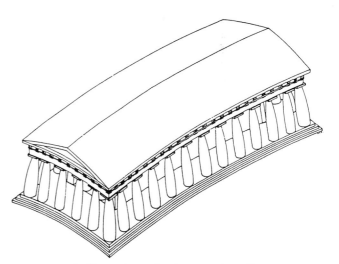

25 (a) The basic 'orders' of Greek architecture, which defined the appearance of all colonnaded buildings from the 7th/6th cent. BC on. The Doric derives from woodwork, the Ionic is based on enlarged furniture patterns and mouldings derived from Near Eastern art. From the later 5th cent. BC was added the Corinthian order, like Ionic but with an ornate capital of layered acanthus leaves and scrolls. (b) A drawing (by. J.J. Coulton) exaggerating the optical refinements applied in the design of a 5th-century BC Doric temple. These were 'intended to correct optical illusions which would make a truly regular temple look irregular' (Coulton).

26 The elements of the Achaemenid Persian stone columns at Persepolis are variously derived. The back-to-back foreparts of animals or monsters resemble dagger pommels, the vertical volutes are from furniture, the palm-like feature is from Egypt, the fluting, bead-and-reel bands and the shapes of bases are Greek, and the floral patterns are largely a Greek reworking of older eastern motifs. Early 5th cent. BC.

27 Mauryan pillar at Lauriya Nandangarh (near Nepal), typical of the isolated columns in various parts of north India, many inscribed with King Asoka's edicts. It is nearly 10m tall, surmounted by a lion (compare [126]); the bulbous column capital is more likely a wooden form translated than a version of a Persian column. The shaft is a stone monolith. 242–241 BC.

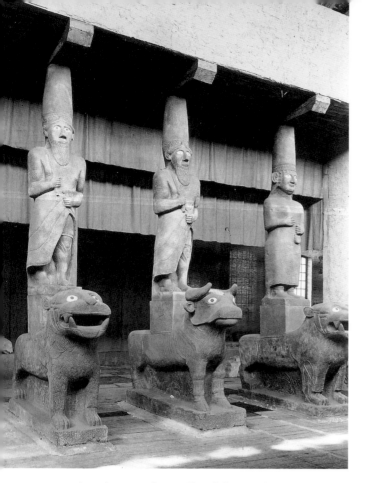

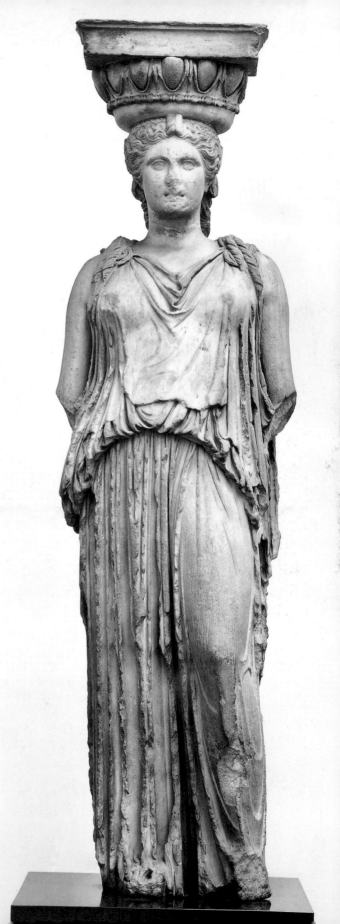

28 The palace-temple at Tell Halaf in north Mesopotamia (modern Syria), a restoration of the palace façade in the Berlin Museum. The broad columned entrance is in the long side of a rectangular hall (bit hilani) peculiar to the area and parts of Anatolia. Here the pillars take the form of divine figures standing on the backs of lions, while griffins guarded the doors behind. About 800 BC.

29 The original 'Caryatid', name given to the female figures used as support columns in the south porch of the Erechtheion temple on Athens's Acropolis. The concept was eastern (see [28]) but here they are figures of attendants carrying phiale-cups, as if to greet the processions that passed the building. About 410 BC. Height with capital 2.31m. London, British Museum.

30 The great stupa at Sanchi in north India. Stupas cover relics of the Buddha and are centres for worship. The hemisphere is a formal translation of an earth tumulus and can reach great heights. The Sanchi stupa has relief decoration concentrated on the railing around the walkway and the great doors (torana, *about 10m high; see [132]*), covered with figure carving. 1st cent. BC.

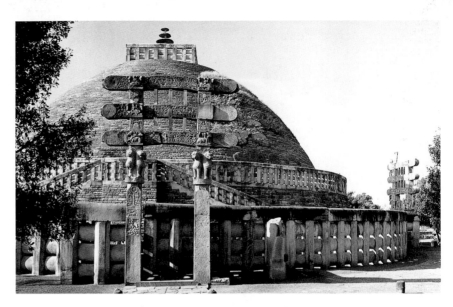

31 A model of the ziggurat of the moon goddess Nanna at Ur in Babylonia. Originally about 26m high. Courtesy of the Bible Lands Museum, Jerusalem, where it is exhibited (photo: M. Amar and M. Grayevsky). About 2250 BC.

32 The complex of burial pyramids at Giza near Cairo. The largest was originally 146m high, on a base 231m sq. They are solid stone, once with smooth facing slabs, and with burials concealed in passages within and below. Earlier pyramids have a stepped profile. The orientation is carefully calculated astronomically. The essential form is that of a geometricized mountain aligned to the heavens. The largest was constructed for King Cheops in the mid-3rd mill. BC. See also [253].

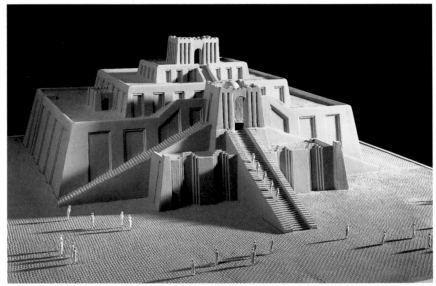

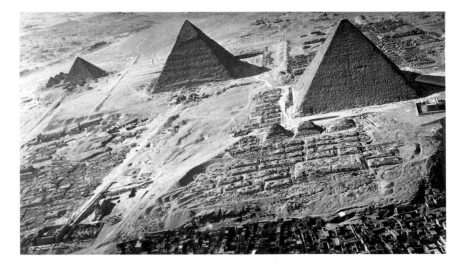

33 (opposite) Toltec 'Atlantes', support-pillars of basalt 4.6m tall, which seem to have formed part of a temple on the North Pyramid at Tula in Mexico. About AD 1000.

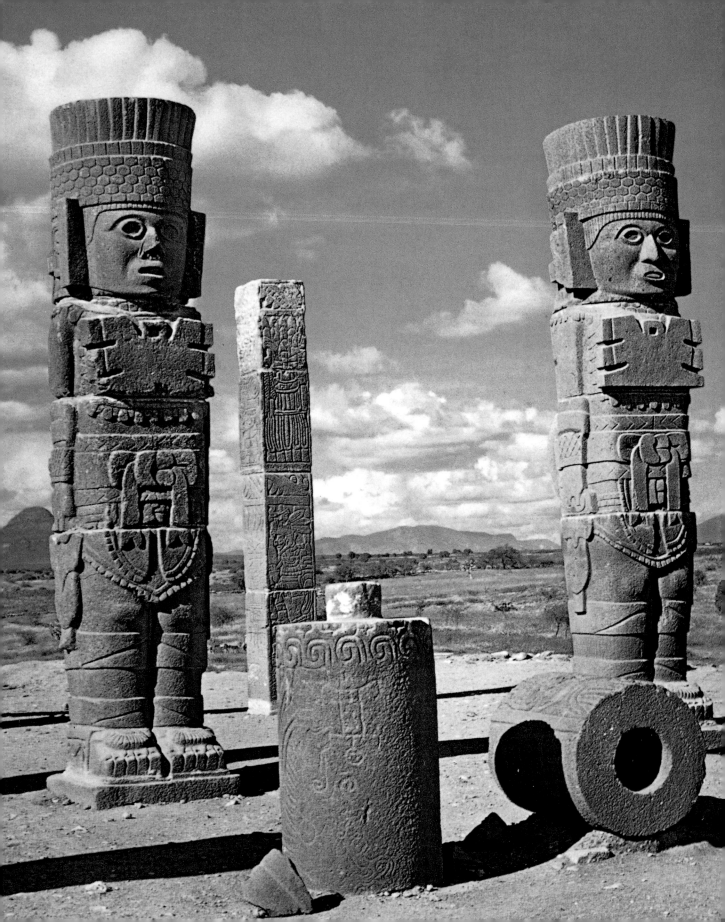

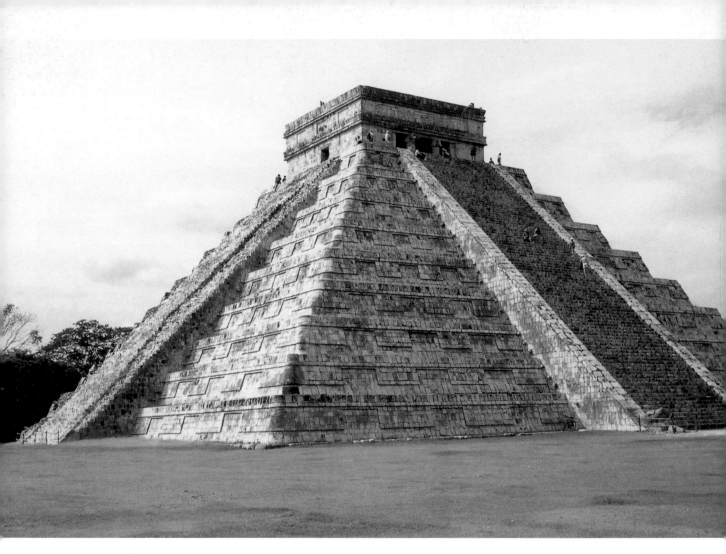

34 The 'Castillo' at Chichen Itza, one of the latest Maya cities in the Yucatan peninsula of Mexico. It is aligned to significant points of the solar year – has 365 steps (4 × 91 + 1) and 18 terraces (two to each level, divided by the steps) representing 18 20-day months (five unlucky days added at the end to make 365). It enclosed a smaller version of the same construction, perhaps over a tomb (see [480]). Height 25m. 9th cent. AD.

35 A 'pitched brick' vault at Tell al Rimah (Mesopotamia, west of Nineveh) of the late 3rd mill. BC. The principle of the arch could be understood and applied anywhere without always generating a totally new architectural style of arch and vault.

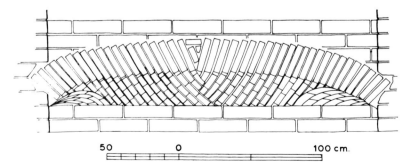

50 0 100 cm.

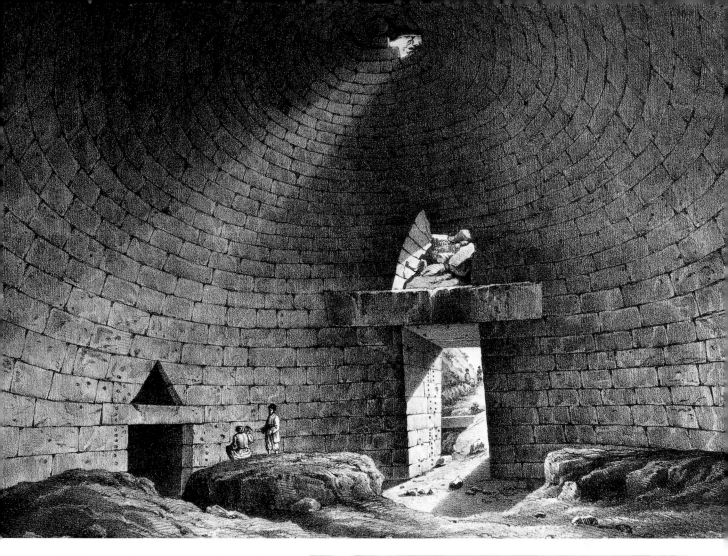

36 Monumental masonry was a feature of Mycenaean architecture, whether slightly dressed, as for the walls of citadels at Tiryns and Mycenae in southern Greece (see [238]), or carefully dressed as for the great 'beehive' tholos tombs, built into hillsides, with their corbelled roofs. This shows the interior of a 'beehive' tomb at Mycenae, at the time of discovery and exploration, drawn by E. Dodwell; the main door at the right is 5.40m high, to its lintel, the ceiling 13.40m high. 13th cent. BC.

37 Corbelling at its simplest but most monumental: a passage within the walls of Tiryns, a castle site near Mycenae in southern Greece. 13th cent. BC.

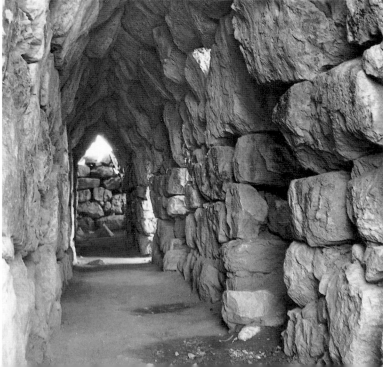

42 Three important Chinese bronze vessel types, each with the way they are drawn as pictographs on the early incised oracle bones from the capital city Anyang (13th cent. BC), and the modern Chinese equivalents.

43 Ornamental inscription of Amenemhat III, from the Fayyum in Egypt. The text describes the setting and history of the temple in which it was displayed, over a door. At the same time as providing a record, hieroglyphs can be composed and symmetrically arranged to make a pictorial composition in its own right. About 1800 BC. Height 1.04m. Berlin, Staatliche Museen 16953.

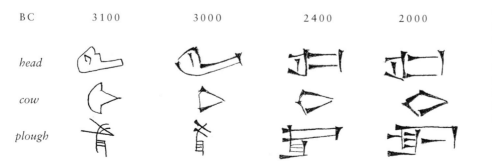

BC	3100	3000	2400	2000
head				
cow				
plough				

44 Sumerian scripts; a demonstration of how quickly a pictograph could become a cuneiform sign, composed of wedge-shaped marks, and effectively disguise its origin.

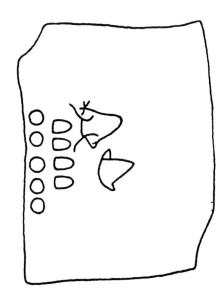

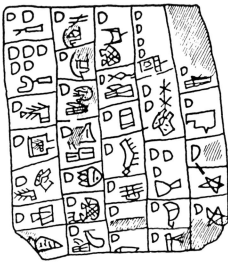

45 Clay tablet from Warka (Uruk) indicating on one side 50 + 4 oxen, on the other, signs representing personal names against each animal or group of animals. These are among the earliest Sumerian pictographs, already highly stylized representations of objects or parts of the body. About 3000 BC.

46 This is from the Hittite site at Kültepe (Kanesh; eastern Anatolia) which housed an Assyrian trading colony. Documentation for business accommodated art also. The clay letter, written in Assyrian cuneiform, is seen within a clay envelope which carries the impression from a cylinder seal. Height 16.2cm. Ankara Museum.

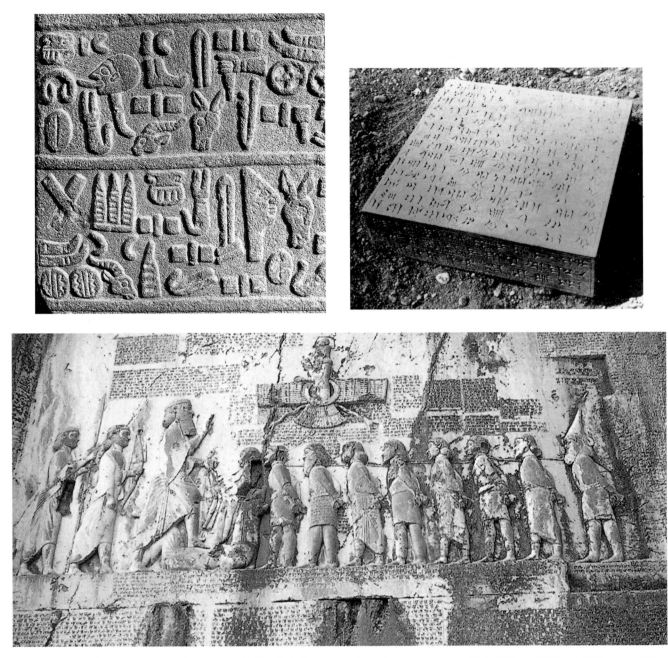

47 Hittite hieroglyphic inscription from Carchemish on the Euphrates. The Hittite is the last of the Near Eastern pictorial scripts, with many of the characters still retaining their original form. 8th cent. BC. Ankara Museum.

48 The Babylonian version of the Persian King Darius I's Foundation Charter for his capital at Susa. Written in cuneiform characters, by then in use for all Mesopotamian scripts, although the common language of the empire was written in alphabetic Aramaic. Late 6th cent. BC. 33.6cm sq. Teheran, National Museum.

49 At Bisitun (W Iran), high on a cliff face, the Persian King Darius I had carved a trilingual inscription describing his exploits, and a relief of him confronting defeated rebels. The inscriptions contribute to the monumental impressiveness of the whole. About 520 BC.

50 Inscribed clay disc from Phaistos in Crete. The script has not been deciphered and is unique (not the usual Minoan 'Linear A'), but is obviously based on pictographs, each probably signifying a syllable. The signs were impressed on the clay from prepared stamps, like moveable type, and are a good example of the scribe/artist creating detailed shorthand forms for natural objects, some features of which may betray Anatolian inspiration. 16th cent. BC. Diameter 16cm. Heraklion Museum.

51 The alphabetic inscription on an Archaic Greek gravestone. The lettering is itself a work of art, each character carefully placed and carved, to the point that in this period the 'hands' of the cutters can be recognized. This is the base of a grave-marking statue, giving the artist's name (the sculptor Phaidimos) which is often accorded as much or more prominence than the names of donors or people commemorated, an expression of the esteem in which artists might be held, or at least of that self-esteem which they could in this way freely indulge. He calls his work 'beautiful to see'. The words in Greek inscriptions generally run on without division, but here there is triple-point punctuation. Mid-6th cent. BC. Athens, National Museum 81. For some fine Roman lettering see [69].

52 Maya hieroglyphs from a stele from Yaxchilan (dated AD 526). These are 'full-figure', more intelligible than those which combine parts of figures and other objects. Major inscriptions are commonly set in two columns, read from top to bottom, but also, more conventionally to our eyes, in rows left to right. See also [479, 481, 482, 487, 489].

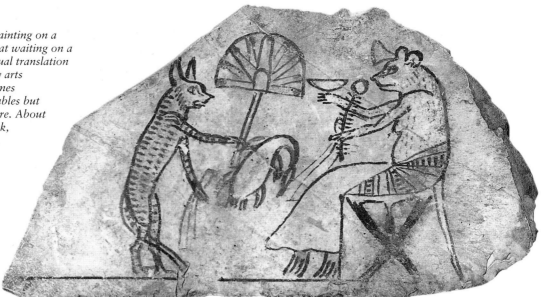

53 Egyptian trial painting on a limestone flake, a cat waiting on a mouse; a comic visual translation found in most early arts worldwide, sometimes depicting specific fables but often generic, as here. About 1200 BC. New York, Brooklyn Museum.

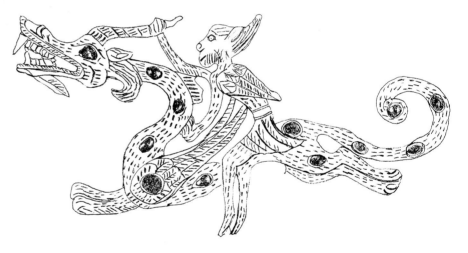

54 Drawing of a comic winged demon riding a dragon, from a gold diadem found at Kargaly (S Kazakhstan near Almaty). The demon derives from the monkey and similar animal/human figures which people Chinese landscapes in this period, immortal spirits of the countryside. 2nd/1st cent. BC.

55 Monkey-scribes. The squatting posture, traditional for scribes, may have suggested to the Maya the image of monkeys, which they often use to depict scribes, as here, painted on a clay cup. Late 1st mill. AD. New Orleans, Museum of Art.

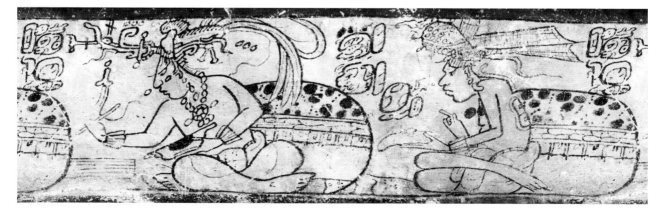

56 A Greek cup made in Boeotia, perhaps for the Cabirion sanctuary where there are several similar irreverent representations of heroic occasions. Here a portly Odysseus fishes from his raft which is supported by wine jars, while the north wind blows him along. Early 4th cent. BC. Height 21cm. Oxford, Ashmolean Museum V 262.

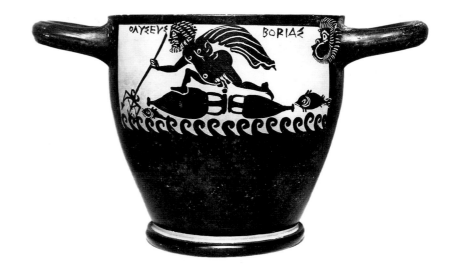

57 Greek pot-painters often made their cups resemble masks, adding painted eyes, often ears, and with the hollow foot looking like a mouth. Here the painter has also translated the nose into a frontal seated dog – a multiplicity of visual punning. Elsewhere in world art the notion of making a pot look like a human figure is widespread, recalled in our use of the terms 'mouth, neck, shoulder, foot' for vases. 'Chalcidian' cup, made in a Greek colony in south Italy. Mid-6th cent. BC. Copenhagen, Thorwaldsen Museum.

58 Two examples of animal-part substitution. (a) A west Phoenician (from Ibiza) 4th-century BC gold ring showing a man's head, his ear, beard and neck as a waterbird, hair as a second bird, the neckline a dolphin. Length 22mm. Madrid, Archaeological Museum 85/75.168. (b) A combination study (gryllus) on a Roman, 2nd cent. AD jasper gem, composed of bearded, beardless and elephant heads. Length 16mm. Vienna, Kunsthistorisches Museum IX 2584.

59 A drawing demonstrating how the volute of a Greek Ionic capital was composed in compass-drawn quarter-circles, according to the formula recorded by Vitruvius, an architect of the period of the Roman Emperor Augustus. The numerals are multiples of the unit side of the square at the centre of the volute eye, the corners of which determine the centres for the quarter-circles.

61 Egyptian drawing of a woman, with the original grid-guide for the figure still showing, from a tomb chapel at Qubbet al-Hawa. These aids to the original sketch would have been painted over. Early 2nd mill. BC.

60 The compass construction for the pattern incised on part of the back of the Mayer mirror (Celtic), 1st cent. BC; compare [598].

62 Guide for the production of small figures of Buddha for the modern tourist trade. Observed by the writer in Sri Lanka.

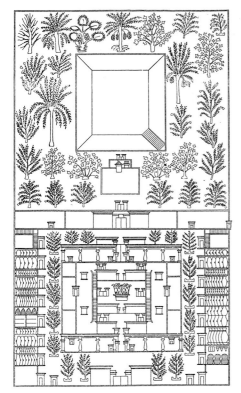

63 Plan of a noble Egyptian estate, depicted in the tomb of Merire at El Amarna. Storerooms, with their jars, surround a courtyard, and trees a pond beyond. 14th cent. BC.

64 Faint drawing (never wholly erased) on the inner court wall of the Greek Temple of Apollo of Didyma (near Miletus), being the architect's 'blueprint' instruction for making the entasis (subtle bulging of contour) of columns [25b], foreshortened from top to bottom. 3rd cent. BC.

65 A Chinese map of the 2nd cent. BC, drawn on silk and found in a tomb near Xi'an. It indicates mountains, rivers and military defences, with nicely stylized indication of forests as tendrils with leaves.

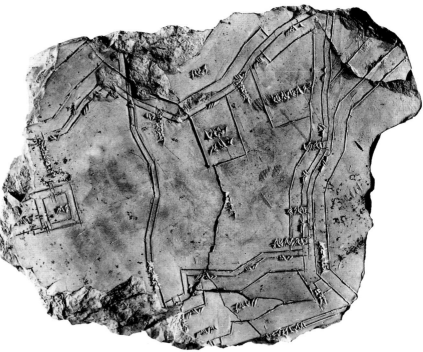

66 A plan from Nippur in Mesopotamia showing part of the town with walled estates, roads, separate properties and a canal (at the top and across the middle), naming owners.

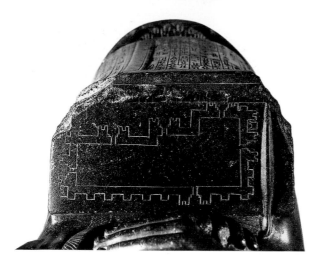

67 *Plan of a citadel, with indications of a measured scale along the top, on the lap of a seated statue of the Sumerian King Gudea (similar to [182]). Paris, Louvre Museum.*

69 *A Roman votive plaque of the mid-1st cent. AD displaying the fine cutting and design of lettering that has remained influential to the present day in western scripts, and architectural plans, apparently of a funeral monument. Perugia, Civic Museum.*

68 *An Egyptian map on papyrus of Wadi Hammamat (on the route west from Thebes to the Red Sea), showing paths between hills with a watering place (centre) and settlement for workmen (top right); in the area of goldmines. Late 2nd mill. BC. Turin, Egyptian Museum.*

72 Athenian red-figure vase showing part of a bronze sculptor's workshop. Owners (or artists) watch as two workmen scrape and polish away blemishes on the cast statue of a warrior, under a shed in the yard. Their tools hang on the wall – with their oil bottles and scrapers for the bath afterwards. Early 5th cent. BC. Width 30.5cm. Berlin, Staatliche Museen 2294.

70 The paintings in the tomb of Rekhmire at Thebes in Egypt are a rich source of illustrations of craftsmen at work. Here sculptors on a scaffold work on a colossal royal statue. About 1450 BC. New York, Metropolitan Museum of Art 30.4.90.

71 Athenian black-figure vase showing a potter at his wheel, which is being turned by a boy. Mid-6th cent. BC. Karlsruhe, Badisches Landesmuseum 67/90.

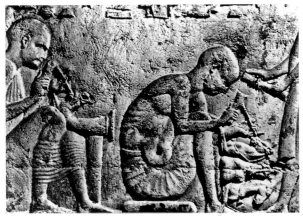

73 Detail of the relief from the tomb of Petosiris in Middle Egypt (Hermoupolis). Artists are putting the finishing touches to a funnel-shaped metal vase (rhyton; see [377]) of Persian type, and an elaborate stand composed of horse foreparts in Greek style: a reflection on the adaptability of some native artists to the favourite styles of their masters. Late 4th cent. BC. In situ.

74 (right) Drawing (by F.C. Cooper) of a relief from the Assyrian palace at Nimrud showing prisoners pulling a sledge, with the help of logs as runners, supporting a massive stone gate figure for installation in the palace. Compare [186, 337]. Availability of mass labour was a decisive factor in such projects. About 700 BC.

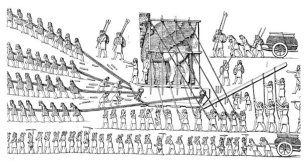

B. CHINA TO EGYPT

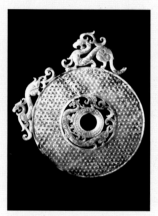

CHINA MAP 1

The unity of China was determined by geography and language, although for centuries anything like unity of rule was only intermittent. China was fertile, dependent primarily on the heavy rainfall, then on the Yellow River and, to the south, the Yangtze; canal building soon became a regular feature of Chinese history. Away from the rather arid north, the climate supports productive agriculture with two or three crops per annum of domesticated millets (northerly) and rice, and the land is otherwise well forested with very few barren mountain areas. Fauna are varied but the horse was only acquired in the late 2nd millennium BC.

China is as much a geographical unity as India. The nomads of the steppes and deserts to the north and west were a threat and at times an inspiration. From the west came use of the chariot, perhaps even metallurgy and writing. To the east Korea was there to be subjugated – it is not treated as a separate entity here although it was a productive centre for the arts from early days. So too was Japan, but it seemed remote to a people who have generally kept their backs to the sea, and was destined to flower in a distinctive though closely comparable way in the arts after the period we consider here, although both Korea and Japan (Jomon culture) were home to individual and early pottery styles. Geography committed China to what has been called a form of 'cultural quarantine', and this degree of introspection can be read as an explanation even for architectural design, from house to city. For present purposes we consider Chinese art down to the end of the Eastern Han empire, to AD 220 – the Western Han (206 BC–AD 9) is the prime period. By this time the more remote foreigner had begun to be of increasing importance in Chinese affairs and arts, Buddhism had arrived, and the Chinese themselves were enquiring west. But whatever was learned from the foreigner was instantly translated into a Chinese idiom, more effectively than most such borrowings that we shall detect elsewhere, and for very long thereafter there was little change in basic styles in the arts although enormous variety in execution.

Neolithic China had been busy – fine pottery with painted decoration on large bowls 75, 76, or plain black in various shapes, and (from the south) with impressed decoration producing low-relief patterns that may have inspired later bronze vessels. As we shall see, the Chinese were also already tackling the problems of working jade in a most accomplished manner.

Definition of the earliest urban architecture in China is none too easy. There were big cities, palaces, temples, but we know very little of them from remains, not much more from pictures and models, and most from texts 77, 78. Wood long remained the prime building material, unlike in most other areas considered here. Wooden buildings could be and were regularly renewed, so that the Forbidden City we visit today in Beijing (itself a late foundation) is mainly new, although probably a fair reproduction of its original form. The highly character-istic Chinese splayed roof is also a late development and may be derived from sagging bamboo roofs, abetted by the manner in which the roof ridge was supported (post-and-beam rather than truss). But the very wide eaves were an early feature 77, together with the creation of ornamental brackets to support them. The style and construction is as distinctive and even longer-lived than any western 'order' of architecture.

Early walled cities, following townships that could reach an area of 20 acres, appear from the 17th century BC on. They are roughly square, with a north-south axis which is like a processional way, except that it could be interrupted by gateways, contributing to the sense of seclusion in each district. Sheer size was expressed in extent rather than height. The Han capital at Chang'an, near Xian, had walls of rammed earth (*pisé*) up to 16m thick and 12m high. The tallest structures in early cities were the city wall and its watchtowers 78, not palaces or temples, although some palaces also had their own pleasure towers, up to five storeys high. The latter, combined with the finials of Buddhist stupas, became the pagodas of later days.

The major early dynasty, so productive of important bronzes, was the Shang (mainly 16th to 12th century BC), centred on An-yang, where we find platforms for palaces and temples as well as underground mausolea. The Great Wall of China is a better memorial to planning on the large scale, itself repeatedly renewed and enlarged, parts of it having been constructed as early as the 5th century BC, to try to keep the nomads in their place. Within the cities palaces are built in walled enclosures, with discrete halls, some of which could be two-storeyed, and with plenty of open park space. At Xi'an (2nd century BC) the palace hall was over 120m long, with a two-storey gallery 16km long leading to the pleasure palace. More thought seems to have been given both to details and to overall layouts than in many other cultures – a serious application of *Feng Shui*. An important type of pavilion known from literature was the *Ming T'ang* (bright hall) which served ritual activities. This attention to diverse building types gave full scope for splendour in execution and decor, not confined only to royal use, although our evidence is more from descriptions than remains, or from the reasonable assumption that not too much had changed by the time we have detailed pictures of towns and palaces.

Royal and princely tombs were dug deep and could be enormous to accommodate the dead and their paraphernalia for the afterlife. Above ground there may have been modest buildings, but always a great mound: that for the famous tomb of Qin Shihhuangdi 101 was over 183m high. The familiar processional ways of big stone figures approaching royal cemetery areas are a relatively late feature 107, as also are the figures flanking structures such as gates and stairs. There was more stone used for tombs than anywhere above ground, except for some towers. Both corbelling and vaulting (also in brick) were practised, but these techniques seem never to have dictated design.

All this contributed to a very distinctive architectural manner, determined by geography, environment and materials, and embodying a somewhat exclusive attitude both to the outside world and to its own population. The Great Wall was built to keep people out, not as a springboard for invasion. In antiquity China seldom looked to expand her territories, except briefly with the early Han far to the west in the interests of trade and the acquisition of horses that could counter the ponies of the threatening Hsiung-nu (possible ancestors of the Huns, a name commonly applied to them) from the north and Mongolia.

Civil administration, a Chinese preoccupation, required its own architecture and other trappings of state. There was a form of coinage as early as the 10th century BC: cowry shells, which might be copied in other materials, then cast miniature implements (spades, knives, etc.) of bronze, with the circular Western form for coinage (plus a square hole) appearing in the 3rd century. Seals in China, intaglio or relief (like rubber stamps), carried inscribed characters rather than images; they were square blocks, elegantly fashioned in metal or stone and often with finely carved backs **111**.

Difficult materials and techniques were the prime challenge in the early kingdoms – cut jade, cast bronze and lacquer. Jade looks soft and soapy, slightly translucent, but it is very hard indeed. Ideally it is white but more often greenish. With patience it can be sawn, ground, polished, drilled (a tubular drill used: a bone or bamboo reed with a stone-dust cutting agent), and even provide a razor-sharp edge, like the flint implements of earlier years. Jade was found in China, but the prime ancient source of nephritic jade was either Siberia or over 1,500km away to the west, at the southern borders of the Tarim Basin (Khotan). It was worth the trouble of seeking out and bringing home, probably in non-Chinese hands in early days. There were other sources later for the more precious jadeite. From the late Neolithic period on it was worked into blades, implements and decorated objects of a 'ritual character', that is, of no obvious practical value but presenting practical forms in a precious material **79–81**. With the Bronze Age come the *bi* – annular discs **82** often carved or incised with stylized animal forms and animal masks (*taotie*) of considerable complexity, in which the natural animal and monster forms are with difficulty distinguished. These are more fully expressed on the bronzes to which we turn in a moment; they owe nothing to the example of the early Animal Style compositions of the steppes, which were generally more controlled in their easterly manifestations (see Chapter Three, C). The jades create a mode long to be apparent in Chinese art. The material seems to have carried implications of permanence if not immortality (whence a famous jade suit of plaques stitched together for a burial of about 100 BC), and comes to be used for more decorative luxury objects, especially statuettes **112**,

but it was one of the earliest and most challenging media for artists.

Bronze casting was an art perfected at an early date (Shang Dynasty) and an improved material was invented by the addition of lead to the alloy of copper with tin. The prime use was for ritual vessels – ceremonial bowls for food, wine or water, animal figures and bells – which have survived in their thousands, many with inscriptions detailing their purpose – as commemorative gifts, or for the ritual of ancestor care **83–85**. Shapes are practical and many go back to Neolithic clay vessels **42, 86**, including tripods with bulbous feet (*li*). Two thousand years later they were being obessively sought out, copied and improved by antiquarians of the Sung Dynasty. Their relief decoration offers us the best view of high stylization in a geometricizing manner of natural and animal forms and masks, related to that of the jades but more monumental, and in a way more disciplined and explicable in terms of a 'grammar of style'. This is a mode which flourished for a long time even beside some more fluid and naturalistic treatment of forms. The use of the lost-wax or *cire perdue* technique for bronze came only in the 5th century BC, and it is not clear whether all earlier bronze techniques, using piece moulds, were learned from the far west – possibly not; there was advanced metal technology being developed nearer China than Mesopotamia, in Central Asia.

The stylizations of figures and masks on the early relief bronzes relaxed in the 5th century BC into more tenuous abstractions resembling a trellis or broken webs of wings and limbs, in some ways closer to the decoration of early jades and one of the most appealing creations of early artists anywhere. Among trails of clouds the limbs and bodies of animals, tigers, dragons, phoenixes and fairy 'immortals' of Taoist fantasy are displayed in infinite variety, involving no little difficulty in identification. But it is a style of decoration which is highly influential in the future development of Chinese art, even calligraphic art, and utterly appealing. In two dimensions it appeared as inlay in bronze, but especially in low relief, as on mirror backs, and on media peculiar to China – jade, lacquer and silk. Everywhere a deep sensitivity to natural phenomena serves as an inspiration to the artist, echoing much of

the Chinese Taoist philosophy, but without giving rise to slavishly accurate reproductions of appearances.

Lacquer is a hard, impermeable and heat-resistant material, derived from the juice of the *lac* tree, which hardens with exposure, can be built up in layers and carved, used as inlay or to coat wooden and other objects, and as a ground for painting. It was used even in the Neolithic period, but the most elaborately painted lacquer begins only in the 4th century BC, often with patterns which seem derived from textiles. As with the bronzes, some of the finer lacquered objects carry lengthy inscriptions naming the various artisans involved in their production. Colours are at first black and red, then enhanced with a wider palette in *lac* or other pigments, with gold and silver inlaid. The medium is particularly expressive of the lace-like patterns **95, 96** we observe on bronzes and in jade. Silk is another important medium and peculiar to the region **99, 100**, a novelty soon to be sought out by distant peoples in the Old World, characterizing its source (the 'silk men') and giving its name to the transcontinental 'Silk Routes'. It is found from Shang times on, valued especially for its strength on the loom, the density of weave that could be obtained, its response to brilliant dyes, and as a field for intricate woven and embroidered patterns and painting.

Human figures are partly geometricized on the early bronze vessels (especially 6th/5th-century BC) which carry friezes of action scenes **90**, and they observe the same conventions as do geometric arts elsewhere, often with a naive but expressive multiplicity of viewpoints, and soon acquiring supple poses without being highly detailed. By the Han period figures are fuller and far more realistic, soon to admit three-quarter views of faces and foreshortening of limbs beneath the heavy dress **105**. Subjects may be historical, martial or domestic, normally in friezes although soon on panels and with figures set up and down the field, not diminished for distance, and with only rudimentary perspective for individual objects – chariots and the like. These are characteristic of the engraved and painted stone tomb slabs of the later Han period **106, 108, 109**; in early China there is no real relief sculpture in stone.

Figures in the round range from some heavily stylized bronzes of the Shang period **88**, which are virtually the bronze vessel reliefs writ large, to the repetitive yet individually characterized and life-size terracotta armies of tourist fame, and, with the Han, to some brilliant expressions of naturalism **102**. Provision of attendants and soldiers to serve the dead was a major concern. At first they were simply slaughtered at the royal grave, as in many other cultures, but they come to be replaced by surrogate models, usually in clay or wood, and these may be life-size, for the Emperor Qin **101**, later reduced in size to one-third for the first Han emperor, and yet smaller. The rest of 'life' in the tomb was catered for by models: the early ones, known only from description, were like a stage set of an imperial city, while the later were more like the apparatus of large dolls' houses. This was a field in which the artist could practise skills in reproducing effectively realistic images of the personnel and paraphernalia of court and military life. Ancestors were important as intermediaries to the gods, and care was taken so that the newly dead would be as well equipped and protected as possible.

There was no hierarchy of major gods and goddesses, but rather minor domestic and rustic deities, 'immortals' who consorted with animals and monsters, and some early emperors who were promoted to being regarded as inventors of skills for their people. So there are no early cult statues such as we see elsewhere, but a variety of smaller bronze statuettes, of human and animal subjects, some quite realistic, often applied to furniture and delicately inlaid in gold and silver **92, 93**. The artist seems almost taken by the idea of 'interior decoration' for its own sake. There was an assortment of monsters which played a part in the Chinese view of the world around them – the Dragon was the spirit of spring, a dominant but more playful than threatening subject, progressing from predatory mammal to airborne reptile. The spirit world conjured by Taoism presented images of immortal but benign demons in various humanoid guises.

The shrinking from the major power statements that are so common in other cultures is at one with the Chinese world-view detectable in all their art. Things changed little over time. When Buddhism was accepted, it happened without much of the Buddhist story-telling

in the arts that was so prominent in India. Instead there was a distinctively Chinese translation of the hieratic Indian (Classicized) Buddha image, and a selection of attendant figures. In early centuries AD more major sculpture in stone was deployed, mainly outside tombs, in styles more familiar from the smaller works in bronze. Meanwhile, painting developed into a major art form, abetted by calligraphic skills which had already been refined under the Western Han.

Floral ornament only becomes important late in Chinese art, often following foreign models, the peony replacing the western lotus. Early figure scenes in jade, bronze or painting may be set in scrolls of clouds and mountains **94, 98, 104**. The 'inhabited' scroll or landscape becomes a prominent decorative feature of Han art. The more fluid, sometimes etiolated versions of figures and creatures seen in painting and bronze relief **93, 95** seem at odds with the more robust traditional styles, and might be explained by the inspiration of calligraphic brushwork. It is possible for single monuments to present quite realistic painting and stylized busy scenes of the spirit and animal world side by side. The contrast is not easily paralleled elsewhere, except where some 'interface' creates a confrontation between the styles of different cultures – compare, for instance, **604**.

The Chinese skills in composition within a circle are also worth noting. They are most apparent on painted lacquer plates and on bronze mirror backs from the 5th century BC on. The patterns range from the geometric, to concentric friezes of patterns and figures, to swirling compositions of the type just described, but the patterns are not mere decoration, and some seem to have some cosmological significance (the 'TLV mirrors'): mirrors, presenting an alternative view of the world, were held to have magic properties in many places. Han mirrors travelled far and were even imitated in eastern Europe, carried there by nomad Sarmatians whom we shall meet in another chapter.

There is something irrepressibly cheerful about Chinese art; the predatory animals seem to gambol rather than tear, even when inspired by the animated groups of steppe art. For all its fire and fangs the dragon would not hurt a fly, and indeed is seen being fed flowers by a countryman-immortal, like a vegetarian. Any creature meant to be horrific looks decidedly theatrical and decorative. There is a lot of smiling and laughing. The rest of the ancient world can barely ever match this in the arts; but how accurate a reflection of the quality of everyday life this might be we can hardly judge. The Han artists offer richly variegated perfection in a variety of styles and media – formal patterns derived from the old bronzes, realistic figures, fantastic and abstract pattern.

If the record of China is superficially very different from that of most others, it was for the reasons stated: its physical, if not always political, unity; its relative isolation, leaving freedom for internal development, not seriously influenced or threatened by outsiders, or manipulated by rival rulers who used art as they might an army; the unusual range of materials available for exploitation (jade, lacquer, silk), rather than only clay and the metals; its self-sufficiency. Its arts were barely appreciated by the rest of the ancient Old World before Marco Polo, nor were they influential except in the Far East, from Korea to the borders of Vietnam (Yunnan), where there was for a while a vigorously realistic school of bronzes **110, 113**, to Indonesia, where China was always the model. But the 'cycle of Cathay' derided by Tennyson in comparison with 'fifty years of Europe' has had a most impressive staying power in the arts. Moreover, China has remained different and exclusive in its arts through the centuries, its old arts alive, at least until recently, but jostled by much from the west in the last century.

CHINESE DYNASTIES

(Neolithic from 7th mill. BC)

Sang	1766–1111 BC
Zhou	1111–481 BC
Warring States	481–206 BC
	(the first centralized state, but repressive, a burner of books)
Western Han	206 BC–AD 9
Xin	AD 9–23 (regressive)
Eastern Han	AD 25–220

75 A Chinese Neolithic Banpo bowl, with its usual decoration within of a human face in a star. Other shapes may carry simple human and animal figures. Named for the site on the River Wei, near Xi'an. 4th mill. BC.

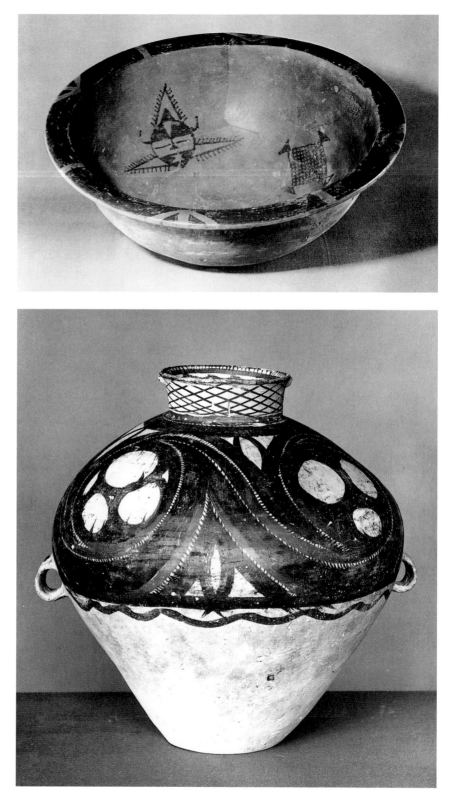

76 Neolithic vase with typical wave-like decoration (Yang-shao culture). These are large vessels, averaging about 30cm high. Comparable pottery of the period in the south Ukraine and Romania could suggest a source for the general style, but over a great distance and independent invention of the motifs is just as likely. 3rd mill. BC. London, Victoria and Albert Museum.

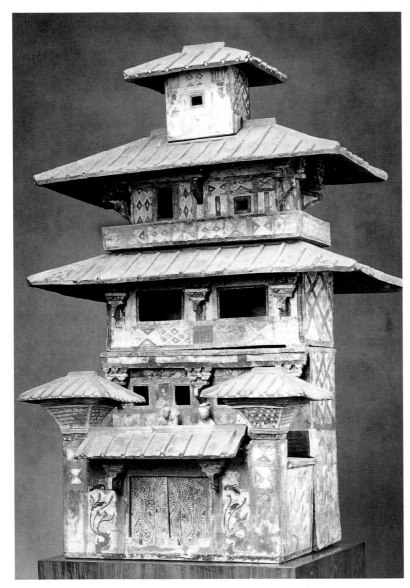

77 Early Chinese architecture, wooden, is known from reconstructions based on excavation and from painted or relief representations. (a) is a reconstruction of the palace at the Qin capital, Xianyang, with the characteristic broad, overhanging eaves, and multi-storey. (b) is from a mural painting in a 3rd-cent. AD tomb (at Anping, Hebei) and gives a good perspective view of roofs and a tower in a town. The Forbidden City in Beijing, as shown to the modern tourist, gives still a good general idea of Chinese principles of layout and design, plus the late feature of the splaying, curved eaves for roofs.

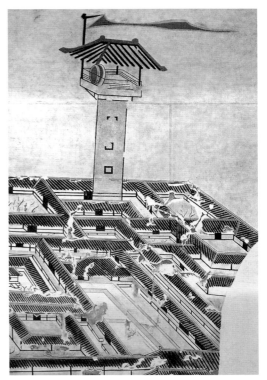

78 A clay model of a house/watchtower. 2nd cent. AD. Height 1.32m. Kansas City, Nelson-Atkins Museum 33-521.

79 A Neolithic jade openwork plaque. The centrepiece is the face of a fanged predator, flanked by scrolls ending in human (?) heads. Such masks long remain a feature of the decoration of jades and bronzes – see [87]. From Fanshan (E China), Liangzhou culture, 3rd mill. BC. Width 10.4cm. Hangzhou, Zhejiang Provincial Institute.

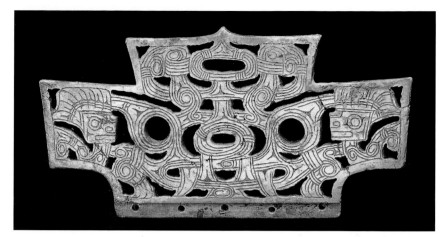

80 Perforated jade tubes (zong), of varying lengths and quite unknown purpose, represent enormous expenditure of labour, suggesting considerable importance and value, while the plain cut decoration on the sides looks almost Art Nouveau. About 1000–500 BC. Height 21cm. London, Victoria and Albert Museum.

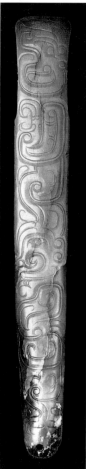

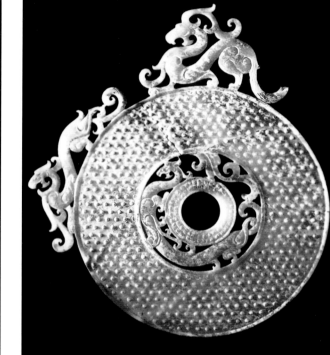

81 A jade implement like a chisel, patterned with stylized animal or natural forms probably derived from contemporary relief work in bronze. About 800 BC. Length 20cm. Kansas City, Nelson-Atkins Museum.

82 A jade disc (bi) with monsters. The discs are a long-lived ritual shape in jade, usually without the figure embellishment we see here. The dragon, a benign monster, takes a variety of forms, at first a somewhat serpentine or mammalian predator, and later mainly reptilian with splayed short legs, but with added horns (one or two) and ears, and sometimes wings. 3rd cent. BC. Diameter 16.5cm. Kansas City, Nelson-Atkins Museum.

83 *Bronze ritual vessel in the form of a tiger clutching (protecting) a man, covered with geometricized animal forms and masks. About 1200 BC. Height 32.5cm. Paris, Cernuschi Museum.*

84 *Bronze bucket (yu), a ritual vessel. A flamboyant treatment of traditional patterns and masks. The interstices of such patterns could be filled with red or black material. About 1200 BC. Height 36.1cm. Washington, DC, Freer Gallery of Art.*

85 *Bronze vessel (ho) with the lid in the form of a relief horned human head in a semi-realistic style contrasting with the rest of the decoration. About 1100 BC. Height 18cm. Washington, DC, Freer Gallery of Art.*

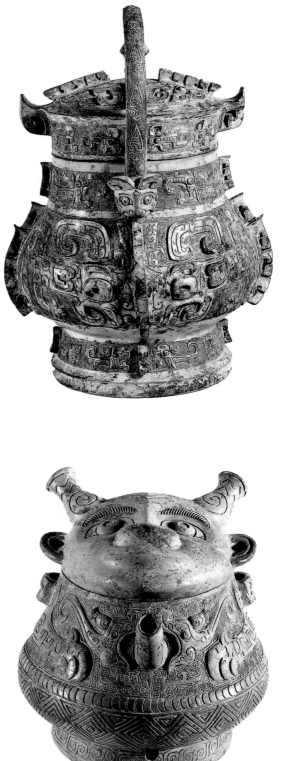

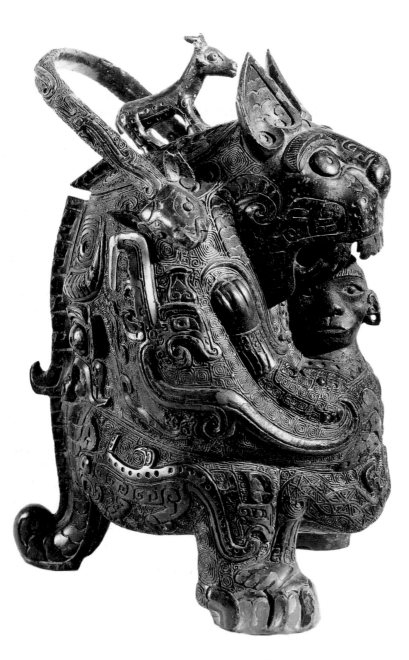

86 *A tripod clay jar painted in red and white with the patterning familiar from jade and bronzes. The bulbous feet appeared much earlier, and recur on bronze vessels, but it is far from clear what the inspiration was. Early 2nd mill. BC. Height 25cm. Beijing, Institute of Archaeology.*

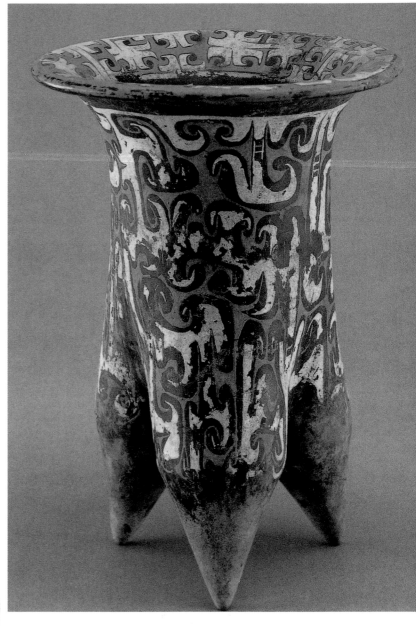

87 *Variations on the ubiquitous monster-mask (taotie) motif as executed on bronzes and in other materials through the Bronze Age. Many of the masks are composed as of two profile views of heads, juxtaposed.*

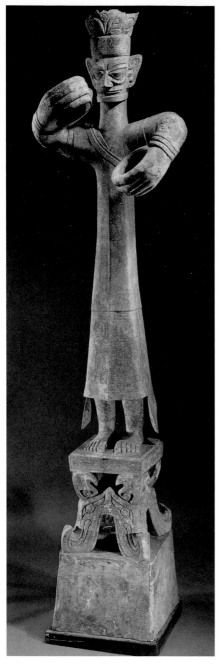

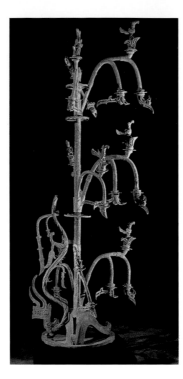

89 A bronze tree with birds (spirits) from the same site as the last. Trees like this are a feature of later Central Asia and Western Han China (some with Buddhas attached), hung around with gold discs or coins, and must be related to the ubiquitous 'Trees of Life' but are more specifically 'Trees of Wealth'. 12th cent. BC. Height 3.84m. Sanxingdui Museum.

90 Bronze vessel (hu) decorated in very low relief, with figure scenes of phoenixes, men fighting tigers, stags and bulls, and various bird demons. Such vessels are a rich source for the iconography of life and the spiritual world. The genre scenes, with a touch of the supernatural, look forward to the more explicit narrative of Han art. About 500 BC. De Young Museum, San Francisco.

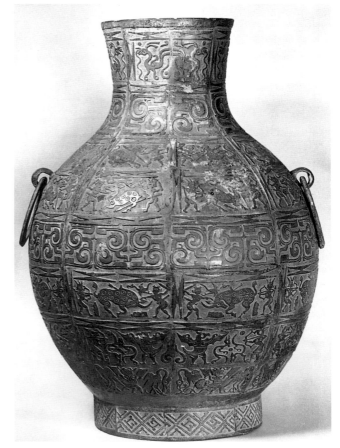

88 Bronze statue of a man, perhaps a ruler. An unusually large example of free-standing sculpture, its forms related to the stylizations of the early bronze vessels with their masks. From a sacrificial pit which contained heads of similar figures, with gold-leaf masks, probably once fitted to wooden bodies. 12th cent. BC. Height 42.5cm. Sanxingdui Museum (Sichuan).

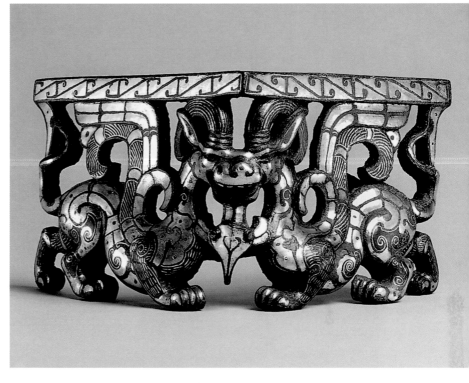

91 Gold hilt of a dagger with interlocking openwork pattern of monsters (the mask heads seen along the centre). 4th cent. BC. Height 11.1cm. London, British Museum.

92 Inlaid (silver) bronze corner support in the form of two horned, winged monsters sharing a single head. This is a very popular decorative style for furniture. The two-bodies-one-head conceit is one adopted by artists at various periods worldwide for corner motifs, like this; and in China compare the taotie masks [87]. 4th/3rd cent. BC. Height 11cm. London, ex-Soclet Collection.

93 Bronze mirror back, with bird-dragons. 3rd cent. BC. Diameter 16cm. Boston, Museum of Fine Arts.

94 Bronze incense burner (boshanlu) inlaid in gold and silver, in the form of a mountain swarming with creatures, from the tomb of Princess Douwan at Mancheng (with [102]). 2nd cent. BC. Height 25.4cm. Hebei Provincial Museum.

95 A lacquered box lid painted with peacocks. 4th/3rd cent. BC. Diameter 20cm. Washington, John Hadley Cox Collection.

96 A lacquered wine cup from Hunan, decorated with deconstructed bird-dragons. 3rd cent. BC. Length 25cm. Kansas City, Nelson-Atkins Museum.

97 A tiger hunt in a mountainous landscape with wild life; inlaid in gold on a bronze tube. The 'flying gallop' for the horse and its rider's 'Parthian shot' from the saddle are motifs derived from the west. 1st/2nd cent. AD. Tokyo, Imperial Academy.

98 A wicker box with lacquer-painted decoration on the lid, from Lo-Lang (Korea) where there was a Chinese commandery (administrative district). 1st/2nd cent. AD. Seoul, National Museum.

99 A dragon embroidered on silk from a tomb at Noin-Ula in Mongolia, probably a regal present from China to the aggressive nomad nobility (Hsiung-nu). 1st cent. BC. St Petersburg, Hermitage Museum.

100 Drawing and photograph of a painted silk banner from the tomb of Lady Dai at Changsha. It seems to show levels of cosmic experience, from the heavenly bodies, sun and moon, through the mortal world, to the underworld. The dead woman and attendants are shown at the centre. 1st cent. BC. Changsha Museum.

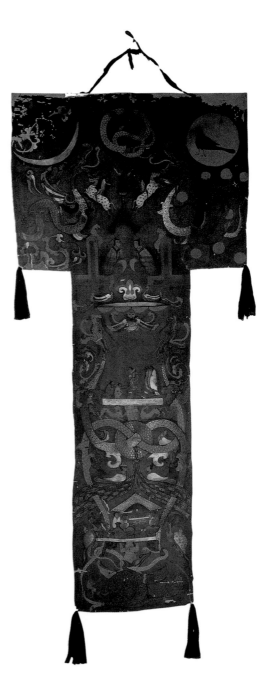

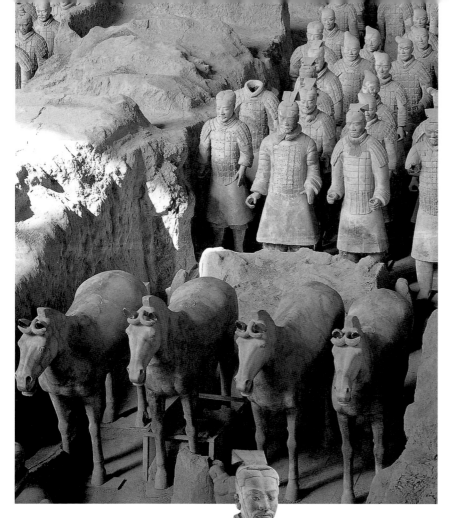

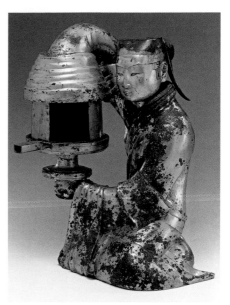

102 *Gilt bronze figure of a girl holding a lantern, from the tomb of Princess Douwan at Mancheng (with [94]). Totally and successfully realistic. Late 2nd cent. BC. Height 48cm. Hebei Provincial Museum.*

103 *A bronze vessel in the form of an elephant, with low-relief decoration of a type derived from that of earlier bronze vessels. Height 34.4cm. 4th/3rd cent. BC. Washington, DC, Freer Gallery of Art.*

101 *Clay warriors and horses (and [b] a single figure), from the army of thousands assembled and buried in the tomb of the first Qin emperor (died 207 BC), who had united China, at Lingtong near Xi'an. They are life-size, moulded but with features individually stylized in a realistic manner. Models of his other servants and civil service must also have been buried for him, but are barely being recovered as yet, in contrast with the tomb of the first Han emperor (Jingdi) where it is figures of the civil service and commissariat that have been uncovered (at one-third life-size), not yet the army. Other recent discoveries at other tombs are of whole bronze chariots and, elsewhere, a terracotta army of figures only 30cm high.*

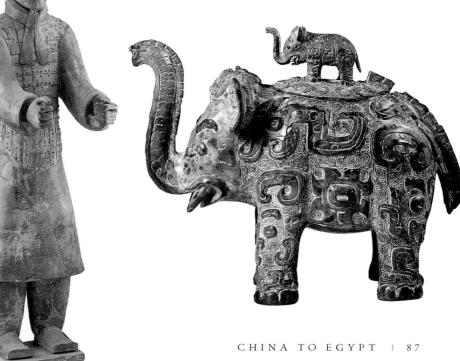

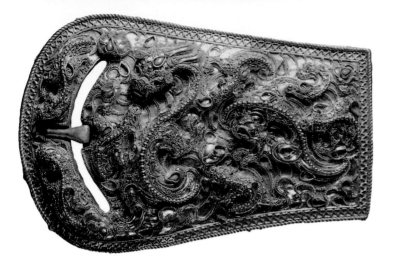

104 Gold belt buckle from Lo-Lang (Korea, see [98]). A dragon, twisted or bursting, is attended by a swarm of baby two-legged dragons, a motif which seems peculiar to these buckles. A masterpiece of filigree and granulation. 2nd/3rd cent. AD. Length 9.5cm. Seoul, National Museum.

105 A painted tile from a tomb shrine near Liao-yang (Manchuria). The faces are drawn in plausible three-quarter views and proper foreshortening of arms is implied beneath the dress. Early 3rd cent. AD. Height 19cm. Boston, Museum of Fine Arts.

106 Rubbing of an engraved relief slab from a tomb at Wu Liang Tz'u (Shandong). Battle on a bridge. The composition is basically in friezes, with no diminution of size for distance, and avoiding overlapping of figures. Mid-2nd cent. AD. Height 78cm.

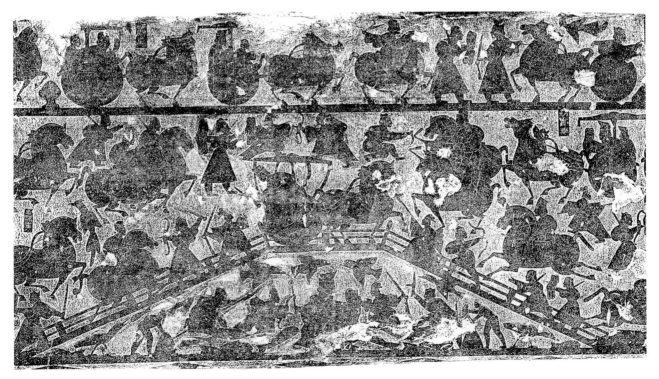

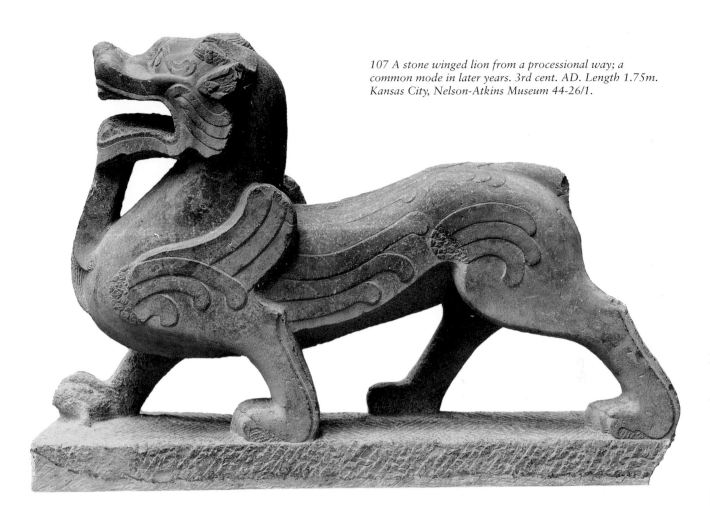

107 A stone winged lion from a processional way; a common mode in later years. 3rd cent. AD. Length 1.75m. Kansas City, Nelson-Atkins Museum 44-26/1.

108 Relief brick from a Han tomb. A popular style of decoration, often illustrated in rubbings since the relief is very low, but it is also subtly modelled, more like three-dimensional drawing. Here we see well-drilling (salt-mining?) and rustic life in a hilly landscape.

109 Wall painting from a tomb at Liao-yang (Manchuria) showing guests arriving at a funeral. The subjects are kept separate in the field but each shows a good sense of perspective and considerable verve – the upturned rear hoofs of the galloping horses. 2nd cent. AD.

110 A Yunnan bronze: a tiger carries a dead ox on his back, supporting it with a foreleg. Height 9.6cm.

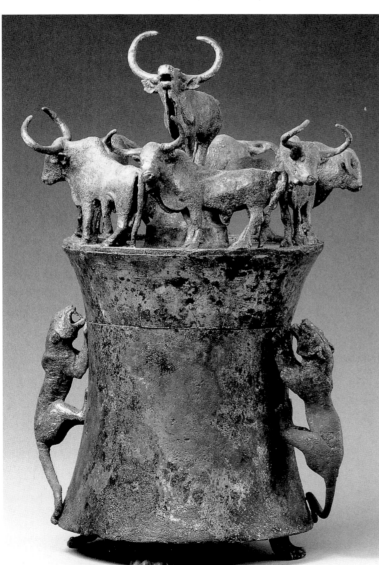

111 A gold seal of the Emperor Wen, from his tomb. The back is fashioned as a dragon; the base is inscribed as being the emperor's administrative seal. Mid-2nd cent. BC. 1.8cm sq. Guangzhou (Canton), Museum of the Nanyue King.

112 A jade dancer, from the same tomb. The fluidity of pose and dress belies the hard material. Mid-2nd cent. BC. Height 3.5cm. Guangzhou, Museum of the Nanyue King.

113 At the south, Yunnan, on the borders of modern Vietnam, was loosely attached to the Han and earlier rulers of China. The province had a distinctive style in bronzes with many studies in the round, free-standing or attached to vessels, of domestic life and the animal world, not stylized in the northern manner, but improving even on some of the more realistic arts of the steppes. Here is a casket (for cowry-money) topped by buffaloes, with tigers as side handles. About 100 BC. Height 43.5cm. From Mt Shizhai in Jinning. Beijing, National Museum of China History.

INDIA AND CENTRAL ASIA MAP 1

Several major rivers rise in an area which, given the generous geography, is readily defined, and they explain why I take India and south Central Asia (a rather vague term) together in this chapter. In the High Pamirs, where Pakistan, China and Tajikistan meet, the River Oxus (Amu Darya) rises and flows west, then north-west to the Aral Sea towards the Caspian. It creates a broad rich valley and plain especially to the south, as far as the Hindu Kush (which continues the Himalaya/Karakoram ranges westwards into Afghanistan), while to the north there are the plains then deserts of modern Kazakhstan, and to the west Turkmenistan, the River Murghab (Margiana) and the borderlands of Persia.

Beyond the passes to the east, the River Indus rises in the western Himalayas, making a steep path south through the mountains before debouching on to the wide and fertile plain which it has helped to create for north-west India (in the geographical sense; now north Pakistan) before entering the Arabian Sea near Karachi. From a source near that of the Indus, the River Ganges flows south, then east across northern India to empty into the Bay of Bengal north of Calcutta, while the Brahmaputra keeps east, then cuts back around the mountains to emerge at the other side of the same delta. Not that far from the Brahmaputra's eastern Himalayan course rise the Yellow River, the Yangtse and the Mekong. This Roof of the Old World is also its mainspring.

The northern neighbours are the hunters and pastoralist nomads of the Eurasian steppes, home to an art which had something to offer the south and east, and which we consider in Chapter Three. Any unities in our area are created by political history and the movements of people as much as by geography, and there is no possibility of describing a Central Asian style in the arts, except for narrowly defined places and roughly defined periods, and only a slightly better possibility of defining an early Indian one. This may be confusing but the amalgam is rich beyond description.

The Indus Valley was the seat of a major Bronze Age civilization, while southern Central Asia, especially Margiana at the west (a complex now clumsily referred to as BMAC – Bactria-Margiana Archaeological Complex), can claim a hardly less distinguished record but one less familiar to Western scholars until recent years. Later, the Persian Achaemenid empire penetrated to India, where a major, mainly Buddhist empire (the Mauryan, then Shunga) soon flourished, to be succeeded in our era by the Kushan empire, whose immediate origins lay nearer the Oxus to the north, and were inspired by both nomad and Greek rule there, and a little by Persian/Parthian with remoter origins that take us close to China. The Greeks in Bactria, along and south of the Oxus, were the distinguished and long influential remnant of Alexander the Great's armed progress to India in the 4th century BC. The Kushans take us into centuries AD, when they adopt Buddhism, and we end with them, well before the Persian/Sasanians take over in much of this area in the 3rd century AD.

The associations of north India with Central Asia had begun in earliest times, in both directions, although dominantly from north-west to south-east. The overland and sea routes to Mesopotamia were also busy, across the Silk Routes in the north, or through Persia, and coastwise into the Persian Gulf, while to the east lay China, beyond mountains, steppes and deserts. The arts of these crossroads of the Old World take on a flavour of their own, despite their sometimes inscrutable sources.

Everywhere, the climate ranges from warm to very hot, except for some very bitter winters in the north and

in the many mountainous areas. Prosperity depended on water – the rivers, irrigation, and in India also the monsoon. In Central Asia, from Persia to the borders of China, we find prodigious plans for irrigation, the most remarkable being the *qanat*, a miracle of organized mass labour and engineering – deep underground channels dug to bring water from the hills to the plains, sometimes over distances of more than 30km. At Mohenjo-Daro in India yet earlier a feature of the town was the Great Bath and the sophisticated drainage and plumbing systems in the houses **17**, **114**. The animal and vegetable resources drew on the diverse riches of both the northern plains and the near-tropical south, to offer, in places, conditions that were as ideal for the development of civilized urban societies as can be found anywhere in the world. Here, after all, both chicken and cotton were domesticated.

The Indus Valley (now Pakistan) boasted a major city at Mehrgarh, west of the river, of some 200 acres extent, from the 7th to the 3rd millennium BC. The classic Indus Valley civilization of the late third millennium BC supported notable cities, at Mohenjo-Daro **17** and Harappa, with a trading post even to the north, on the Oxus, and clear evidence of two-way communication with Mesopotamia. The cities had a 5km periphery with a fortified citadel, granaries, large assembly halls, but no conspicuous palaces or temples; the construction material was brick. The economy was mixed – agriculture, pastoral (especially cattle) and fishing. In the arts, the distinctive stone seals attest both writing (still undeciphered) and a society that needed to use them **116**; the practice could have derived from the west but not the chosen forms. The animal figures on the seals manage to be both realistic and decorative, and apart from them there is minor sculpture, including some stunning near-realism unmatched elsewhere so early **118**, **119**. All the trappings of a sophisticated society, accomplished in both domestic and visual arts, are present, but they do not survive the arrival of Aryan invaders, Indo-Europeans from the north-west, who introduce a culture which is also illuminated for us by remarkable texts – the Vedic hymns. So there are varied sources for the early Aryan dynastic rulers who were to face the eventual, if often temporary, intrusion from the

west of Achaemenid Persians, then Macedonians with Greeks, Parthians, and yet more Central Asians.

We turn back north now, to Central Asia, along the Oxus and across to the Caspian Sea and Persia, and first to the major Bronze Age cultures about which we have come to learn only in the last fifty years. But there were great cities there and fortified towns. The finds in the earliest, of the late 3rd and 2nd millennia BC, share much with Persia and Mesopotamia in their arts, notably the composite or inlaid figurines and vessels of stone **123**, **124**, **174** whose origins may lie in the east rather than west. A notable material for these is the soft grey stone, chlorite, mined at Jiroft (near Bam in Persia) and carried east and west. There are also other distinctive local styles and products for a society where the noble two-humped Bactrian camel is a major factor in life and art. The cities and palaces are generally square in plan **18**, often heavily fortified with round corner towers, and some (as Altyn Tepe) with something like the *ziggurat* stepped mounds of Mesopotamia. The occupants used seals – the mark of a sophisticated society but going beyond the usual Mesopotamian cylinders into a wide variety of metal stamps and figure seals of local inspiration **121**, and they made distinctively decorated and inlaid bronze axes which incorporate animal forms **120**, reflecting practices very unlike those to the west.

These arts of the oasis cities are not simply versions of nomad art, yet they are not quite metropolitan. Some of the arts, and even the architecture, also strangely suggest links not simply with Mesopotamia but farther west, with Anatolia and Syria, and carry the hint of moves west to east in the 2nd millennium BC, rather counter to the expected flow. This is, after all, the high road east-west-east, the hub of a 'world-system' in the view of some scholars, for nomads who become creators of settled empires (Medes and Persians), and for assertive westerners, and, in the minds of many, for the Indo-Europeans whose homelands are generally nowadays placed farther west or north. But this is no ordinary 'interface'. The Bronze and Iron Age arts and architecture of these Asian cities are not yet easy to characterize, and later in the Iron Age they give place more to the styles of the plains and steppes, since the lands from the borders of China to the Caspian Sea

were swept by nomads, many of whom settled, and the area of the Bronze Age cities had then to absorb also the effect of new invaders from the west. Genghis Khan had many predecessors with only slightly less grandiose ambitions. Nor was this an area only for nomads and pastoralists, since Central Asia also took a lead in developing metallurgy in ways that may have affected China and might not have depended at all on the west.

Balkh, just south of the Oxus, the ancient city of Bactra, was deemed one of the greatest of antiquity, Mother of Cities to later generations, but its early days are indecipherable under a massive site with the collapsed walls of constant reoccupations. In the 6th century BC it was the alleged home of Zoroaster (Zarathustra), whose philosophy/religion was embraced by Achaemenid Persia and survives today in Persia and with the Parsees in India. The Achaemenid Persian empire embraced much of south Central Asia from the late 6th to 4th centuries BC, and left its mark too, notably in architecture (mainly brick), but more accessibly in the precious-metal finds of the (rather variegated) Oxus Treasure now in London **351**, **353**, and even farther afield closer to Mongolia, in the Altai **352**. In Afghanistan, at the core of the massive brick mound in the ancient city of Kandahar, lie the outlines of an Achaemenid Persian fortress.

The Persians were followed and displaced by Alexander the Great's Macedonian and Greek army, and he went yet farther and founded new Alexandrias. Between them they introduced to Central Asia the plans and many of the details of Mediterranean city architecture. There had been Greeks in Bactria before, many of them deported there by the Persians, and there was a strong connection with their god of wine, Dionysos, partly from the myth that he came from the east, reinforced by the effectiveness of the area for growing grapes. Meanwhile, a Greek kingdom which had seceded from the Macedonians in the 3rd century BC and flourished in Bactria along the Oxus, kept in touch with the homeland and produced many distinctive works in the Classical mould but betraying eastern origins, not least some highly original coinage **141** which in time provided the model for Indian coinage. The Greek city on the Oxus at Aï Khanoum was essentially Hellenistic Greek with some eastern 'fire temple' architecture and a few Persian details acquired from the Persian town that it replaced. The visual experience of its citizens would not have been all that unlike those of their kin at home; at least, until they raised their eyes over the great river to the mountains of Central Asia. It included the provision of a Greek theatre and a display of Delphic maxims for proper behaviour to match the Indian King Asoka's, which were inscribed on columns farther south (see below). To the west the Parthians had taken over Persia from Alexander's successors in the 3rd century BC, and their arts show elements of the Classical tradition as well as their own Asian heritage (from east of the Caspian).

Bactrian Greek art is Hellenistic Greek with eastern trimmings but in no way inferior in technique and originality to products of the homeland – a quite unusual colonial 'interface' with an art and culture 5,000km away to the west. But the ability of Greeks to infiltrate distant and foreign parts was more than matched by the east's ability to absorb and translate all comers, a characteristic which can be observed to the present day.

The arts of our area from the 5th to 1st centuries BC were thus heavily affected by the arts of the west, Persian and Greek. But the Mauryan Empire of north India (4th–2nd centuries BC) was founded at about the time Alexander the Great was moving east. Its first king, Chandragupta, met Alexander, while Alexander's successor, Seleukos I, ceded to him the border provinces in exchange for five hundred war elephants. The empire was mainly Brahmin (early Hindu) by faith, but the Buddha had been born in the 6th century BC and in the 3rd century the Mauryan king Asoka adopted his religion, tiring of the incessant slaughter which had become the regal way of life. Stone-cutting now becomes a major feature of the arts in the service of the man-god, from architecture to major statuary and narrative reliefs. The working of iron is an important novelty, and the development of western-style coinage, inspired by Persia (ex-Greek).

A text, the *Arthasastra* by Kautilya, an Indian Machiavelli, gives us the prescription for a Mauryan state, economy and city, and helps us to understand the material remains and glimpse something of the

structure of an ideal Mauryan society, rather as Plato had recently done for Greece. Mauryan architecture had truly monumental aspirations at the capital, Pataliputra (Patna), far to the east along the Ganges. No little influenced by the Persian example, it was visited around 300 BC by the Greek Megasthenes, who describes it as the greatest city in the world. Its pillared hall measured 34 × 43m and its fortified area stretched over 10km along the Ganges. Here there were stone columns but not quite an 'order' of architecture, of which we see something in the isolated columns topped by animals on which Asoka's edicts were inscribed and which are found all over north India **27, 126**. These are 12–14m high, and here at least sheer height was meant to engage attention, but the form may have been inspired by Persian columns which were structural not free-standing: figures on free-standing columns were more in the Greek manner. Of the same architectural family are the pillared halls of Buddhist India (the *chaitya* **130**), often rock-cut. Stone reliefs show that there had been a very ornate style for palatial architecture in wood, which persisted for many centuries in the east and was characterized by the pointed arch for gates and windows. It has remained typical of much Indian architecture and furniture.

The figurative arts, Hindu and Buddhist, were determined by religious iconography, which in the years after the 4th century BC came to be no little affected by a lingering Persian tradition, but especially by a Greek one from the Indo-Greek kingdoms of Central Asia and north-west India (3rd–1st centuries BC). These added an almost architectonic, Classical element to what one must regard as a native style exemplified by a very supple and sensuous treatment of the human figure, probably deriving from clay modelling and long to be a hallmark of Indian art **129, 132**. It provides a vivid contrast with the more controlled and less vigorous Greek *contrapposto*, which was the Classical mode for relaxed figures **299, 301**. The combination was striking and it determined Indian sculptural style in the arts for the future, both Buddhist and Hindu. The great domed stupas **30** were imposing in their sheer size (they covered relics of the Buddha) but also involved walls, gates and a peripheral walkway, decorated with stone reliefs of figure and narrative, commonly helped out with religious texts like captions **131–34**. This is the start of major work in stone for Buddhism, the related Jainism and eventually Hinduism, for centuries to come, accompanied by ornate and colourful arts in precious materials, and painting, including the earliest in the famous Ajanta caves **135**. The earliest architectural complexes are mainly of the Shunga dynasty, succeeding the Mauryan, exemplified at the great stupa sites at Bharhut and Sanchi in north India, at Mathura, and to be continued at Amaravati, far in the south-east, ultimately in Sri Lanka (Ceylon) and South-east Asia.

While the Mauryans and Shunga flourished, the Greeks left in Central Asia, in Bactria, were on the move. In the 2nd century BC they were displaced south, and Indo-Greek kings founded another Greek city at Taxila in north-west India, near where the Indus comes down from the mountains, a junction for routes from the south to the north-west (to the Oxus) and north east (into the Tarim basin, now west China). Taxila was laid out in regular blocks like contemporary towns in Greece, and for a while was to be occupied by Saka from the northern plains, and Parthians from the west. The Greek presence was still to be felt in the 1st century AD; it had already affected aspects of Mauryan art and was to have a continuing influence and, as we shall see, would help form a more Classical, but local style for Buddhist art (Gandhara).

Greek displacement from the Oxus and Bactria was caused, directly or indirectly, by the invasion of northerners, the Yueh-chi, who had been pushed west from near the borders of China. These were to have a distinguished career in Central Asia and India, introducing not a little of what had been practised on the eastern steppes and in China. It was they who established the Kushan dynasty, which also embraced north India in the mid-1st century AD, and lasted until the 3rd. By the end of the 1st century AD their kings had adopted Buddhism, while Indo-Greek art had introduced Classical ways with narrative and at last an image for the man-god, a concept familiar to Greeks, but not to Buddhists, who had hitherto deliberately shunned such intimacy and indicated his presence by a

symbol only – a footprint or a tree. The result was a remarkable blend of Indian plasticity tamed by Classical realism and narrative formulae, in an art well expressed in the Gandhara area in the 1st to 3rd centuries AD, and with more emphatic Indian presence farther south **146–51**.

The range of scenes of the life of the Buddha which appear on stone reliefs decorating the stupa monuments can be interpreted in the narrative terms of Greek and, by then, Roman art. Many scenes are simply adjusted from the Classical repertoire and some figures seem simply Greek, though with slightly adjusted dress. This prolific treatment of the Buddha and the cycle of stories of his life and teaching, was long-lived and it travelled with Buddhism back through Central Asia, even to China, then Japan. In India it could accommodate the challenges of popular religion and Hinduism, and attempt representation of cosmic events in a literal way **157**, subjects which the arts of other cultures, as in Egypt, sought to manage through symbolism alone.

Apart from the stone reliefs, which look so drab in our museums, their grey slatey stone having lost its gilding, there were many minor works, often in precious material, which presented Classical subjects often on objects of western invention, but orientalized in part or whole – especially the cosmetic palettes **142**, ivory **152** and much jewellery **138**, **143–45**, **575**. The identity of the artists defies even speculation, but their background and training are immediately apparent, and depend on arts far to the west. Direct trade with the Mediterranean, through Alexandria and over open seas past Arabia, once the monsoons were understood, was vigorous, mainly in raw materials such as spices and gems, while through Central Asia the Silk Routes were also delivering to the west their treasures from China. Rome was beginning to take an active interest in eastern trade and Roman coins can be copied where Greek used to be the only model. Much of the Classical style introduced to the Kushans is that of a Greece which was already part of the Roman empire, but continuing old traditions. It is instructive to observe how Greek figures were re-interpreted for eastern occasions and identities **138**, **144**, **153**, **154**, **156**, **158**, without obscuring local tradition in the rendering of features **155**.

In the arts, the story of south Central Asia and India differs from that of China mainly because of the diverse areas involved, but especially because of their easy accessibility from north, east and west. The result is a considerable variety in styles over many centuries, from Chinese to Classical, and with strong local modes which were never wholly suppressed, all of them serving communities and dynasties in ways, from the major architectural to personal ornament, which we recognize worldwide. We are seeing often the effect of interfaces between the major urban civilizations, and from a very early date, from Mesopotamia and Persia, from China, then most apparent with Classical Greek intrusion in the Hellenistic period and later. The major powers and arts of Europe and Asia had at last met in a significant way to determine much that was to follow in the 1st millennium AD, at least until the coming of Islam. This was to establish a definitive form for eastern Old World arts, which more than rivalled what had lingered from the Roman and Byzantine empires, beside the strong and little-changing Buddhist and Hindu traditions. However, for all the imperial trappings of the great cities of the desert, Bactria and north India, it is not easy to share the visual experience of its members except in particular places and at particular times, so mixed is the parentage of their arts.

CENTRAL ASIA (SOUTH) AND NORTH INDIA	
3rd–2nd mill. BC	Indus Valley cultures (Mohenjo-Daro, Harappa)
3rd–2nd mill. BC	Margiana Bronze Age cultures
6th–4th cent. BC	Achaemenid Persian rule
327–325 BC	Invasion of Alexander the Great
3rd cent. BC– 1st cent. AD	The Bactrian Greek kingdom and Indo-Greek successors
322–185 BC	India: Mauryan dynasty (Asoka 269–232 BC)
185–72 BC	India: Shunga dynasty
AD 30–320	India and Central Asia: Kushan dynasty

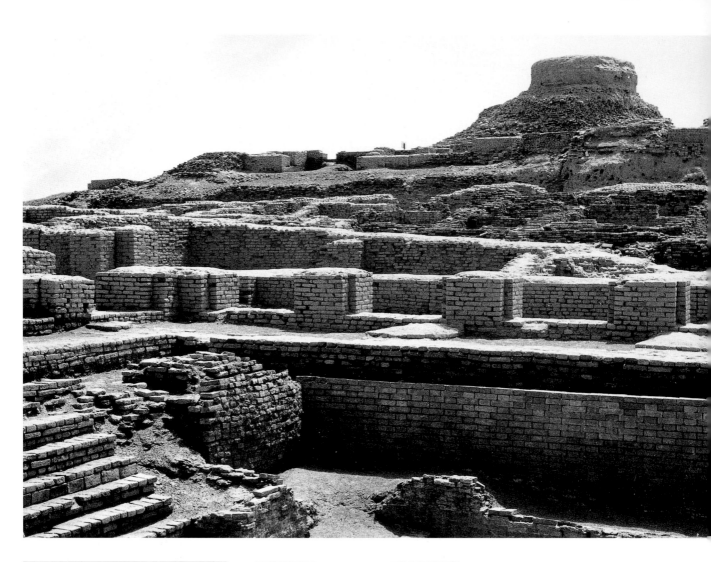

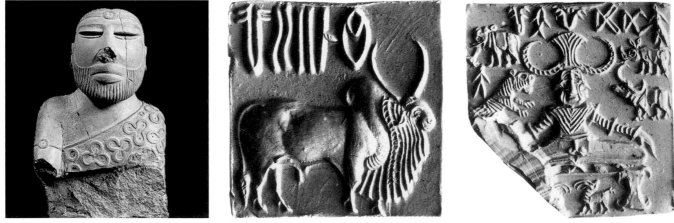

114 (opposite) The Great Bath at Mohenjo-Daro: a major feature of the site where the management of water, for ritual as well as comfort, seems to have been of high importance. The rest of the city was laid out in blocks of courtyard houses, and there was a fortified citadel; see the plan [17]. The monument at the top of this picture is Buddhist. About 2000 BC.

115 (opposite) Stone bust of a ruler or god from Mohenjo-Daro, about one-third life-size. About 2000 BC. Karachi, National Museum of Pakistan.

116 (opposite) Two square steatite seals, from Mohenjo-Daro, of the Harappan period in India, around 2000 BC. (a) The regal bull (zebu) is the commonest subject, next the rhinoceros and elephant; (b) carries a rare representation of a cross-legged deity who must relate to the later gods of the area, with their animal attendants and symbols. The stones were treated and fired to give a glossy finish, and their script is not yet deciphered. 3.5cm sq. London, British Museum, and New Delhi, National Museum.

117 Clay jar for storage, from Lothal, Harappan culture. Trees, flowers and birds are images of the real world used here almost as abstract decoration. For fine wares the Indus peoples were early users of the potter's wheel. Agra, Department of Archaeology.

118 Limestone torso of a man dancing, of the Harappan culture. Another remarkable lifelike study, understanding both posture and the quality of flesh. Height 10cm. New Delhi, National Museum.

119 Bronze figure of a girl from Mohenjo-Daro. An incredibly lifelike study of gawky, loose-limbed pubescence. About 2000 BC. Height 11cm. New Delhi, National Museum.

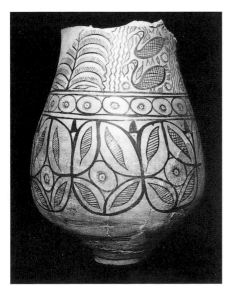

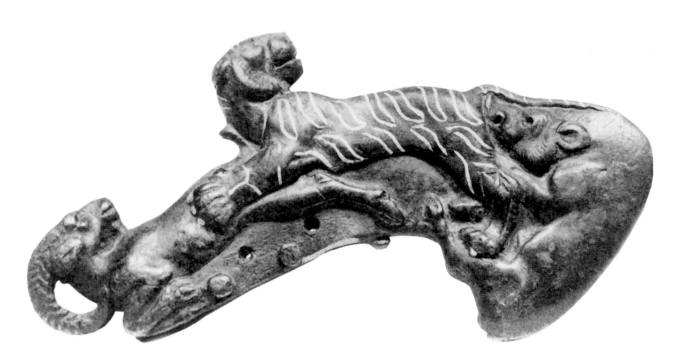

120 Bronze axe-head inlaid in silver, the cutting edge formed by the spine of a boar, following a tiger attacking a goat, all cast in the round. Few similar objects are known, assigned dates anywhere in the 2nd millennium BC well into the 1st, and apparently from Margiana and east Persia. The style has something of Mesopotamia combined with Asia, and the probable origin is in the Central Asian cities of south Turkmenistan of the Late Bronze Age. This is a case where the simple existence of the object far outweighs the loss of information about its origin and date (it was found in Pakistan). Length 17.8cm. London, British Museum ANE 123268.

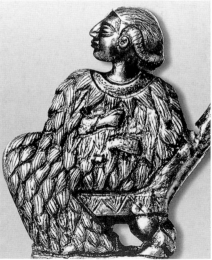

121 Drawing of a stone seal-amulet with its front in the form of a Bactrian camel, in low relief. The back and base are cut in intaglio: the back with birds over a charging bull, who has thrown a man (? – the legs behind), and human figures, below a cable; the base with an archer pursuing a goat over rocks, his dog beside him. This is a seal-type unique to the area but the two-humped camel will long remain a popular subject. From Togolok 21 (Margiana). Late 2nd mill. BC? Height 3.2cm.

122 Silver pin head, also from Togolok 21, in Margiana. The seated woman with her fleecy dress matches several seated, composite stone figures from the same area, attesting a local style which had spread from eastern Iran. Ashgabat, The National Museum of Turkmenistan named after Saparmurat Turmenbashi.

123 Seated goddess made of chlorite, limestone and bitumen for the hair. These composite figures have been found in some numbers in Margiana (see preceding caption); they are probably locally made, in a technique well represented also to the west, in Persia/Elam, and carried to India. Height 22.5cm. Teheran Museum.

124 Chlorite conical vessels, pocked for inlay, appear in eastern Persia and Central Asia and may be classed with the inlaid or composite human figures (as the last) of like distribution. They are decorated in low relief with figures of divinities and symbolic animal groups, very like Mesopotamian, and this example was found in Mesopotamia, at the Inanna temple at Nippur. 2nd mill. BC. Height 14.2cm. Baghdad, Iraq Museum.

125 Reconstruction (by Percy Brown), based on stone reliefs at Sanchi, of the gateway and façade of the city of Kusinagara in Magadha (near Patna). 2nd/1st cent. BC.

126 Lion capital from Sarnath, once on a column (like [27]) and supporting a sacred wheel/disc. The realistic detailing of the animals, including those in relief on the base, is more Classical than Indian in style. The group has been adopted as a symbol of the modern Indian state. Height 2.15m. 3rd cent. BC. Sarnath Archaeological Museum.

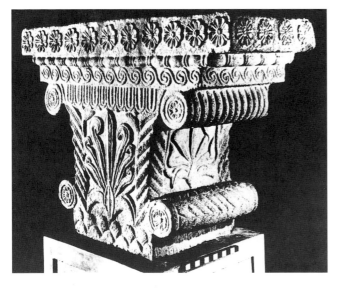

127 Stone capital from Patna. The form is that of wooden capitals seen on Indian reliefs, not a little influenced by Greek pilaster capitals, while the flame-leaved palmettes are also of Classical inspiration. 2nd/1st cent. BC. Patna Museum.

128 Stone disc from Taxila (Sirkap site). These mysterious objects, some flat, some pierced, are typical of the Mauryan period in India. They are carved in delicate low relief with divine and other figures and florals, presaging the great importance of the lotus motif in later Indian art. 3rd/2nd cent. BC. Diameter 9.6cm. New Delhi, National Museum.

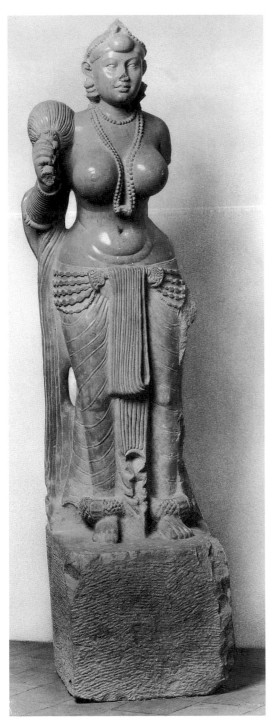

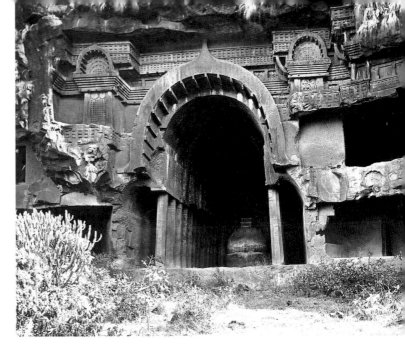

130 *The entrance to the apsidal, rock-cut* chaitya *hall at Bhaja (west India), showing the translation of wooden architectural forms, including the typical Indian pointed arch for doors and windows. The height of the door is over 10m. 2nd cent. BC.*

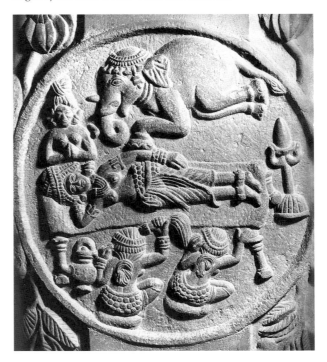

129 *Life-size sandstone figure of a yaksi (earth spirit) from Didarganj (near Patna). Her full figure is enhanced by the high polish which appears on much Mauryan sculpture. Otherwise the features and anatomy owe much to Classical art, even archaic (probably via Persia) in the treatment of dress. 2nd/1st cent. BC. Patna Museum.*

131 *Roundel from the railing of the stupa at Bharhut. It shows the dream of Queen Maya, the mother of the Buddha (personified in the elephant). The combination of elevation and plan (bed and body) is naively direct and the story is told by an assembly of all relevant figures with their appropriate gestures or attributes. 2nd cent. BC. Calcutta, Indian Museum.*

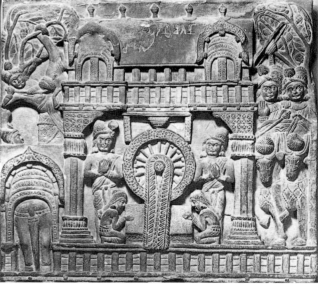

132 One of the gateways to Stupa 1 at Sanchi (a), and the figure (b) attached to another gate there (see [30]). The latter is an exuberant and supple study which owes little or nothing to anything Classical but exhibits a style long apparent in Indian art. A similar, standing figure of ivory was found in Italy in the ruins of Pompeii (AD 79), and inscriptions suggest that some of the Sanchi reliefs were carved by ivory-workers. 1st cent. AD.

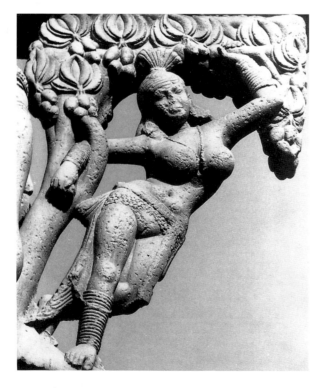

133 Stone relief from the stupa at Bharhut. A narrative composed of formal figures and groups with no little live observation (at the left, the back of a horse disappearing through a doorway, and above it an elephant being restrained from tearing a tree), and fearless treatment of unusual poses. A royal visit (in an ox-drawn chariot, right) to the Buddha, never shown in human form at this date, but by symbols; here the turning Wheel of the Law. 2nd cent BC. Washington DC, Freer Gallery of Art.

134 (opposite) The head of a yaksi at Bharhut. 2nd cent. BC.

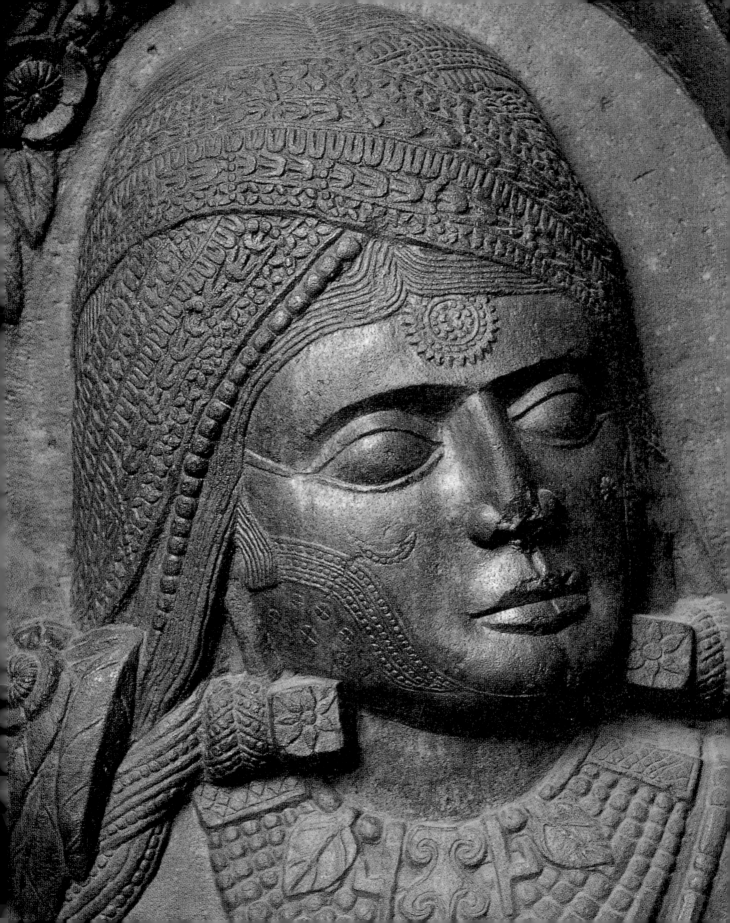

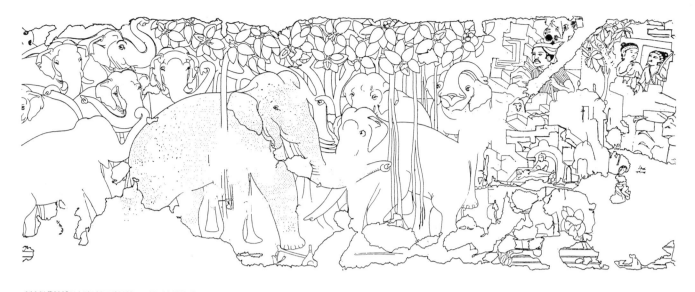

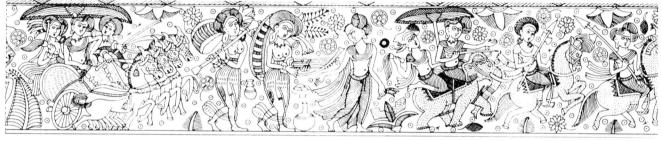

135 The paintings in the Ajanta caves, some even as early as the 1st cent. BC, show that the medium allowed even freer and more ambitious composition than did relief sculpture. The group of elephants is shown with figures in profile, three-quarter and frontal view, realistically grouped: one is the Buddha incarnation, sacrificing his tusks.

137 Clay moulded plaque from Bengal: a yaksi. These plaques, often very elaborate, were 'popular' art and as widespread in their production as the Hellenistic Greek clay figurines. The general type, however, goes back to the days of Harappa. 2nd cent. BC. Height 21.3cm. Oxford, Ashmolean Museum Eastern Art × 201.

138 A tiny gold sphinx, like a Hellenistic earring but here made to serve Indian dress (a turban pin, or necklet clasp). She holds a tablet on which we read in Greek THEA, 'goddess'. From Kashmir, 1st cent. BC/AD. Height 3.8cm. Private Collection.

136 Incised frieze on a bronze vase from the Khangra district (SE of Kashmir; the 'Kulu vase'). A royal procession on horses, elephant and chariot, with music. In such a scene it is not easy to judge whether a principal figure is repeated (on elephant and in chariot), or separate vignettes are juxtaposed, or a single occasion envisaged. Overall it depicts a royal progress. 1st cent. BC. Height of frieze about 12cm. London, British Museum OA 1880-22.

139 Ivory rhyta (horn-shaped drinking cups or funnels) from Nisa, a Parthian site between the Oxus and the Caspian. This is one of a hoard, probably booty from Greek Bactria where the type is also represented. The style and most of the subject matter is Greek, with some local features; the shape and other details appear in metal examples from Parthia which are totally Hellenistic in style (as [377]). The forepart of (a) is that of a horned, winged lion of Greco-Persian origin. The detail (b) is from the neck of another rhyton with very Greek figures, possibly of poetesses. 2nd cent. BC. Height of detail of frieze 8cm.

140 Gilt silver disc from horse harness of a type found around and east of the Caspian. The war elephant is Hellenized in having a turret, and its saddle cloth is decorated with a Greek sea-monster (ketos), a creature influential in the arts of Central Asia and north India. Probably 2nd cent. BC. Diameter 24.7cm. St Petersburg, Hermitage Museum.

141 Gold coin, the largest struck by any Greek anywhere, of the Bactrian King Eucratides. He calls himself Great King, as did the Persian kings, and on bilingual coins for India maha-raja. The riders are the Greek gods, the Dioscuri. Many of these divine types on Greek coins are taken up in later coinage in north India, while classicizing representations of the gods themselves appear on later wall paintings in Central Asia. Mid-2nd cent. BC. Diameter 5.5cm. Paris, Bibliothèque Nationale.

142 A common product of the Taxila area of north India in the 1st cent. BC/AD is a small stone palette (10 to 15cm diameter), a Hellenistic form, in the east often decorated with Greek subjects, sometimes slightly translated for the east with elements of Indian dress. This has figures in a mixture of Greek and Asian dress, but a Dionysiac subject (for a god whom the Greeks thought had once invaded India). His priest is at the centre placing something on an altar beside a woman holding a siren-shaped rhyton. Below, a boy leads a lamb for sacrifice; at the right is Tyche – the Greek goddess of Good Fortune who served as the goddess Hariti in India – and another figure (pouring wine?). 1st cent. BC/AD. Private Collection.

143 Gold group from Taxila, showing a youth importuning a girl, probably a version of Cupid and Psyche. Such versions of Greek figures, including Aphrodites, are popular at Taxila and in Central Asia, and they introduce realistic Classical anatomy and relaxed poses. This type of Greek 'loving couple' group may have helped inspire similar Indian statuary groups (mithuna). 1st cent. BC. Height 4.6cm.

144 A silver bowl made in the east, probably north India, under the strong influence of Hellenistic style and iconography but totally translated in terms of much of the dress, and the action not obviously expressing any unified narrative that we can discern but rather a succession of groups whose identity is not always easy to explain even in Classical terms. The figures were originally gilt and there was niello on the decorative border. 3rd cent. AD? Diameter 19.1cm. Washington, DC, Freer Gallery of Art 45.33.

145 Bactrian sites near the Oxus were occupied by the Yueh-chi while they were founding the Kushan dynasty, and finds from regal tombs at Tillya Tepe reveal that mixture of Greek Bactrian, nomad, even Chinese and Indian subjects, which characterizes earliest Kushan art of this area. This innovative eastern version of a Greek subject shows Dionysos and Ariadne, on a lion, accompanied by a drunken satyr before them, and a Victory crowning them. The last is a figure much copied in Indian art. This is a gold pendant, inlaid with turquoise and paste, from the dress of what might be an Indo-Greek princess, a consort to the local king and sacrificed at his funeral. In the Greek manner she carried a coin in her mouth and in her hand – Charon's fee for passage over the Greek Styx to the Underworld. Buried in the mid-1st cent. AD. Height 6.5cm. Kabul Museum.

146 Gold reliquary casket set with garnets, from Bimaran (E Afghanistan). Figures in an arcade are a Classical motif but here the pointed arcades are Indian, and the relaxed posture of the figures, which possibly include the Buddha, derive from Classical art, rather than Indian. 1st cent AD. Height 7cm. London, British Museum.

147 The marble head of a Boddhisattva (aspiring Buddha, if not the Buddha himself) with quite Indian features, but the hair treated as it would have been in the Classical world of the 2nd/3rd cent. AD. Height 59cm. Vandoeuvres, George Ortiz Collection, Cat. no. 173.

148 An early stone figure of the Buddha treated like a Classical god in features, pose of head and limbs, and fall of dress, which is itself Indian, however. 2nd cent. AD. Once at Mardan.

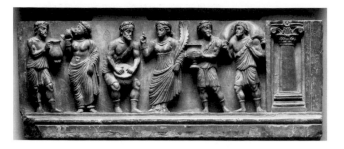

149 Schist relief (a stair-riser) from the Peshawar Valley (Gandhara). Several of these early and very classicizing reliefs make no reference to the Buddha yet must come from Buddhist monuments. Here a woman is provided with a drink, there is music (a drummer) and more wine is brought up in a pot and wineskin. The figures are quite Classical in pose, the drinking woman wears a Greek himation but bares her body, the other is more fully dressed as a Greek, but both have eastern bangles and anklets. The pillar at the side contains a Greek Corinthian column. 1st/2nd cent. AD. Height 16.5cm. Cleveland Museum of Art 30.329.

150 Elements of Greek architecture were inherited from Bactria and the Indo-Greeks, and sometimes put to original use. Here the overhanging acanthus leaves of a Greek Corinthian capital shade a seated Buddha. From Jamalgarhi (Gandhara). Width 42cm. London, British Museum OA 1880-357.

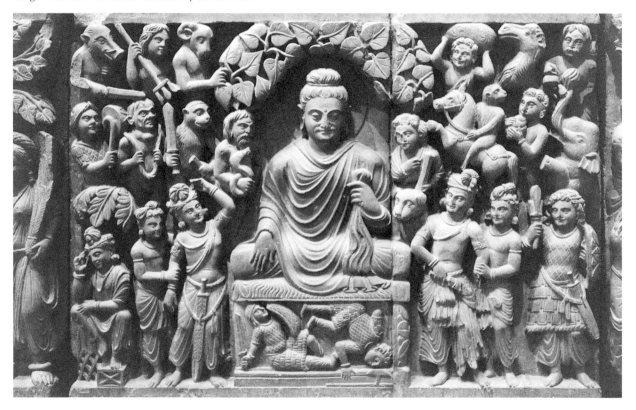

151 Later Gandhara reliefs retain the Classical treatment of dress and pose but the dress itelf is Indian and the subjects commonly from the life of the Buddha. This one has a strictly symmetrical composition but resolved into many separate studies. The Buddha in contemplation beneath the bodhi tree is being unsuccessfully distracted by the attacking host of Mara, shown in the upper two registers by figures with or like animals, while the god's supporters stand at the front (one at the right with Classical corselet and Central Asian sword), not actively fighting (only the Buddha's stool shows battle) but signifying their role by their identifiable presence. The figures were originally heavily gilt over the blackish schist. 2nd cent. AD. Height 50cm. Washington, DC, Freer Gallery of Art 49.9.

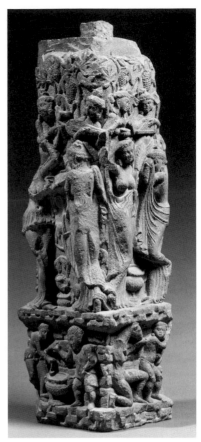

152 Ivory lid of a box from Begram (near Kabul) where there was a hoard of mainly 1st-century AD objects from as far distant as Rome and China, but no substantial trace as yet of Buddhism. The incised figures of women are Indian, recalling the most voluptuous of the stone figures. But the frieze around is a Classical floral with mixed Classical monsters at the corners. The Hellenistic florals become very popular, with the botany adjusted to the region, from India to China, to become as distinctive a border motif in the east as they long were in the west. The formal Indian lotus-leaf friezes can be very like Classical 'leaf-and-dart'. 1st/2nd cent. AD. Height 29cm. Formerly Kabul Museum, present whereabouts unknown.

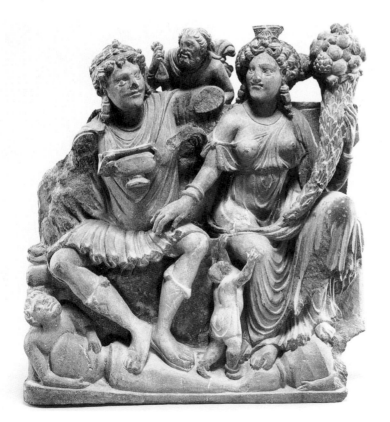

153 Red sandstone pillar from a stupa at Mathura (just south of the Ganges) with Classical Bacchanalian figures and vines but of Indian type and dress. This is one of the latest expressions of the style, before more stereotyped but no less lively figures express the following, Gupta style in sculpture. 2nd cent. AD. Height 80cm. Cleveland Museum of Art 77.34.

154 Another late classicizing group, of Indian deities: Pancika, recalling Ares, and Hariti, like Greek Tyche with a cornucopia, Classically posed. From Takht-i Bahi (Gandhara). 3rd cent. AD. Height 27.3cm. London, British Museum OA 1950.7-26.2.

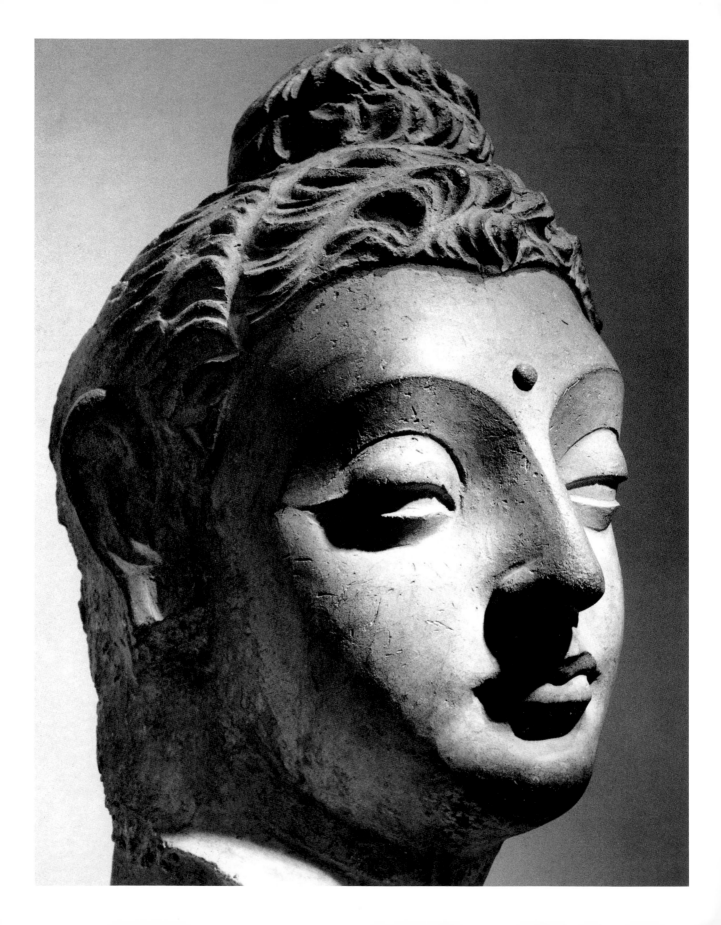

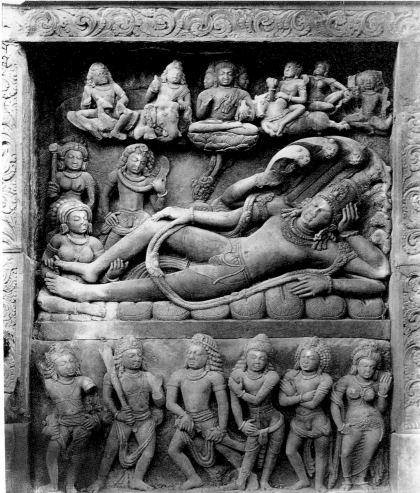

156 Vajrapani with a thunderbolt in a clay group with the Buddha, whom he protects; but the posture and head is that of a Classical Herakles with his club, a type devised in the 4th cent. BC, and at the other side of the Buddha was a Hariti, like a Greek Tyche. At Hadda (east of Kabul). Destroyed?

157 The mature Indian style tackles the problems of complicated narrative, depending very much for recognition on tradition and attributes. Vishnu sleeps on the coils of the multi-headed serpent Ananta, and dreams the creation of the world, shown by Brahma seated on a lotus which rises from him. Other figures are 'family' or express attributes. Such scenes attempt the most complicated narratives of ancient art, only fully intelligible, however, to the well-informed. On the Vishnu temple at Deogarh (near Patna). 5th cent. AD.

155 (opposite) Classical elements are never quite lost in the later period but the features and hair are totally Indianized. This is a stucco head from Gandhara. 5th cent. AD. London, Victoria and Albert Museum I.M.3-1931.

158 A silver dish, once the prized possession of the Mirs of Badakshan (NE Afghanistan). An eastern misinterpretation of a Classical scene. The two women at the left are really pulling a chariot on which a god (here more like Herakles than Dionysos) sits with a cup and a small female companion (an Ariadne originally). The joined Cupids above should hold a wreath and a jug; another helps push the wheel. Behind, there is a skipping satyr. The panther in a bowl below derives from Dionysiac imagery. This ghost of Classical iconography was produced in the east in the early centuries AD, and was followed by Sasanian versions where the central figure is made a goddess. Diameter 22.6cm. London, British Museum ANE 124086.

The broad valleys and plain created by the Rivers Tigris and Euphrates run south-east from the mountains of eastern Anatolia (Turkey) to the Persian Gulf (through Iraq) where, for the last 300km, their channels were far closer together in early antiquity. The mountainous northern areas towards the Black Sea and Caspian form part of the story – ancient Urartu, Media and Armenia – as does western Persia, especially Elam at the south. To the west, there lies an easy and short route through Syria to the Mediterranean, and thence south along the Levant coast towards Egypt, through Phoenicia and Palestine – completing what has been called the 'Fertile Crescent'. Overland and sea routes lead into Arabia, and east to Central Asia and India, and these were in use from an early date. But it was the natural richness of the so-called Land of the Two Rivers that guaranteed its role in the early development of urbanism and agriculture, and the challenges offered by the need to master techniques of irrigation and, especially in the south, drainage. We have observed already the contribution of northern Mesopotamia to the extant record of the earliest arts of man the town-dweller **10**.

In Mesopotamia, with major cities discernible by the 6th millennium BC, there is, down to the 6th century BC, a succession of local dynasties, ruling areas between the rivers and beyond, sometimes in conflict, but generating an unmistakably unified style in the major arts, since each responded to the need for an idiom to express power and continuity, and inevitably aped the achievements of their neighbours or predecessors while trying to outdo them. Their names generally reflect areas of concentrated wealth – Sumerian (southern: Nippur, Uruk, Lagash), Akkadian (central: Agade, Ur), Assyrian (northern: Assur, Nineveh, Nimrud), Babylonian (southern: Larsa, Mari, Babylon and intrusive Kassites), Elamite (south-eastern: Susa), and so on. We are dealing with some five millennia during which materials and influences from neighbouring major cultures are influential at all times, but some generalizations become possible. Until the latest period Mesopotamia gave more than it received from the rest of the Old World.

The early architecture of the delta included large buildings of reed, in the latter-day home of the Marsh Arabs of Iraq. We see pictures of them on cylinder seals **204a**. Thereafter and to the north major architecture is of mudbrick, not always baked, and it is massive **19**, **167**, **168**. Stone is commonly cut only in later years for some palatial buildings and waterworks, and especially for architectural sculpture, but by and large this is an architecture of brick, and it well demonstrates the monumental possibilities of the medium and the heavy rectangularity of the forms it encouraged, although there was an attempt at a brick vault **35**, with no immediate followers that we can detect. One of the earliest cities, Warka (Uruk), had a wall some 10km long, while 6th-century Babylon occupied a rectangle of 1.5×2.5km, either side of the Euphrates, and an 8km wall enclosed its suburbs.

Walls were massively impressive, punctuated by buttresses and towers, and regarded as a proper field for decoration: in the 4th millennium BC at Uruk, walls featured pattern mosaics of coloured clay pegs **166**, which

appear also on cylindrical columns, such as never become a major decorative feature in Mesopotamian architecture. In the 1st millennium city walls may be decorated with coloured, glazed tiles, including relief figures of protective monsters, such as the lions and dragons at Babylon **195**, all lending colour to an architecture which may otherwise seem drab to us, but where even the stuccoed brick was commonly painted. Palatial buildings were tall, block-like, with courts and processional approaches, while the famous Hanging Gardens of Babylon **168**, one of the Seven Wonders of the Ancient World, demonstrate a feeling for a landscape ambience. Temples for the epiphanies and worship of the gods were mounted on raised platforms which became progressively taller to make the characteristic *ziggurat* form **31**, an artificial mountain raising the priests towards their gods, and symbolizing the mountains from which all wealth (water) flowed, as well as perhaps providing a model for the Tower of Babel ('and they had brick for stone, and bitumen for mortar' – Genesis 11.3). In an essentially flat landscape such artificial hill features were the more conspicuous, while the towns themselves became great flat-topped mounds through rebuilding over collapsed masses of mudbrick. Modern excavators have often had to tunnel for the remains.

The earliest arts, of pottery and stone figures, follow conventions of figure-drawing and pattern which we meet in many other places **159–61**. Mesopotamian sculpture, even in early days, adopts an idiom which is persistent. It dwells on rounded forms, the cylinder, cone and sphere, the product of clay modelling, it may be. In the south, stone for sculpture had to be brought from a distance. By contrast, Egyptian sculpture developed a characteristic rectangularity, perhaps because it was from the first devised for architectural settings. The earlier arts of Mesopotamia make much of stone and, as far as possible, colour, especially through inlays of stone, bitumen or shell. They include figure subjects, generally rustic or warlike occasions, but also rulers and priests. These are rendered with heavy forms and stereotyped postures, with not much detailing of dress, but this rather formal style, for larger figures in the round or relief, becomes the norm.

Individual sites generate local traditions in rendering figures of gods or worshippers **160**, **173**. Low relief on vases or stelae is a popular medium for demonstration of power **170**, **179**, **180**, and imaginative use of inlay for more decorative purposes **174**, **177**, **178**. Some major work in metal indicates confident and sometimes complicated techniques of hammering and casting **163**, **175**, **183**. A rigid frontality is also favoured, and can make even flat relief figures, such as animals on smaller objects, turn their heads out to the viewers **171**, three-dimensionally. Otherwise there is the common figure convention of profile heads and legs with frontal torsos. We do not find action groups in the round, rather than passive figures of gods and kings; there are, however, massive monster figures in the near-round to guard gateways **186**. In low relief such creatures, with divine figures and groups, come to cover many palace interiors and are our major source for the monumental figurative arts of the 2nd and early 1st millennia BC.

The carving of palace reliefs is relatively shallow, surely helped out with colour (always missing now). These are the most expressive of all the Mesopotamian arts, sophisticated narratives which had to abjure the frontality of the larger figures in the round or half-round. Subjects, disposed on entrance and throne-room walls, are regal: a successful campaign **188**, or personal prowess in the field against wild creatures, especially lions, which were bred for the hunt in the royal parks **189**. They include far closer, realistic observation of animal forms than of human ones, which are heavily patterned; although they are easily matched in antiquity elsewhere, the specific idiom is unmistakable. There is some repetition of figures and groups, but overall the scenes are individually devised and executed: each is an original conception of its artist and not a stereotype. Other reliefs, with religious subjects, are more repetitive. Painting was an alternative to the low relief on walls, but little has survived **187**. The compositions are in friezes but often very tall, and also often set in registers or sometimes on oblique ground lines, with no real perspective or diminution for distance, but representing a common mode for such multi-figure scenes worldwide. The scenes fill whole walls, not mere panels, and there are vast differences in the degree of

crowding of figures permitted. They are presented timelessly, as elsewhere, even where specific campaigns are depicted, and annotated on the relief by inscriptions; that is to say, the same figure (usually the king) may be duplicated and there is no deliberate attempt to record the progress of events, as in a long campaign, rather than individual actions, including the less violent ones in camp, but with some emphasis on prisoners and their fate, from impalement to dismemberment. Less martial scenes include some record of construction of palaces and fortifications **74**. The visitor to a palace so adorned would have been overwhelmed with these statements of success and power, and this was of course the major intention. It was an art for consumption at a particular place and for a particular audience, not the public at large, but it must have involved large and permanent palace workshops.

Proliferation of palaces was a sign of strength, and remains so in this area to the present day. Each king made a new palace, or more than one, without destroying those of his predecessors, though sometimes 'borrowing' some of their relief decoration. Indeed, some kings deliberately sought out old foundations and their written (and to them legible) foundation records, so that the spirit of continuity of power could be literally demonstrated through their architecture. There is even something like the creation of historical museums for booty or memorials of ancestral success, kept up and added to over centuries, as at Babylon and Elamite Susa. This is very much art in the service of history and posterity, with no great expression of joy – even what looks like a formal picnic turns out to be a celebration of success, attended by the severed head of the defeated **193**.

There was absolute command of the most complicated techniques with precious metals and ivory, also with bronze, including lost-wax casting, and eventually of iron. Hammered vessels are often decorated in quite high relief with figure scenes. Non-figure decoration is generally floral, with formal friezes of rosettes, lotus flowers and palmettes, as borders and dividers, a reflection of what must have been the common patterning of textiles and rugs **190**.

These were patterns which were to be copied and reworked by Greeks from the 8th century BC on, and eventually returned east in a new guise. I have mentioned glazed tiles, and glass techniques too (though not yet for clear glass) were learned from Egypt. While the arts so far discussed seem mainly of indigenous inspiration, early rivalry with Egypt brought knowledge of the arts of the Nile, which differed mainly in materials, purpose and style, while there seems to have been a constant flow of peoples from the east beyond Persia, which was intermittently influential and which brought, for instance, precious and ornamental stones such as lapis lazuli to the west.

We are mainly concerned here with élitist and palatial arts, and there was much specialization in the palace workshops. Jewellery is not especially ornate but there is imaginative use of colourful inlay on other objects **176–78**, best known from the excavation of spectacular tombs, like those at Ur. Although humbler crafts are apparent, they did not attract the same ingenuity and originality. But there is one exception – the major, if miniaturist, craft of seal-making. Seals were not the perquisite of the ruling classes only, but also of minor officials, merchants or indeed anyone who had cause to authenticate or claim possession of a document or object by adding his seal. This was important where official literacy was of some significance in management of materials and dealings with the foreigner. Every Babylonian carried a seal, said the Greek historian Herodotus in the 5th century BC. They are dominantly cylinder seals, not stamps, since these could readily be rolled across the end or face of an inscribed clay tablet (cuneiform inscriptions were most easily impressed in clay; see **46**). Most seals are no more than 2 or 3cm high and many are inscribed, cut in hard and (to us) semi-precious stones. They are preserved by the tens of thousand, which is not surprising since they represent production over some two and a half millennia across the whole area. Their iconography is generally of divine figures or worship, or animals: animal fights played an important symbolic role throughout the Near East. The composition was inevitably a frieze, recurrent

depending on how far you could or had to roll the seal. A few might show heroic occasions and involve real narrative, but the subjects are hard to identify with certainty now beyond something generic implying king/hero against monster, which was a common theme in all the arts. Many show deities receiving attention or demonstrating their power. Animals are popular subjects, and there was no great effort to make each seal exactly unique; the simple act of sealing was the decisive factor. But they demonstrate a development of styles of the first importance for the art historian and some are masterpieces of miniaturism, a major art on a minor scale, while their iconography is the richest of all the surviving media, and the frieze compositions no doubt played their part in the devising of larger decorative arts. As in many other parts of the world, texts, such as the Epic of Gilgamesh and Creation stories, seem not to have directly affected the artists' choice of subjects or detail of treatment.

There were several border cultures, even empires, shorter-lived, but each generating distinctive art forms, ultimately dependent on the Mesopotamian model. Elam in south-western Persia was a link to peoples farther to the east **192**. In the mountainous north the kingdoms of Urartu, Armenia and across to the Caspian Sea are best recorded in their metalwork **191**, **196**, **197**, **199**, **200** and stone architecture; they may look as much to Anatolia and the west. In the Persian hills the Luristan culture offers some very individual decorative metalwork **198**, **201**, an isolated but long-lived phenomenon thanks to the area's relative inaccessibility. These demonstrate how influential Mesopotamian styles proved to be, over millennia. By various intermediaries, they were in time to affect also the arts of the Mediterranean world, and, more directly, those of their successors in the Achaemenid Persian Empire.

However, the arts of Mesopotamia and of its immediate neighbours east and west rarely evince the humanity and feeling for the natural world which characterize cultures farther east and on the Mediterranean, however inspirational they proved to be for others. We are far less aware here of anything below the palatial, expressive of power, except perhaps on the seals. Most of the pottery, a good marker of the visual experience of lesser folk (as it was in China, the Classical world and the Americas), is generally drab.

Together with the monuments of Egypt, the Mesopotamian palaces excavated in the 19th century helped form contemporary Western views of ancient art, usually as a foil to the more familiar and generally later Classical, and with a strong Biblical allure. The acute were not slow to spot the interconnections, but on the whole the differences were more conspicuous. In the panorama of the early works of man the despot and his artisan servants, the similarities may be no less significant.

MESOPOTAMIA: SUMMARY PERIOD OUTLINE	
Early Dynastic	3000–2334 BC
Akkadian	2340–2193 BC
Neo-Sumerian, Ur III	2125–2004 BC
Old Babylonian	2025–1594 BC
Mitannian, Kassite, Old Assyrian	1600–1100 BC
Neo-Assyrian/Babylonian	1000–539 BC

159 A polychrome clay dish from Arpachiyah (near Nineveh) showing decoration that clearly derived from wickerwork. This must have been a very common inspiration for the creation of geometric and curvilinear pattern, as also was weaving. Early 5th mill. BC. Baghdad, Iraq Museum.

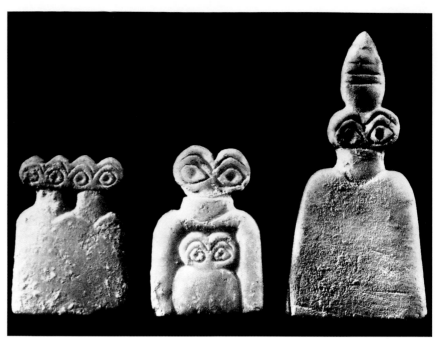

160 Stone 'eye-idols' from Tell Brak (northern Mesopotamia). The eye was an important amuletic symbol in Mesopotamia, and was often emphasized in early sculpture. These idols symbolize a goddess, sometimes a goddess with child. Late 4th mill. BC. Baghdad, Iraq Museum.

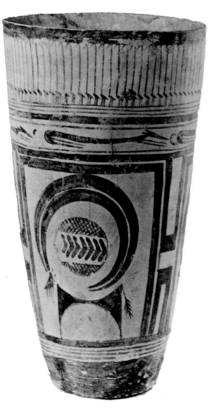

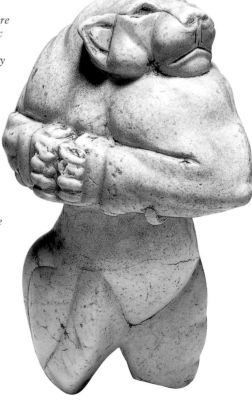

161 In early Elam (SW Persia), there is much fine pottery with geometric and animal forms as painted decoration. This beaker is delicately patterned with stylized waterbirds, running dogs and an ibex, its horns framing a disc pattern. The Samarra pottery of Mesopotamia is related and this black-and-white style can be traced on early pottery to as far east as Pakistan. About 5000 BC. Paris, Louvre Museum.

162 A crystalline limestone figurine of a lion-man, probably Elamite (SW Persia), inlaid with studs of lapis lazuli. An early intimation of the anthropoid animal monsters which will characterize Mesopotamian art for centuries, here rendered with considerable attention to real animal forms. About 3000 BC. Height 8.4cm. New York, Brooklyn Museum.

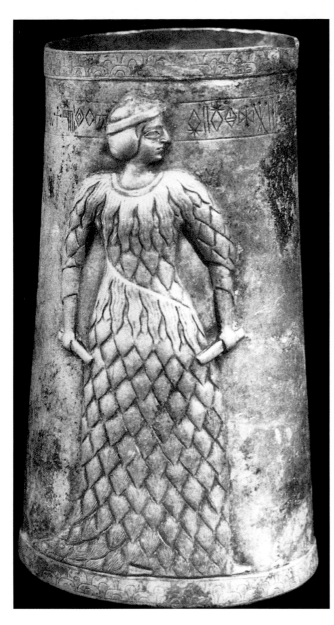

164 *Figure of a man made of steatite, limestone and shell, from near Shiraz (Persia). Composite figures of stone and shell are a feature of early Persian and Mesopotamian art. He was holding something, probably an offering, under his left arm. Perhaps related to the composite and inlaid stone figures and jars of western Central Asia [123, 124]. About 2800 BC. Height 11.7cm. Paris, Louvre Museum.*

163 *Silver vase from near Persepolis with the relief figure of a goddess and an Elamite inscription. The figure and dress are echoed in both Sumeria and western Central Asia at this time [cf. 122, 123], and Persia may have had much to do with the creation and diffusion of the type. Height 19.3cm. Teheran Museum.*

165 *Figurine of a man with goats' horns, of copper alloy. About 3000 BC. Height 17.2cm. New York, Brooklyn Museum.*

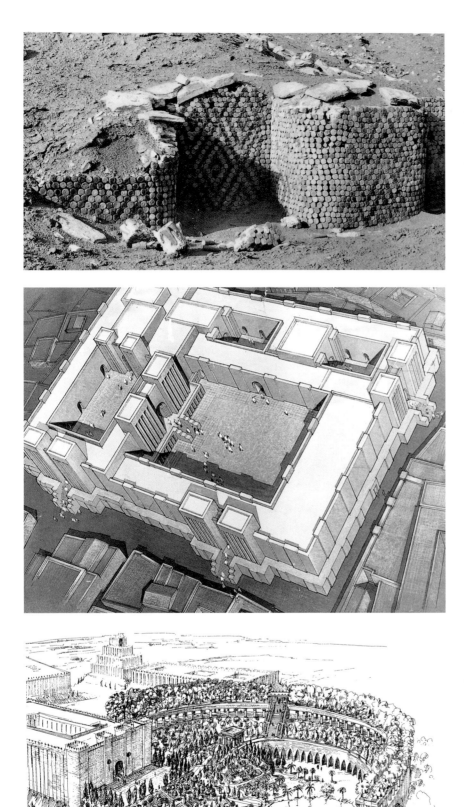

166 Part of the courtyard wall of the temple of Eanna at Warka (Sumerian Uruk). Brick half-columns are decorated with a mosaic of clay cones of black and white (elsewhere, some of red) in zigzag patterns, and the niches with diamond patterns. About 3000 BC.

167 The Temple of Ishtar at Ishchali (near Baghdad), in a reconstruction drawing by Harold D. Hill. Kingdom of Eshnunna, early 2nd mill. BC. About 100 × 60m plan.

168 The 'Hanging Gardens of Babylon' in a reconstruction drawing by Terry Ball, published here by permission of Stephanie Dalley whose work inspired it, and who has shown that the gardens were probably at Old Babylon (= Nineveh), built by Sennacherib. They were terraces of trees, fed by ingenious irrigation from the lake below. Early 7th cent. BC.

169 The marble mask of a woman, from Warka (Uruk), probably for fastening to a wall or wooden statue. The mouth and chin are remarkably realistic compared with the treatment of brows and eyes. About 3000 BC. Height 20cm. Baghdad, Iraq Museum.

171 A limestone jar, its spout guarded by two lions; on the body relief lions attack bulls, their heads turned out to the viewer. From the Eanna temple at Warka (Uruk). Early 3rd mill. BC. Height 20.3cm. Baghdad, Iraq Museum.

170 A large alabaster vase decorated with low-relief figures, from Warka (Uruk), the Eanna temple. This is an early attempt at depiction of a multi-figure scene of offering. In the top register (b) a goddess stands before two standards receiving a bowl of fruit (?) from a naked man, behind whom another figure (largely missing) may be the king, offering a net garment of some sort, held by a third. At the right two women are set on stands, with another standard, over a bull; and behind them in two registers are offering vases, including two animal-vases. This is the most basic use of frieze compositions for such a scene, a scheme that is little varied for centuries to come, but here they decorate a truly monumental vessel (nearly a metre high). Lower friezes have more naked offerants, animals and trees. About 3000 BC. Baghdad, Iraq Museum.

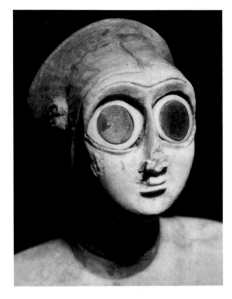

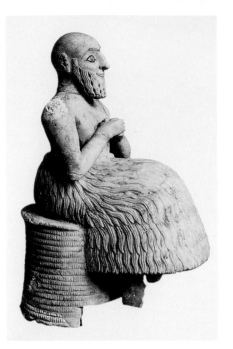

172 The alabaster figure of Ibihil from Mari (middle Euphrates). His eyes are of shell and lapis lazuli set in bitumen. About 2500 BC. Height 52.5cm. Paris, Louvre Museum.

173 A group of limestone figures of a god, consort and worshippers, from the temple of Abu (Lord of Vegetation) at Eshnunna (Tell Asmar; north of Babylon, east of the Tigris). The eyes (b) are inlaid shell with black stone pupils, the hair and beard stained with bitumen. The tallest figure (the god?) is 72cm high, with animal figures carved in low relief on its base. The clasped-hand gesture has a long history in the area and signifies prayer and greeting – like the open hands on chest in the east today. About 2600 BC. Baghdad, Iraq Museum.

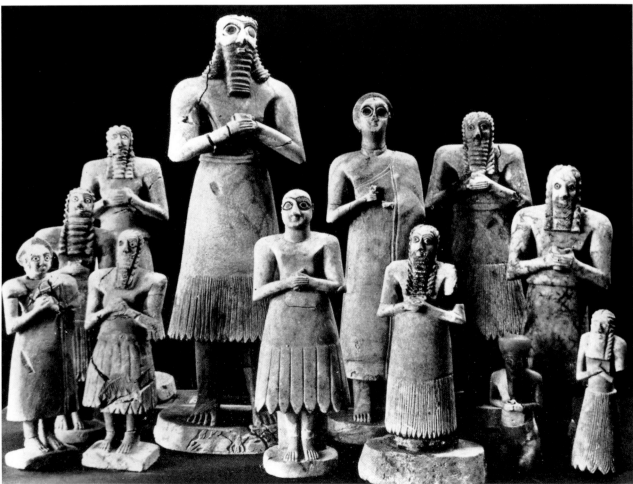

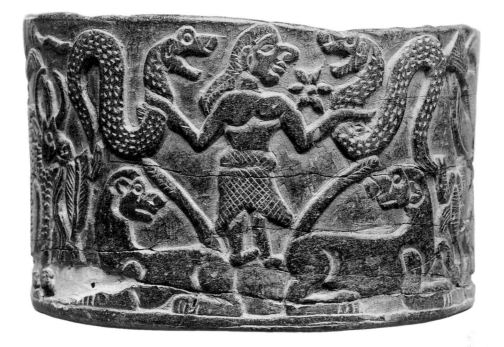

174 An Early Dynastic chlorite bowl, from Khafajeh (near Baghdad), with relief figures of animals, a lion-fight and snake-handlers. The material is from east Iran, whence perhaps the style; it was also used for objects made farther to the east, in Central Asia [see 123, 124]. About 2500 BC. Height 11.5cm. London, British Museum ANE 128887.

175 The copper relief of a lion-eagle and stags, from Al'Ubaid, near Ur. An early example of the lost-wax technique of casting. About 2450 BC. 1.07 × 2.38m. London, British Museum ANE 114308.

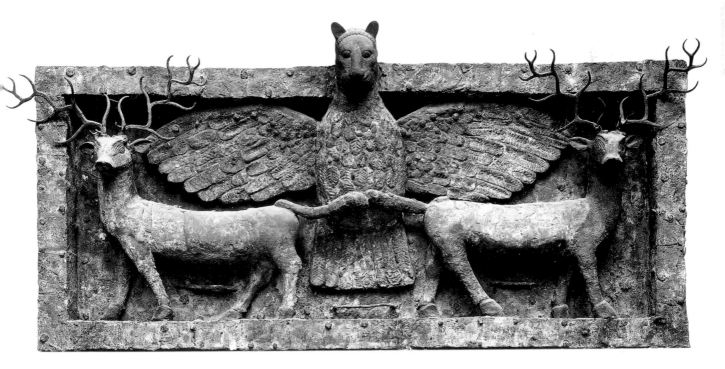

176 Sir Leonard Woolley's excavations at Ur are justly regarded as the most spectacular revelation of Sumerian architecture and art, especially the finds from the royal tombs. The ram at a tree was a popular eastern symbol for pastoral wealth (and probably contributed to the story of Abraham and the ram in a thicket). This figure is of wood, covered and inlaid with gold, silver, shell and lapis lazuli. About 2500 BC. Height 45.7cm. London, British Museum ANE 122200.

177 From another tomb at Ur a lyre/harp was recovered, the sides of its sound case made of wood, inlaid with shell set in bitumen (an oil-rich area). The panel scenes mix man and animal in cult scenes: a wild hero controls two man-faced bulls; a jackal and lion attend to a sacrifice of animal parts; a donkey plays a bull-headed harp attended by a bear and a small creature with a rattle; a scorpion-man with a gazelle. This anthropoid behaviour of animals is commoner in early Egyptian art (see [53]), but goes on to inform stories such as those of the Greek writer Aesop. This too is surely humour. About 2500 BC. Height 21.5cm. Philadelphia, Pennsylvania University Museum

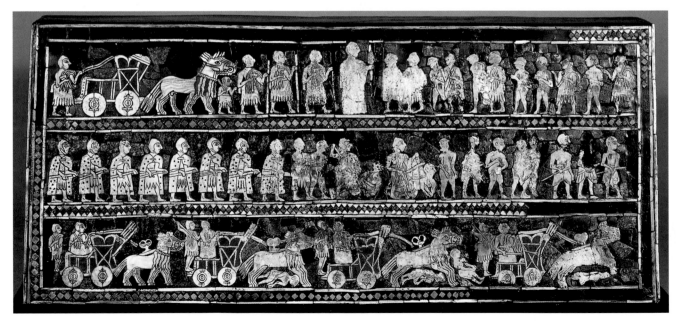

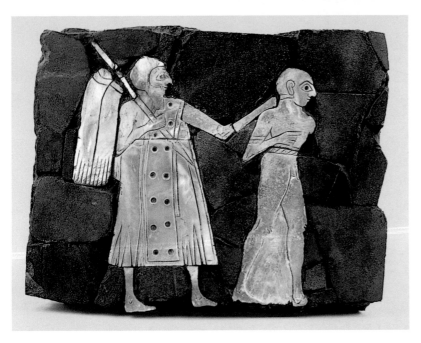

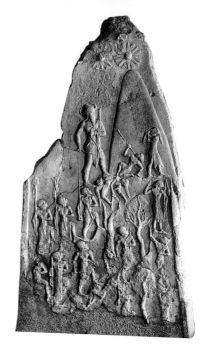

178 An inlay style, using white stone, shell or ivory, was widely used to decorate boxes, for large panels decorating buildings and a variety of large objects, such as the so-called 'standard' from Ur (a; opposite), with figures of shell and red limestone inlay on a background of lapis lazuli set in bitumen. The scenes are on one side warlike, on the other peaceful. (b; above) is from Mari, with more ambitious and svelte figures of a warrior and prisoner. Domestic and rustic scenes are also subjects for this technique. The basic profile-frontal style for figures seems no bar to depiction of a wide variety of activities. About 2500 BC. (a) Height 20.3cm. London, British Museum ANE 121201; (b) Aleppo, National Museum.

180 The sandstone stele of King Naram-Sin of Sippar (north of Babylon, Akkadian), celebrating his success over wild hill folk, the battle being shown realistically on hilly ground at the foot of a mountain topped with a divine symbol. The inscription records that it was taken from Sippar a thousand years later by the Elamites, for their 'museum' at Susa in Persia, where it was found. About 2250 BC. Paris, Louvre Museum AO Sb 4.

179 Even in frieze compositions there are possibilities of variety through scale and placing. This is a fragment of a two-sided limestone stele from Tello, celebrating a victory and the determination by conquest of boundaries between territories. On one side a large god with a mace has gathered defeated enemies in a net; on the other, the top frieze has a phalanx of warriors trampling enemies – a fine pattern of heads, spears and feet; but the next frieze places a second rank above and behind the near rank, implying depth without perspective, following a larger figure in a chariot. About 2470 BC. Height about 73cm. Paris, Louvre Museum.

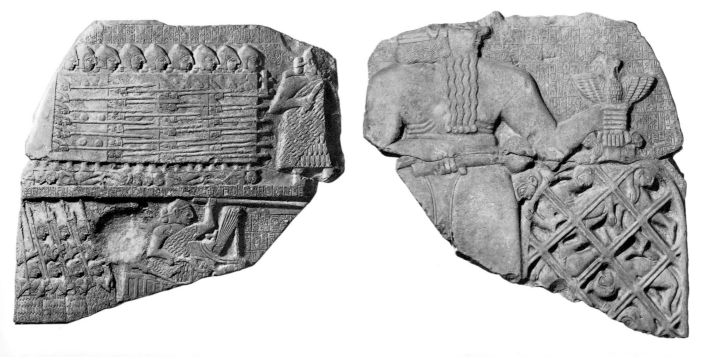

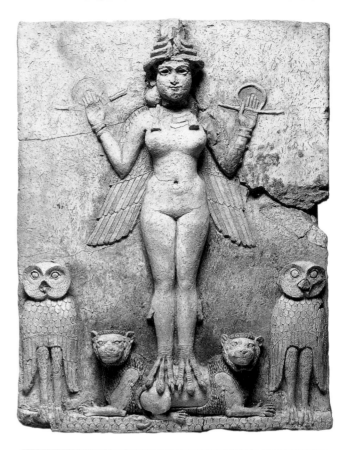

181 A clay relief plaque showing an underworld goddess (Inanna/Ishtar) with the usual horned headdress, but with all the trappings of terror: nudity, wings, measuring cords for man's life in her hands, talons for feet, attended by birds of darkness (owls), standing on two lions. Smaller clay plaques with relief scenes of religious subjects are a feature of the period, for less than palatial offering. Early 2nd mill. BC. Height 49cm. London, British Museum ANE 2003-7-18.1 (the 'Burney Relief').

182 A diorite seated figure of the Sumerian King Gudea, from Tello (north of Ur). Folds of dress and anatomy are boldly stylized, and the inscription, his dedication to the god Ningizzida in the temple he had built, is a major part of the image. See also [67] for a similar figure holding a plan of his city. About 2100 BC. Height 45cm. Paris, Louvre Museum.

183 The copper (cast) head of an Akkadian ruler, from Nineveh. About 2200 BC. Height 36.6cm. Baghdad, Iraq Museum.

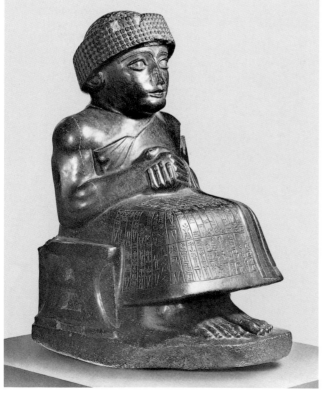

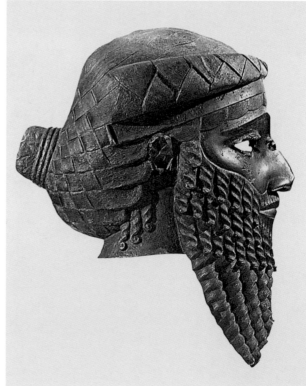

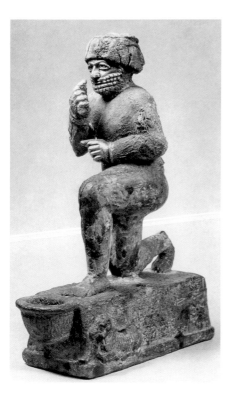

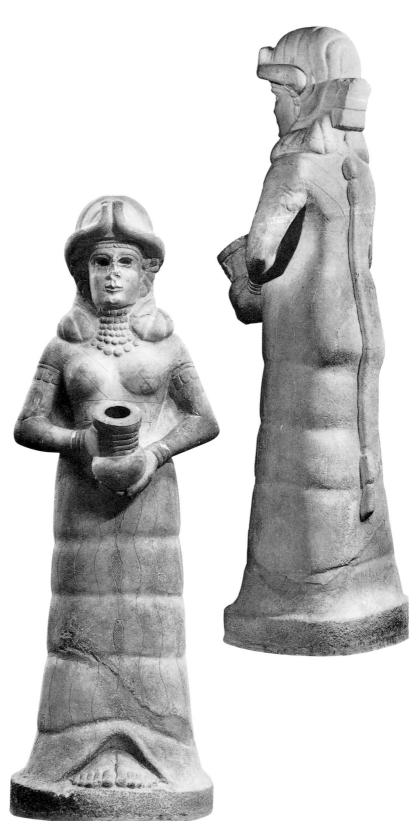

184 *An Old Babylonian bronze figure of a kneeling man, with gilding, probably from Larsa (near Uruk). He is praying for the life of the famous lawgiver Hammurabi, who is mentioned on the inscribed base, which carries a relief scene of the king before a goddess. This is an unusually supple pose for a figure in the round at this date. About 1750 BC. Height 19.5cm. Paris, Louvre Museum.*

185 *The stone figure of a goddess holding a bowl from which water flowed, rather like a fountain figure, but the motif was a common one to indicate divine beneficence. From Mari (middle Euphrates). About 1760 BC. Height 1.49m. Aleppo, National Museum.*

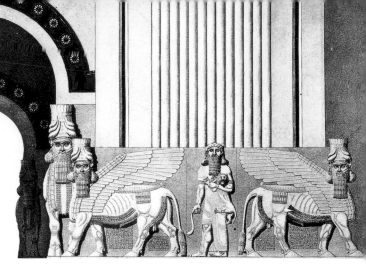

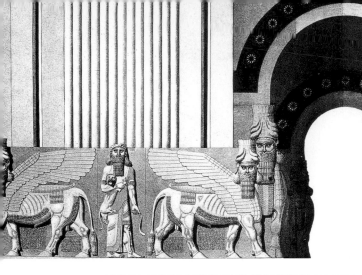

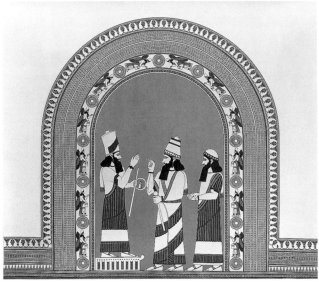

186 High relief and semi-round figures form the entrance to Sargon II's throne room at Khorsabad. Compare [74]. Late 8th cent. BC. Height of wall 4.85m.

187 A reconstruction of the painted wall of Sargon II's palace at Khorsabad. Late 8th cent. BC. Height 13m.

188 (a) A battle beside a river, from the low-relief decoration in alabaster of the palace of Assurbanipal at Nineveh. The figures are composed roughly but not rigidly in registers. Inscriptions in the field describe the action. (b) A priest holding a goat and branch. About 650 BC. Height of (a) about 1.3m. London, British Museum ANE.

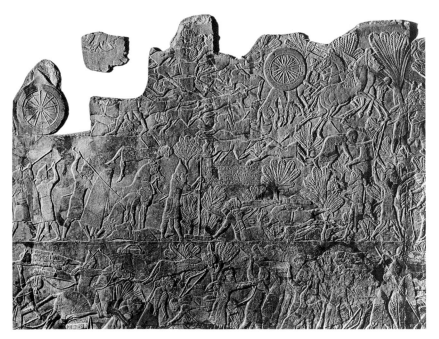

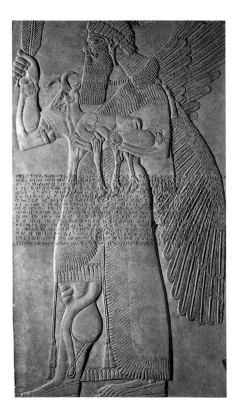

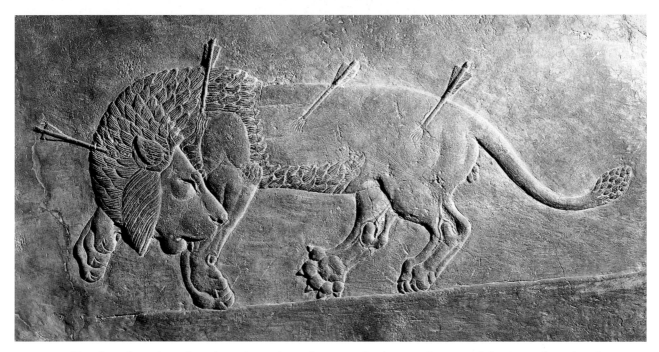

189 A royal lion-hunt frieze from the palace of Assurbanipal at Nineveh. The animals are carefully observed (a), though manes and muscles are carefully patterned, and the horses run in the 'flying gallop' which was a long-preferred mode for Near Eastern artists, as it has been in later centuries (even 18th-century AD English horse-race paintings); although unrealistic, it is highly expressive. Height (b) 65cm. London, British Museum ANE.

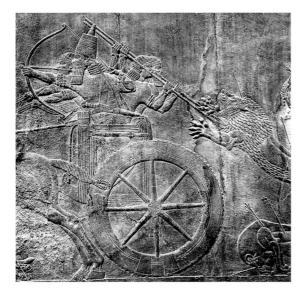

190 (right) The lotus, bud and palmette patterns of Assyrian art, so carefully regimented, are the basis for floral patterning for long afterwards in the Classical world, where they achieve a bogus realism. This threshold, from the same palace as the last, must reflect the patterning of carpets. 3.7 × 2.4m. London, British Museum ANE.

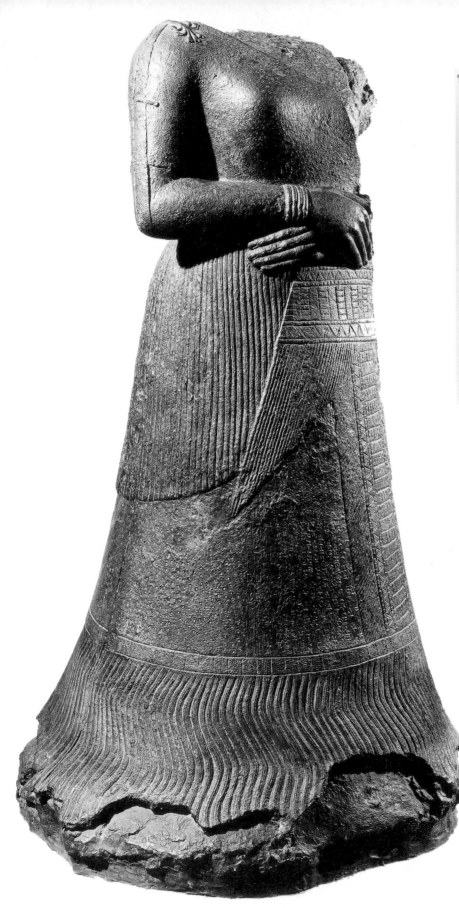

191 The arts of N Persia (this gold beaker with bulls is from Marlik, near the Caspian) acknowledge Mesopotamian styles, but in detail and execution are no less open to the looser, more fluid styles of the east. About 1000 BC. Height 17.5cm. Teheran Museum.

192 The arts of Elamite SW Persia (notably at Susa) are close to those in Mesopotamia, but with individual treatment of, for instance, the bronze Queen Napirasu, a heavy bell-shaped figure with delicate chased patterns on her dress. 13th cent. BC. Height 1.29m. Paris, Louvre Museum.

193 This may look like relaxed entertainment – Assurbanipal reclining on a couch with his cup (dining behaviour taken up by Greeks and then Romans), his queen seated, musicians, in a setting of vines and palms; but on the tree at the left hangs the head of the defeated king of Susa. From Nineveh. About 650 BC. Height 55cm. London, British Museum ANE 124920.

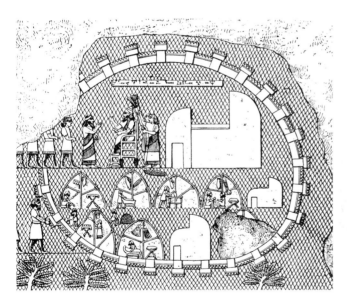

194 A detail from a relief at Nineveh. The usual combination of plan and elevation is used here to create a form of narrative. The king receives an important visitor to his city, while in separate round huts provision is made for the guest – food and bed.

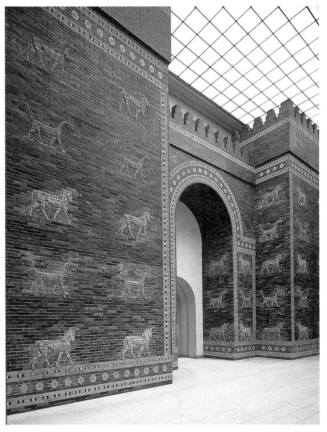

195 Dragons and bulls in polychrome glazed brick decorate the façade of the Ishtar Gate at Babylon, as restored in the Berlin, Staatliche Museen. Early 6th cent. BC. Height of animals about 1m.

196 Gold bowl from Hasanlu in Azerbaijan, just south of Lake Urmia. The general style relates to the Marlik gold (see [191]) but here there is a strong narrative subject, if not readily equated with any known epic story. At the right a hero is fighting a mountain god supplied with monster heads, and a flow from the mouth of the bull pulling a weather-god's chariot above, with many other divine figures and events set rather loosely in registers and not otherwise closely interrelated. About 1000 BC. Teheran Museum.

197 The potter's art in the Near East seldom evokes high originality of design, but a series of red vessels from south-west of the Caspian (Amlash) offers exceptional studies of animal forms. About 1100 BC.

198 Luristan, a mountainous area in west Persia, has produced a wide range of bronze ornaments and harnesses of the 9th–7th cent. BC in styles affected by Mesopotamia and even the nomadic, but still highly idiosyncratic. This is the low-relief decoration of a pin head. Symmetrical composition is dominant in the style.

199 The kingdom of Urartu, in Armenia, is notable for ambitious bronze work of the 8th/7th centuries BC. This bronze griffin-monster, once gilt, from Toprak Kale (its hind legs are talons, as often in Mesopotamia), is a creature with a long future in Syria and the Classical world. About 650 BC. Height 21.7cm. Berlin, Staatliche Museen VA 775.

200 Urartian metalwork is also characterized by tendril-like patterning associated with florals, as on this belt from Zakim (E Turkey). 6th cent. BC. St Petersburg, Hermitage Museum.

201 A bronze pole top from Luristan, another speciality for this area, here composed of stylized goats and lion heads. London, British Museum ANE.

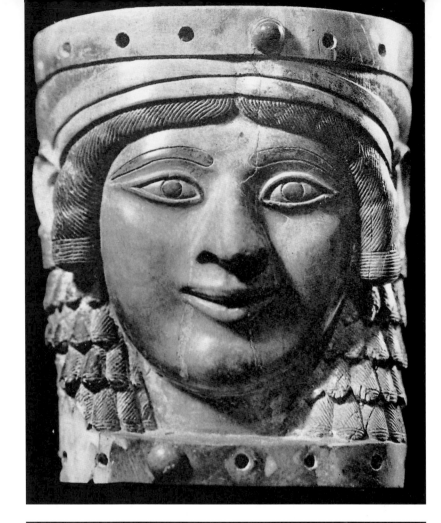

202 *Much of the ivory work, usually from furniture, in Mesopotamia and Syria, repeats the familiar formal motifs and styles of major art, as in this 'Mona Lisa' head from Nimrud. The ivories were partly painted and gilt, often with cloison inlays. 8th cent. BC. Height 16cm. Baghdad, Iraq Museum.*

203 *Other ivories of the region can be assigned by style to different studios, from Assyria to Phoenicia. The latter is characterized by strikingly Egyptianizing subjects, like this negro with a monkey and goat. From Nimrud, around 700 BC. Height 13cm. New York, Metropolitan Museum of Art, Rogers Fund, 1960.*

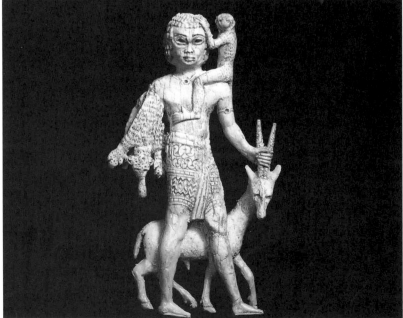

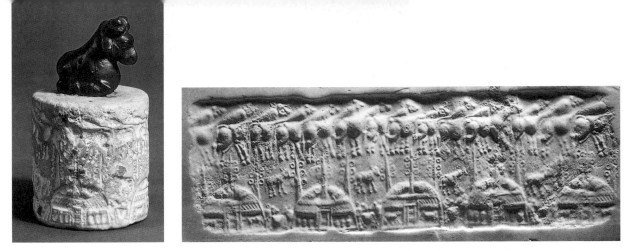

204 (a) Sumerian magnesite cylinder with a silver figure of a ram as handle. The rolling shows cattle at their byres and storage in reed and wooden structures. About 3000 BC. Height overall 8.5cm. Oxford, Ashmolean Museum 1964.744. (b) Some virtuoso studies of men and animals are among the earliest on Akkadian cylinder seals. On this agate the king/heroes are lifting still struggling lions on to their shoulders. Late 3rd mill. BC. Height 36mm. London, British Museum ANE 89147. (c) The gods are depicted with attributes and a minimum of activity, when not fighting monsters. At the right on this impression from a greenstone seal a two-faced attendant stands behind the water god, with his streams and fish. Then a winged fertility goddess has defeated the sun god, who is cutting his way out of the mountain below to rise at dawn; then a god of the hunt with bow and lion. Akkadian, late 3rd mill. BC. Height 39mm. London, British Museum ANE 89115. (d) The Mitanni occupied Syria and northern Mesopotamia in the 2nd mill. BC. Their seals have an unusual finesse with much use of a fine drill for detail. Here goats, a lion and a monkey attend the sacred tree beneath a winged sun-disc and two men approach with animal offerings. 15th cent. BC. Serpentine; height 26mm. Private Collection. (e) Old Assyrian animal studies on seals anticipate the realism of later reliefs. Here a winged man pursues an ostrich and her young. Grey marble; height 31mm. 13th cent. BC. New York, Pierpont Morgan Library. (f) Neo-Assyrian serpentine cylinder on which a king pursues a winged lion-monster (with taloned hindlegs and an ostrich tail), over a dragon, with a winged sun-disc and other symbols in the field. Height 37mm. New York, Pierpont Morgan Library.

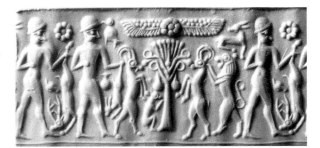

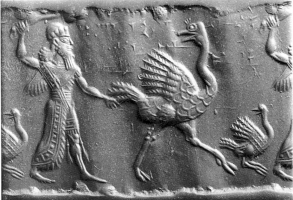

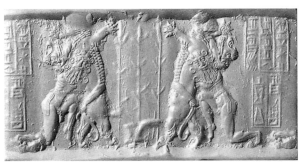

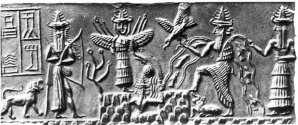

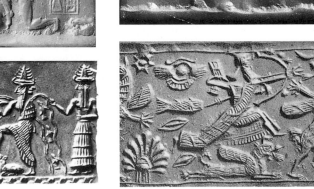

Anatolia and Bronze Age Greece are taken together here because the Aegean Sea which lies between them links no less than it divides. Anatolia (modern Turkey) is distinguished geographically for its high plateau which afforded almost ideal conditions for early agricultural settlement, and at a very early date (as we have seen already at Çatal Hüyük **11**, **13**), enough for some to argue that this is one of the earliest homes of the Indo-Europeans.

The major rivers are the Hermos and the Maeander in the west running into the Aegean Sea, the Sangarios and Halys in the north running into the Black Sea. Access south-east to Syria was not easy but the plateau runs off east into more mountainous country, metal-rich, in which the Mesopotamian rivers rise and where the homes of the Urartians, Armenians and Medes are to be found. The long coastline was relatively unimportant – on the Black Sea to the north it is largely inhospitable, on the Aegean to the west it became dominated by Greeks, whom the Anatolian kingdoms of Hittites, Lydians and Phrygians ignored for as long as they could, and the south coast was little more than a good route from the Aegean to Cyprus and the Levant, with little by way of useful coastal plains until Cilicia at the east. So Anatolian cultures tend to be partly introspective, partly oriented to the east, though eventually much affected by what was happening to the west, in the Greek Aegean world.

In the early Bronze Age we know of the local kingdoms, their wealth and architecture, from finds such as those made by the German archaeologist Heinrich Schliemann at Troy (the so-called 'Priam's treasure', but dating from far earlier than Homer's myth-historical king), or the Copper Age animal standards of Alaca Hüyük **205** which seem to presage as much as they echo nomad arts far to the east. A 2nd-millennium site in the east (Kültepe-Kanesh) served virtually as an Assyrian colony controlling trade between Mesopotamia and Anatolia, and reminds us of the source of much that was to be accepted in the west.

The main centres for this realm, and its successors, stood in and around the sweep of the Halys river at the centre north. Here lay the capital of the Hittite empire, Bogazköy (ancient Hattusas), founded in the 3rd millennium BC, and nearly as well documented with architecture, artefacts and written records as the Mesopotamian cities themselves. The Hittite sites display a fearless command of stone architecture **211**, **213**, which is relatively new for the Near East, and almost an obsession with decorating and carving natural rock faces **212**. This was perhaps a way of recruiting the landscape to glorify kings and gods without recourse to high building, as in the cities of the *ziggurats*. Hattusas itself is a colossal site, well over 300 acres in extent, graced by animal-flanked gates and by massive temples of stone, equipped with ranges of storerooms which reflect on the secular/divine authority which guaranteed the prosperity of the state. While the appearance of the figures, groups and animals in Hittite art broadly resembles that in Mesopotamian art, the dress, content and compositions do not. There are gateway monsters, but they are smaller here, carved from single blocks of stone **213**, and there are no big narrative reliefs. Seal-engraving flourishes – cylinders **215**, but also a range of distinctive stamp seals, often cut with a more miniaturist finesse than those to the east. They display a script of pictograph/hieroglyphs **47**, but the Hittite language was also written in the cuneiform script of the east. This confirms the links with Mesopotamia.

In the 2nd millennium BC the Hittites had pressed deep into Syria without seriously affecting Syrian dependence on the east. But at Alalakh (Tell Atchana), near where the Orontes turns west to the Mediterranean from the south, was a city whose wealth demonstrated

the importance of this route, and its finds reveal knowledge of Greek Bronze Age arts. This was a major east-west-east route to the Mediterranean, and in the west it could take travellers to the sea.

Down to about 700 BC 'neo-Hittite' princelings in Syria and Cilicia fostered styles in architecture, sculpture and decoration 214, 216–19 which were to fuel the Greek orientalizing revolution to a degree unrivalled by any other source. Here we find the models for the patterning of animal bodies, several 'new' monsters, the application of statuary to architecture in ways the Greeks were to copy ('Caryatid' pillars 28, 29), and decorative patterns on dress and architecture. All this probably hastened the creation of the Greek Archaic style, which was born from the decay of those major arts long before established in Mesopotamia, Syria and Anatolia, and filtered to Greece partly through a Greek trading town at the mouth of the Orontes (Al Mina).

Western and much of central Anatolia, meanwhile, enjoyed somewhat different fortunes from those of the last of the Hittites. The great city of Troy, on the Hellespont, had fallen, probably to Greeks, at the end of the Bronze Age. Thereafter central Anatolia was occupied by Phrygians, perhaps from Thrace (Bulgaria) beyond the Hellespont, and their art is virtually sub-Hittite, soon to be much affected by Greek 221. Their capital lay at Gordion on the Sangarios, the city of golden King Midas of Greek legend – who was also a real Phrygian monarch; his tomb has been excavated. Nearer the coast lay Lydia, its capital at Sardis on the Hermos, where the arts came to bear something more of the stamp of the Greeks living in the coastal cities of Ionia and the offshore islands 224, but also contributing to them no little of its own Anatolian heritage. Indeed, Sardis was very much an oriental city for its buildings and architecture. The tombs of Phrygian and Lydian kings lay in wooden chambers beneath massive tumuli, more like Central Asia than anything between, while the great Phrygian rock-cut façades serving cult retain more of the Hittite tradition 220. The tomb finds reveal an art of sophisticated pattern 222 while the figurative work remains mainly eastern.

By the mid-6th century BC King Croesus of Lydia had thought to challenge the kingdom of Media, far to the east, and had already won over or absorbed the coastal Greek cities, who were impressed as much by Lydian wealth as by Lydian armies, though somewhat scornful (or jealous) of their luxurious and hubristic behaviour, to judge from the remarks of local Greek poets (Sappho and Alcaeus on Lesbos). When Sardis, heavily fortified with stone walls but with palaces of brick, fell to the Achaemenid Persians in 546 BC, a new chapter begins for Anatolia, while in the Aegean world the changes wreaked by the east had set fast in the process of moulding the beginnings of Classicism, as we shall see.

We have been brought west, to the Aegean, and must turn also to its western shore, and go back in time to the earliest urban civilizations of Greece. The land of Greece is a geographical entity of a type unparalleled in other areas we have studied. It has to be appreciated in terms of both land and water. The Aegean Sea is in many respects the focus. Minoans and Mycenaeans from Greece had visited and settled on its eastern shores and islands, although their Greekness only became important at the end of the Bronze Age, and remained so until the Ottoman Empire. The Aegean is studded with islands, culminating at the south in the largest of them, Crete.

The Greek mainland is hugely indented, with a chain of islands running along its west coast into the Adriatic. The only major plain in Greece is Thessaly, in the north, with Mount Olympus the defining feature farther north. The Boeotian plain in central Greece was not wholly drained in antiquity. Otherwise the land is cut up into many discrete entities by mountain ranges, not all of them easily passable, but most allowing access to the sea, which was a major means of communication and resource for food. Mountainous Arcadia in the centre south was the only major landlocked area. All this made much of Greece a country of mariners. It was a land which offered little for the farmer except grazing, and in time a degree of specialist agriculture: the olive and vine. Mineral resources were modest. Living in Greece off Greece itself was never easy, and it is not today.

The Bronze Age arts of Greece are discussed here because their links with the following Classical period do not go deep, while the two main Bronze Age cultures, the Minoan and Mycenaean, have much to do with Anatolia

and the Levant, even Egypt, and their populations probably derived from the east, the Mycenaeans being Indo-European, the earlier Minoans not. It is impossible, at any rate, in many periods, to divorce consideration of this area from what was happening on the opposite shore of the Aegean Sea, which was effectively as much the heart of Greece as was the south Balkan mainland.

The story starts in the south, in Crete, where the Minoan civilization developed early in the 2nd millennium BC. It can, in a modest way, bear comparison with the achievements of Egypt or the east, and in no small degree it depended on them, yet it remained distinctive rather than simply derivative, to an extent unrivalled by any of the arts which we have surveyed in cultures to the east, as far as Persia, which were physically contiguous with each other and to varying degrees interdependent. The Cretan population was not Greek-speaking (we cannot read their language, written in 'Linear A', a syllabary with no obvious eastern inspiration) and probably came from Anatolia originally. As in the eastern empires its palaces were also major administrative centres and managed distribution of goods, and were architecturally not that unlike some in Anatolia which were set around with storerooms. But in an island over 250km long there were several such palatial centres and the interrelationships are never clear.

With the Minoan Cretans we can reasonably take the islanders of the Cyclades to the north, even if only on geographical grounds. Here, in the Neolithic period, there had been an interesting production of minor marble sculpture, rather more ambitious than that of the people to north and east, and more influential in the 20th century AD than in antiquity. The 'Cycladic idols' are deceptively primitive, and their svelte forms are largely dictated by their material – flakes of white marble – and the techniques of abrasion that produced them **226**. Most of them simply stood, or rather lay, in graves or shrines, but nearly all are known only from chance finds and plunder and not, incredibly, from controlled excavation; a tribute to local modern enterprise by non-archaeologists.

The Minoans were not obviously martial in their interests and we find no substantial fortifications. Their art offers a range of media and techniques to match those of their more powerful contemporaries to the east and in Egypt, yet wholly distinctive for the period. In the smaller arts at least there is a command of realism, especially in depiction of the animal world, that is not easily rivalled at this date. The larger wall paintings are often of cult or genre, but not organized into formulaic groups like those of Egypt, nor dedicated to involved narrative, and are more consciously decorative. Painting was not only for walls **235**, while the compositions we see in a dependent palace in the Cyclades **234** are uncharacteristic of Crete or the east.

There seems no bid for the effect of sheer size, indeed there is rather a deep appreciation of the miniature. Pottery decoration could be florid and colourful, closely observant of nature **227, 228**; this is an early display of the Greek world's readiness to use pottery as a field for original art. Minoan gem engraving – stamp seals in hard stones, shaped as discs (lentoid) or ovoid (amygdaloids) rather than the eastern cylinders and scarabs – was exquisite **232**, and the best, we might judge, of the age, ranging from formal scenes of cult to highly imaginative animal studies, poses and groups, that lead one to recall the nomad arts, and which dazzle beside the more mannered creations in this medium in Mesopotamia or Egypt. More attention too seems to have been paid to the choice of colour in the stones used for seals, especially the multi-coloured.

Major architecture was of stone, but set in a timber framework. It was rather formless in plan for palaces, set around central courtyards, but admitting something like an 'order' of columns and colonnades, multi-storey without aspiring to great height, and better equipped for domestic comfort than most contemporary structures in the Near East **226**. The palaces made good provision for storerooms and their overall plans may also owe something to western Anatolia, when we look there at the palace of Beycesultan – centre west, near the source of the Maeander in the kingdom of Arsawa. The variety and quality of Minoan art can match that of longer-lived cultures east and south, and was displayed in a wide range of materials and forms, notably jewellery and the smaller stone artefacts **236, 237**. Without it the Greek art of the Mycenaean world would not have looked the way it does.

By the end of the 3rd millennium BC the true Greeks

had entered their ultimate homeland from the north, Indo-Europeans, very possibly from Anatolia on the other side of the Hellespont. Their culture spread over most of the Aegean islands, with some settling on the Anatolian coast, which the Minoans had also visited, and a continuing eastern Aegean interest which is signified in one way or another by the stories of their attack on the trading city of Troy, as well as by the finds at that great site at the very end of the Bronze Age.

We can see the structure of this Greek world best in the Late Bronze Age with the help of archaeology and the ghost of that Bronze Age 'heroic' society to be glimpsed in Homer's poems, with the oral tradition which leaked into later Greek art and literature. The country was divided into discrete kingdoms, notably larger than the city-states that would emerge in the Iron Age, and the people are named by us after one of the greatest of them, Mycenae. There was monumental stone architecture, for fortifications which later Greeks took to be the work of giants **37**, **238**, for less ambitious palaces **239** of the *megaron* form (rectangular with columned porches), and some remarkable beehive (*tholos*) tombs with corbelled vaults built into hillsides **36**. We begin to perceive a feeling for fine monumental masonry for its own sake, not simply for its size or how it might be decorated. This is the world of Schliemann's 19th-century discoveries at Mycenae and Tiryns, and much excavation since. In the finds made in the royal graves, especially at Mycenae, we can observe the early influence of the very foreign arts of Minoan Crete, adapted to Greek usage, as on weaponry, which was not a serious subject for the Minoans **240–44**; the Mycenaeans were a warrior race **245**.

We may miss something of the fluidity of Minoan design in Mycenaean art. Instead there is a certain geometricizing of forms and a feeling for symmetry which might be taken as hallmarks of 'the Greek' in later years. There are even patterns which call to mind the arts of pastoral Europe **241**. But it is in Mycenaean Greece that we find some of the most brilliant Minoan or Minoanizing displays of realism in the arts **242**, **244**. In a way Minoan:Mycenaean is rather as Greek: Roman, if we do not take the equations too literally, but this is an early exercise for the art historian in observing the relationship of abstraction to realism.

Bronze Age Greeks explored west, to south Italy, Sicily and Sardinia, without exerting profound influence on local artisans. But their own arts were influential locally in the Levant and Egypt, while they took an increasing interest in Cyprus, which was soon to become as much Greek as eastern in its culture **245**, **247**.

In the last period of the Bronze Age Greek kings ruled Crete also and the Minoans were eclipsed, having devised a script (Linear B) for the Greek language after the pattern of their own. And soon after about 1200 BC all were eclipsed by forces yet to be properly understood, but essentially a series of catastrophes, some perhaps natural, which seem to have accompanied an influx of other Greeks from the north, and which led to the destruction of the palaces, of the complexities of their administration (both political and agricultural) for large tracts of Greece and Crete, of writing (including the writing of Greek in the new script), of seal-cutting, of a great proportion of the population, and of the sophistication and advanced techniques of Minoan and Mycenaean arts. But what followed proved to be not so much a Dark Age, as it has been called, as a renaissance.

SOME ROUND DATES	
3rd mill.	Cycladic idols
3rd mill.	Hittite empire founded
end of 3rd mill.	Arrival of Greeks in Greece
early 2nd mill.	Emergence of Minoan culture in Crete
18th/17th cent. BC	Early Minoan palaces
16th/15th cent. BC	Late Minoan palaces
1500 BC	Thera eruption
1450 BC	Mycenaeans in Crete
1350 BC	Destruction of Knossos
15th/13th cent. BC	Mycenaean citadels
1200 BC	Collapse of Greek Bronze Age societies
700 BC	Last neo-Hittite kingdoms in SE
10th–6th cent. BC	Phrygians and Lydians in Anatolia
546 BC	Persians take Lydia, then Greek Ionia

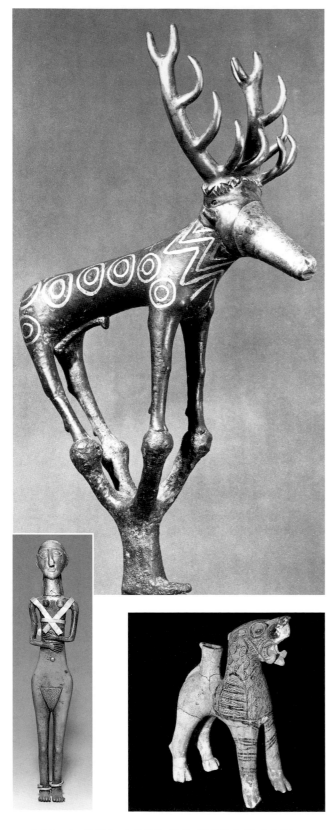

205 A bronze and silver figure of a stag, probably the top of a standard, from an early phase of the site at Alaca Hüyük (near Bogazköy), a type of object matched later in Central Asia. Such large (53cm) symbols of the Hittite weather god were placed in graves, together with openwork bronze 'solar discs'. About 2000 BC. Ankara Museum.

206 The gold (the head and straps) and silver figure of a woman from a grave near Ankara. About 2000 BC. Height 24.4cm. Ankara Museum.

207 A clay lion-vase from Kültepe. Decorative pottery and animal vases are long a speciality of Anatolia, into Classical times. They are designed to pour from the animal mouth (a rhyton). 18th cent. BC. Height 19.5cm. Ankara Museum.

208 Clay vase decorated with painted relief figures in ritual scenes. From Inandik. About 1400 BC. Height 82cm. Ankara Museum.

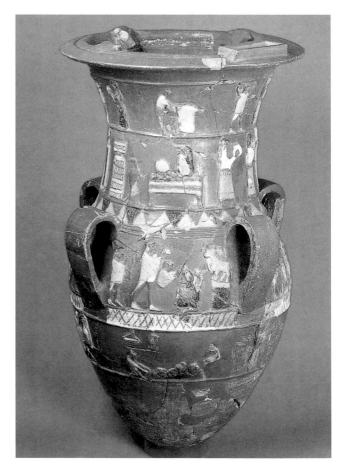

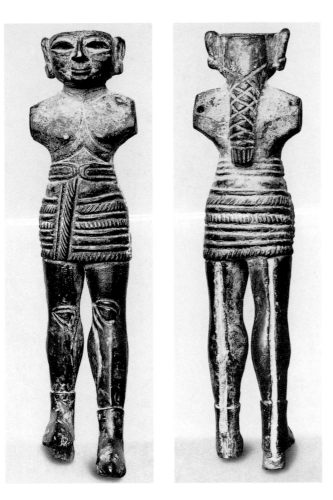

209 A Hittite bronze figure of a god, from Latakia, Syria. 14th cent. BC. Height 15.3cm. Paris, Louvre Museum.

210 Temple I (64 × 42m) at Bogazköy (Hattusas), the Hittite capital, surrounded by storerooms, set just inside the fortifications at the northern (lower) end of the site. 13th cent. BC.

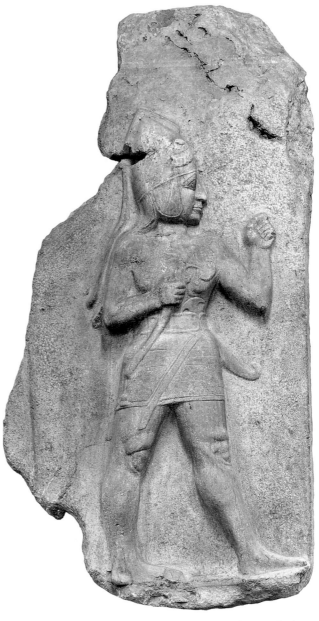

211 The outer jamb of the Royal Gate at Bogazköy, with the relief figure of the god Sarruma, wearing the typical conical Hittite headdress and holding a battle-axe. About 1200 BC. About life-size. Ankara Museum.

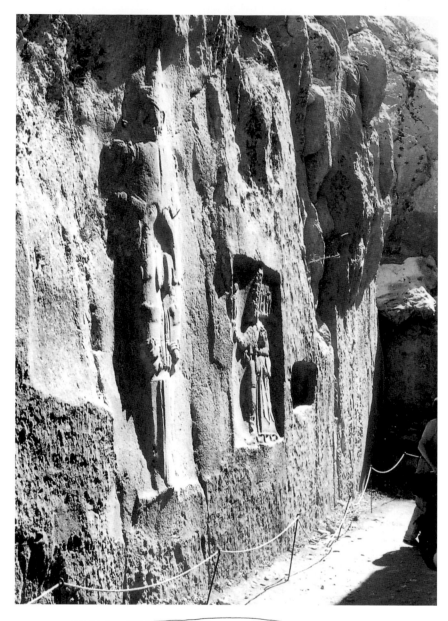

212 Close to Bogazköy, an outcrop of tall, jagged and riven rocks, is the site (Yazilikaya) of a Hittite cult place, distinguished less by the low buildings set around it than for the carving on the rocks themselves. The reliefs here show the 'dagger god' – the haft composed of lion bodies, topped by a head; and of the god Sarruma protecting a Hittite king (a); and the drawing (b) is of a group of gods, in the same complex. About 1300 BC.

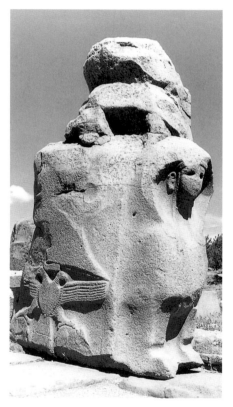

213 Sphinxes are carved on the colossal jambs of the city gate of Alaca Hüyük. The walls are made of massive blocks of irregular shape (very roughly ashlar) but most carefully jointed. 13th cent BC.

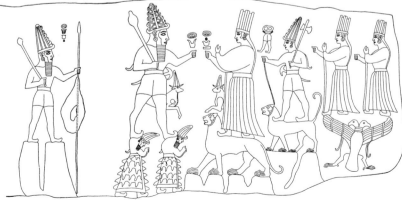

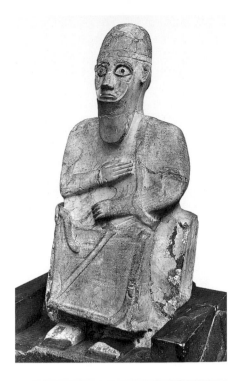

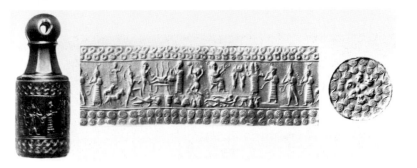

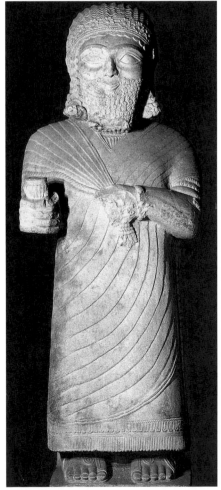

214 King Idrimi of Alalakh (in the Syrian plain near the Orontes): a limestone statue (height 1.04m) seated on a basalt throne decorated with lions. The figure is covered with a long cuneiform inscription which amounts to a royal autobiography, by a named scribe. 16th cent. BC. London, British Museum ANE 130738.

215 A Hittite haematite seal, combining the functions of a cylinder and stamp, with scenes of deities, sacrifice and offering. About 1600 BC. Height 5.8cm. Boston, Museum of Fine Arts.

216 A limestone statue of a king, from Arslantepe (Malatya), near the Euphrates. The type looks Mesopotamian but the semi-realistic treatment of the dress folds attests a new interest which will be more fully developed in Anatolia by Greeks. 8th cent. BC. Height 3.8m. Ankara Museum.

217 A relief from Carchemish, on the Euphrates. A winged lion with both human and lion head. This type of monster was the inspiration for forms devised for Greek monsters, which they called sphinxes or chimaeras. The sculptural style at the site owes as much to Mesopotamia as to the Hittite past. 10th/9th cent. BC. Height 1.34m. Ankara Museum.

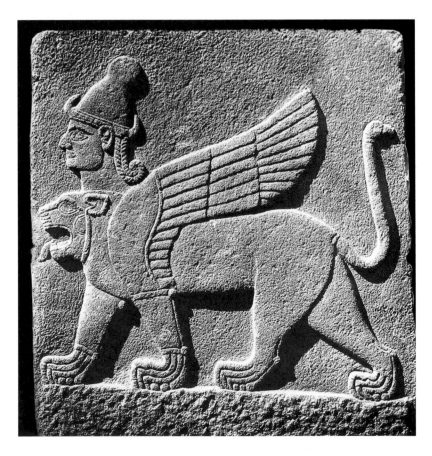

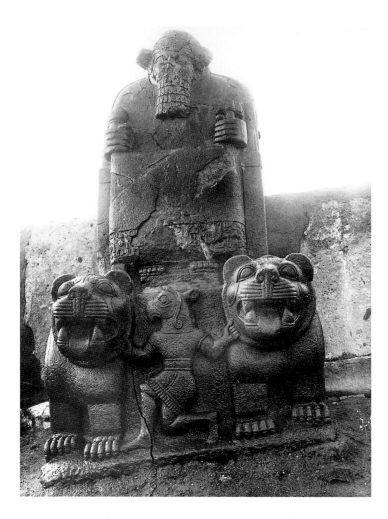

218 The basalt statue of a seated god on a base flanked by lions held by an eagle-headed demon (the head of the latter, with ears and neck-curl, is adopted by Greeks for their 'griffin'). From Carchemish. 10th/9th cent. BC. Height about 1.6m. Ankara Museum (base; the statue is destroyed).

219 Neo-Hittite reliefs from the walls of Karatepe, Cilicia. They form a frieze of disparate subjects, with local versions of an eastern sun god (with an eagle head supporting a sun-disc), the Egyptian goddess Isis suckling Horus beneath a palm tree, and a heroic lion-fight (though the lion is diminutive). The rather naive juxtaposition of subjects and the style with big round heads is typical of the place and period – the old Mesopotamian styles in major art are declining and accommodating more that is familiar in smaller works in ivory or beaten bronze. Late 8th cent. BC. Height 1.23m.

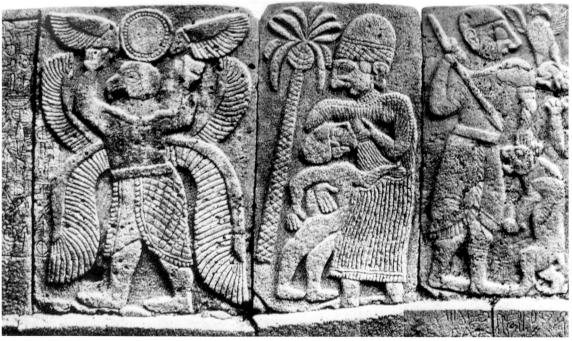

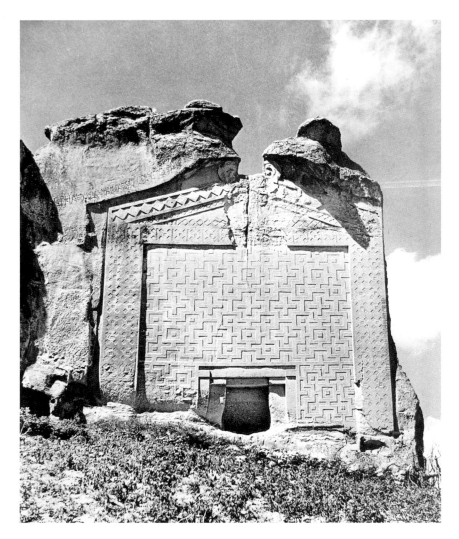

220 The rock-cut façade of a cult place with an inscription which mentions King Midas of Phrygia, near Eskishehir, north-west Anatolia. The heavy geometric decoration matches much that we see in other Anatolian art of the period, copying textile patterns. Such façades are uniquely Phrygian, and often carry relief animal decoration. Late 8th cent. BC. Height 16.9m.

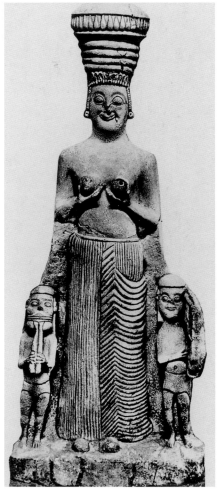

221 The statue of a goddess with attendant musicians from a temple at Bogazköy. Her dress attempts to render the fall and splay of folds in the manner of the incipient styles of western (Greek) Anatolia, but the heavy features are sub-Hittite/Phrygian. Later 6th cent. BC. Height 1.26m. Ankara Museum.

222 Wooden furniture from the Phrygian tombs reveals arts of carpentry and inlay barely attested in most areas we study here, except for Egypt and the Roman world. This is a reconstruction (by Elizabeth Simpson) of an inlaid table of boxwood, juniper (inlays) and walnut (table top), from the 'Tomb of Midas' at Gordion. Late 8th cent. BC. Ankara Museum.

223 A mosaic in naturally coloured pebbles from a house or sanctuary at Gordion. An early example of this technique for floors but haphazardly composed of a series of patterns which recall textiles, a surprising and deliberate exclusion of any sort of plan or symmetry in design. 8th cent. BC. Drawing by S. Last, Gordion Excavations.

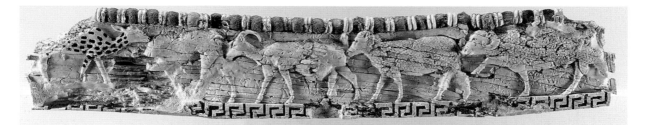

224 *Lydian ivory relief, with amber and gold detail, from Kerkenes Dag in east Anatolia, an area fought over by Lydians and Medes. The style resembles that of East Greek vase painting and there is a certain freedom of movement (the ram's raised foreleg) that is less than wholly oriental. We have very little of the luxury crafts for which Lydia was famous. Early 6th cent. BC. Length 29.5cm.*

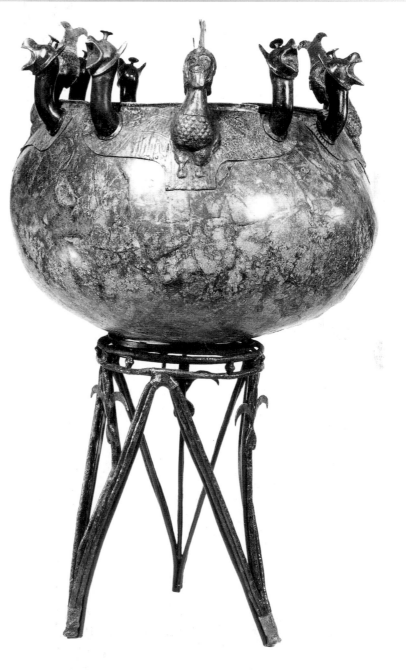

225 *Cyprus was an intermediary for much Syrian art for the Greek world, and the island held a large Greek population, soon with a new syllabary script devised for it, from the 12th cent. BC on. This bronze vessel, of the 8th cent. (from Salamis in Cyprus), shows the Graecized-Syrian mode of attaching griffins and warrior-sirens to the rim of the bowl, much practised in 8th/7th-century Greece. Height 1.25m. Nicosia, Cyprus Museum.*

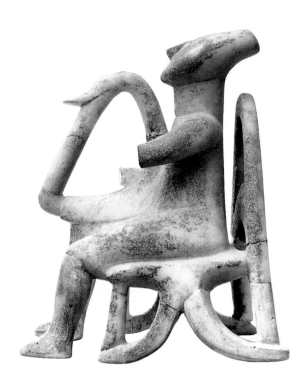

226 These figures are known only from the Cyclades islands, of the 3rd millennium BC. They are worked in white marble, by abrasion, and most present remarkably stylized forms of women, helped out with some minimal painting of features. They seem a final statement of the earlier, but aggressively female, Neolithic figures of Europe and the east. All may come from graves (virtually none has ever been properly excavated, and they are easily forged), so this seems a strictly localized but sophisticated artistic phenomenon. (a) A seated harp-player from Keros, a rare example of an action figure. Height 22.5cm. Athens, National Museum 3908. (b) The typical standing (better, lying) form for most of the female figures, from Amorgos. Height 1.48m. Athens, National Museum.

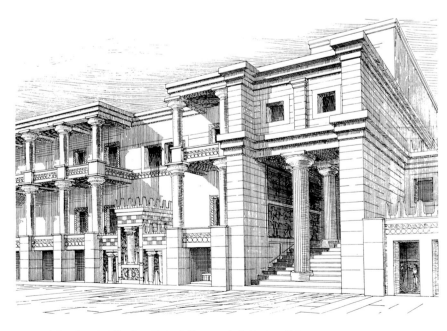

227 The 'Palace of Minos' at Knossos, named by Arthur Evans for the legendary Cretan king. The palace is built of stone and timber with rooms arranged around a large central courtyard, traditionally the locale for the ritual 'bull games'. It was surrounded by long magazines for the storage of oil and other goods since it was a redistribution centre for produce of its territory. There are some columnar elements – plain wooden shafts with bulbous capitals, accurately reconstructed in areas where parts of the palace are preserved to three storeys high around staircase wells, and it was approached by paved roads ending in stairs. This is a restored view (by F.G. Newton) of the façade of the west wing looking on to the palace court. 16th/15th cent. BC.

228 A polychrome vase from the Old Palace period at Phaistos (south Crete), with abstract semi-floral decoration. The dark-ground polychrome style (mainly reds and white) was much favoured in the island at this time, also for cups of eggshell thinness (Kamares Ware). 18th cent. BC. Height 27cm. Heraklion Museum.

229 A clay rhyton (pouring vase) from Phaistos. This 'marine style' presents realistic free-field compositions, here of nautili, anemones and rocks. The Minoan artist's eye for the natural world found expression even in non-palatial arts. About 1500 BC. Height 20.2cm. Heraklion Museum.

230 Steatite vases with relief decoration (usually gilt) are a feature of the later Minoan palace period and exhibit no lesser skills in observation and natural variety. On this fragmentary example from the Villa at Hagia Triadha, a group of harvesters proceed singing to the music of a rattle (sistrum). About 1500 BC. Diameter 11.5cm. Heraklion Museum.

232 Examples of seal engraving in Minoan Crete. The engraving is all on hard stone (mainly quartzes) requiring use of a cutting wheel on a lathe or bow. (a) A blue chalcedony seal (impression) showing acrobats in a field of lilies, from Knossos. 17th cent. BC. 21mm wide. Oxford, Ashmolean Museum CS 204. (b) A haematite seal showing two griffins attacking a bull, from Crete. 16th cent. BC. 25mm wide. Oxford, Ashmolean Museum CS 342. (c) A cornelian 'talismanic' seal (impression) from Crete. In this group of seals it seems that technique leads to a deconstruction of natural subjects (animals, ships, buildings, etc) into near-abstraction. This example carries a cuttlefish and two small fish, executed in simply cut grooves and scoops. 16th/15th cent. BC. Length 20mm. Oxford, Ashmolean Museum 1967.937.

233 Clay sealing from Chania, made by a gold ring. An exceptionally complicated device showing a prince with a sceptre standing atop a palace built on a rocky shore. 14th cent. BC. Height 27mm. Chania Museum.

231 Major statuary in the round is not a feature of Minoan art but there are many rather rough-cast bronze figures of men and women worshippers, some colourful statuettes of 'faience' (glazed clay), and some more ambitious groups and figures in ivory, with gold attachments. This is one of the finer bronzes, of a woman, possibly mourning or praying, bare-breasted and wearing a flounced skirt. The dress (and degree of undress for such formal figures) is peculiar to the Minoan world. Height 18.4cm. Berlin, Staatliche Museen Misc. 8092.

234 Minoan palace walls carried painted decoration of figures and flowers, sometimes of action, like the famous bull-leapers. The civilization of the Cyclades islands to the north is very closely related to that of Minoan Crete, but some of the wall paintings are more complex than those of the Cretan palaces. This is part of a painting from Akrotiri, on the island of Thera (Santorini), overwhelmed by the explosion of its volcano in about 1500 BC. The scene, of a harbour and town, is presumably of everyday prosperity, probably not concealing any historic or mythical narrative, since none of the narrative conventions of early art can be discerned – obvious focal or repeated figures or groups, etc. Having no identifiable context or function this seems close to being 'art for art's sake', or at least a prominent demonstration of a civic commonwealth. Greek Bronze Age styles of wall painting are very unlike those of the Near East and Egypt, and there are even signs of their influence abroad – no doubt from travelling or captive artists. The detail shows women and warriors on shore, and at sea the aftermath of a battle or piratic raid. Santorini Museum.

236 A ceremonial stone axe-head from Mallia; another universal practice, to marry an animal figure to a practical form or utensil [120]. The pattern of interlocking spirals was a cover pattern also used architecturally in the Greek Bronze Age (as on a tomb-chamber ceiling at Orchomenos in central Greece) and probably derived from Egypt. About 1600 BC. Length 14.8cm. Heraklion Museum.

235 A detail from a painted limestone sarcophagus found at Hagia Triada, one of the smaller palatial sites in Crete. A ritual procession, with music, and the pouring of an offering between posts topped by double axes, which were potent religious symbols. 13th cent. BC. Heraklion Museum.

237 Early goldwork may be judged by its competence in construction with wire (filigree) and granulation. This gold jewel from Mallia (a palace site in north Crete) shows two wasps with a honeycomb(?). Bronze Age Greek jewellery used human and animal decoration to a far greater extent than the Mesopotamian. About 2000 BC. Width 4.7cm. Heraklion Museum.

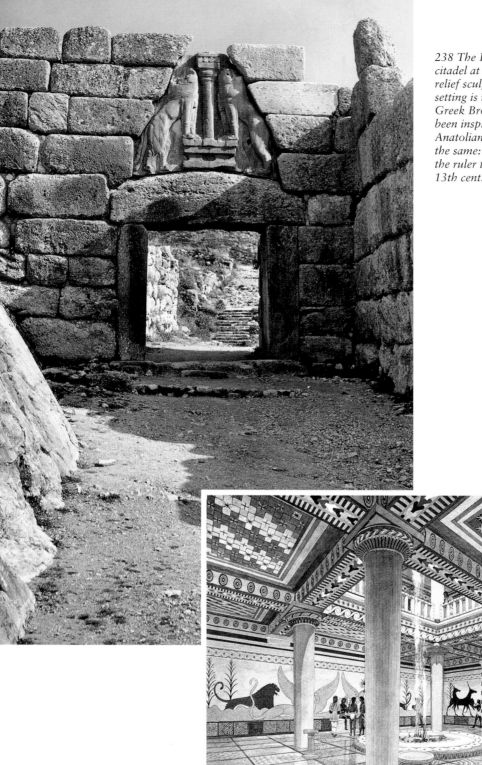

238 The Lion Gate entrance to the citadel at Mycenae. Such prominent relief sculpture in an architectural setting is not characteristic of the Greek Bronze Age and may here have been inspired by knowledge of Anatolian practices. Its intention is the same: to declare the power of the ruler to visitors or enemies. 13th cent. BC.

239 The reconstructed interior (by Piet de Jong) of the megaron hall in the 'Palace of Nestor' at Pylos. About 1200 BC.

240 A bronze dagger inlaid in gold, silver and niello (a black enamel), from a shaft grave at Mycenae. Cats chase fowl in a riverside setting, with fish and papyri. The subject seems a very free rendering of an Egyptian scene. About 1500 BC. Athens, National Museum.

241 Gold roundels from a grave at Mycenae. The curvilinear patterns, strictly composed, seem foreign to much else in Mycenaean art but hark back to some of the patterns on 'pre-Greek' works in south Greece (at Lerna) and much farther north. About 1500 BC. Diameters about 6cm. Athens, National Museum.

242 A gold cup from Vaphio, near Sparta. An exceptionally realistic account of the capture of wild bulls – here one is caught in a net – outdoing the realism of the best of the Assyrian reliefs and indeed anything later. This is one of a pair – the other shows the tethering of a decoy cow. About 1500 BC. Diameter 10.8cm. Athens, National Museum.

243 A Mycenaean gold ring showing two men fighting lions, from north Greece. The symmetricality is at odds with the compositions on most Minoan gold rings. In the Greek Bronze Age there may have been some real experience of lions, as not later when representations of lions depended on copying foreign arts. The ring type derives from the Minoan where the decoration is commonly of cult. About 1450 BC. Bezel 33mm long. Péronne, Danicourt Museum.

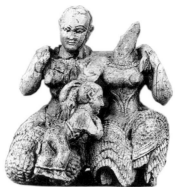

244 An ivory group of a child (god?) with two women (nurses?), wearing the usual flounced skirts, with bared breasts, of the élite Bronze Age world of Greece. A very realistic 'family group' in concept and poses, though probably of divinities, from a shrine at Mycenae. 15th cent. BC. Height 7.2cm. Athens, National Museum 7711.

245 A Mycenaean clay mixing bowl (crater) from Enkomi, Cyprus, where the style was very popular, probably initiated by immigrant potters. The highly stylized human and animal figures anticipate, in all but style, those of the Geometric renaissance in Greece two centuries later [287]. This is the last stage in the transformation of the earlier, more realistic treatment of the animal and vegetable world in Greek Bronze Age art. Here there is a chariot, a figure holding scales and another carrying an ingot (?). About 1200 BC. Height 37.5cm. Nicosia, Cyprus Museum, Enkomi tomb 17.1.

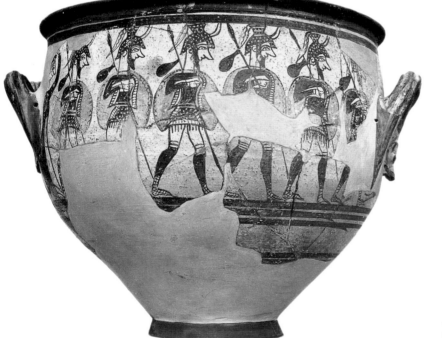

246 The Mycenaean 'Warrior Vase' from Mycenae, an uncommon example of wholly human figure decoration on a Mycenaean vase. The warriors have horned helmets and a woman behind them bids farewell (?). About 1200 BC. Height 41cm. Athens, National Museum 1426.

247 A horned warrior god in bronze standing on a metal ingot, a major source of Cyprus' wealth in the Bronze Age and thereafter (the word copper is derived from 'Cyprus'). About 1200 BC. Height 35cm. From Enkomi, Cyprus. Nicosia, Cyprus Museum.

The civilization and arts of Egypt have revealed themselves to the rest of the world in dramatic ways. In antiquity Greeks, then Romans, were attracted to Egypt's obviously extreme antiquity and the exoticism of its arts. More recently Napoleon's invasion **650** generated an Egyptomania which spread throughout the Western world. Biblical associations and the longevity of its styles of art and writing seemed to mark it out as something exceptional in the history of man. In some respects these popular reactions were founded in fact, but the early art and artists of the Egyptians shared universal aspirations; it was just that they realized them through the adoption of a most distinctive and long-lived idiom which always contrasted strongly with the achievements of their contemporaries and successors. Essentially, their home was also a very different land physically from those in which most other ancient cultures were fostered.

The annual inundation of Egypt by the River Nile, generated by the rains in Ethiopia, produced a broad strip of highly cultivable 'Black Land' (Egypt's ancient name) for some 800km north of the southern cataracts (rapids, ending at Aswan), which only partly inhibited access to and from the south and the riches of Sudan and Africa beyond. Its dependence on the regularity of seasonal flooding, rather than other natural resources, was absolute. At the north the delta on the Mediterranean was nearly 150km wide; to the west there was nearly impassable desert, to the the east much the same, except for a rather dry coastwise access at the north across Sinai to the Levant, and a route across from the Nile to the Red Sea, opposite the religious centre at Thebes ('Egyptian' Thebes, not Greek: for tourists, essentially Luxor, Karnak and the Valley of the Kings).

Geography made Egypt a prime place for early agriculture, capable of yielding two crops a year, but also made its society as introspective as that of China. Although some aspects of the beginnings of its agricultural-urban society might have been indebted to the Mesopotamian example, in detail the Egyptian way of life was an indigenous creation. They were never great explorers of Mediterranean waters: they did not need to

be, despite the fact that routes were easy, they could make good ships and distances were relatively short.

The ruling dynasties came and went, but they were generally bred internally, or could be at times generated by Libya to the west or by Nubia to the south. Sporadically, the country divided politically into North and South. Overall, however, there was an undisturbed unity of culture, language and art which must have contributed to the fact that the highly distinctive idiom for the arts which had been developed in Egypt by the third millennium BC lasted, with very little basic change in appearance, styles, subjects and techniques, for more than three thousand years. There are indeed occasional doldrums, as in the 'Intermediate' periods, and each major period has sufficient individuality for the basic development in style to be a real subject for Egyptian art history. There is no room here to trace details of change, except for the remarkable Amarna period **261–66**, and the slight effects of the intrusion and even dominance after the late 6th century BC of Persians, then Macedonians and Greeks, then Romans. No other early civilization could boast such a record, except China, and since it is manifestly not a record of progressive stagnation, it says much for the skills of the early artists and designers, and the realized

intentions of their royal patrons, that it proved so well founded and so, we must judge, successful, for so long. But it was also subject more than most to the conservatism that we have found necessary to many major and despotic arts. This conservatism is perhaps less apparent in style, which never seems merely mechanical, than in technology, especially the technology of the arts which were slow even to accept the possibilities offered by metalworking, except in gold. Thus, there was no true 'Bronze Age' in Egypt. In this respect, and in the conservatism, some parallels can be invited with the record of arts in Central America, where the political scene was far more varied.

Egyptian art is overwhelming in its stylistic idiosyncrasy, its at-first-sight unlikeness even to the various other arts of the urban world with which it made contact. In this must lie much of its unceasing appeal to modern eyes. Renaissance Italy had taken some note of Egyptian 'style' and it was more generally revealed again to European inspection in the late 18th century. Of all ancient civilized arts it has always seemed the most foreign, and both Greece and Rome had gone through a phase of Egyptomania before the French invasion under Bonaparte then reawakened northern interests, which were again revived after the finds in the tomb of Tutankhamun in the 1920s **269–72**. This is almost as near as we can get to an art which can seem both human and alien, yet its motivations and achievements are wholly in keeping with those of advanced early cultures elsewhere, however special its idiom. It is easy to see how it continues today to be a focus for speculation about the exotic, magical, even extra-terrestrial in the arts.

Religion was a greater inspiration than political power, and the higher arts were devoted to the exaltation of the gods and of the kings who acquired something like divine status. The afterlife was as real and omnipresent as everyday life, yet this was not a people obsessed by the more threatening aspects of the other world, but rather at ease with it and even in control of it. Although much that is revealed through their art is quite exotic, yet more relates directly to what we wish to know about the trappings of life of the people, from king to peasant. The visual experience of the Egyptian of any period is easier to recapture than most. In what it tells us of Egyptian life, their representational art more than makes up for the lack of any very sophisticated narrative art; and for all the exoticism, the more we learn about Egyptian ways, the more appealing they seem to be, the less determined by human greed and excesses. Much may be due to the relative ease of acquiring the necessities of life there; much to isolation from jealous and powerful neighbours. And our knowledge is enhanced by a rich literature, from love poetry to tradesmen's accounts to guides for the afterlife.

Egypt of the years before its First Dynasty (about 3200 BC on) showed as much promise as had Mesopotamia, and with many broad similarities in its arts – relief records of military success **252**, impressive minor stone statuary of rulers or priests **248** as well as observations of everyday life **249–51**, without as yet much indication of the distinctive styles about to be forged.

In the Dynastic periods the prime material for architecture is stone, hard stone, handled fearlessly, on a massive scale, with absolute precision in finish **24, 33, 253, 254**, and with only occasional use of mortar (for bedding, not adhesion) and wooden clamps. Most of the work was done in the most time-consuming way, by pounding (with dolerite balls) and abrasion, stone-on-stone. There were copper chisels that needed constant sharpening but could do much; iron was ignored even after iron tools had been introduced and their efficacy shown. This is craft-conservatism to the highest degree.

In such a bright country with open skies over deserts, colour was important, not least on architecture, although we can appreciate it now only in protected wall paintings, and on statuary and architecture we may find that it can distract the eye from other more formal qualities of excellence. Colour can both diminish and enhance fine sculpture and architecture, and its accidental absence, observed and perpetuated by the artists of the Renaissance and neo-Classicism, has heavily conditioned our attitudes to Egyptian as well as to many other early arts of man. In one genre, painting, Egyptian art demonstrates an exceptional command of colour, as well as displaying a degree of technical and

representational dexterity unrivalled before the Classical; in the sculpture we have only the form to judge.

Temples were more important than palaces, but required protection, while cities needed fortification and their exterior walls are often patterned by a succession of door-like niches, as well as being supplied with bastions and towers **255**. In the temples the kings performed their most important functions, and on the walls their divinity and prowess in war **268, 282** and in the hunt, traditional élite activities, were displayed much as they were on Assyrian palace walls but without quite the same variety, and without the detailed narrative scenes. The practice of cult, of the intercourse of kings and gods, was the other main subject for the artist. The great wall circuits, the massive pylons with their battered faces, speak for strength as much as defence. Within, height was more important than breadth of unimpeded space, and roofing spans were narrow, with wood or stone. Corbelling was common but the true arch or vault avoided until the late period. Multi-columned halls are the main design feature **254**, combined with processional plans, from building to building, and in approaches to temples, often flanked by lines of statues.

The areas covered by the major sanctuary buildings at Thebes dwarf even those of Central America, let alone the east until Angkor Wat. The one-piece stone obelisks (the derogatory Greek name for them, meaning 'little spits') soared up to 30m high **254**, representing the rays of the sun, whose disc is omnipresent in art, winged or carried in a boat across the heavens. The obelisks are the portable (with difficulty) insignia of ancient Egypt which we can now admire from Central Park in New York, to the banks of the Thames in London, to the Place de la Concorde in Paris. Royal tombs, when not buried out of the sight and reach of robbers as in the Valley of the Kings at Thebes, aspire to assault and graft themselves on to the very heavens – the pyramids – and were laid out with geometric precision revealing considerable astronomical understanding **32, 253**. They were a permanent reminder of the glory of past kings and of their assumed continuing presence and influence on Egypt's fortunes.

Columns are designed on the model of supports in other materials – tree trunks, bound reeds – with a variety of capitals **24** in the form of palms, lotus blooms or with goddess heads (Hathor), but not quite so rigidly determined as the Greek architectural orders were to be. Exteriors, interiors, column shafts, all were fields for figure decoration and hieroglyphic inscriptions. Room and tomb interiors may have all their walls and even ceilings painted with figure scenes of life or the divine, providing the dead with a form of immersion in virtual cosmic reality **279**. The genre scenes in non-royal tombs were of an everyday 'life' of work and pleasure which the occupant was guaranteed to enjoy even in death.

Much of the carved decoration in stone was in sunken relief e.g., **262, 268, 276–83**, especially for exterior display – an unusual and almost exclusively Egyptian technique which buries the very shallow relief in the stone surface, leaving the edges to cast a strong defining shadow around each figure or symbol. The Assyrian narrative wall reliefs **188–90** are at least as shallow but stand proud of the surface, and did not have to compete for so long in the year with such a brilliant sun, being mostly indoors.

The dedication of many artists to guaranteeing an afterlife for their patrons was the motivation for the greater part of Egyptian art that has survived. In some Old Kingdom burials plaster masks were modelled over skulls and torsos, or semi-portrait limestone 'reserve' heads which might prove better survivors than the mummified bodies **257**. Later mummy cases are fields for elaborate ritual paintings and more formal masks in precious materials **271**. Ultimately, in the Roman period, the head is covered with a realistic Classical painted portrait of the dead on a wooden panel **436**.

Sculpture in the round or half-round has an architectonic quality. Figures are often applied to walls or door-jambs. Many stand free, but the life-size and larger stone figures are regularly carved in one piece with a back pillar which stresses their stolidity without detracting from their vitality. In standing figures the back and one leg remain strictly vertical, while the other leg is pushed forward unrealistically **256**, expressing a permanent potential for movement, never realized, rather than actual movement. Only smaller

sculptures, and in other materials such as wood or bronze, balance the figures more realistically **259**, as will the Greek which owed much to them.

The free-standing figures seem impassive; there are only a few, rather formal action groups. Action is for reliefs or painting, where it is rendered effectively within very clear conventions. These insist on a strict combination of frontality (mainly torso) and profile (head and legs), for human figures. But within these conventions almost any pose and action can be depicted, even occasionally quite relaxed posture. This is especially apparent in many tomb paintings, and time and again what seems determined by rigid convention is lightened by a flash of realism **258, 266, 273, 283**.

'Official' Egyptian art is nothing if not conventional, but it is never boring: an apparent contradiction that looks for an explanation. Throughout the history of Egyptian art there are examples of closely observed realism in the rendering of human and animal life, yet the overall result is generally unrealistic. These are artists able to render life as well as did any Classical Greek but who deliberately avoided it. Their idiom is based on close knowledge and observation of the real but it was deliberately translated into something else, something more timeless than mere realism, the limitations of which we shall consider with Greek art. The result is an art which brilliantly expresses what lies beyond realism, the divine, the immortal, in keeping with the main purpose of Egypt's major arts.

For a while, in the Amarna period of the 14th century BC, a semi-realistic element intrudes in the sculpture and painting, producing, among other short-lived novelties, a new idiom for the human head and more emphatic modelling of the figure, based on life but not copying it **261–66**. Significantly it is the product of the pharaoh Amenophis IV's adoption of a 'new' religion devoted to a revised view of the sun god (Aten), and of a new name (Akhnaten) for himself. In the studio of his sculptor Tuthmosis, where the famous bust of his queen Nefertiti **263** was found, there were also plaster casts taken from live (or dead) human heads **264** – models or inspiration for major work in stone which, however, never reproduced the realism of these models, since this would negate their purpose.

Egyptian portraiture is not quite portraiture in our sense of the word, nor is it totally divorced from the real. The artists understood human anatomy well enough but did not translate their knowledge into strict definition of subcutaneous muscles and tendons, nor the engineering of the skeleton, but generalized it into something less specific, more timeless. It is this quality of the sculptors' work that we instinctively recognize and appreciate, which we may even prefer to the more restlessly realistic Classical. It was certainly longer-lived. Looking at Egyptian art, we may perhaps better understand Plato's suspicion of artists who counterfeit nature (*mimesis*) rather than pursue ideal forms, and understand why Michelangelo gradually moved away from the strictly real to an evocative semi-abstraction of live forms.

The Egyptian sculptors observed canons of proportion for their figures **61**, commonly related to head height, but this was more a matter of ensuring uniformity of scale, especially in multi-figure compositions, or as an aid to enlarging from models or sketches. On individual figures it was never so prescriptive as to determine that every kneecap or elbow had to be in exactly the same relative position. Measuring the world in terms of finger, palm, hand, cubit and foot was a matter of mathematical convenience and convention, not an absolute prescription for their arts.

In figure scenes the landscape or architectural elements were subject to the same discipline that we have met elsewhere in world art, in combinations of elevation and plan **23, 275**, not perspective, while differences in scale meant differences in importance not distance **268–69**. Still life could be carefully recorded **280**. In the human figures gesture, posture and some facial contortion indicated emotion or effort, while the foreign or exotic **276, 281, 283** was more carefully observed than the everyday, which was generalized. Greek art long observed the same restraint. For the regal scenes inscriptions defined identity and achievement, while a vast complex of symbols and attributes identified the supernatural. Combinations of religious concepts could be, sometimes naively to modern eyes, expressed through combinations of symbols or figures, human and animal. Formulaic groups, often

repeated over centuries, defined and identified ritual acts, notably in the Book of the Dead, a long illustrated text **274** which served as a passport-guide to the afterlife. Everywhere the exquisite hieroglyphs presented live forms within the written formulae and helped determine their overall effect, being themselves an art form **43**. On monuments they were never wholly superseded by abbreviated or less precise versions, such as the 'hieratic' or what appears in other cursive scripts.

Egyptian art is not all stone architecture and sculpture. The richness of finds in tombs and the conditions of burial have told us more about the arts applied to furniture **269–70** and dress, to materials that generally perish, than have finds elsewhere, except perhaps where the conditions are as wet as, in Egypt, they are dry. So we can turn to much else of a variety matched for this period, in this Chapter, only at times in China. The jewellery is exquisite and colourful **272**. For seals they at first used cylinders with simple patterns, like those of Mesopotamia, but came to prefer stamp seals carved or moulded in the form of the sacred scarab beetle and these, like the Chinese seals, carried inscriptions, usually royal names or mottoes rather than figure subjects. The form became the standard for amulets and seals through much of the Mediterranean world, for Phoenicians, Greeks and Etruscans.

In early days Egyptian civilization had not developed without knowledge of Mesopotamia, and there are points of contact in the pre-Dynastic arts. Some Egyptian kings came to have extra-territorial ambitions and even challenged Assyria. The result, in the arts, was generally to ensure that it was Egyptian styles and subjects that were well diffused through the Levant and Anatolia, while there was very little return traffic in kind. But the Egyptian styles that travelled were pretty rather than profound: slim-winged discs, a variety of gods, demons and headdresses, scarabs, some jewellery techniques **321-24**.

When foreigners, first the Persians, then Alexander the Great's Macedonians and Greeks, did take up residence, the effect on the arts was slight but perceptible, with a few engaging attempts to reconcile the Classical with the Egyptian in later years **73, 285,** and when Egypt fell more and more within the ambit of Roman ambitions. Classicism was long confined to the Mediterranean seaboard – notably the new city of Alexandria. A Cleopatra could be shown either as a Classical princess or in the traditional Egyptian style, depending on whether the context was Greek or native Egyptian, and in Egyptian areas the buildings commissioned by Romans were in Egyptian style. There were many hybrid products, not least the magic gems **284** that combined Egyptian with Classical Roman. Yet the essence of Egyptian style survived for as long as did the religion (rather than the rulers) which it served. Only when the temples were closed by imperial decree did the Egyptian style also expire and give place to a doll-like version of the traditional Classical, for a Christian, Coptic population **286**.

TABLE OF MAIN PERIODS	
Early Dynastic Dynasties I–II)	3200–2780 BC
Old Kingdom (Dyn. III–VIII)	2700–2160 BC
First Intermediate (Dyn. IX–X)	2160–2134/2052 BC
Middle Kingdom (Dyn. XI–XII)	2134–1786 BC
Second Intermediate (Dyn. XIII–XVII)	1786–1570 BC
New Kingdom (Dyn. XVIII–XX)	1570–1085 BC
Third Intermediate (Dyn. XXI–XXV)	1085–663 BC (XXV = Nubian)
Saïte period (Dyn. XXVI)	664–525 BC
Persian domination (Dyn. XXVII–XXXI)	525–332 BC
Ptolemaic Greek	332–30 BC
Roman domination	30BC on
Closure of pagan temples	AD 385

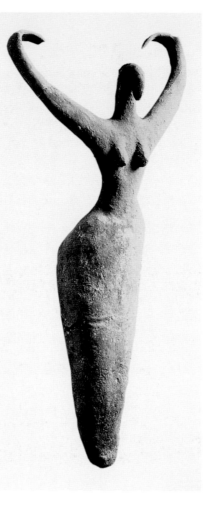

248 A basalt figure of a man wearing a codpiece, and achieving already a degree of monumentality shared by several other stone statues of the period, but in no significant way prefiguring the artistic idiom of Dynastic Egypt. Naqada culture. About 3000 BC. Height 40cm. Oxford, Ashmolean Museum 1922.70.

249 Pre-Dynastic Egypt can be judged in much the same terms as the early period in Mesopotamia, yet is distinctive in subject matter, style and much else. This clay figure of a woman is from Ma'mariya (Naqada culture, its main site just north of Thebes). It resembles figures painted on pottery of the period, apparently dancing. Late 4th mill. BC. Height 29.3cm. New York, Brooklyn Museum.

250 A clay pot decorated, as are many of this class, with a representation of a ship and animals, in a version of the universal early style. Decorated pottery is not prominent in the history of Egyptian arts; Nile and delta clay does not lend itself to the production of a very fine ware. Later 4th mill. BC. Height 24cm. Berlin, Staatliche Museen 20304.

251 A stone hippopotamus. About 3000 BC. Length 30cm. Copenhagen, Ny Carlsberg Glyptotek.

252 The palette of King Narmer, made of green slate. The figures and subjects resemble comparable commemorative monuments in Mesopotamia. The king's name appears top centre in an architectural frame (serekh), with the head of the cow-goddess Hathor at either side. Narmer in procession with standard-bearers approaches piles of decapitated enemies; notice the grades of scale. The twisted necks of the monsters framing the dish of the palette (probably for mixing kohl – eyeshadow) derive from Mesopotamia too. Below, the king as a bull gores his enemy (on another palette he is shown as a lion). From Hierakonpolis, an important southern centre in the early period. About 3000 BC (start of the First Dynasty). Height 63cm. Cairo, Egyptian Museum.

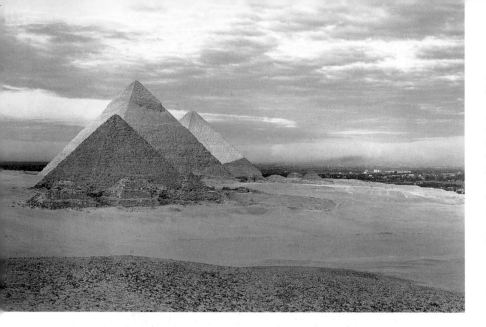

253 The great pyramids at Giza are products of Egypt's Old Kingdom (mid-3rd millennium BC; see also [32]); most carefully aligned to the heavens, and originally finished with a smooth stone surface (the very earliest are more emphatically stepped in profile). Tomb chambers are carefully hidden within and below the solid structure. The pyramids are linked to the Nile by causeways ending in 'valley temples', and these were plentifully supplied with statues of the king in attendant buildings; that of Chephren with the Great Sphinx, which bears the king's features. Height of the Great Pyramid (of Cheops) originally about 146m.

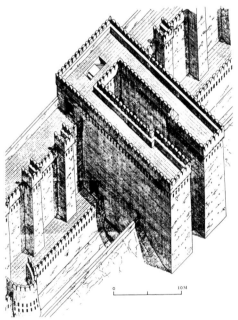

255 The Middle Kingdom fortification of the west gate at Buhen (lower Nubia, some 400km upstream from Aswan), reconstructed. 2nd mill. BC.

254 The entrance to the Temple at Luxor erected by Rameses II, with colossi and obelisk, palm capitals to the columns within. 13th cent. BC.

257 A limestone 'reserve' head from a Dynasty IV tomb at Giza; a life-size semi-portrait of a negro princess, helping ensure the survival of the deceased in her authentic appearance. Mid-3rd mill. BC. Boston, Museum of Fine Arts 14.719.

256 Statue of King Mycerinus and his wife in dark green diorite. They share a joint back pillar/slab. The king wears the usual apparel of headcloth and kilt but is otherwise naked; his wife's long dress does not conceal details of her body. Mid-3rd mill. BC. Height 1.42m. Boston, Museum of Fine Arts 11.1738.

258 A limestone group of the dwarf priest Seneb and his family, from Giza. Dwarfism was no bar to high office and there is plentiful evidence that dwarfs were respected figures in Egypt. Late 3rd mill. BC. Cairo, Egyptian Museum.

259 A copper statue of a king from Hierakonpolis; cast in pieces, riveted together, so not requiring the back pillar for stability which appears with stone statues. About 2300 BC. Height 75cm. Cairo, Egyptian Museum.

260 A painted limestone statue of a scribe, in traditional posture for such important palace officials. His eyes are inlaid, of alabaster, black stone, silver and crystal. About 2500 BC. Height 53.7cm. Paris, Louvre Museum.

261 A colossal statue of Akhnaten (Amenophis IV), whose reign saw the inauguration of the new 'Amarna' style in art. From Karnak. About 1360 BC. Cairo, Egyptian Museum.

262 A sculptor's trial piece in limestone showing the heads of King Akhnaten and his wife Nofretete (Nefertiti), with the elongation of features and skull characteristic of the Amarna period; from El Amarna. Such 'trial pieces' for carving or painting, on limestone flakes, represent the work of both students and masters. About 1350 BC. Height 15.7cm. New York, Brooklyn Museum 16.48.

264 A plaster life- or death-mask of a man, from the studio of Tuthmosis at El Amarna, demonstrating the artist's preoccupation with the realistic forms which he chose not to reproduce in finished work in stone. About 1350 BC. Berlin, Staatliche Museen.

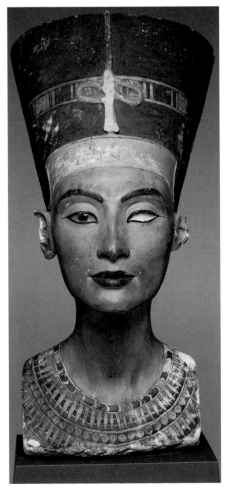

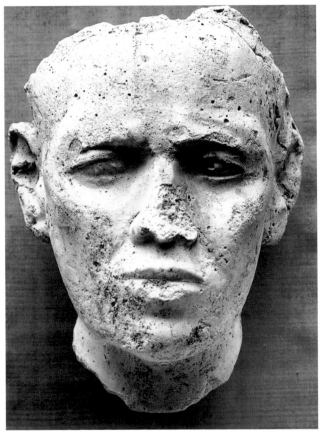

263 The bust of Nofretete (Nefertiti) from the studio of the sculptor Tuthmosis at El Amarna; probably the best-known example of Egyptian art. Height 48cm. Berlin, Staatliche Museen.

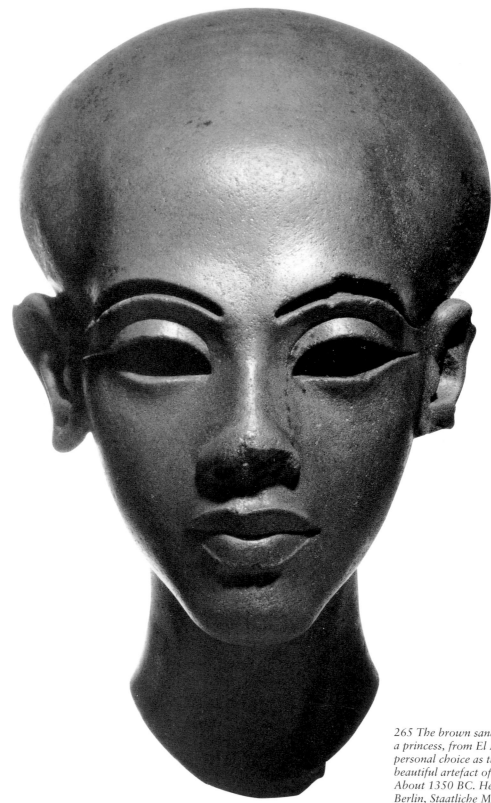

265 *The brown sandstone head of a princess, from El Amarna. A personal choice as the most beautiful artefact of antiquity. About 1350 BC. Height 21cm. Berlin, Staatliche Museen 21223.*

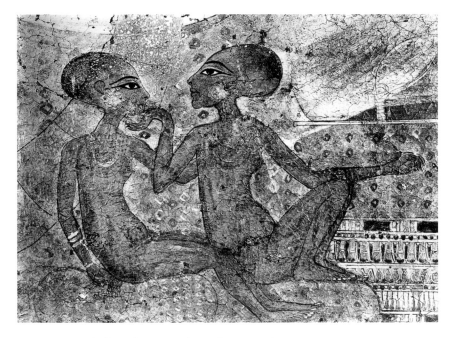

266 Detail of a wall painting from El Amarna showing two princesses in an intimately realistic pose. About 1370 BC. Oxford, Ashmolean Museum 1893.1-41(267).

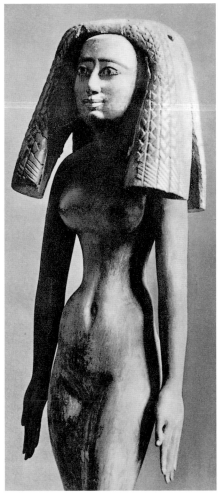

267 The wooden figure of a woman (Imeret-nebes). The anatomy is carefully observed but not literally rendered. The material allows a suppleness of modelling not easily achieved in stone-carving and more like relief or painting. About 1800 BC. Height 48cm. Leiden, Rijksmuseum van Oudheden AH113.

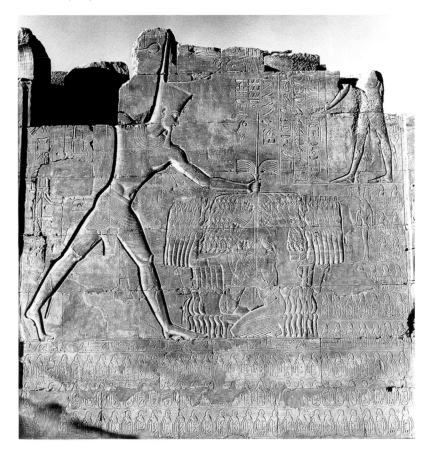

268 The relief showing Tuthmosis III smiting a handful of foes, which fills the façade wall of a pylon at Karnak. Below are rows of captive peoples, their identity revealed by the inscribed cartouches which make their bodies.

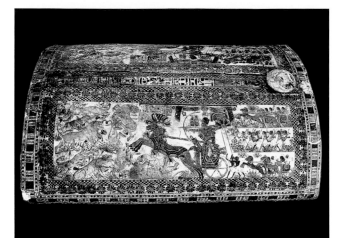

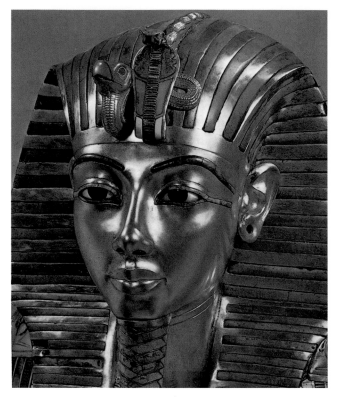

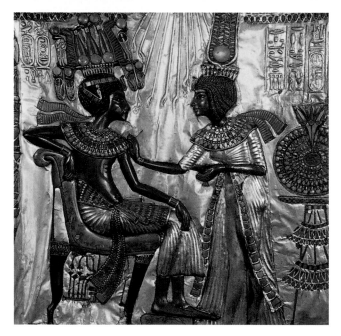

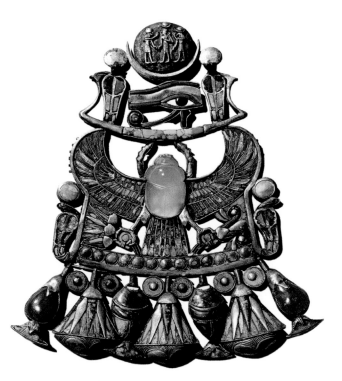

269 A casket of painted wood from the tomb of Tutankhamun (died 1339 BC), with scenes of the king at battle and hunting. Scale indicates status – the king largest, his followers in three registers of chariots and his confounded foes, smaller. Length 61cm. Cairo, Egyptian Museum.

270 A chair back from the tomb of Tutankhamun, made of gold and silver sheets, with coloured glass and stone inlays. The queen anoints the king; from above fall the rays of the divine sun, with hands at their ends to bless him. Cairo, Egyptian Museum.

271 The funeral mask of Tutankhamun; gold with inlays of coloured glass and stone. Cairo, Egyptian Museum.

272 A pectoral pendant from the tomb of Tutankhamun, of gold, silver, precious stones and glass. Height 14.9cm. Cairo, Egyptian Museum JE 61884.

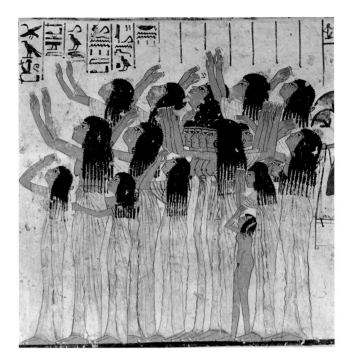

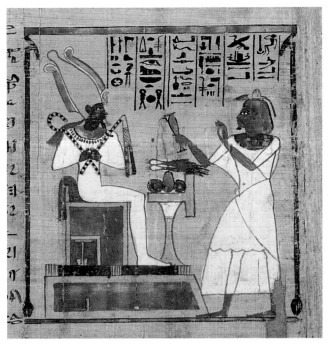

273 A painting of women mourning, from the tomb of the vizier Ramose at Thebes. The stereotyped figures, poses and gestures still allow enough variety to create an effectively emotional scene. About 1360 BC. Chicago, Oriental Institute, University of Chicago.

274 A drawing on papyrus (paper of interlaced and pressed dried reeds) from the 'Book of the Dead' in the tomb of Pawia-enadja. The dead man supplicates the god Osiris to be able to attain reunion with his body in an afterlife. 10th cent. BC. Berlin, Staatliche Museum P 10466.

275 A painting of fowling and fishing, from the tomb of Menna at Thebes. The elevation-and-plan convention – the river, the central inlet with fish and the papyrus thicket beyond – still allows an approach to the realistic, largely in detail (the birds above, the broken papyrus stems, the gestures of the women in the reed boats). About 1350 BC.

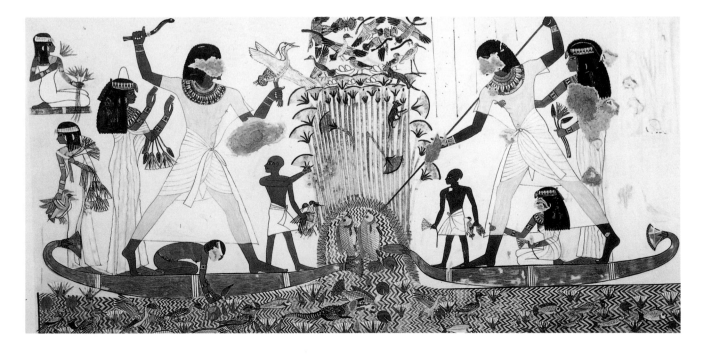

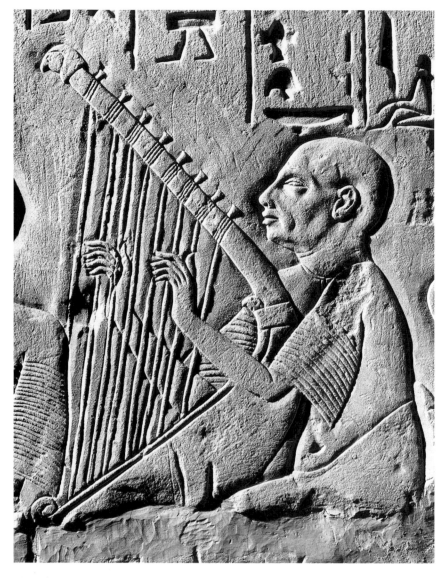

276 A relief showing a blind harpist from the tomb of Paatenemheb at Sakkara. About 1330 BC. Leiden, Rijksmuseum van Oudheden.

277 A relief from the tomb of Thetha (Tjetji). This encapsulated much that we admire in Egyptian art: the simplicity of form combined with meticulous detail. It also well demonstrates the effect of light and shade in outlines created by the technique of sunken relief. About 2100 BC. London, British Museum.

278 A relief scene of hairdressing on a coffin from Deir el Bahari. The burials of noblewomen were no less well provided with guarantees of continued personal attention in the afterlife than those of men. Such activity was otherwise commonly secured by the burial of wooden models of servants at work, in home, on the river or in the countryside. Dyn. XI. Cairo, Egyptian Museum.

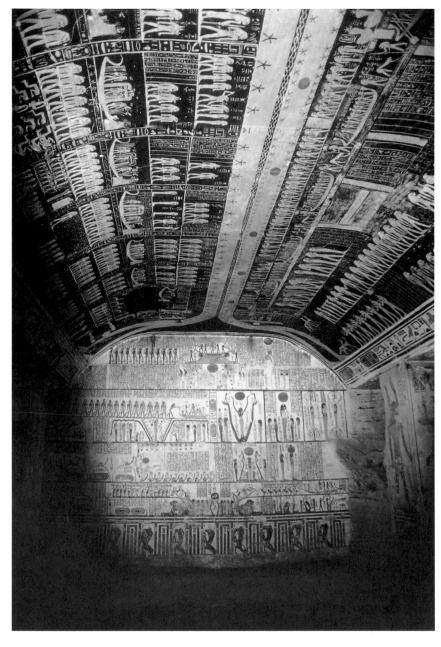

279 The interior of the tomb of Rameses VI (died 1134 BC) at Thebes. It was common for the entire surfaces of major tombs to be decorated with painting or relief, depicting the appropriate rituals and, as here on the ceiling, statements of the cosmic order.

280 A detail of the painted offerings on a Dynasty XII coffin from El Bersheh. Stippling and intricate brushwork, with shading, produce a realistic effect for objects and creatures presented in a wholly formal and unrealistic physical context. Boston, Museum of Fine Arts.

281 Copy of a painted study of a foreigner from an early New Kingdom tomb at Thebes. Artists were closely observant of foreign or abnormal physiognomy.

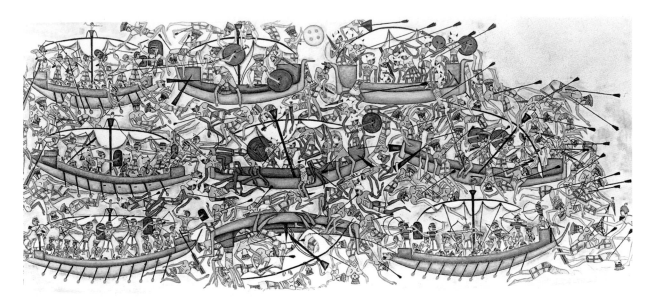

282 The defeat of the 'Sea Peoples', raiders from the Mediterranean world who invaded the Levant and Egypt in the late 12th century BC and were repulsed by Rameses III. This is part of a relief on the wall of a temple at Medinet Habu (SW Thebes), showing a sea battle, the foreigners carefully distinguished by their dress. About 1150 BC.

283 A detail of a relief at the same site showing captives from Rameses' campaign, differentiated by their dress and physique: thus, probably, a Libyan, a Syrian, a Hittite, one of the 'Sea People' and a Canaanite. Chicago, Oriental Institute, University of Chicago.

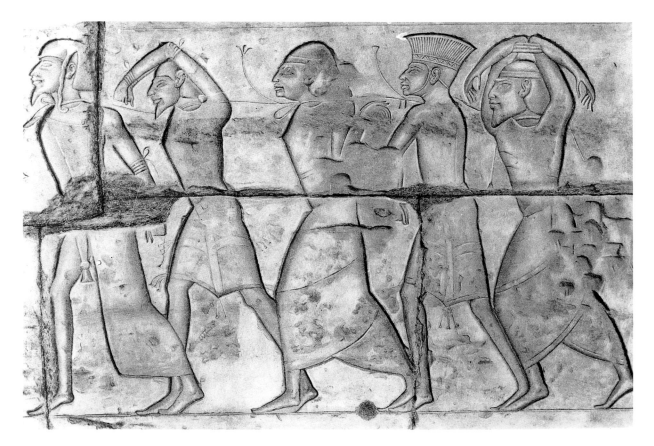

284 Roman Egypt was a hotbed of mysticism and magic, well expressed in a rich series of magic ('Gnostic') amulets which offer various traditional Egyptian subjects alongside Classical and Jewish ones, and many new combinations and monsters, with magic formulae and inscriptions, often in gibberish Greek. This haematite amulet has a magic inscription around an ouroboros (snake eating its tail), with figures of Egyptian Isis, Anubis as a mummy, Chnoubis (a lion-headed serpent) and Osiris as a mummy; over what is taken to be a representation of a sealed human womb. The summary style is common to much of the gem engraving of the Roman Empire. About AD 200. 17 × 12mm. Vienna, Kunsthistorisches Museum IXB 1255.

285 The granite statue of Horsatutu. His dress, although realistic, clings to the body forms which, with the features, betray the influence by this date of Greek realistic portraiture. 3rd cent. BC. Height 1.13m. Berlin, Staatliche Museen 2271.

286 A version of Classical art and mythology served the Coptic Christian world. The style reminds one very much of Western 'folk art' at various places and periods. On this textile the Greek god Apollo pursues Daphne, who escapes him by turning herself into a tree, as in any Roman version of the episode. But here she also responds by offering him a Christian cross. From Antinoopolis. 4th/5th cent. AD. Paris, Louvre Museum E 29302.

The Classical, Greco-Roman arts have exercised a profound effect on styles in architecture and the representational arts worldwide. Yet Classical Greece, where it all began in the 5th century BC, cannot justly figure on the same terms as the other temperate urban cultures considered in this Chapter, while the later diffusion of Classical arts was largely a function of the Hellenistic Greek and Roman empires. When the Classical style was developed, Greece could hardly claim to be a major cultural entity or political power on the world stage.

We might call it a civilization, but small-scale, minute in terms of power, geography and population, with no definable political core, and insignificant when compared with the other world powers, from China to Egypt, which we have already surveyed, although it did for a while successfully confront one we have yet to consider (Persia), and its arts were to have a wider and longer influence than all the others.

So Classical Greece needs separate consideration, to discover why, before Rome intruded, it cannot in political and social terms compare with, say, Egypt or the Aztec empire, yet it was able to be the cradle of arts of even greater longevity. I should apologize if I seem Greco-centric in bestowing this separate treatment, but readers may discover that this is by no means a bias in this book, and without this introduction to the Classical some arguments in other sections may seem obscure. We shall in fact find here much which reflects directly on man the artist's response to his environment and service to his community; also, for a change, considerable evidence for the exercise of personal choice, which perhaps makes Greek art more 'modern' in the way that their culture can also be described as that of a 'modern civilization'.

Geography plays a major role in the story, having an effect on the development of a social structure which can be seen, at least in the 1st millennium BC, to be largely responsible for the perceived development and diffusion of Greek art. But in the crucial years we do not see much which can match the monumentality of concept and execution which characterizes the imperial centres elsewhere. The parallels are rather in presentation – the biggest is not often the best, while it was in concept as much as execution that the true influence lay. If this section seems out of scale, it is because it has to be.

The relative poverty and the discontinuous character of the land, coasts and islands occupied by Greeks were discussed when we looked at their Bronze Age (pp. 135–37). They explain the Greeks' early exploration of other Mediterranean shores, for which they were exceptionally well placed. In the 8th to 6th centuries BC serious colonization planted Greek towns on the shores of Spain, France, Italy, North Africa, in the upper Balkans and around the Black Sea. This was unparalleled enterprise for the period. Harold Macmillan said of Britain that 'We are a small country with little in the way of natural resources other than our wits' – the same was true of Greece.

Beginnings – the world of the Minoans and Mycenaeans – have to be distinguished from what happened after about 1000 BC. They were highly influential, not in the obvious way of providing a physical springboard for later development, but rather in an intellectual one which depended on the intellects of the later Greeks, not of their Bronze Age predecessors. These

we have seen to be as much distinctive cousins of the major civilizations of the east and Egypt, as products of what it meant to be living in a land like Greece.

The break with the Bronze Age was almost complete. It was marked by the collapse of the palace-centred kingdoms in the face of forces still not altogether clear to us – invasion, revolt, climate change, massive depopulation. What followed, leading to the full Classical, was strikingly different, but the ghost of the heroic Bronze Age was to haunt Greek literature and art for centuries, in their content if never in their form and function. It created a myth-history used by Classical Greeks with a subtlety unsurpassed by other people in its use of the past, and bearing a message for the many European successors to their tradition. And it had left on and in Greek soil the record of a past which was in fact conceptually foreign, but which Greeks recruited to support their sense of belonging.

There was no new 'Greek state', as there had been Minoan and Mycenaean kingdoms, which were capable, if we believe Homer, of concerted action; and there never would be again except in the form of a Roman *colonia* or as part of the Byzantine and Ottoman empires. The geography of Greece dictated the independence of enclaves comprising a single city with outlying villages in discrete valleys or plains, or on coastal strips and islands. The population built up again slowly in the five hundred years after the Bronze Age collapse without inheriting whatever dynastic systems had helped determine the Bronze Age kingdoms, except in a broad sense determined by kinship and dialect. It was like a microcosmic and rapid rehearsal of the way older cultures had developed elsewhere. The agricultural element must gradually have overtaken the pastoral, and material wealth began to grow only with seafaring, which sought out new homes but also materials from all quarters. Most such ventures were individual efforts, sometimes by quite small Greek states, notably those in the Euboean straits, and Corinth, later Miletus in the eastern Aegean. The cities seldom collaborated, and often competed.

In Greece itself competition was the keynote, and new fighting techniques, which were in time to revolutionize all ancient warfare, were practised on neighbours to gain material rather than land, and in a ritual of 'hoplite' warfare of citizens in ranks, quite unlike the élite-plus-rabble style of earlier, even 'Homeric', warfare, which was general in the larger empires. All this contributed to a greater sense of general corporate loyalty to one's home town, even to a form of democracy in decision-making, but never to a 'Greek nation'. When there was a common threat, as from Persia in the early 5th century, barely half the Greek-speaking states found it possible, and even then with extreme difficulty and misgivings, to act together to repel it, and the enemy found many collaborators. Any partial unity soon dissolved in jealousies, and one of the results was a brief period of considerable power left in the hands of one state, Athens. This happened for a short time in the 5th century, just when the High Classical style in art was developing.

A common factor, unrecognizable in the rest of the Old World, was the desire for display or show at all levels of society, not just by the ruling élites who were always a minority and of changing identity, and of whom there were so many up and down Greece. It was always more important to make a visible and permanent display on a tomb, with monuments and figures, than to fill it with riches. Art was used to confirm status, personal and corporate, and religion was generally the medium exploited. The Parthenon 295 was more a display of authority to the rest of Greece, and of complacent reassurance for mini-imperialist Athenians, than it was a monument of piety and thanks to the goddess Athena. In this way the Greeks perfected the use of art as a tool of state propaganda and individual advertisement, from the devices chosen for official coinage 316 to the prolific use of inscriptions to identify owners, dedicators and even artists 51. The Romans refined these processes for the modern world. But the largest structure in a Classical Greek city was its main temple; next its theatre 310.

All that was shared by Greeks was language and religion, and this created only a veneer of Greekness. Different loyalties and strong local independence, without any dominant power to command service or tribute, left each city-state to work out its own destiny, and their artists to serve their community in ways that seemed best to artist and customer, not to political or military authority. Thus, through roughly the 9th to 6th centuries BC, although a common idiom for Greek art can readily

be made out, it developed independently, sometimes in towns only a few hours' travel from each other. There was ready borrowing of styles and techniques, much being determined also by observation of the non-Greek. Language was the major bond, and we can see that dialect groups were roughly coterminous with 'art-style' groups. Evidence of Greek awareness of their ethnicity may seem a problem for some strains of modern scholarship; it was not for the Greeks themselves. The foreigner was perceived as 'barbarian' not because he was wild and uncultured (usually not the case, as the Greeks acknowledged), but because he did not speak Greek and talked 'bar-bar'.

Soon after the Bronze Age collapse we see the humbler artists, potter/painters, reworking older floral patterns and shapes with a new respect for geometrical form and precision 289. It was as though the ruler and compass had replaced the free and fluent Bronze Age decorative techniques. The same geometry and sense for proportion overtook also the gradual readmission of representations of the human figure in art 287, 288. Patterns and formulae for the depiction of events such as funerals and fighting were created, and the conventions were not unlike those of geometric arts elsewhere in the Old World. In the 8th century the arts were exposed, through Greek enterprise, to the styles of the Near East, especially Syria. This led to new manners in depiction of the figure, human and animal, and to a new range of pattern, floral rather than geometric 290, 291, as well as a growing acquaintance with luxury materials – gold and ivory. But the basic principles already apparent in the so-called Geometric period (900–700) barely faltered, and were always to inform Greek art.

The east also taught Greeks how to write again. A rich literature developed, based on a strong oral tradition which continued to offer a variegated tapestry of Greek myth-history on which the imagination of artists could freely work, without any constraints of political or even religious direction. Few law codes were written down and annals were no more than lists of priests or Olympic victors, but a lot of energy was expended in inventing and standardizing 'Greek myth' by artists and writers, although not in unison. There were no 'canonic versions' of the stories, and writer or

artist was free to extemporize. This was to provide a paradigm for social behaviour which can be traced in Greek visual arts as readily as it can in literature or on the Classical stage.

Archaic Greek art of the 6th century BC carried the seeds of the Classical of the 5th. They might be identified also in the arts of the east and Egypt, but there they never germinated to the same effect. I pick out three influential Archaic characteristics – narrative formulae, architectural form and pattern (not always on buildings), and the role of the human body in statuary. Later we shall see what they led to in the 5th century; remembering that these numbered centuries are meaningless before Christ, simply a convenience, their beginnings and ends sometimes accidentally approximating to significant political or art-historical transitions.

The subject matter for Archaic Greek art was largely divine or myth-historical, sometimes everyday life (at all levels except the purely political which was always to be shunned), with a certain amount of animal-frieze decoration derived from the east, and probably of little deeper significance beyond lending life to, energizing, the objects decorated. These were generally of practical value or they recorded piety through wealth. A major field for us is the decoration of clay vases which, thanks to their material, have survived well and were obviously a favoured medium for narrative, even into the 4th century BC, more so than the more valuable metal vases.

Narrative scenes were composed in short friezes or tableaux and chose a significant aspect of the story – not always the most energetic – and conveyed the subject, already known to the viewer, by the identification of figures through their attributes, dress or sometimes inscriptions, as well as the action 292, 293. This was not generally conceived as a specific moment in the narrative – any more than it was in most of the ancient world, and even later, virtually down to the invention of the camera. It is a common enough manner elsewhere in antiquity, where the only real alternative was a succession of scenes (like a strip cartoon), or repetition of the same figure in one scene. In Greece scenes and groups could acquire a formulaic character without in any way eliminating the possibility of introducing nuances of meaning and mood, by pose and gesture. The practice somehow enabled

artists to generalize the message of a scene and go beyond simple reporting, and the method held throughout Classical antiquity. The figures themselves resembled life in form and action, like those of Egypt and the east, without copying life too closely.

In the land of marble, architecture proved to be the most subtle of the arts, probably rivalling any other of antiquity, even in dealing with sheer size when called upon. It is far more intellectual than it may appear, but it can please the eye even in detail and fragment, while the very varied idiom that was developed for whole buildings and façades has proved appealing down to the present day. Excellence of execution and detail were as important in the largest of the arts as in the most miniature, and the effect of the whole was never diminished by over-elaboration. The architectural orders **25a** for columns and upperworks of stone buildings are peculiar to Greece in antiquity. For their usage they owe little if anything to Egypt or the east, and anything comparable in antiquity afterwards was derived from Greece – in the east (to Persia **26** and India **127**) and throughout the Roman Empire. The Doric order had been developed in the 7th century BC by petrifying wooden forms; the Ionic in the 6th century by enlarging eastern furniture patterns. Their use in peristyles and colonnades defines all Greek monumental architecture. They are a sublime expression of proportion and rhythm on a monumental scale, and changes over time are subtle and slight, reflecting the spirit of the arts of each period, admitting just one new order, the florid Corinthian, once the High Classical period was past. Study of the buildings shows that proportion was more important than pure mensuration, and this is to prove another very Greek characteristic in all arts. At their best (the Parthenon) subtle refinements of line – nothing was quite straight or vertical – provided optical correction for structures which might otherwise seem too box-like **25b, 65**. There was colour everywhere, even on plain walls to soften the glare of reflection.

Building plans behind the colonnades were simple. Temples were simply houses (*oikoi*) for the cult statues, not for ceremony, since sacrifices took place at the outside altar. Theatres were cut into the hillside, usually large enough to accommodate the whole (male) population of a town **310**; only in the 4th century was a raised stage introduced in them. From the 5th century on there were more civic buildings, especially in 'democratic' Athens. For all the subtlety of design that went into their architectural achievements – and they are more variegated than a superficial view of the apparently unvaried temple type might suggest – the Greeks were always intensely practical in execution and planning.

The archetypal statuary types, naked males and dressed females (*kouroi* and *korai*), owe their overall appearance to eastern models (for the women), to Egypt and to life (the Greek male's readiness to exercise and go naked **296, 297**). Most are executed in hard stone (marble), foursquare in appearance, carvers' works. Their proportions are determined at first by a degree of emphasis on important parts (shoulders, length of leg), then more on life, and probably not much affected by the Egyptian canons of proportion, themselves not all that rigorously applied in Egypt. Pattern was no less important – for the males the pattern of musculature, for the females the pattern of loose dress falling in cascades of zigzag folds. Relief sculpture, applied to architecture or slab monuments like gravestones, follows the same principles and can be cut very deep, almost in the half-round, unlike the practice in the early east and Egypt. It was also a medium for narrative, on buildings.

The attempts at realistic rendering of detail in sculpture and of action in narrative drawing brought Greek artists of the early 5th century to the point at which they began to copy live forms by looking at them carefully and not simply rendering them conceptually. This is highly novel, practised only piecemeal elsewhere in antiquity by that date, and within a generation Greek artists are consciously looking at life and trying to render it in a totally realistic manner **299, 301**. The impetus towards such a revolutionary step lay in Archaic attention to accurate patterning of live forms, and in sculpture was abetted by a shift from carving to modelling, which meant that the figures were built up in clay from within, not cut back from the exterior of a block. Modelling even began to provide a starting point for figures carved in marble – the clay models were copied with some primitive but effective mechanical aids in measuring; but best are the bronzes cast indirectly from the modelled clay original (see above, p. 46). Even in the 5th century, there may be

evidence for casting from life for some body parts – the Greeks were ever practical.

There was, of course, more to it than such realistic detail. The foursquare figures of the Archaic period betray no knowledge of how a human body is constructed. Even in action figures, of which there were few in the round, there is no subtle expression of balance. Now, at last, in the Classical period a standing figure may be shown in repose **299, 301**, one leg slightly bent, the other bearing the weight, with the resultant realistic shift in the set of the back and dropping of one shoulder, the beginning of that *contrapposto* observed by Renaissance artists. In two dimensions, true foreshortening of limbs and objects begins to be accurately rendered, and perspective views of isolated objects (not the single vanishing point of the Renaissance). This too is revolutionary in the arts of man, barely anticipated in some drawn or low-relief Egyptian figures. It was readily abetted by the new modelling techniques for major works, building up on armatures, as it were on a true skeleton, while the new red-figure technique on vases **302, 303** allowed the supple use of a brush to express the new style better than did the graver in the old black-figure technique of silhouette **292, 293**.

But is this not all a shade mechanical? To some degree it is, but in the main period of practice, the middle and second half of the 5th century, and sublimely on the Parthenon **300** and in a few statues, originals or known to us from close copies of later periods, the sheer accuracy is mitigated by an essential adherence still to pattern and proportion. Sculptors defined their ideal figures in terms of proportion, not absolute measure, and they wrote books about it **301**, while the feeling for pattern made the figures in detail, if not overall, rather better than life. This is idealized realism, not portraiture of individual models – indeed, it retarded the development of true portraiture, but in a nobler cause. When the Parthenon marbles reached London nearly two hundred years ago artists realized what the effect could be of close observation and rendering of natural forms, rather than the glossy approximations to which the west had become accustomed thanks to the Renaissance and neo-Classicism. Idealized realism does not need to be sentimental; indeed, it militates well against sentimentality in subject and expression, and

for truth to basic principles of form and anatomy.

A by-product of the Greek artists' interest in depicting the male nude gave rise to the concept of 'heroic nudity', which much affected classicizing arts down to the 19th century AD. It had no validity in Greek antiquity, where the phenomenon is a result of the Greek practice in life and their artists' expression of it, sometimes perhaps to an exaggerated degree. What was appropriate for an athlete was appropriate too for an active god or hero, and eventually for human rulers who aspired to divinity.

The Classical revolution of the 5th century BC was the work of several gifted artists, not even a single school, moving towards a common but as yet undefined goal. We can understand it because, with hindsight, we know what happened next; they did not, and it must have seemed an age in which everything seemed possible in the arts. This is a confidence we detect at the same time in Greek literature and thought, where the foundations were laid for what we call Western civilization.

It is the speed of change that is truly amazing, and a telling parallel can be drawn with similar arts of a much later period far away. Chinese representations of the Buddha derive much from Indian prototypes, including a virtually archaic (in Greek terms) patterning of dress, which might at several removes even owe something to Archaic Greek style (partly via Persia, then India). The dress at first conceals body forms but gradually comes to be used to express them, and there is even an occasional *contrapposto* relaxing of the stance. The change took place over some three centuries, the 4th to the 6th AD; in Greece the same changes took less than fifty years. In other respects the development in Classical representation of dress can be seen to have been almost as inevitable as the changes in representing the body. A parallel can be seen in European painting suggested by the recent *Fabric of Vision* exhibition in London's National Gallery: we move from flat patterning (Giotto) to the purely Classical of the 15th century (Mantegna), to 16th-century Baroque (like Hellenistic) when the dress acquires a life of its own, ending with the theatrical dressing up of the 17th/18th century (like Roman). But antiquity never relapsed then into neo-Classical Romantic Simplicity. The parallel is clearly conditioned by the fact that the aims and appearance of Greek art remained the criteria for the

Renaissance and afterwards, and so the learning process is also accidentally mirrored, with the help of technical progress, though antiquity needed no *camera obscura* or *lucida* to achieve virtual reality.

The Archaic narrative conventions suited the new style, generalizing from the particular. And in the arts a product of this generalizing was an effect which many might disparage – an indifference to material and scale. We judge the style and quality of the inch-high figure on a gemstone **313** as we would a life-size statue of the period. Fired clay, metal, wood, stone – the material had minimal effect on the resultant style, and there was a general desire to disguise and obliterate all evidence of technique, which in other periods and places might be deplored. We can see from later periods that colossal scale goes ill with any virtually realistic rendering of human figures, unless it is viewed at a great distance (the Statue of Liberty, some Buddhas), even when impersonating gods. An extra modicum of height for a statue of a hero or god, or enlargement for figures to be seen at a distance on a building, can work. Anything more surrenders the illusion of reality, becoming vulgar and ostentatious, however impressive. It was seldom practised except for cult statues which were meant to impress by their opu-lence and superhumanity, and were helped by being hidden in the mysterious and dark interior of a temple **305**. We perhaps need shed no tears that we have lost them. The Greeks were great miniaturists – Pheidias made gems as well as statues – and the luxury arts in Greece are no less important than the monumental, while they generally better retain their colour, lost in major (larger) arts.

There is at the same time another characteristic of the Classical which informs more than even the idealized realism of the sculpture. This is a devotion to the execution, in whatever medium at whatever scale, of the most accurate, indeed meticulous, detail. It is a finesse which is not pernickety, since it can be seen to enhance the message of the whole – patently true in sculpture, as we have seen, but no less apparent in architecture. When we wonder that the pedimental sculptures of the Parthenon are so carefully finished even behind, out of mortal view, we are presented with the proposition that in this context the creation of perfection was more important than its display to mortals, which is why the marbles are best understood in museums, nose to nose, rather than skied on a building; and best when they can be directly compared with the very different work of other ancient cultures.

The idealized realism of the 5th century survived through the 4th, when experiment began to open new possibilities for both figures and dress. Not the least of these is the realistic treatment of the female nude, where the degree of added idealization simply enhances the message of sensuality **306**. By the end of the 4th century new manners are beginning to intrude and we are into the period of the Hellenistic monarchies, when art, as we shall see in a later section, begins to serve the broader, less democratic, ambitions of monarchs and emperors.

But what of this 'realism'? In Greece it was pervasive in more than just sculpture – e.g., the dress of **304** – and we have stories of painters achieving successful *trompe-l'oeil* panel pictures: a 4th-century Greek painter could render grapes that deceived the birds, or a curtained tableau which a painter rival tried to unveil. Scenes begin for the first time in the history of art to sct figures into an accurate ambience or landscape. This too is the period of the beginnings of true portraiture which combined realism with psychological comment on character, expressed first for the legendary or recently dead **312**.

Many of the other arts considered in this book, outside the Classical tradition, were capable on occasion of producing what we must regard as wholly realistic renderings; in other words, work that depended on observation and copying of natural forms. These are unpredictable, however, and seem the achievement of individuals whose interests were not generally shared or who attracted no following. Sometimes, as in Egypt, the values of realism were indeed recognized but not exploited in finished works, for which more stylized forms were judged more effective; we can appreciate their success in this and can see how well they even survive enlargement to the colossal. After all, to show a god as a totally realistic human also shows him as mortal and vulnerable, which was not altogether the desired effect.

Elsewhere it is the occasional Indian statue or figurine, an American head, Assyrian animals, that show the artist looking and remembering carefully as well as thinking, although hardly to the point achieved in Greece with the

whole human figure. It is a very private activity, not easily achieved in crafts dictated by expectations, in which individual choice and invention are strictly subordinated to some established canon of style, deemed necessary and appropriate to a particular regime or religion. It was possible in Greece because it was a country in which individual invention could be indulged, flourish and prevail, and this due as much as anything to its politically chaotic social structure.

Without being evangelical, Classical art succeeded in proving acceptable to widely different races, themselves used to very different styles in the arts. How could this be so? In the Hellenistic Greek world it could acquire an almost baroque flavour. For Rome it was part of the Greek canon in literature and art which they so much admired, and which was by then inherent even in what might seem more native to them – the arts of Etruria and the Italic peoples. When Rome moved east, Greek art became Byzantine and turned to a degree of abstraction that was in time to contribute to the Gothic in Europe without totally disguising its Classical heritage. In Egypt resistance was, as we have seen, almost total until Christianity was dominant and the Classical art that was adopted (Coptic) was a somewhat trivialized version. Farther afield to the east, we saw that it may have been the realistic style that had a natural and immediate appeal which could be appreciated beside, and even eventually modify, the more familiar native manner, as in India. Even within the 4th century Greek sculptors, with their style and subjects, were recruited for works of a more dynastic character by eastern rulers 307, 309, 328.

The Classical could carry with it various other art conventions – true portraiture (but never much fancied outside the Classical world), the humanizing of a deity or hero in depiction whether monumental or in narrative (notably in Buddhist India), some narrative formulaic conventions, and much subsidiary patterning, geometric or floral. The media for dispersal of the new conventions are less readily judged, but Greece had promoted both the use and design of coinage, in which the new manner was well displayed 316, 317. There were other portable goods which were demonstrably influential – engraved gems and cameos among them; and in a shrinking world, observation of the arts of Mediterranean countries in

their homelands could have counted for something, as well as the practices of travelling artists.

Whatever the means and reasons, diluted versions of Classical realism became a commonplace through much of the Old World, even if perceptible only in minor detail (as in the Far East), without their birthplace, in 5th-century Greece, ever having achieved the same status as the major urban cultures, or being at all affected by the arts far to north and south. This was to happen only in periods later than those considered in this volume, to mutual benefit, though the Classical, even in Europe, could easily acquire an old-fashioned or even marionettish air. It is, after all, arguable that realistic art is unreal, in that images are devised by man to convey messages about the real world and man's place in it, not to counterfeit it, and that this is the true function of the artist. Perhaps this is why Classical art did not survive long in its purest, 5th-century form, and most of what we admire thereafter is translated for other purposes. Most Classical art was, however, at whatever scale and in whatever medium, an art of the people as much as an art of the bosses, and a far more public art than those most readily associated with other ancient cultures, which may be more palatial in their settings; while the styles of the imperial arts elsewhere tended to disappear along with the regimes that created them.

SOME GREEK DATES	
1050–900 BC	Protogeometric styles
900–700 BC	Geometric styles
750–600 BC	Orientalizing styles
600–475 BC	Archaic art (*kouroi, korai*)
508 BC	Democratic reforms in Athens
490, 480/79 BC	Persian invasions
480–450 BC	Supremacy of Athens
460–400 BC	High Classical art; Pheidias, Polyclitus sculptors
447, 438 BC	Parthenon started, consecrated
404/3 BC	Defeat of Athens by Sparta, restoration of democracy
353 BC	Mausoleum begun
340– BC	Macedonian control in Greece
336–323 BC	Reign of Alexander the Great
335– BC	Aristotle teaching in Athens

287 A Geometric grave-marking vase from a cemetery in Athens. The maeander, hallmark of the Geometric, has taken over much of the decoration from the curvilinear. Even the eastern-inspired rows of animals (two on the neck) are more like geometric patterns, while the symmetrical pattern at the vase centre only resolves into a scene of mourners at the bier of a dead woman on close inspection, with stylized stick-figures and no detail of body or dress. About 750 BC. Height 1.55m. Athens, National Museum 804.

288 Small bronze groups follow the conventions of geometric figure-drawing but can compose narrative groups, of which this is one of the more complex. A hunter-hero (wearing a helmet), with his dog, attacks a lion which has seized one of his flock. Under the base a swastika pattern is cut and could be used like a seal or stamp. Late 8th cent. BC. Height 10.25cm. Vandoeuvres, Ortiz Collection Cat. no. 83.

289 A Protogeometric vase from a cemetery in Athens. The older floral patterns have been geometricized by the use of a multiple brush used like a compass, for half- or whole circles. The patterns are carefully disposed to suit the shape of the vase, not in free field. 10th cent. BC. Height 41.5cm. Athens, Kerameikos Museum 544.

290 Contact with eastern arts leads to more detailed drawing of figures and freedom of narrative expression through movement, here on an Athenian vase. The flowers and animals are also gifts from the east, but the main subject is Greek mythology, Herakles rescuing his bride (seated big on the chariot) from a monster centaur Nessos (left). About 650 BC. Height 1.06m. New York, Metropolitan Museum of Art, Rogers Fund, 1911.

291 The head and neck of a bronze griffin, once decorating a bronze cauldron at Olympia. The monster derives from the east (Syria), as does its placing on a bowl (see [225]), but the creature has been Hellenized with a slender serpentine neck and long ears. Early 7th cent. BC. Height 36cm. Olympia Museum B 945.

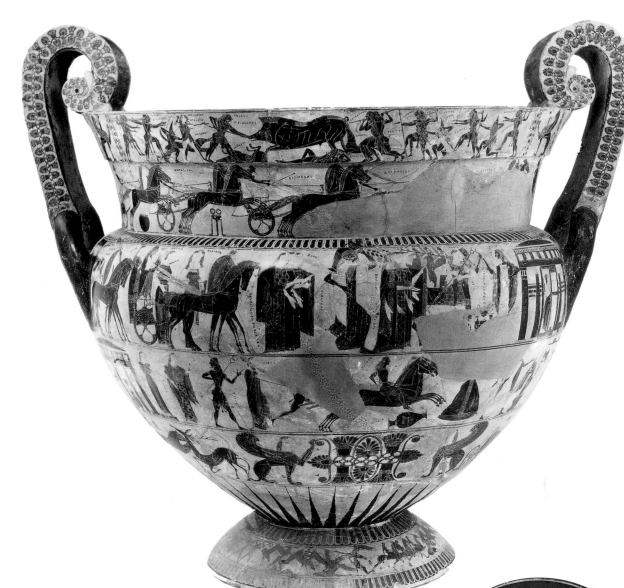

292 Silhouette figures picked out in red and white, with carefully incised detail (the 'black-figure' style) and sometimes identified by inscriptions, are the main 6th-century mode for Greek vase decoration and narrative. The 'François Vase', found in an Etruscan tomb at Chiusi in north Italy, a good market for such Athenian vases, carries ten different myth scenes, 270 human and animal figures and 121 inscriptions. About 560 BC. Height 66cm. Florence, Archaeological Museum 4209.

293 A touch of realistic composition in a Laconian (Spartan) cup showing the scene of Herakles with the dog of Hades, Kerberos. The magnificent monster-dog occupies all the circular field, whose edges cut off all but Herakles' leg and hands holding his club, and the back of Hermes leading them at the left. This is a novel example of a theme strictly obeying the available field, rather than adapting to it, and of the artist's desire to dwell on the most aesthetically compelling figure, the monster not the hero. About 540 BC. Width 19cm. London, Erskine Collection.

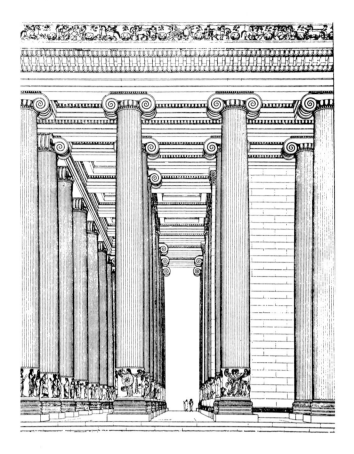

294 In early stone architecture the Greeks sought the truly monumental in the semi-oriental context of the east Aegean (Ionia), as in the Temple of Artemis at Ephesus, designed in the new Ionic orientalizing order. Details of mouldings are ornate, sculptural embellishment lavish, and we have to add colour for details. The reconstruction (by F. Krischen) shows the multiple ranks of columns (over 17m high) around the central hall, which housed the cult statue. Designed in about 550 BC.

295 The Doric order of architecture is simpler but dependent more on the application of regular proportion to all parts, from overall plan to details of ornament. This is best displayed in the Parthenon in Athens (designed about 450 BC), which is also one of the largest (70m long) and more ornate of the Greek Doric temples. It is seen in this model of the Acropolis, with the Doric entrance way (Propylaia) in the foreground, and at the left the Ionic Erechtheion temple. Notice how crowded the buildings are and therefore how misleading the isolated Parthenon seems on the Acropolis rock today. Toronto, Royal Ontario Museum.

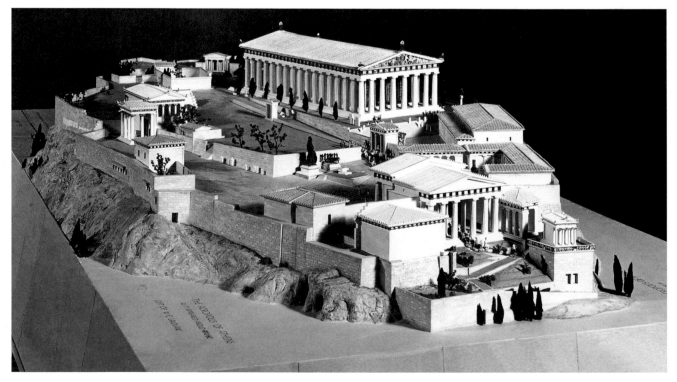

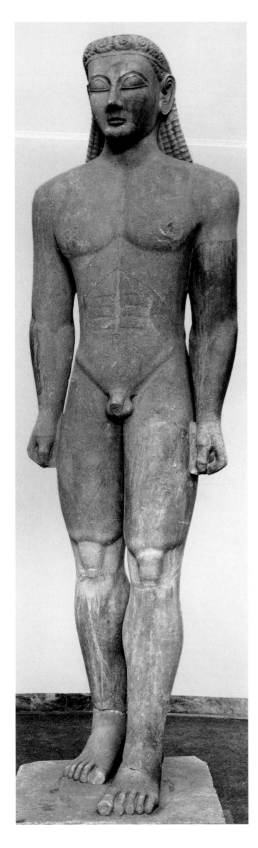

296 The naked kouros figure served as grave-marker or dedication in the late 7th to early 5th century BC. It bears a superficial resemblance to Egyptian figures, which at least inspired the use of such hard stone (marble, easily accessible in Greece). The foursquare figures are designed overall and in detail as patterns, gradually becoming more like life in time but never truly realistic. Most are around life-size or slightly larger but in the islands in east Greece there was short vogue for colossi, up to 10m high. This is one of the larger, earlier, from Sunium in Attica. About 590 BC. Height 3.05m. Athens, National Museum 2720.

297 The kore, like the kouros, relies on pattern, of dress not anatomy, and colour (missing), and is another archetypal Archaic figure, dependent on elaborated eastern forms. The base declares that this was dedicated by Nearchos to the goddess Athena, made by Antenor. About 530 BC. Height 2.55m. Athens, Acropolis Museum 681.

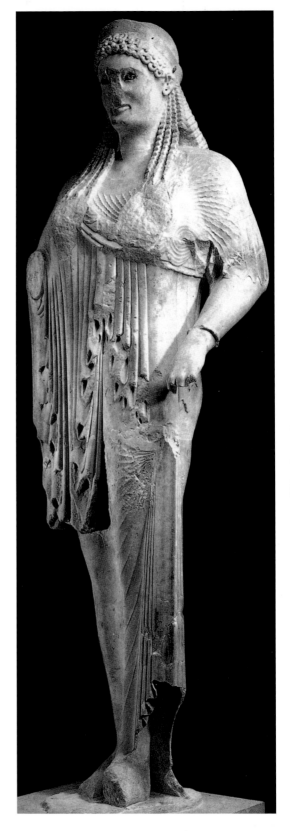

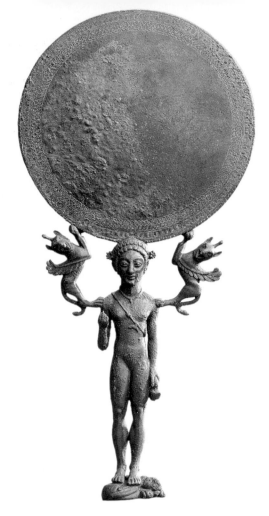

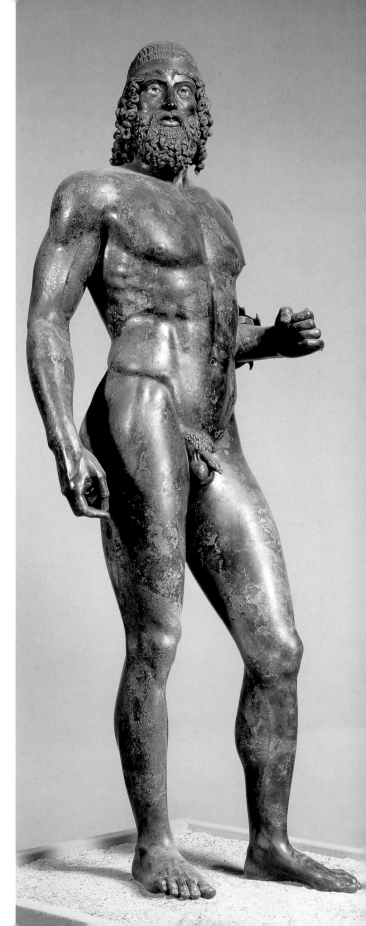

298 A bronze mirror handle in the form of a naked girl, an eastern motif delicately adapted here. At this date a naked woman in art more probably indicates a goddess than a mortal. She is flanked by griffins supporting the mirror disc (polished bronze) and she stands on a lion. This is Laconian, from an area too readily associated with austerity ('Spartan') but the source of much fine art in the Archaic period. About 525 BC. Height 35.5cm. New York, Metropolitan Museum of Art, Fletcher Fund, 1938.

299 With the 5th century major sculpture came to depend on modelling (for cast figures or for copying in marble) rather than carving, this permitting far greater realism of pose and detail. This bronze has some Archaic severity still but is in an accurately observed relaxed stance. The lips and nipples are in copper, the teeth silver. We need to think of it not as an isolated nude, as we see it in the museum, but holding a big round shield and spear or sword, and in a line of similar figures. It was made for a Greek sanctuary about 450 BC, but recovered, with a similar figure of an older warrior, from the sea off S Italy at Riace (en route as loot to some Roman setting). Height 2m. Reggio di Calabria, Archaeological Museum.

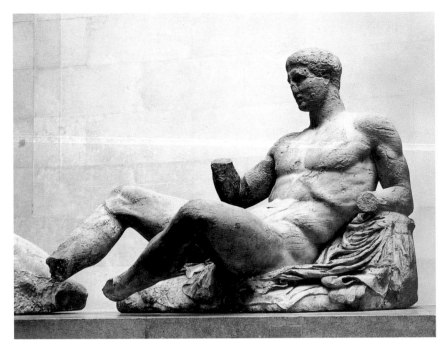

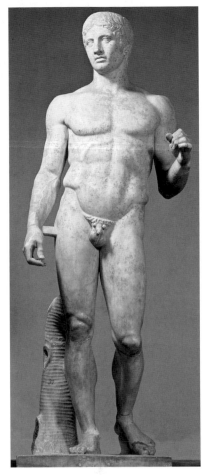

300 Total realism through modelling, in detail and pose, is achieved by the mid-5th century and typified in the statuary made for the pediments of the Parthenon. These works depend wholly on acute observation of the live model, only slightly idealized, but rendered at over life-size. This is the Dionysos from the east pediment. London, British Museum.

301 The element of idealization, and importance of proportion, in the new realism, were the subject of intellectual debate for leading artists. Polykleitos embodied his views in a book and a statue (the Kanon) of about 440 BC, of which we have copies of the Roman period. It expresses the basic contrapposto of limbs and torso. Height 2.12m. Naples, National Museum.

302 A new technique for vase painting had been devised in Athens in the late 6th century, 'red figure'. It allowed experiment with the new poses and details, since all lines were brushwork, but there was little or no colour or serious attempt at shading, and the figures are set against a glossy black ground. This composition, from a vase of about 480 BC by the Kleophrades Painter, is still Archaic but shows the potential of the technique, and is also a subtle narrative account of the Sack of Troy, dwelling on five episodes: salvation (at the left Aeneas saves his father and son; at the right two Athenian heroes rescue their grandma who had been a slave at Troy); feminine suffering and courage (rape of Cassandra, second from left; Andromeda fights back, second from right); utter sacrilege (centre, the killing of Priam on an altar by Achilles' son, brandishing the body of the old man's grandchild): a total visual statement of both a familiar myth and the horrors of war. Naples, National Museum 2422.

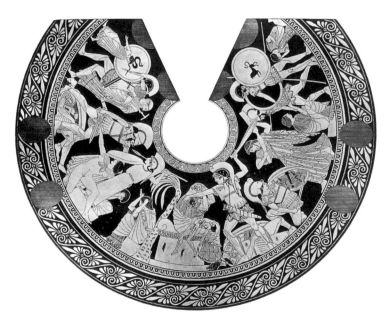

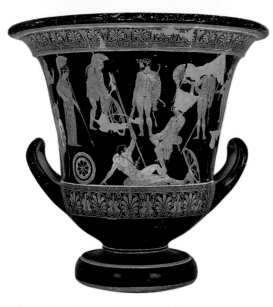

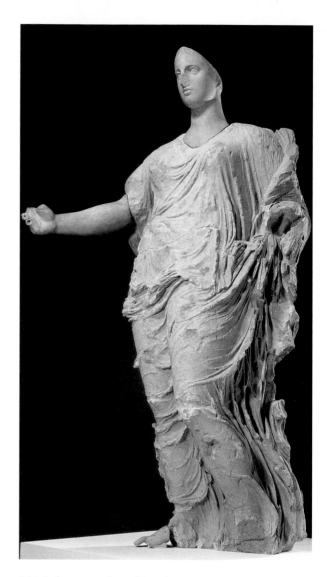

303 The works of vase painters who left no signatures can be recognized from close attention to instinctive details of drawing, like handwriting, a technique applied by Giovanni Morelli in the 19th century to early Italian and Flemish painting. This is the reverse of the name vase of the Niobid Painter. It shows a statuesque Herakles accompanied by Athena and heroes, all in poses suggestive of tiredness (Herakles has furrowed features and grits his teeth). There is good reason to think that this may copy the figures, and certainly the composition, of a painting in Athens that depicted the Battle of Marathon episodically – here the closing assembly of victorious supporting immortals. The scheme, with figures up and down the field and no diminution of size for distance, was a short-lived early Classical mode, associated with the name of Polygnotos, painter of walls and panels, and became popular for larger vases. About 460 BC. Height 54cm. Paris, Louvre Museum G 341.

304 Cult statue of a goddess from south Italy or Sicily, where the lack of fine white marble encouraged the use of limestone, with imported white marble reserved for the flesh parts – head, arms and feet, as here. The new realism embraces dress as well as anatomy. Late 5th cent. BC. Height 2.37m. Malibu, J. Paul Getty Museum 88.AA.76.

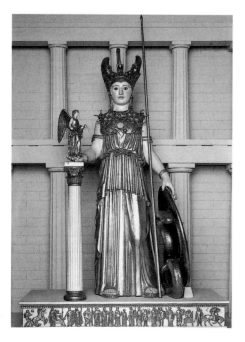

305 Athena Parthenos. Model reconstruction of the hybristic cult statue of gold and ivory, about 11.5m high, made by Pheidias for the Parthenon in the third quarter of the 5th cent. BC. It was long influential as a statement of divine authority, as frontally imposing as any eastern god, but in the new relaxed style of Greek idealized Classicism. From now on those Greek states or rulers with near-imperial aspirations would emulate this rather uncharacteristic display; closest is the colossal seated Zeus made also by Pheidias, for Olympia, a figure that was to model for Christian images of godhead. Model in Toronto, Royal Ontario Museum.

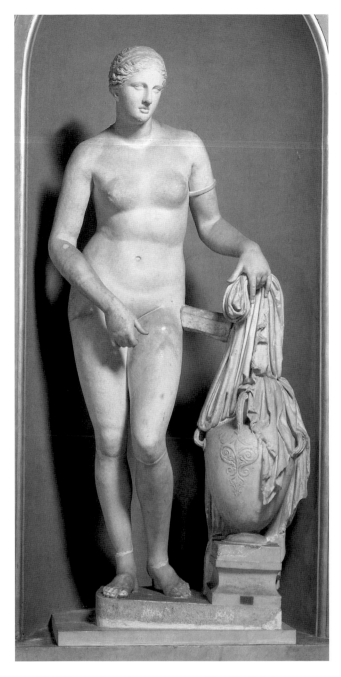

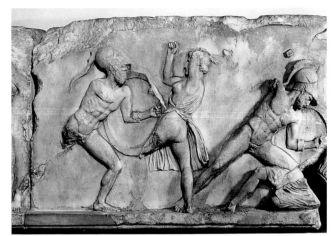

307 *Effective realistic depiction of violent action was probably best displayed in the mythological relief scenes on public monuments. This is from the original Mausoleum – tomb of King Mausolus of Caria at Halicarnassus – a very un-Greek and grandiose conception but designed and executed by Greek artists. We see part of a scene of Greeks fighting Amazons; notice the composition of figures falling away to the right, and the expert portrayal of the twisting, battling Amazon at the centre. Mid-4th cent. BC. Height 89cm. London, British Museum 1014.*

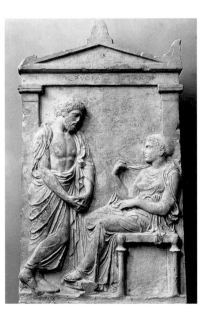

306 *Women in sculpture were hardly afforded the same realistic approach as were the male subjects, whose nudity was favoured because it was familiar in Greek life and offered the right visual opportunities for display of anatomical geometry. With the 4th century the female nude, as a marker of sensuality rather than simply fertility, is born, long to dominate western artists' attention. This is a copy of Praxiteles' influential study of Aphrodite for a sanctuary at Cnidus (where it was once indecently assaulted). The original, about 350 BC. Height 2.05m. Vatican Museums 812.*

308 *A Greek gravestone from Athens, husband and wife. The reliefs generally show the dead as in life but with intimations of loss or sorrow and sometimes confrontation of dead with live. These define the essentially humanist, even feminist, tone of middle-class Classical cemeteries. About 370 BC. Height 93cm. Athens, National Museum 3472.*

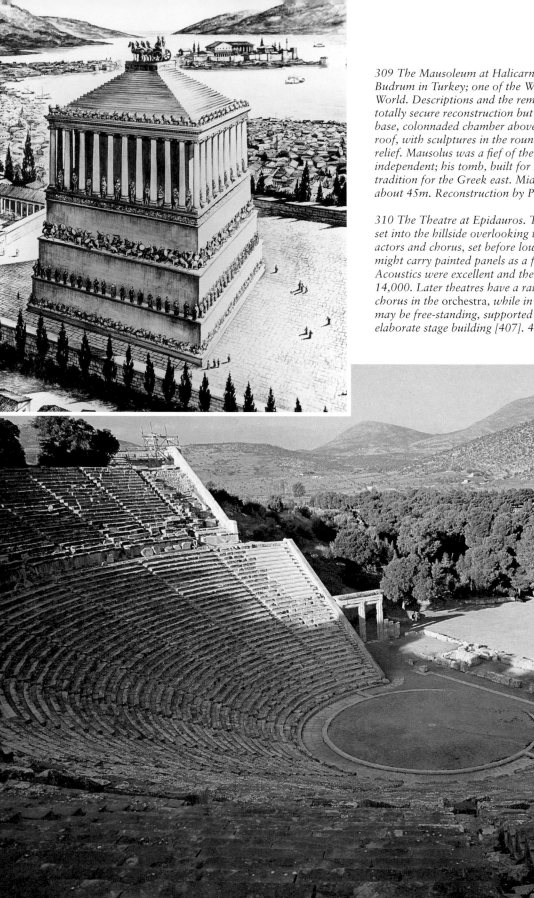

309 The Mausoleum at Halicarnassus (see [307]) – modern Budrum in Turkey; one of the Wonders of the Ancient World. Descriptions and the remains still do not allow a totally secure reconstruction but the essentials are a high base, colonnaded chamber above, and stepped pyramidal roof, with sculptures in the round and in high and low relief. Mausolus was a fief of the Persians though virtually independent; his tomb, built for him by his wife, is in a new tradition for the Greek east. Mid-4th cent. BC. Height about 45m. Reconstruction by Peter Jackson.

310 The Theatre at Epidauros. The arcs of marble seats are set into the hillside overlooking the orchestra, the area for actors and chorus, set before low stage buildings which might carry painted panels as a form of backdrop. Acoustics were excellent and the auditorium could seat 14,000. Later theatres have a raised stage, leaving the chorus in the orchestra, while in the Roman period theatres may be free-standing, supported on vaults, with high and elaborate stage building [407]. 4th cent. BC.

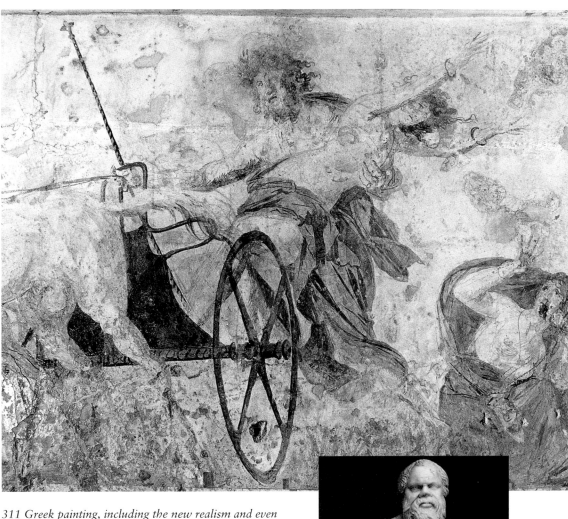

311 Greek painting, including the new realism and even trompe-l'oeil, kept pace with the new Classical sculpture but is barely preserved. Major wall compositions of the 5th century showed mythical events (the Sack of Troy, the Underworld) and the occasional real battle, heroized (Marathon), with the figures set up and down the field and no perspective. By the end of the century there were panel pictures depending on colour, shading and line, more 'modern' in appearance (much copied for walls at Pompeii). This is from the wall of a tomb at Vergina in Macedonia, showing Hades carrying off Persephone on his chariot. Mid-4th cent. BC.

312 In portraiture idealized realism militated against a true likeness in favour of a 'psychological study', so portraits down to the mid-4th century tend to be of the long or recently dead. This is a 2nd-century AD copy of a 4th-century BC portrait figure of the philosopher Socrates (died 399 BC), dwelling on his 'satyr-like' features. Greek portraits are generally of whole figures, not just heads or busts, but in the Roman period the heads only are more commonly copied. Height 27.5cm. London, British Museum.

313 'Style' and colour (so often missing) were more important in Greek art than material or scale. Only gold would normally never be covered, but silver and ivory could be gilt, and carved marble was regularly coloured. This is a carved intaglio gem of pale blue chalcedony, a hard quartz that had to be worked with a lathe and cutting wheel, which would have had no more embellishment than a probably precious-metal setting – a rare relic of Classical antiquity that remains precisely in the state in which it left its maker. It is only 33mm high yet no trace of the cutting technique is left, and the figure of a Victory with a trophy can be judged with no concessions made for its minute size, but as though it were major sculpture. Mid-4th cent. BC. London, British Museum, Walters 601.

314 Miniaturist gold work relying on form rather than added colour like enamel (a slightly later preoccupation) is exemplified in this earring pendant showing a Victory in her chariot. Mid-4th cent. BC. Height 5cm. Boston, Museum of Fine Arts 98.788.

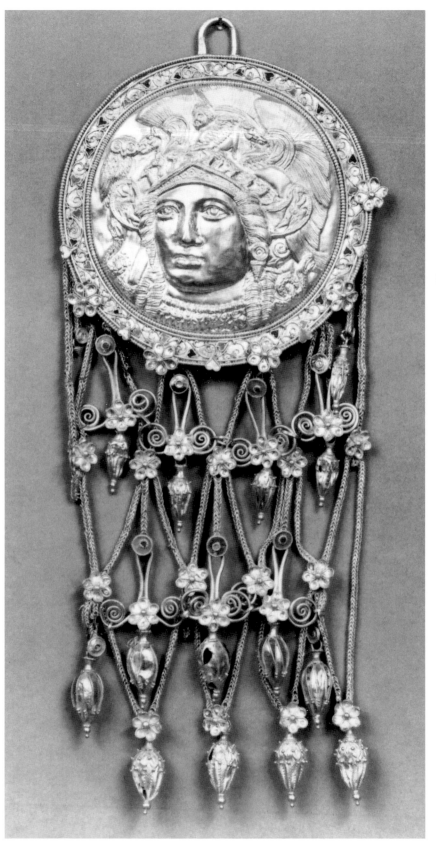

315 Luxury goods lacked nothing in use of precious materials yet often observed a certain restraint in detail and avoided excesses of coloration. This pendant, its disc showing the head of the Athena Parthenos [305], was made for a foreigner's tomb in the Crimea (Kul Oba). The export trade often encouraged some relaxation of standards of expensive simplicity. 4th cent. BC. Width of disc 7.2cm. St Petersburg, Hermitage Museum.

316 An Athenian silver coin. Athena was worshipped elsewhere but her head, kept as the device on Athens' coins into Roman times, declared for all the origin. So too did her owl, on the reverse, and Athenian 'owls' were copied in mints from western Europe to Arabia to Central Asia. About 440–430 BC. Diameter 24mm.

317 Other states whose ambitions were less global than Athens' could afford to exercise a broader choice in coin types, and employed die-cutters of a quality equal to the best gem-cutters. This is the reverse of a silver coin of Naxos in Sicily, about 460 BC, with a crouching satyr. Diameter 27mm.

D. PERSIA TO ROME

THE LEVANT AND WEST MAPS 3, 6

In the Levant, the coastal lands from south Turkey to Palestine, the common environmental factor is not only one which could promote profitable farming or empire-building, but it is also a matter of the geography of easy communication, by land to north, east and south, by sea to the west.

This promoted trade and enabled the rapid spread and absorption of both wealth and experience, as well as producing a significant intermingling of races. As a result, although there are few places and periods where a wholly distinctive and locally developed art can be discerned, much will prove to be an amalgam which is largely the product of observation of, or of intrusion by, neighbours in Anatolia, Mesopotamia and Egypt. But colonization in and trade with the other end of the Mediterranean also resulted in the development of a distinctive tradition in the arts, however bastard its origins; so this has to be a matter of the Levant *and* the West.

The lands from Syria south to the borders of Egypt were not in antiquity the home to any major empire or the cradle of any locally very distinctive style in the arts, yet they are crucial to our understanding of arts east and west. They are one of the early homes of urban development and agriculture (e.g., at Jericho), and being on the major route between Mesopotamia and Egypt they shared and were profoundly influenced by the aspirations of both these major centres of early civilization, who from time to time marched and fought through their lands. We associate the coastal strip with Canaanites and Phoenicians. Inland and beyond the mountains of Lebanon is that extension of Syria which accompanies the upper reaches of the River Orontes, past Damascus, and leads more directly from Mesopotamia and the eastern desert to the lands of the kingdoms of Israel and Judah, thence to Palestine and Egypt.

The Bronze Age arts of the area had been derivative in various ways from the example set by others, and were generally less than monumental 318–21. This was the land of the Canaanites, the home of Semitic peoples whose contributions to world history have proved more spiritual than material, and whose arts have often been aniconic, dwelling rather on depiction of the animal and vegetable world, or abstract. There was a major coastal city in the north at Ugarit (Ras Shamra), an important source for the Late Bronze Age, and farther south, Byblos, Sidon and Tyre.

The inhabitants of the coastal lands eventually looked west, to the Mediterranean, often even more securely and actively than they were able to look inland – except at the north, along the Orontes valley. At the end of the Bronze Age the area was a melting pot for western folk on the move – at the south Philistines (perhaps displaced Greeks) and other Sea Peoples whose attacks on Egypt we have remarked 282, 283. Later, the Phoenicians, from their major city ports, were intermediaries and porters for the Assyrians. In the Iron Age the Temple of Solomon in Jerusalem (10th century) was no doubt a major architectural work, but descriptions suggest that it was impressive as much for its applied details in metal as for its sheer size or innovative planning. Phoenicians of the coast were said to have played a major part in its construction and it seems to have been less a matter of massively handled masonry than of high competence with wood and stone, such as we see elsewhere in Israel

and Judah, but hardly on a level to compete with the architectures of Assyria or Egypt.

Other Phoenician arts owed as much or more to Egypt as to the north, partly a legacy of the Bronze Age. Egyptian forms and figures are lightly adapted and, in gold, silver and ivory, a strong Egyptianizing style evolves which affects Cyprus and the west, including Etruria **322, 324–25, 386–87**. Its influence in Greece was minimal beside that of Syria, and a modern tendency to attribute to the Phoenicians as much influence in the arts of the Mediteranean as in commerce is not supported by the evidence. In the 5th/4th centuries BC their most pervasive products were scarab seals, cut in a variety of styles – Levantine, Egyptian, Greek **334** – and glass.

For themselves the Phoenicians looked perforce as much to the seas as did the Greeks. Greeks and Phoenicians were in fact very similar peoples, and the Phoenicians might almost be regarded as honorary Europeans in the light of their Mediterranean history – or the Greeks as honorary easterners. From Phoenicia, via Syria, Europe learned its alphabets. In the north the Greeks had opened up routes through Syria from which they were to profit more than the easterners. The Phoenicians had a negligible role in this but, like the Greeks, they looked farther afield for materials and trade goods, for themselves or their masters. A result was that in the 8th century BC both Greeks and Phoenicians were sailing west, the Greeks to colonize new lands and create a home-from-home, at first in south Italy and Sicily, later in isolated ports in north-east Spain and on the coast of France, the Phoenicians to set up trading posts in north Africa (Tunisia), Sardinia and Spain. But the Greeks sought materials too (trade commonly precedes the flag), while the Phoenicians found it worth their while to settle down on the north African coast, at Carthage. There they developed a culture which was strangely eclectic of the east and Greece, but in time militarily strong enough to match the great powers of the western Mediterranean – Greeks, Etruscans, even Romans. Carthage was one of the great cities of antiquity, best known to us now for its cemeteries not its buildings, for minor antiquities not major arts, and for presenting an amalgam of eastern with Classical styles, not so much an interface as a child of a mixed marriage. In the Phoenician homeland, now dominated by Persia, the Classical, and its artists, could be more whole-heartedly welcomed, and with spectacular results such as the 'Alexander Sarcophagus' **328**.

Carthaginian, or generally 'Punic' (west Phoenician), arts readily reveal their diverse sources, and have to be judged largely from clay artefacts and jewellery **330, 331**, while in Spain they came to help inform a local art of considerable individuality. Punic art, and the colonial Greek art of Sicily and south Italy, were western manifestations of major arts created at the eastern end of the inland sea, and were both to affect the development of arts in Italy (Etruria and Rome), as well as through the interface with Spain **332, 333** and Europe. In the Greek colonies the arts can be judged on the same terms as those of the homeland, with minor differences due to distance and materials (no white marble **304**); they became as rich as any in Greece itself.

Cyprus should perhaps be seen to be part of this story after about 1000 BC. It was visited from all points of the compass and well placed for access and trade to all shores, yet its arts still retained a considerable individuality **326**. In the Iron Age Cyprus reflected much that was native to Greece, Syria and Phoenicia, whose peoples had settled there **324, 325**. The island society was in many ways more akin to that of Mycenaean Greece, with several kingdoms, than to anything more Levantine, eventually becoming wholly Greek in aspect in the 5th/4th centuries BC. Farther afield, the Levant was the source for arts that were to flourish as far away as South Arabia **335** – deserts were no more a bar to migrant arts than seas.

In the Mediterranean world we have broken away for a while from the record for the arts found in the securely land-based empires to east and south, and over the years several different focuses of activity develop with barely differentiated styles. In time burgeoning Greek influence proves all-pervasive and soon, with the growth of Rome, all will change, in purpose if not in appearance.

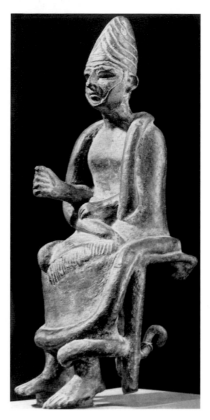

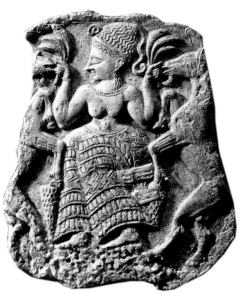

318 Ivory head from Ugarit (Ras Shamra). 13th cent. BC. Height 16cm. Damascus Museum.

319 Bronze god from Qatna (near the upper Orontes), in a style deriving from Mesopotamia but with a breadth of treatment of face and figure which characterizes much Levantine production in the later Bronze and Iron Ages. About 1600 BC. Height 17cm. Paris, Louvre Museum.

320 Ivory lid of a box from Ugarit, showing a bare-breasted goddess holding corn, with goats. This is almost certainly Mycenaean Greek work, or a copy of it, and further evidence for an early display of Greek interest in the Levantine coast. The style (and dress) is imitated in other works. About 1200 BC. Height 13.7cm. Paris, Louvre Museum.

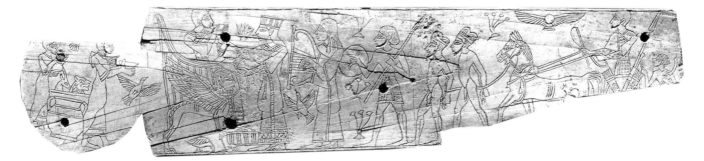

321 Incised ivory plaque from Megiddo. A prince returns in his chariot with prisoners; at the left a prince (the same?) on a sphinx throne is attended with food, drink and music. 12th cent. BC. Length 26cm. Jerusalem, Rockefeller Museum IAA 38.780.

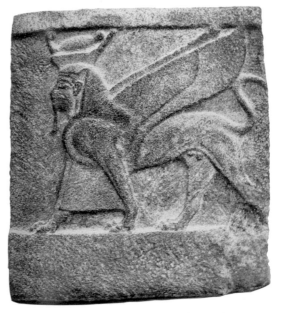

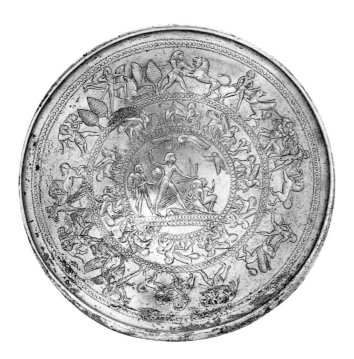

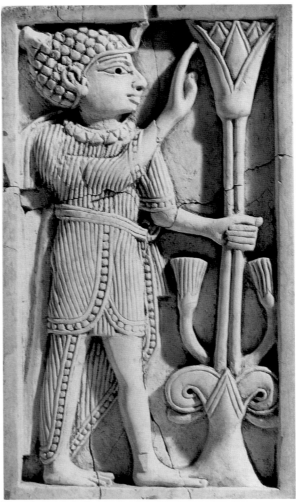

322 *The interior of a Phoenician gilt silver bowl, from Idalion, Cyprus. The centre group and sphinxes around are quite Egyptian but the outer frieze has heroic encounters with lions and griffins, variously inspired. These Phoenician bowls, with rather simpler bronze ones of Syrian inspiration, were widely distributed in the Mediterranean, notably to Cyprus and Etruria. 7th cent. BC. Diameter 18.5cm. Paris, Louvre Museum AO 20134.*

323 *Basalt relief of a sphinx, from Damascus. The type is wholly Egyptian, with double crown, chin beard and apron, but winged, as are most Levantine sphinxes. About 800 BC. Height 80cm. Damascus Museum.*

324 *Phoenician ivory plaque from Nimrud, the Assyrian site which has yielded many ivories from furniture, including much of Phoenician origin. The figure's dress is Levantine, headdress Egyptian (with cobra-uraeus forepiece), the 'sacred tree' a common feature of Levantine art. About 800 BC. London, British Museum ANE 118147.*

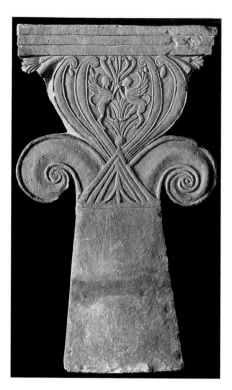

325 Pillar capital from Golgoi, Cyprus. The volutes form part of the traditional eastern 'sacred tree' converted to architectural decoration, and here attended by two sphinxes rendered in the Greek style. Early 5th cent. BC. Height 1.38m. New York, Metropolitan Museum of Art, Cesnola Collection.

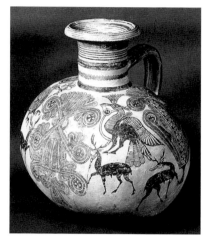

326 Archaic Cyprus is the home of a distinct group of polychrome vases (figures mainly in red and black) which defy close comparison with any made to the west or east, both for their sense of colour and the extravagant style of the figure drawing; a decidedly popular rather than palatial art, spanning the 7th cent. BC and beyond. This example offers a variety of wild life and elaborated versions of the 'tree of life'. From Kition. Height 30cm. Oxford, Ashmolean Museum 1885.366.

327 One of the earliest known stone sarcophagi with relief decoration was used for King Ahiram of Byblos in the 10th cent. BC. The king on his sphinx throne receives offerings. Length 2.16m. Beirut, National Museum.

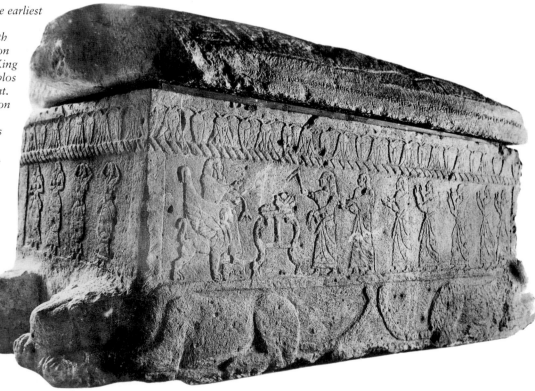

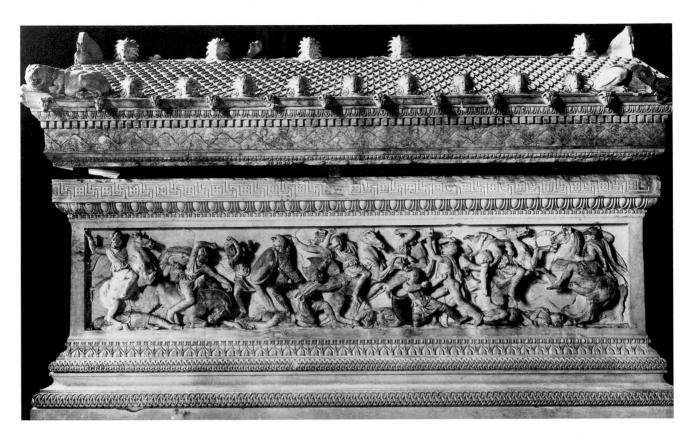

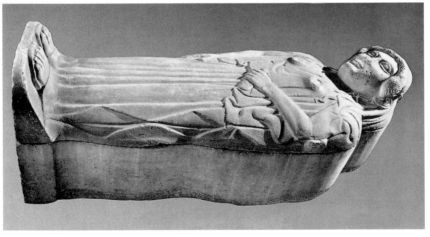

328 The notion of relief-decorated stone sarcophagi was taken up by Greeks in the later 6th cent. BC and had a long history, into Roman times. Several fine marble specimens were made by Greeks for the Phoenician kings of Sidon in the 5th and 4th centuries. The latest, the 'Alexander Sarcophagus' (since the Macedonian king is shown hunting on one of its sides) was for King Abdalonymos. The style is pure Greek and of as high quality as any of the homeland. Late 4th cent. BC. Height 1.95m. Istanbul Museum.

329 The alternative Phoenician type of stone sarcophagus followed the form of the human body, with elaborately carved head, a scheme copied from Egypt. In the Classical period these are carved in marble and provided with heads in the Greek style, probably by Greeks, and in this case also given Greek dress. The type travels thence also to the Punic west, such as the example shown, from Pizzo Canita in Sicily. Length 2.3m. Palermo Museum.

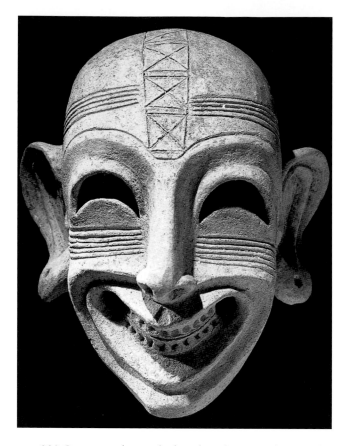

330 *Grotesque clay masks from burial sites (tophets) in the Punic world remind us how the arts are obliged to deviate in the interests of virtually magical expression into modes more familiar in many less sophisticated societies in all ages. From Carthage. Height 15cm. Tunis, Bardo Museum.*

332 *Alabaster statuette of a Punic goddess (Astarte) on a sphinx throne, from Galera, near Granada in Spain. 6th cent. BC. Height 17.8cm. Madrid, Archaeological Museum.*

331 *A Punic/Phoenician gold bracelet, decorated in repoussé style with granulation for all details, from Tharros in Sardinia, one of the earliest Phoenician settlements in the west. It has typical Phoenician 'cup-palmettes' and the Egyptian hawk-headed scarab beetle, here with four wings. Compare the Phoenician styles also introduced to Etruria at this date [387]. 7th/6th cent. BC. Length 12.8cm. Cagliari, Archaeological Museum.*

333 A hieratic figure in limestone from Cerros de los Santos in Spain, an amalgam of Punic and archaizing Greek motifs, serving Iberian religion. 4th cent. BC. Madrid, Archaeological Museum.

334 Green jasper scarabs are characteristic of the Phoenician world in the Persian period, and many have been found also in the Punic west. The range of subjects reflects the varied influences at work in the Mediterranean – Egyptian, Syro-Phoenician, Greek. These examples depict (a) an Egyptian subject – Isis with Horus; (b) a Levantine – a bull-headed deity before an incense-burner; and (c) a Greek – a frontal horseman with a warrior and dog. The scarabs mark the virtual end of seal-engraving in anything other than a Classical style, or something derived from it, in the east. 5th cent. BC. Lengths about 15mm. (a) Ibiza Museum 3811; (b) London, British Museum, Walters 356; (c) Madrid, Archaeological Museum 38249.

335 South Arabia may seem distant but it was linked commercially with the Levant, and was the legendary home of the Queen of Sheba. Early art from the Yemen shows the northern connections quite clearly but the most characteristic products are rather hieratic statuettes and reliefs of alabaster of the 6th century BC to the 1st AD. The piece shown is the figure of a 1st-cent. BC king. Thereafter there is ambitious classicizing sculpture in stone and bronze, reflecting the role of the area on the Roman trade routes to and from India, beside a continuing 'native' style. Height 88cm. Aden, National Museum NAM 612.

THE PERSIAN EMPIRE MAP 3

The Achaemenid Persian empire (named from its alleged founder) flourished from the mid-6th century BC until its overthrow by Alexander the Great in the later 4th. Persia had for long been the meeting point of east and west, and home to various distinctive but regional regimes and arts, as in Elam, but this was the first time it appeared as the home of what bade to be a world power. Its arts proved by necessity to be an amalgam of the experiences of its empire, which ran from the Aegean to India, but they also acquired a potent identity of their own.

The land itself, coterminous with modern Iran, is unpromising, much of it covered by mountains or desert, though rich in mineral resources. The terrain of mountain valleys may have left its cities less exposed to easy attack than were the cities of Mesopotamia and the eastern plains. It lay athwart all the major southerly land routes between Asia and Europe.

Achaemenid Persian arts are among the most unusual of the Old World. They are no less individually distinctive than the Egyptian, yet they are almost wholly derivative from the arts of others – their subject peoples. Moreover, the prime imperial style for the major arts seems to have been determined by the beginning of the 5th century BC, and remained virtually unchanged thereafter. Indeed, it seems almost the product of an inspired committee, if not of the Great King himself, Darius I, challenged to create an art fit for a world empire, based in a country where there was no strong and immediately precedent tradition on which to build. In barely fifty years the so-called Great Kings found themselves rulers of all lands from eastern Europe (on the Black Sea and the north Aegean), to the Caucasus, Central Asia and north-west India, to Egypt. Before them had fallen the empires of the Medes, Lydians and Babylonians, all Egypt, and the native eastern kingdoms from north of the Oxus to beyond the Indus. It was the arts of the subject peoples to the west that composed Persian imperial art.

A prime requirement for the new empire was a style of palatial, court architecture for a country with no strong tradition in elaborate stone-working. The first expansion of empire was under Cyrus in the mid-6th century BC, first north-west against the Medes who seem to have had some pretensions to imperial status; then farther west, to Lydia and the Aegean Sea, where King Croesus had his palaces while Greeks were already making colossal marble temples decorated in their new Ionic style (forerunners of 294). These all made an impression, and the Persian kings seem to have made a habit of collecting foreign advisers and artists from an early date. Persian palaces were to be mainly composed of large multi-columned halls, like massive petrified tents, dependent on ambitious work in stone and wood, as well as brick 336. For the capitals and bases of their columns 26 decorative mouldings were devised which were inspired by a mixture of Greek, Mesopotamian, Anatolian and Egyptian motifs, and with no little enlargement of what was essentially furniture. Egypt in particular was drawn upon for the design of doors and windows 338 and the use of 'palm capitals'. The result is an 'order', rather more variegated than the Greek, a mite fussy, but impressive, and it remained unchanged throughout the period of empire. We can judge this since each king built a new palace, sometimes more than one, at the major sites of Pasargadae, Susa and Persepolis, and we have a range of royal, decorated rock-cut tomb façades, unvarying in their scheme, for over more than a hundred years 339. But yet again we have to add in our imaginations the missing colour and gilding.

Architectural sculpture copied the Mesopotamian, with the human-headed beasts at gateways 337, but

there was no overall relief decoration on palace walls as in Assyria, and as yet little evidence for interior painted decoration. Instead there are low-relief friezes, heavily processional in their composition of troops or tribute-bearers at the great new site of Persepolis, with some tableaux of the king enthroned, a king/hero fighting a monster, or a lion-and-bull fight **340–42**. The visual effect on subject races bringing tribute from Lydia, Scythia, Babylon, India and Egypt was calculated to leave them in no doubt about who ruled the world. Many of the sculptural forms of the reliefs were also Mesopotamian but, from the late 6th century on, the archaic Greek method of patterning dress in splaying folds with zigzag ends was adopted, and retained over years when Greek sculpture was rapidly evolving the Classical style, to which the sculptors in Persia remained supremely indifferent. Major sculpture in the round is exceptional, and declares its varied sources of inspiration quite clearly **344**. Inscriptions naming the artisans involved (at Susa), as well as the modern scholar's assessment of style, go to demonstrate the diverse origins of Persian imperial art and the artisans recruited to create it, as well as its unshaken authority for nearly two centuries.

Apart from some early above-ground royal tombs with western origins, the royal tombs were concealed behind massive rock-cut façades which portrayed in relief the king and subjects in the usual style, as on the palaces, and architecture which shows that it was not just the columns that owed much to Greek inspiration, but also the upperworks **339**. One of the greatest rock-cut monuments of antiquity is Persian **49**.

One result of this focusing of interest on rulers and ruled is that we lack much by way of the narrative art, which has proved so informative elsewhere, rather than statements of power. Persian religion, with its simple fire temples and versions of Zoroastrianism, seems not to have lent itself to an involved mythology inviting depiction of either real or imagined ancestors or any notable pantheon of gods, but there is good scope for displaying the activity of the Great King, both as ruler and as intermediary with the divine **341**. This is well shown in seal-engraving, the last major demonstration of the art of the cylinder seal in the east **345**. Imperial Persian administration over such a vast area depended on detailed organization, new roads, and methods of accounting in which the sealing of documents played an important part. Aramaic had become the *lingua franca* of empire from east to west, and its script was to be the inspiration of many new scripts for local languages, as far as India. Persian governors (the satraps) seem not to have been oppressive, provided taxes were paid.

The major imperial arts are best displayed in Persia itself. They were not imposed on subject peoples, whose own traditions in the arts were far older, but they merged with them and in places encouraged the development of local skills in the interests of demonstrating and recalling ultimate Persian authority. This is clearest with the decorative metalwork of Anatolia, much of which found its way into Europe **348, 349**, to be influential there. Of other crafts there is inlaid jewellery, including cloison enamelling, learnt from Egypt, diffused throughout and beyond the confines of the great empire **350, 351**, even original 'Persian carpets' **352**. Most of the figure work declares its origins in Mesopotamian or Egyptian art, but in Anatolia there was also a distinguished series of engraved gems which combined eastern techniques with Greek subjects and attitudes **346**.

The monumental Persian arts barely survived Alexander's conquest, though they remained influential for a while beyond it, as in India. The Persian arts of the rest of the empire played some role in the development of the arts of successors, even Greek, but especially the Parthian and later Sasanian, and even *their* successors. They are an unusual demonstration of how a new regime sought, by a skilful blend of the arts of its subjects, to express its sovereignty in the same way as did so many other ancient cultures – by monumental architecture at the capital cities, by a figure art that demonstrated the power of the king and the helplessness of his vassals, by a diffusion of the new arts through an empire that had more to teach them in these matters, that they it. It was no more dictatorial or cruel than other empires; in many ways more tolerant, and it was admired for this by many Greeks. Oddly, women are almost invisible in Persian art, and the common people knew their place, as soldiers and servants.

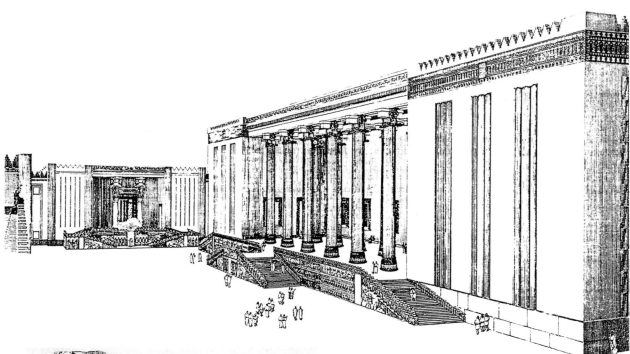

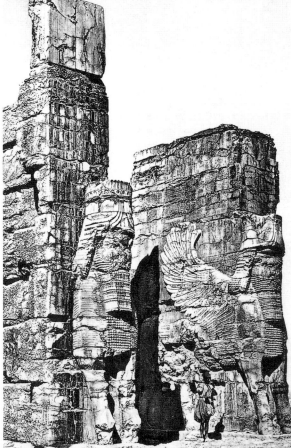

336 A reconstruction (by F. Krefter) of part of Persepolis, a site of administrative and palace buildings built on a platform over half a kilometre wide, mainly in the early 5th century. Characteristic building plans are of hypostyle halls with stairways and lower walls decorated with relief sculpture. The outer wall bases and stairs are of colossal masonry. The buildings shown were up to 20m high. On earlier sites, as at Pasargadae, there are traces of masonry techniques devised and used by Greeks in Anatolia.

337 Major gateways at Persepolis are built on the Mesopotamian plan, with monster guardians (compare [74, 186]). Early 5th cent. BC.

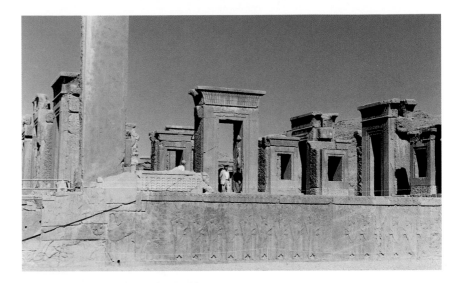

338 The doors and windows of Darius' palace at Persepolis are of Egyptian form, but admitting the Greek bead-and-reel moulding. There is a relief parade of soldiers below the balustrade, with a lion-and-bull group, of typical Mesopotamian type, one which is repeated throughout the site in just this form and style.

339 Royal tomb façades, rock-cut, all present reliefs showing the king facing a fire altar, the god Ahuramazda hovering overhead, on a dais supported by subject peoples, ethnically dressed, over a colonnade like that of a palace and an Egyptian-framed door. The upperworks over the columns copy the Greek Ionic style. The scheme is identical for each king. The idea of such major rock-cut monuments derived from earlier, Elamite practice in the area.

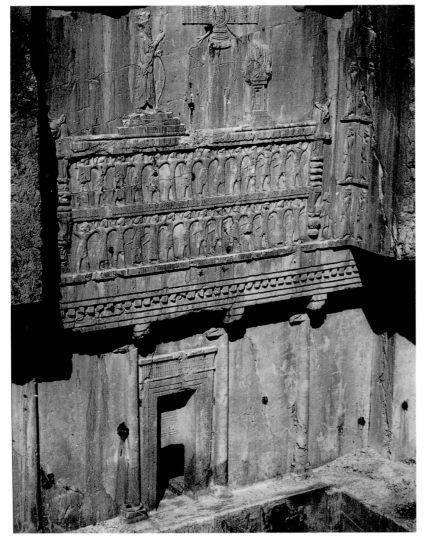

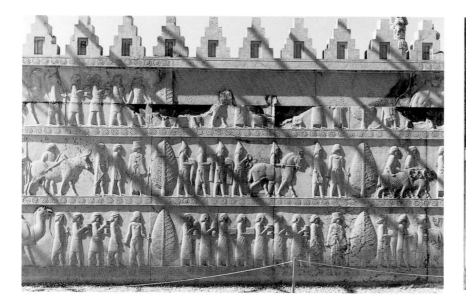

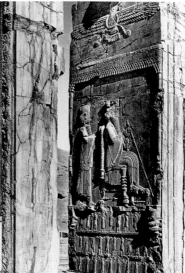

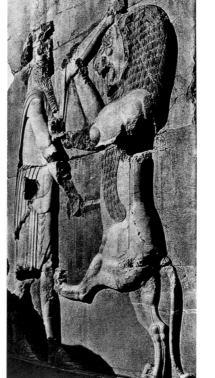

340 Relief showing subject peoples in native dress bearing offerings, from beside the stairway to the Apadana Hall at Persepolis. Mid-5th cent. BC.

341 The King enthroned beneath a canopy, the god Ahuramazda hovering in a winged disc above. The throne is supported by subject peoples. From a doorway at Persepolis.

342 A Persian hero/king confronts a lion. Leo persica was smaller than the African, and conspicuous for its belly hair (see [189]). Very few now survive, in north India, but they could be hunted as well on foot as on horseback. This relief is in a doorway at Persepolis. 5th cent. BC.

343 Decoration in glazed brick had been practised in Babylon [195], and in Persia it may owe something too to an earlier, Elamite practice, and to Egypt. At Susa the walls were decorated with warrior guardsmen such as this, made of moulded bricks, modelled like the stone reliefs, but covered with brightly coloured glazes and patterns that, oddly, ignore the modelling of body and folds of dress (much the same happened in Archaic Greek drawing and relief sculpture). About 400 BC. Height about 1.8m. Berlin, Staatliche Museen.

344 This statue of King Darius in Egyptian stone was made
in Egypt but taken to Susa where it was found. A very rare
example of the familiar Persian sculptural relief style
expressed in three dimensions, though in a very block-like
way with no real concession to body forms. It has the
traditional Egyptian back-pillar and other fragments
suggest that the head looked very Babylonian. The figures
on the base are in Egyptian style, showing subject peoples
kneeling on cartouches (at the side) and the symbolic
binding together of Upper and Lower Egypt at the front.
There are hieroglyphic and trilingual cuneiform inscriptions
on the dress. About 500 BC. Original height about 2.7m.
Teheran Museum.

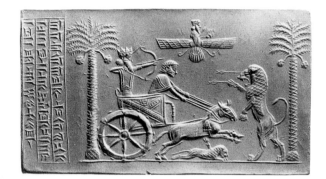

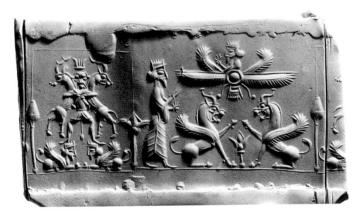

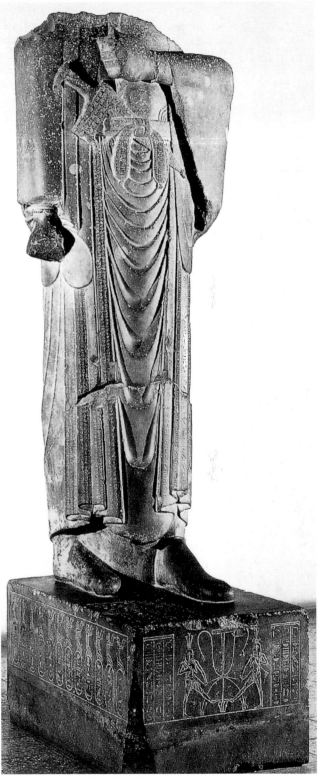

345 Cylinder seal rollings. (a) Agate, showing King Darius
hunting lion from a chariot, from Egypt. Height 33mm.
London, British Museum ANE 89132. (b) Blue chalcedony,
the king salutes Ahuramazda, hovering over winged horned
lions, and to the left Bes (a demon borrowed from Egypt,
appearing often in Persian art) holds stags over sphinxes.
Height 36mm. London, British Museum ANE 89352.

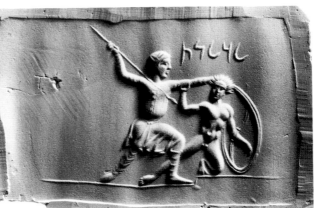

346 Anatolia seems the home of studios of 'Greco-Persian' seals which treat Persian subjects in a Greco-oriental manner but in a style which avoids Greek realism and exploits patterns suggested by technique. Most are of the later 5th/4th cent. BC. (a) Impression of a scaraboid of chalcedony showing horsemen hunting lion and boar. Width 30mm. Cambridge, Fitzwilliam Museum E.2.1864. (b) Rolling of a chalcedony cylinder seal in a more Greek style showing a Persian killing a Greek. Height 24mm. Paris, Bibliothèque Nationale, Seyrig 1972.1343.5. (c) A blue chalcedony scaraboid with a fine animal study of a hyena. Height 25mm. Malibu, J. Paul Getty Museum AN.76.92.

347 The head of a Persian in Greek style on a silver coin minted for a Persian satrap in Anatolia. About 400 BC.

348 Gilt-silver amphora from Bulgaria (Duvanli),
with monsters as handle and spout, and Hellenized
versions of floral friezes; probably made in Anatolia.
The monster handles are a feature of Achaemenid
vessels. 4th cent. BC. Height 27cm. Sofia Museum.

349 Gilt silver dish from Bulgaria (Rogozen), probably
made in Anatolia. The form is Persian but the florals and
the sleek griffins whose tails join the palmettes are Greek.
4th cent. BC. Width 18.8cm. Sofia Museum 22397.

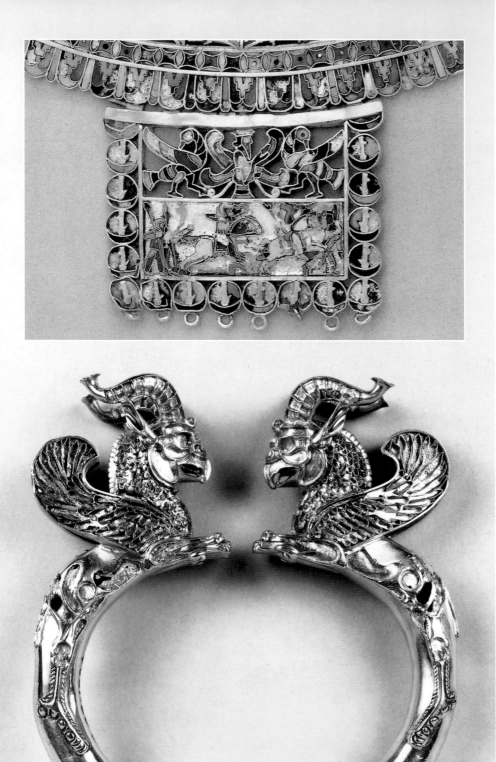

350 Pectoral of precious metals with a colourful enamel-cloison gold openwork plaque showing winged Ahuramazda flanked by birds, over a scene of Persians pursuing Scythians; surrounded by roundels with the god in discs. There is a Greek weight inscription on the back. 4th cent. BC. Shigaraki, Miho Museum.

351 Gold bracelet with cloisons for enamel or precious stones, from the Oxus Treasure in Central Asia, a hoard largely composed of Persian jewellery and other objects. The winged, horned griffins are popular Persian monsters of the period. 5th/4th cent. BC. Width 11.5cm. London, British Museum ANE 124071.

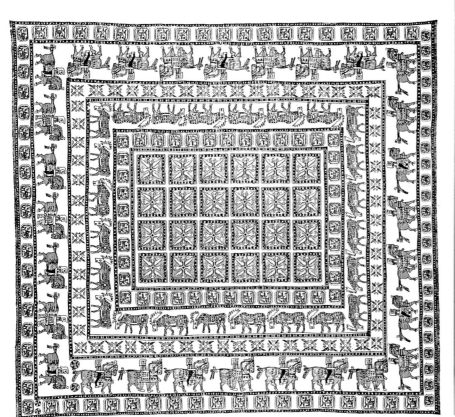

352 A carpet from one of the frozen tombs of the Altai (Central Asia) of Persian manufacture or closely copying a Persian carpet, with purely Persian Achaemenid patterning. Such carpets also reached Greece, and their patterns were painted on tomb walls in Macedonia beside purely Classical figures. 4th cent. BC? Width 1.9m. St Petersburg, Hermitage Museum.

353 Also from the Oxus Treasure, a naked figure in silver, wearing Persian headdress (gilt). The nudity but not the stiff posture seem Greek, yet this is presumably meant for a Persian dignitary or hero. 4th cent. BC. Height 29.2cm. London, British Museum ANE 123905.

The victories of Alexander the Great, followed by his death in 323 BC, left the Achaemenid Persian empire in the hands of Alexander's Macedonian generals. They quickly divided the spoils, in the absence of any successor with Alexander's vision of world empire and ability to fashion it. The Antigonids sought to control Greece itself from Macedonia; the Ptolemies ruled Egypt; the Seleucids ruled from Anatolia and Syria to the east, through Persia and beyond, and came closest to being the heirs to the Persian empire, until the new state of Parthia pushed them back west of the Euphrates in the mid-3rd century BC, leaving behind only the Greek kingdom of Bactria in Central Asia, which we have already visited; in western Anatolia there was an important enclave of Attalids who had to face invasion from the west by the Gauls, and to its east was the kingdom of Pontus.

The world of Greek art became geographically more un-Greek in its distribution and patronage, and increasingly centred on production for cities with imperial ambitions, rather than the smaller city-states – in Macedonia itself, and notably in Athens, Pergamum, Delos, Rhodes, Antioch, Alexandria – while an overall access of wealth and air of cosmopolitanism enriched artistic production for a wider range of the population. The Greek cities of the west, in Sicily and south Italy, played their part, and there were rich and powerful princes there, even if their territories were smaller. Their arts and proximity meant that they were to play a major role in the introduction of Hellenistic Greek arts farther north in the Italian peninsula, to Rome. Macedonia itself had been heavily influenced by Greek arts, serving palatial needs, but also by the arts of Thrace and the upper Balkans, and not without contact with Persian Anatolia. To the east, the new Hellenistic kingdoms were to be more directly affected by lingering Mesopotamian, Persian and Levantine styles, and in Egypt, to a very minor degree, by the Egyptian 73, 285.

The cities tell the story of progress in architectural arts, which were to be influential through the Roman Empire that embraced and succeeded them. The other arts developed from the High Classical in ways which were to be no less influential for the future of Western art. Classical art now comes of age and serves grander aspirations than those of the Greek city-states; and increasingly it competes for the attention of neighbours, as we have seen already with the Indo-Greeks in Central Asia and India.

For the first time since the Bronze Age we find Greeks planning major cities and palatial settings: to use the word 'theatrical' for some of the effects may not be altogether misleading. In various locations for towns, palaces or sanctuaries, notably in the planning for Pergamum 354, rising terraces bear a succession of temple and palatial buildings, together with the new monumental expression of civic buildings like stoas, gymnasia, theatres and lawcourts. Houses and palaces are based on courtyards, normal for the Mediterranean, but hitherto best seen in the relatively bourgeois plans of the 4th-century town at Olynthos in north Greece, which recalls inter-war suburban middle-class development in Britain, without the back gardens but each with a 'parlour' dining room. Now too more emphasis may be placed on façades. The colonnade (*stoa*), often multi-storeyed, was an old plan for sanctuary buildings but is now constructed to hold civic offices or shops and becomes as important a royal gift to any city as a temple 355. Administration and commerce, not just religion and defence, are beginning to dictate the appearance of cities 21. There is altogether more deliberate planning and design for custom-built

structures to serve the state and not simply to exalt the ruler, and there are more new cities whose planning was not constrained by history and existing buildings on the same site.

Sheer size counted. In earlier Greece there had been a very short vogue for tall (even up to 10m high on Delos) figures of youths **296**, and some of the temples, especially in Ionia, were far larger than a decent setting for a cult statue, which was their prime function, required. Now we have the Colossus of Rhodes (a bronze Apollo 32m high) and a rebuilt Temple of Artemis at Ephesus **294**, both to be hailed as Wonders of the World, beside the Pyramids of Egypt and Babylon's Hanging Gardens, and at Alexandria the famous lighthouse (Pharos), over 100m high. The traditional architectural orders were observed, with the common use now of the more ornate Corinthian order, whose composition of acanthus leaves introduced a new element to the ornate floral decoration exhibited by Hellenistic arts at all sizes and on any object **375, 380**.

Statues for dedication in the major sanctuaries now include portraits, including royal family groups, or action groups illustrating a myth or battle or hunts **357–59**. This three-dimensional display sculpture is new. Portraits tend still to idealize **363, 365** but there is more scope for royal portraiture on coinage **373**. The sanctuaries and civic buildings, and commemorative monuments in marketplaces, are the places for display of the major arts; less so the cemeteries, but for some exceptional royal tombs in Anatolia and the east, which were no little affected by earlier eastern practice and often resembled petrified and geometricized tumuli, heavily decorated with statuary. Such was the archetypal Mausoleum **309**. There is a continuing use of relief stone sarcophagi, again mainly in the east, and home-trained Greek artists, especially sculptors and architects, found theselves in demand far from home and practising a purely Classical style **328**.

In treatment of dress and the human figure the 4th century had continued the High Classical trends of the 5th; in the Hellenistic period more emotion may be sought, in faces but also in postures, and a baroque swirl of drapery added to the illusion **364**. But the male is still the principal, the female more often a subject for display of dignity or sensuality **362**. Absolute realism is modified for the sake of effect, often achieved through exaggeration of detail. This is well observed in the relief decoration of some monumental architecture, notably the Pergamum Altar of Zeus **356**, but no less in individual figures and groups, which can be contemplative (weary Herakles, Ajax considering suicide **366**) as well as active. The subjects are sometimes almost grotesque **360, 361** and they are clearly for purposes other than the traditional dedications, close to becoming art for art's sake, to decorate palaces and public buildings. The proportions for the human figure adjust to the new mood – small-headed athletes, high-waisted women and a deliberately sensual use of the nude, which by now was more than just a naked figure – this was a precursor of a major genre for Western art. The growing tendency for rulers to assimilate themselves to heroes and deities meant that they could be shown naked, virtually as divine athletes **363**, the first demonstration of something like 'heroic nudity'. Another aspect of this is a brief interest in producing versions in the styles of Archaic **372** and High Classical Greek art, often for the new Roman market **417**. The Brave New World retained a certain nostalgia for its past.

Metal vases are far more ornate than hitherto, at all sizes **375, 376, 379**, not without some inspiration from eastern taste **375, 377**. Jewellery becomes far more colour-conscious in the use of stone inlays and enamelling where the Classical had relished plain gold. Alexander had opened to the Mediterranean sources for new and more precious stones from the east. The cameo was invented, and larger objects cut in relief in precious stone are luxury demonstrations of the technique **378**. Engraved gemstones are now normally for setting in finger-rings or as pendants **374**, and the figures and heads (more portraits) cut on them closely reflect the styles of major art.

The carefully painted clay vases for everyman gave way to moulded relief cups, imitating metal, or plainer wares decked out with gilding, relief and coloured pattern. In some places the mould-made clay figurines, gilt and painted **367**, bid to be regarded as a major art form, even if they appear rather cloying

to our taste (the 'Tanagra figurines'). There is no denying their high competence in execution, although they lent themselves too readily to mass production and so to degeneration of type and detail.

True panel painting was clearly a major art. We glimpse it mainly in copies made in the 1st centuries BC/AD for villas in Italy **370**, occasionally in original form on tomb walls **311**. It clearly lacked nothing in skilful deployment of chiaroscuro, colour, three-dimensional composition, and could be deployed in panels or in major wall compositions, sometimes in series creating rooms of virtual mythical reality. Landscape becomes a major subject for the first time, not yet quite for its own sake but as a setting for the mythological **371**, although human-figure groups remain the stock choice. Closely related is the new art – mosaic, which progressed from the use of multi-coloured pebbles to minute glass, stone and clay *tesserae* which could very closely mimic brushwork **368, 369**. A four-colour palette for early Classical painting was hypothesized by later writers such as the Roman Cicero and Pliny – white, yellow, red and black (effectively dark blue) – and can be detected in Hellenistic or Hellenistic-derived painting and mosaic.

It was largely the Hellenistic arts of the Greek kingdoms that were influential beyond their borders to the east, even after they had been absorbed by Rome. But in many respects elements of style could be seriously misunderstood by local artists in the desert cities **381, 382** and in the new Persian realm of Parthia **383**.

We might well regard the Hellenistic as a high point in Greek art, passing beyond idealized realism into new areas of emotion and narrative, moving from an ideal interpretation of the world to a positive attempt to create an art that more closely and intimately engaged the viewer. It diversified more than any of the other ancient arts that we study here, and although its future under Rome became mannered, if not stagnant, it left vital traces in the arts of mediaeval Europe, until its renaissance in Italy. Indeed, the visual experience of parts of a Hellenistic city or house must have been almost like that offered by city centres and palaces in parts of Europe and America since the 16th century, for their layout and architectural decoration; one thinks of parts of Philadelphia or Bath and many Italian cities.

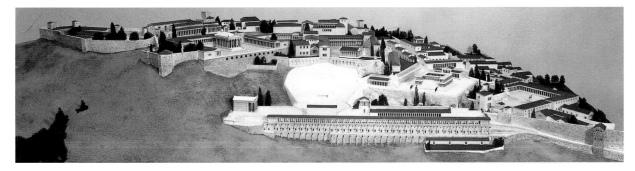

354 Model of the acropolis of the city of Pergamum, on the east coast of the Aegean, built for the Attalid kings, beginning in the 3rd cent. BC. It rises on terraces up the acropolis, flanked on the west (left) by long stoas and the theatre. Below is the marketplace, then the terrace of the Great Altar of Zeus [356], and terraces with the temple of Athena, and for the Roman Emperor Trajan who completed the scheme. Along the east flank are the palaces. Berlin, Staatliche Museen.

355 This Stoa, reconstructed in the 1960s in its original position facing Athens' ancient marketplace (Agora), had been given to the city by Attalos II of Pergamum in the mid-2nd cent. BC. It is a significant and popular new civic building type, housing shops and offices, and with broad colonnaded areas which could accommodate small assemblies (recently an EU summit). Here the lower order for the columns is Doric, with Ionic inside, and for the upper-storey palm-capitals which seem a Pergamene speciality.

356 The Great Altar of Zeus at Pergamum is a hollow square (sides about 35m), colonnaded, with reliefs around its outer and inner walls. The outer relief depicted the battle of Gods and Giants, at more than life-size (height 2.3m), an old subject used by Greeks often to reflect on their victories over barbarians (hitherto Persians, here invading Gauls). Anatomy and dress are both treated with verve rather than verisimilitude – the deep-sunk eyes, louring brows – and are so wedded to the architecture, even crawling alongside the approach stairway, as to seem to energize the whole in a manner beyond simple narrative decoration. 2nd cent. BC. Berlin, Staatliche Museen.

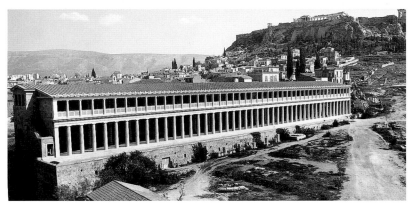

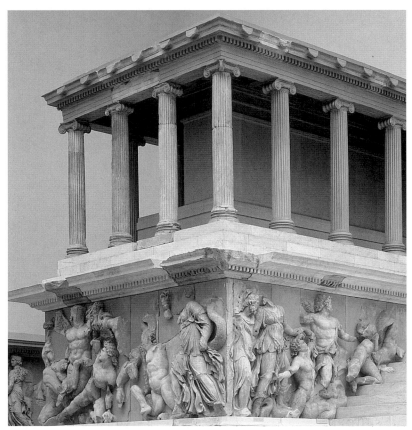

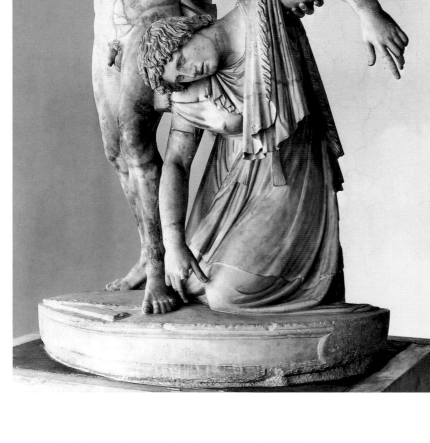

357 Attalid success against the Gauls was also commemorated by groups of statues set up in Athens and at Pergamum. This is a possible reconstruction of the group at Pergamum (a), the centrepiece a Gaul holding his dead wife and slaying himself, shown here in a Roman-period copy (b); beside him the famous Dying Gaul. The Gauls fought near-naked, like many Greeks, so this is not altogether heroic nudity but is a strong expression of strength and nobility in defeat, and the choice of subjects an indication of Greek respect for their foes. Late 3rd cent. BC. Reconstruction of whole monument by H. Schober. Height of group (b) 2.11m. Rome, Terme Museum 144.

358 The Laocoon. A copy of the original, which was made by three Rhodian sculptors about 200 BC, found in Rome in AD 1506, a major inspiration for Italian baroque sculpture. A Trojan episode in which the priest Laocoon struggles to save his sons from the serpents sent by Apollo to punish him and a good example of the expression of emotion through anatomy as well as facial expression. Height 1.84m. Vatican Museums 1059, 1064/7.

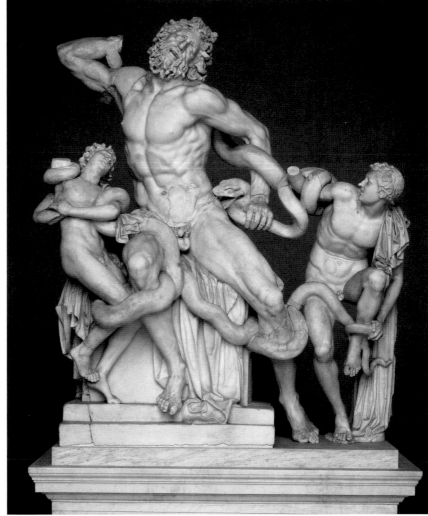

359 Four groups of copies of Hellenistic statuary depicting myth can be reconstructed from the way they were displayed in a grotto at Sperlonga, nearly 100km south of Rome, created for the Roman emperor Tiberius. Here is a model of the copy of the group created around 200 BC, over-life-size, of Odysseus and his companions blinding the giant Polyphemos (Cyclops). Reconstruction by B. Conticello.

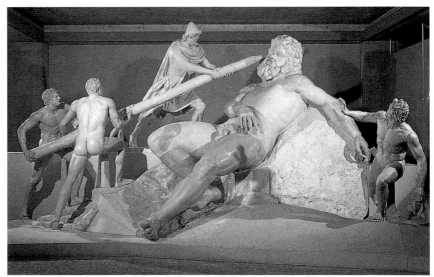

361 The grotesque and deformed could be treated with no little sympathy, notably in Alexandria – Egypt had a long and good record in such studies long before the Greeks arrived; here a bronze statuette of a hunchback dwarf. Hamburg, Museum für Kunst und Gewerbe.

360 Unflinchingly accurate depiction of old age, infirmity and even deformity accompanies the Hellenistic extension of Classical idealized realism. An old woman carries her basket to market, in a copy of a statue of about 200 BC. Height 1.26m. New York, Metropolitan Museum of Art, Rogers Fund, 1909.

362 Sensuality, male or female, was readily expressed in the new style. A hermaphrodite here is rebuffing a satyr. Copy of an original of the 3rd/2nd cent. BC. Height 90.6cm. Dresden, Skulptursammlung.

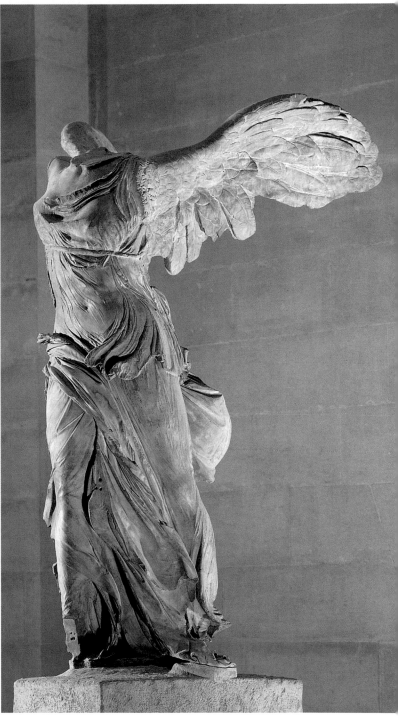

363 Male nudity becomes appropriate for rulers as well as gods, athletes or warriors. This bronze statue is the portrait of a Hellenistic prince. 3rd/2nd cent. BC. Height 2.2m. Rome, Terme Museum 1049.

364 This marble Victory was posed on the prow of a ship, commemorating a naval victory, on a hillside on the island of Samothrace (NE Aegean), and no less dramatically displayed today, at the head of a staircase in the Louvre Museum. The dress exposes rather than conceals the body. 3rd cent. BC. Height 2.45m. Paris, Louvre Museum MA 2369.

366 Stock figure types are adapted for different identifications, as in earlier periods. This one might serve an athlete or weary hero such as Herakles, or, in this bronze statuette, the hero Ajax, holding his sword, contemplating suicide, or Odysseus at the entrance to Hades. 1st cent. BC. Height 29cm. Vandoeuvres, Ortiz Collection Cat. no. 220.

367 A clay figure of a woman from Myrina on the coast south of Pergamum. Tanagra in Boeotia (central Greece) has given its name to this whole class, but such figures were made over most of the Greek world, and especially in western Anatolia. The heavy enveloping dress is typical of the major statuary which these figurines closely resemble. All originals were highly coloured. 3rd cent. BC. Height 24cm. Berlin, Staatliche Museen TC 674.

365 A copy of the portrait of the 4th-cent. politician and orator Demosthenes, made by Polyeuktos in 280 BC. Politician portraits are of standing figures; philosophers are seated. The presentation of portrait heads or busts alone is a relatively late development. Height 1.92m. Copenhagen, Ny Carlsberg Glyptotek 436a.

368 Part of a pebble mosaic from the floor of a palace at Pella in Macedonia. A stag hunt – a motif inspired by the royal hunts of the Persian empire but conducted heroically here by naked Greeks. The figures are in part sharply outlined by lead strips. About 300 BC. Width 4.9m. Pella Museum.

369 The use of small tesserae for mosaic enabled greater detail and a wider range of colour, but keeping to the basic painter's range of red, yellow, black, white. This large mosaic decorated a wall at Pompeii and apparently copies a famous painting of one of Alexander's battles. The terrified Persian king flees from Alexander. About 100 BC. Naples, National Museum.

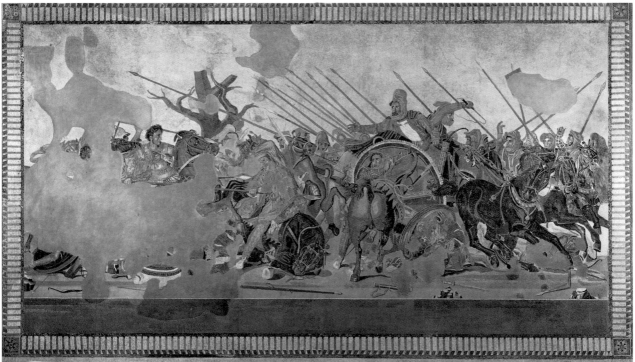

370 Some of the paintings on Roman walls seem to copy Hellenistic originals as accurately as we know the sculptors copied marbles. This, from a public building at Herculaneum (below Vesuvius), shows Herakles finding his son Telephus in the presence of a lady personifying Arcadia. Naples, National Museum.

371 Landscape begins to be valued for its own sake as a setting for myth, not cursorily indicated by a tree or rock as hitherto. A series of paintings from a house in Rome copies a Hellenistic cycle of scenes illustrating Homer's Odyssey; here the Laestrygonians attack Odysseus and his companions. Height 1.16m. Rome, Vatican Museums.

372 There was a short vogue for production of reliefs and statues which reproduce the superficial features of Archaic Greek art – 'archaizing' – producing tiptoe figures and mannered pleats like these of Dionysos and three Seasons, on a marble relief. 1st cent. BC. Height 32cm. Paris, Louvre Museum MA 968.

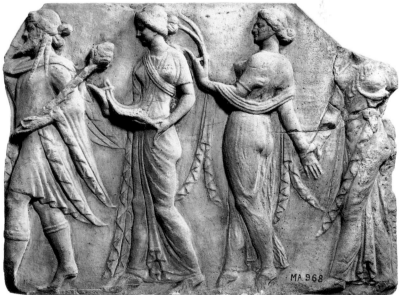

373 Silver coin with a portrait of King Mithradates III (reigned 220–185 BC) of the kingdom of Pontus (NE Anatolia). The reverses of these royal coins commonly carry figures of tutelary deities, and the king's name and titles.

374 Gem-engraving is now for jewellery rather than sealing, exemplified by the invention of the cameo, exploiting the different-coloured flat layers of onyx. The engraved gemstones are most commonly now set in finger rings. They favour portraits but an increasing range of genre scenes also which, with the unabated interest of Roman patrons, generated probably the largest repertoire of subjects of any medium in Classical antiquity.
(a) Sapphire ringstone with the head of a god (Poseidon?). 3rd cent. BC. Diameter 22.5mm. Karlsruhe, Badisches Landesmuseum. (b) Cornelian ringstone (impression) with the youthful Alexander as Zeus, holding thunderbolt and aegis (the snake-trimmed magic skin), the eagle at his feet. Inscribed 'NEISOU' (name of the artist or owner). Height 29mm. St Petersburg, Hermitage Museum.

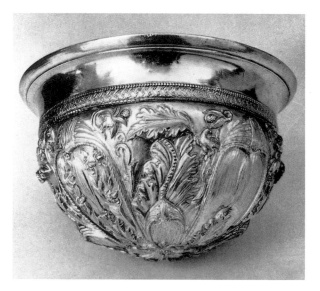

375 A silver cup with elaborate relief florals such as became a regular feature for such vessels, in clay or metal. The footless cup is adopted from the east (the Greeks long preferred cups with feet and handles). It is inscribed with its weight (51 drachmai), a reminder of the bullion value of all such vessels, which probably outdid the value added by the artist. 2nd cent. BC. Diameter 12.7cm. Toledo Art Museum 75.11.

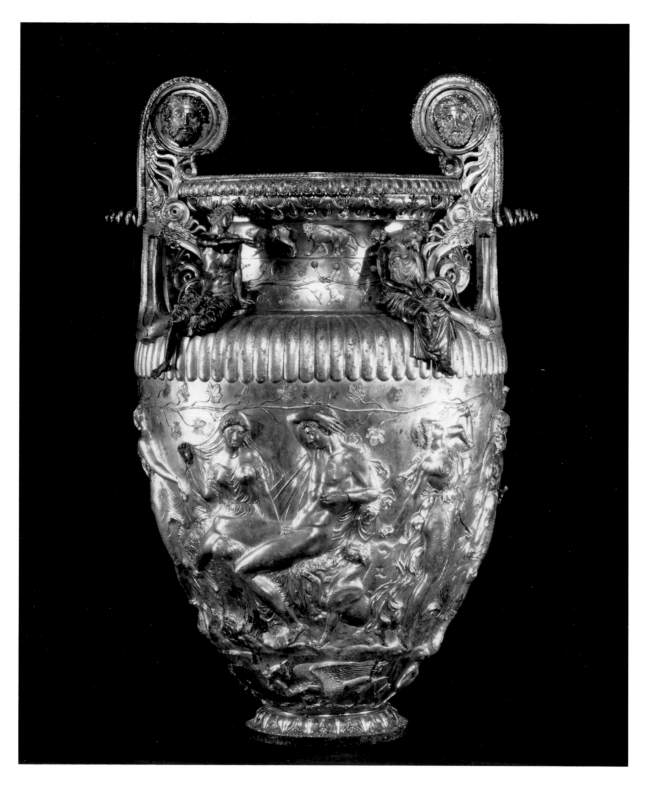

376 The Derveni crater, from a tomb in Macedonia. Relief figure decoration covering metal vases is rare before the Hellenistic period. This is one of the earliest and most ornate, with figures in the round on its shoulders and a high-relief Dionysiac scene on the body. It is of gilt bronze. Late 4th cent. BC. Height 70cm. Thessaloniki Museum.

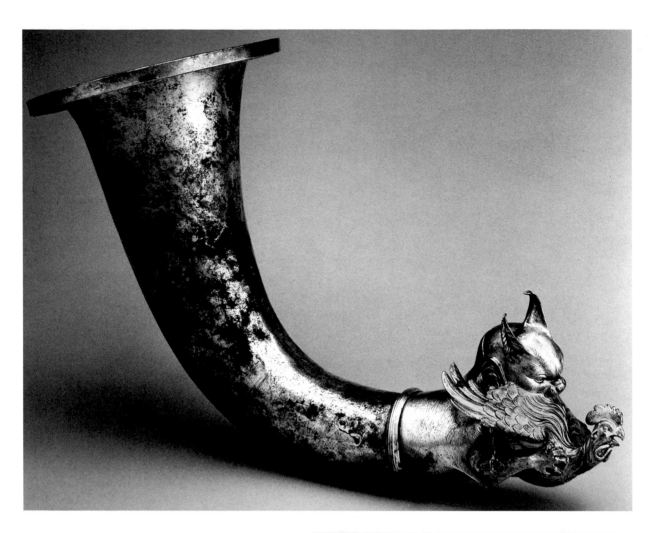

377 Another eastern shape which was popular with Classical craftsmen working for the eastern empire was the horn-shaped pourer (rhyton) with an animal head or forepart at the spout. This, of gilt silver, has an Asian lynx seizing a fowl. Compare the Bactrian ivory example [139]. 2nd cent BC. Length 41.4cm. Shigaraki, Miho Museum.

378 Alexander the Great opened the eastern market for precious stones of a range and size hitherto not known to western artists. The 'Tazza Farnese' is carved in Indian sardonyx, probably in Alexandria, showing at the left the personification of the Nile, with other deities popular in Ptolemaic Egypt. 2nd/1st cent. BC. Diameter 20cm. Naples, Archaeological Museum.

379 *A silver cup and its relief decoration drawn out. It is from a hoard in Pakistan, but probably made in Alexandria. It carries an interesting medley of the type of subjects favoured for such plate throughout the Roman Empire and especially in the Greek east: a Dionysiac statue presiding over a feast, with an Eros wearing a big mask; and some grape-handling by a child before the goddess Tyche, with various paraphernalia, including a sundial on a column. 1st cent. BC/AD. Height of frieze about 10cm. Private Collection.*

380 *Here the fantastic Hellenistic floral composition is rendered in purple and gold cloth, found in a royal tomb at Vergina (of 'Philip II'). Width 61.6cm. Thessaloniki Museum.*

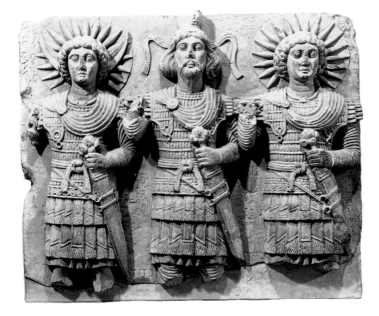

381 The desert caravan city of Palmyra in eastern Syria was semi-independent under Rome but its art is as much Mesopotamian as Classical, and these are eastern gods in Classical armour; from the temple of Bel at Palmyra. Mid-1st cent. AD. Height 56cm. Paris, Louvre Museum.

382 A spirit of revolt and independence frayed the Hellenistic character of the eastern kingdoms. In Commagene, north Syria, monumental sculpture for a new dynasty produced a near-parody of Classicism, retaining something of the hieratic character of older eastern art. Here King Antiochos I, in Armenian garb, is greeted by an orientalized Herakles. The site at Nemrud Dagh has his tomb, dominated by a row of colossal un-Classical seated gods. This relief is at Arsameia, near by. Mid-1st cent. BC. Height 2.26m.

383 In Persia itself, now Parthia, the new rulers from Central Asia embrace much of Hellenism, notably the techniques of its arts. This Parthian ruler, from Shami (near Susa), is hollow-cast in bronze like contemporary Greek statuary. 1st cent. AD. Height 2.2m. Teheran, Museum.

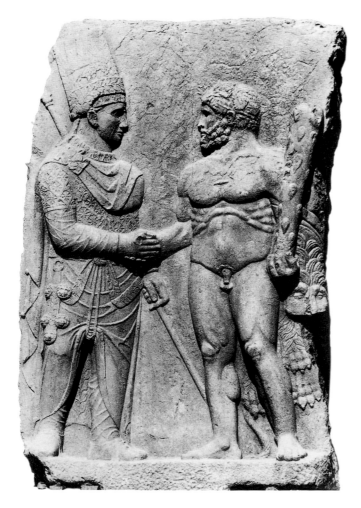

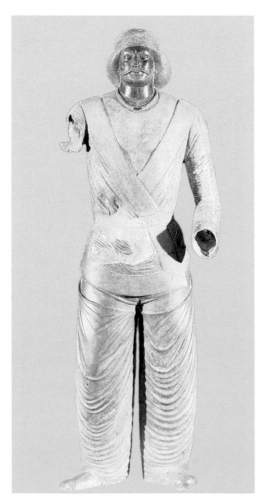

ITALY AND THE ROMAN WORLD MAP 3, 6, 7, 8

Although this section deals largely with the Roman Empire and its handling of the Classical tradition, over parts of the world whose earlier urban cultures we have already considered, we have to start at the point where Roman awareness of and reaction to the character of Greek civilization needs to be accounted for. Italy fulfils the ecological conditions for the development of a strong culture based on agriculture and the control of a large population, and eventually of a population of many races whose energy could be deployed for major works of architecture as readily as for military purposes. Their varied abilities in the arts were there to be recruited to demonstrate a new Imperial ideal. The Empire's achievements represent the culmination of those expressions of power, religion and personality through art, which have been observed in earlier cultures whose lands were overrun by the Romans, from Mesopotamia, the Levant, Greece, Egypt, north Africa, into Spain and Europe. But we must go back to the beginning, the period of new peoples and arts arriving from the eastern end of the Mediterranean.

Greeks and Phoenicians had been spreading the word about the urban arts of the east and of Hellenism to the western Mediterranean from the 8th century BC on. At this time, in central northern Italy and its islands, there were local developments in the arts, affected heavily by the newcomers from the east, which were to have no little influence later on the arts which served the rise of Rome and the establishment of her Empire.

Etruria, north of Rome (Tuscany), was not unlike Greece in owing the independence of its confederacy of some dozen city-states to its geography of steep hills and valleys, clearly marking off their boundaries, and unlike the broader landscapes of most of the rest of the Italian peninsula. Down to the 8th century BC town life was much as that of northern Italy and Europe, and its arts (known as Villanovan, but these are the same people) well served by local resources of iron and copper, which were to make it a target for the foreigner. It is no accident that the characteristics of Etruscan art emerge at just the time that the Phoenicians were settling in Sardinia, and the Greeks on Ischia farther south (an island offshore to Naples), but also on the mainland in Campania south of Rome.

Sardinia was not as innocent of major art and architecture as much of central Italy had been. The Nuraghic culture had flourished there since the Neolithic, with remarkable stone structures including conical towers 384, fine ashlar masonry and accomplished use of corbelling 39. Later, we find a range of bronze figures that seem not unrelated to the later Etruscan, though with different subject matter 385. The break with what the east was about to offer the island was not total, but nearly so.

The Phoenicians soon changed the complexion of the arts in Sardinia to the 'Punic' styles we considered before (p. 193). On the mainland, the Etruscans learnt from them luxury crafts in gold and ivory 386, 387, with figure and floral subjects well familiar in the Levant; this was their 'orientalizing revolution', subtly different from that enjoyed by Greece. But at the same time the Etruscans learnt from the Greeks geometric and orientalizing decorative patterns and styles in narrative art, and an alphabet. The result was that the Etruscan luxury arts depended on the Phoenicians' example, the more plebeian arts on the Greeks', as in vase painting, a genre they learnt from them 388. And in the long run the Greek

won because Greek goods were more successfully traded, their art offered more to entertain and was more visible, while their artists were themselves close by and busy for Etruscan masters **395**. Etruscan gods adopted Greek appearances, while Greek gods and heroes, with their stories and names adjusted, were themselves borrowed, to offer sometimes bizarre new interpretations of figures and scenes which had been treated somewhat differently in their homeland.

The appearance of Etruscan art is borrowed yet it is more than a pastiche. Etruscan taste and craftsmen introduced a wild sense of colour and feeling for moderate distortion of natural forms, combined with an equally effective control in composition: less controlled than the Greek, or at least different, and perhaps therefore more appealing to many. This mongrel art was at its height in the Archaic period of the 7th and 6th centuries BC, when it achieved a notably coherent and distinctive style. Thereafter it more painfully followed the Greek lead, commonly the colonial Greek one from the south, excelling mainly in metalwork **394, 399–402**, gem engraving **397** and wall painting (preserved in tombs **396**), with a particular flair for major sculpture in clay **391, 393** rather than stone. On metal we catch fine incised reflections of Greek drawing styles and subjects **400, 401**, while the scarab gems outdo their models as jewels and can match them in finesse of engraving but were slow to keep up with the developments of Classical art in its homeland. The tombs are furnished and decorated like houses, under stone-girt tumuli, much more like Anatolian practice than any Greek, but thereby also more informative and protective of their contents. Their stone monuments and stone or clay urns **403** demonstrate a considerable difference in approach to the other-worldy from the Greek, and often attended by supernatural figures. The interiors are our only source for knowledge of the probable appearance of Etruscan houses and palaces, while for the towns, which waxed rich on trade with the foreigners and from their bellicose attitude to neighbours, we know really nothing more than their stout walls. Their temples were to have something to contribute to the Roman by way of plans rather than decoration **390**.

Outside Etruria, the native peoples of Italy found themselves at first neighbours to Greek colonists in the south and in Sicily, then absorbed by Rome. Their native arts often remind us more of Europe than the Mediterranean, even in the south, and proved persistent despite the messages of their more aggressive neighbours **389, 392**.

Rome, the capital city of the state of Latium on the River Tiber, started its history of art in the same way as its Etruscan neighbours, but its people spoke an Indo-European language, close to Greek. The different political history of Rome, however, and the special genius of its people (and I do not mean for the arts) led to something very different. Its foundation, traditionally dated to 756 BC, corresponded with the first stirring of Etruscan art. Rome then successively won by force of arms Etruria, the western Greek colonial world, the Punic world in Spain and north Africa, Greece itself, Anatolia to Mesopotamia, the Levant, and Egypt. By the time the Roman Republic, a severely organized near-democracy with some inspired leaders, had turned into a formal Empire with an emperor (Augustus, from 27 BC), Rome ruled an area as great in extent and potential wealth as any other in history, from the Atlantic to the borders of Persia, from the Rivers Elbe and Danube to Upper Egypt. This was an Empire bound by a common law, carefully managed communications and a brilliant military and administrative machine, but within which it was possible for individuals to become patrons of the arts and for slaves to become free and wealthy. The need to express and glorify the importance and power of Rome encouraged major civic projects throughout the Empire, from Hadrian's Wall to temples in Egypt and Mesopotamia.

Rome was broadly tolerant of the habits and religion of its subject peoples, as the Achaemenid Persians had been, but imposed many of its own views on art and architecture. These were developed from the Classical arts of Greece, and they were applied both at a high level of ambitious architecture, and at a more mundane level which won favour among the populace of whatever race or religion. This apparent uniformity was no less real for being artificially created.

In the early 4th century AD economics, politics and Christianity split the Empire into a Roman West and a Roman East (at Byzantium/Constantinople/ now Istanbul), while repeated incursions of nomad neighbours from north and east (Huns, Goths, Vandals, Visigoths) from the late 2nd century AD on further gradually dissolved unity of rule. At the same time the arts too were beginning to diversify for various reasons, political and ideological, as we shall see later.

The arts were as effectively diffused through the Empire as its edicts, and changes in them mirror the changes in the political scene. 'Provincial' becomes a true designation for much of the Empire's art, as it developed and was practised in the Roman provinces. The ability to plan and control was Rome's strength; as its poet Virgil saw, it was not for Romans to make lifelike bronze statues but to rule an Empire, 'to spare the conquered and war down the proud'. But this was by no means an Empire of philistines and illiterates, and although the visual arts were mainly derivative and only occasionally innovatory in use or design, the architecture was sublime. It must be remembered that we are dealing with a very long period, far less marked by change in the arts than the Classical and Hellenistic Greek had been, but responding quickly to new needs and circumstances.

Under the Republic the arts were much affected by those of Hellenistic Greece, at home and in the colonies. Little was added but there are areas which seem peculiarly Roman, for example in realistic portraiture **413–15** where some have seen the influence of the old Roman custom of keeping wax busts of ancestors. But Roman generals were bringing back works of art as plunder from Greek towns, sculpture and paintings as well as valuable *objets d'art* which could be carried in the triumphal processions, and Rome itself was soon to be peopled with statues and even whole architectural-sculptural complexes taken bodily from Greece. To read, write and view Greek was the hallmark of the élite, although there was a strong intellectual resistance under the Republic among conservative thinkers who remained deeply suspicious of corruption by Greek manners. But for the majority of the wealthy and influential everything Greek was admired and copied, and the time was ripe for the creation of a true Art Market, with the deliberate collection of works of art – Greek of course – by politicians, private tycoons and emperors.

However, a taste for art in the Greek style did not necessarily carry with it an understanding of or sympathy for the function of Greek art on its home ground. The orator and statesman Cicero considered carefully the financial, rather than the aesthetic, implications of choosing to buy statues of Maenads (Bacchants) or Muses through his agent in Greece. The Classical statues and classicizing works throughout the Roman Empire served a quite different world and in quite different contexts, and were often sought out specifically for gardens or libraries. They designated 'Rome' far more than Greek art had deliberately designated 'Greece', and although most appearances were borrowed from the Greek, their messages were different for a quite different people with quite different aims. Thus, Greek statues of naked men were an embarrassment to the Romans, but they were not avoided – just given a heroic identity, Achilles, or used for Roman rulers who aspired to divinity.

Greek artists had responded briskly. Original bronze statues in Greece were moulded and the plaster casts taken to studios in Italy where copies could be made in marble – the source of our knowledge of the appearance of many a lost Greek original. Greeks complained that their statues were always smeared from the effects of being repeatedly cast. Old styles, the Archaic and High Classical, were aped, and there were even some new, if vapid, compositions in these styles made in the more enterprising Greek-manned studios in Italy, looking very like expensive fodder for Grand Tourists **372, 417**. For the most part original production, when not copying, was a matter of creating minor variations on standard Greek types, even for portrait statues of emperors **414**. In the Late Republic and early Empire virtually all artist signatures are of Greeks, while artistic activity in the Greek east tended, in all but architecture, to continue to set the pace in the major and luxury arts, and to staff the many studios of Italy and the west. The interest did not abate, indeed it grew in the 2nd century AD, the period of the greater

proportion of the copies of Greek sculpture that have survived. Gardens and villas (Hadrian's at Tivoli, near Rome, and there were comparable ones in Greece itself) were laid out like theme parks of Greek art and architecture, but like nothing ever before devised in Greece, while the rape of Greek originals continued to contribute to the appearance of whole cities: Rome and, later, Constantinople.

Greek styles of composition and Classical idealized realism dictated the creation of new work – generally in relief rather than sculptural groups – for monuments and decorative display **422–25**. These are truly Roman. By the 4th century AD, however, a dramatically new style was being introduced, more naive at first sight, with frontal figures and groups engaging more directly with the viewer than the Classical **454**, which one had to admire as it were from a distance. Art for a Christian world confronted its people rather than simply narrated the exploits of its emperors, gods and heroes. The contrast is clear on the Arch of Constantine **452** where old and new are juxtaposed. The new mode is inspired by the east, and no little encouraged by messages of a Christian if still Imperial world. It will be the mode of Byzantine art and the mediaeval in Europe, bearing traces only of the Classical which had to be more consciously recovered for artists much later. But it was the Classical narrative compositions and figures of the Empire that had inspired the beginnings of Christian and even Jewish iconography **453**: the Classical groups of sages served as models for Apostles, classicized Isis and infant Horus for the Virgin and child, Olympian Zeus for God the Father.

It was in architecture that the Roman world offered its most positive innovation. Roman architects were as adept with the use of stone as the Greeks, but fired brick became again a major medium for the larger structures, whether or not faced with marble. Augustus claimed to have changed Rome from a city of brick to one of marble: that is to say, Greek in appearance, even if the marble was often only a veneer. From an early date ambitious architectural complexes are being created, at least as varied as any Hellenistic **404**. The uses of concrete had been discovered in Campania, a Greek region south of Rome, and we find a Greek above-ground vault even

in the Hellenistic period in Sicily (at Morgantina) constructed with series of interlocking clay tubes. However, these Greek initiatives in the west awaited Roman exploitation, and the Romans used the arch and vault fearlessly where Greece had used such forms occasionally and commonly out of sight – presumably an aesthetic choice. This produced a new architectural visual experience of arcade and dome **38** to add to the Greek colonnades, which were retained along with all the Greek orders of decoration. It also encouraged more introspective buildings with plain exteriors and not the ubiquitous Greek colonnades; such was the basilica **406**. Many new building types were evolved from the Greek or were newly invented to serve the entertainment of the masses. Greek theatres had been cut into hillsides **310**; the Roman can be free-standing **407**, and doubled to make amphitheatres for displays other than the strictly theatrical **409**, like the Colosseum in Rome. Palace and villa retain the basic courtyard scheme but multiply and enlarge the units **410**, which may have all-over painted walls and floor mosaics, and are combined with formal garden elements which are decorated with sculpture. Multi-storey apartment blocks, as at Ostia **405**, may have been anticipated at Alexandria. Remarkable engineering works for viaducts and aqueducts are no less works of art **41**. In all such projects the arts of the sculptor could be recruited for decorative effect, and the mode is Empire-wide.

Art had never not been an organ of state propaganda in antiquity. Under Rome, however, it ranged from the obvious demonstrations of power and the cult of the individual (the emperor), to more subtle exaltation of the qualities of justice and security under the *pax romana*, which could be expressed on coinage or in temple and altar decoration **411, 422, 424**. The old Greek practice of placing dedicatory statues on high, single columns reaches its peak in the Roman columns, such as that of Trajan in the Forum of Rome **423**, with relief scenes of his triumphs wound around its shaft, up to the statue of the emperor, 38m above ground level. Size was still important. In Rome under Augustus an Egyptian obelisk, mounted so as to be nearly 30m tall, served as the 'hand' of a sundial pavement some 400m wide, across an open area beside the Altar of Peace, marking

not just the seasons and hours but subdivisions – a marriage of art and science.

The Greek artists' presentation of their gods as men had been abetted by a readiness for Hellenistic rulers to be assimilated to gods or heroes **363**, and easily, under Rome, for them to be deified in life and have their portrait heads set on figure types devised for Greek gods **414, 419–21**. This could happen at other levels of society too, and a senior Roman matron might be presented as a naked Aphrodite **416**. The fact that Rome did not tolerate the everyday nudity that had been acceptable in Greece was no hindrance, it seems. Greek mythology served Rome, with few changed names but much enhancement from Roman poets, especially Ovid, often with stories that found no echo in contemporary arts but which were to be picked up by the neo-Classicism of the 18th and 19th centuries. It could serve state myth as well as providing perhaps more entertainment than moral instruction for the populace.

Religious processions in the Greek world had attracted as much invention from artists in portrayal, often on a large scale, of divine and heroic activity, no less than any Renaissance pageant. The description of Ptolemy II's procession (*pompe*) in Alexandria in the 3rd century BC tells as much. Rome used the style for military triumphs, and for civic and dynastic occasions. These provided new, literally theatrical opportunities for the portrayal of subjects otherwise familiar only in the more static arts. Roman triumphal arches reflect the same attitudes, memorializing success monumentally **452**.

Massive mausolea – virtually architectural tumuli – are for emperors, but relief marble sarcophagi for family vaults are the preferred method of burial for the élite, especially from the 2nd century AD on, and a result is the near-mass production of them at various centres in the Greek world, wherever the marble was to hand, and in Italy where sources of a suitable white marble was at last exploited at Carrara. The whole Empire was the source for various coloured marbles for architectural use and, where appropriate, even sculpture (unpainted, then). Greek use of colour contrast in stone was by comparison modest. The subjects on many of the sarcophagi are Greek

mythology, or celebration of the dead by portrait and attendant deity, sometimes with a hint of an afterlife **426–28**. Representation of the heroic and divine was as commonplace as it had been in the Hellenistic period but possibly carried less conviction. There was some scope here too for portraiture **418** but most of the commoner sarcophagus types seem to have been supplied 'off the peg', from stock.

For the luxury arts the evidence is rich since the Empire was large and the main sites and cemeteries have been well explored, while much survived above ground to serve, with various degrees of suitability, Christian monuments and furniture. The devastating eruption of Vesuvius in AD 79 preserved as intact as we might wish the furniture and wealth of houses and villas in Pompeii and Herculaneum, whose rediscovery in the 18th century effected a revolution in the decorative arts of Europe.

The use of relief figure-decorated silver plate had been adopted enthusiastically from Hellenistic Greece, often with similar Classical or decorative subjects but occasionally with expressly Roman content and mood **437, 438**. Glass becomes a luxury product when it is a matter of producing layered 'cameo glass' which could be carved on vessels such as the 'Portland Vase' **440**. Otherwise there are virtuoso vessels of clear glass in a variety of forms, blown and cut **444–46**, and multicoloured miniaturist compositions (*millefiori*). Mosaic decoration for floors and walls becomes commonplace. Some major mosaic compositions are attempted for the capital city and its dependencies in the early Empire **429**, but in later centuries the most imaginative and colourful work appears more in Syria, in the Greek east generally and north Africa, than in Italy itself. In the capital there are some interesting innovations based on inlays of coloured stone **450**.

Wall painting continues to develop the Hellenistic themes with the same techniques, but new schemes of decoration including *trompe-l'oeil* architectural, with true perspective properly mastered **430–34**. These can display some striking compositions of pure fantasy, and with the decoration of all walls in single rooms, this begins to aspire to an effect of virtual reality, attempted later by 19th-century Panoramas

and modern computer-generated images **431**. In many respects painting was probably the senior art of the Roman world, after architecture but beside sculpture in the round which was generally devoted to portraiture, and we can see that, at least in figure work and groups, the design of relief sculpture was often dependent on motifs and compositions devised or expressed in painting.

Hellenistic Greeks had already begun to theorize about their arts; this went further under Rome, and literature and the arts were more consciously wedded by the authors of *ekphraseis*, elaborate and often emotional prose descriptions of works of art (usually painting), real, improved or simply imagined.

In gem engraving the range of motifs and materials for ringstones increased massively **442, 443**, cf. **455**. They clearly served a very wide range of the populace since many rings and stones are tiny and quite summary in their execution. Under the early Empire the cameo technique is used for some large imperial propaganda statements that are for display rather than wearing **441**, and cameo portraits of emperors were no doubt valued gifts to governors and favoured non-Romans. The craft declines in the 3rd century AD but has continued to be practised in Europe without interruption until the present day. Specialist collections of gems were being made already by Hellenistic rulers and there is record of several such cabinets in the early Empire. Art collecting by now signified status and wealth; it was practised with some discrimination and served well by the best artists. Some early imperial engravers specialized in making intaglios with copies of famous Classical heads or statues **442b**, much as engravers of the 18th/19th century provided gem copies of statuary in the Roman collections for the Grand Tourists from Europe.

From the late 1st century BC on, the function and status of the arts in the Roman Empire were virtually the same as those in the Western world since the Renaissance, and very little like those we can detect in any other ancient culture. The visual experience of a visitor to early imperial Rome would not have been all that different from that of one in the 16th century AD. The creation of the art market and art for art's sake had spelled the end of the artist as a servant exclusively of the essential religious and social functions of rulers and the ruled in the Western, classicized world. There was no limit now to what he might regard as his function, except what was imposed by patrons. 'Artistic integrity' could thereafter be exercised only in the service of religion, as indeed was the case under Byzantine Christianity, the Buddhist, mediaeval Gothic, Islam.

SOME ROMAN/ITALIAN DATES	
8th cent. BC	First Greek and Phoenician settlements in west
756 BC	Foundation of Rome; ruled by kings
509 BC	Roman Republic founded
396–264 BC	Italy south of the River Po annexed
228/7 BC	Illyria (Greece, across the Adriatic), Sicily and Sardinia annexed
215–146 BC	Macedon and Greece defeated and annexed
146 BC	Carthage defeated and annexed
63 BC	Anatolian and Levantine provinces organized
47–44 BC	Julius Caesar dictator in Rome
30 BC	Egypt annexed
27 BC	Octavian becomes Emperor Augustus (died AD 14)
AD 96–192	Antonine period (Hadrian AD 117–38)
AD 312	Christianity becomes official religion
AD 324	Constantine founds Constantinople
AD 410	Sack of Rome by Visigoths

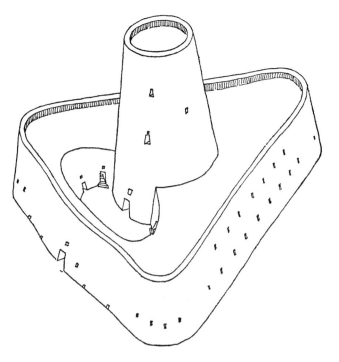

384 The Nuraghic tower and complex at Sant'Antine in Sardinia. The massive stone construction and ambitious corbelling within [39] are in the megalithic tradition which runs from Britain through parts of the Mediterranean, even to Bronze Age Greece. Mainly early 1st mill. BC. 18m high.

385 The small bronze figurines that are equally characteristic of Sardinian art, of the period before Greek or Phoenician intervention, are in a more Mediterranean tradition, and bear some resemblance to early Etruscan. (a) A monster warrior with two shields. (b) An archer wearing a horned helmet; height 17cm. (c) Mother and child; height 10cm. Cagliari, Archaeological Museum.

386 An ivory box from the Pania tomb at Chiusi. The relief friezes have Hellenized florals (top, bottom, and between the figure friezes), ships and vignettes of Greek myth (Odysseus escaping Cyclops, holding on under a ram, right of centre top); warrior and women mourners; two friezes of various creatures in a mixed Greco-eastern style including an eastern 'Tree of Life' (centre below). The whole is Phoenician in overall appearance and technique but already deeply infected by Greek subjects. About 600 BC. Florence, Archaeological Museum 73846.

387 A detail of a gold bracelet decorated with a relief panel of three women holding branches or trees – oriental goddesses introduced from Phoenician art. They are in relief, but all detail is rendered in gold granulation, soldered on to the gold sheet. Etruscan artists long remained adept at the most intricate techniques of gold-working. From the Regolini-Galassi Tomb at Cerveteri. Mid-7th cent. BC. Vatican Museums.

388 An Etruscan clay jug (olpe) for oil, copying a Greek shape and with a colourful re-interpretation of Greek orientalizing decoration. Vigorous juxtaposition of colours, producing a skewbald effect on animals, is a strong feature of Archaic Etruscan painting on walls and vases. About 580 BC. Height 15.4cm. Florence, Archaeological Museum.

389 A Daunian (Adriatic coastal area, east of Naples) gravestone with incised and painted decoration. A good example of an utterly distinctive and relatively long-lived local style, not affected by the Greek or eastern. Late 7th cent. BC. Height about 60cm. Manfredonia Museum.

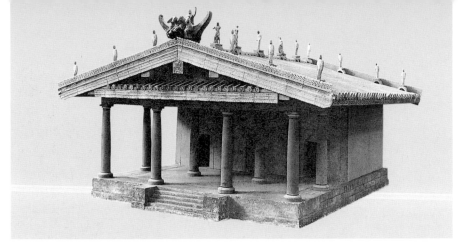

390 Etruscan architecture accepted the trappings of the Greek, especially revetments and sculptural decoration in terracotta. But temple plans tend to deep columned porches with the whole set on a base or podium, features which are retained under Rome. The Greek architectural orders are copied but the 'Tuscan' column, with a simple ring capital, tends to take the place of Doric. This is a reconstruction of the 6th-century BC temple at Veii.

391 Etruscan artists specialized in major works in clay where the Greeks would have used stone. This is the centrepiece of a pediment group from a temple at Pyrgi. Athena attends an episode in the story of the 'Seven against Thebes', with, in the foreground, Tydeus sinking his teeth into Melanippus' skull, a gruesome detail which a Greek artist would probably have shunned for such a setting. Early 5th cent. BC. Rome, Villa Giulia Museum.

392 Greek and Phoenician styles were not altogether dominant in the Archaic period in central Italy. This is probably a cult statue from Capestrano in a style which derives from an older, more European, tradition in Italy, only its size (2.09m) and material (limestone) suggesting some inspiration from the new arts of Etruria and Rome. It is from east of Rome, near the Adriatic, inscribed in an alphabet derived from Greek. 6th cent. BC. Chieti, National Museum.

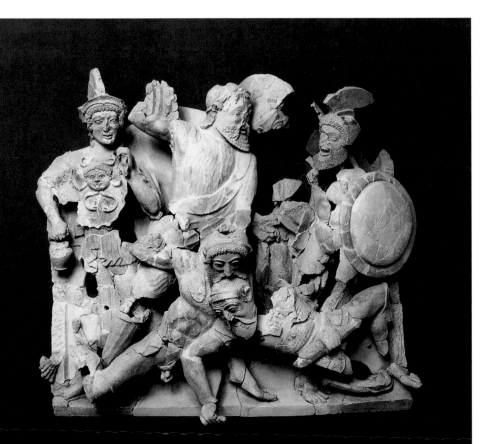

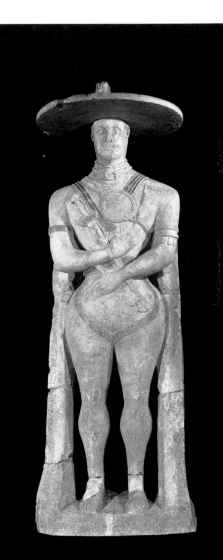

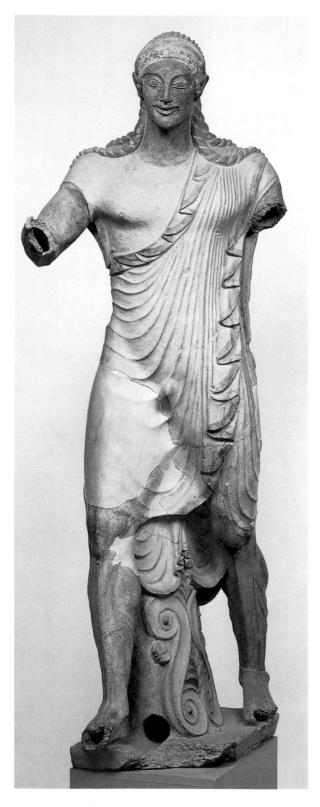

393 The Apollo of Veii, one of the clay figures that strode along the ridge of his temple, an Etruscan mode of temple decoration, not Greek. It is a very mannered version of Greek late Archaic. About 500 BC. Height 1.8m. Rome, Villa Giulia.

394 A bronze chariot from Monteleone. The front is decorated in relief with a scene of Achilles receiving armour from his mother Thetis but with unexplained animal additions, although devised with close knowledge of Greek art. Etruscan 6th-century art is much affected by East Greek, Ionian styles, either from the colonies or the result of emigration into Etruria of artists displaced by the Persians. The figures tend to be more svelte than those of mainland Greek art. Mid-6th cent. BC. New York, Metropolitan Museum of Art, Rogers Fund, 1903.

395 Detail from a 'Caeretan hydria', a water jug, certainly the work of an immigrant artist from East Greece, where the style is not attested on vases but in panel painting, working at Caere (Cerveteri) in the later 6th cent. BC. The style is, for Greek vases of the day, remarkably colourful and must be influenced by wall painting. This shows a hero, perhaps Herakles, confronting a sea monster. Paris, Niarchos Collection.

396 Achilles ambushes Troilos at a fountain on a wall painting from a tomb at Tarquinia. The iconography and story are Greek (Trojan War) but treated by an Etruscan artist in a way that almost obscures the story, through unusual use of relative scale for animals, architecture and heroes, and adding a variety of shrubbery unknown to Greek art. Later tomb paintings are more closely Classical in style if not subject. About 540 BC. Florence, Archaeological Museum.

397 Gem-engraving was introduced to Etruria by Greeks in the later 6th cent. BC. The favoured shape is the scarab, more elaborately carved than in Greece, invariably in dark red cornelian, especially dyed for use. Such scarabs were still being made in the 2nd cent. BC. Their backs are more carefully carved than they generally were in Greece, thus more like jewellery and often elaborately set in gold. This is an early example, and the disconsolate heroes named are five of the heroic 'Seven against Thebes', a Greek myth very popular with Etruscan artists. Early 5th cent. BC. Length 16.6mm. Berlin, Staatliche Museen F 194.

398 Athenian decorated pottery of high quality was imported to Etruria in great numbers. The local pottery either copies the Greek, or is in burnished black bucchero. Many of the bucchero vases adopt plastic forms or decoration, like this one of a man with two crowned creatures – horse or fowl? 6th cent. BC. Vatican Museums.

399 Bronze chimaera, from Arezzo. A monumental treatment of the monster from Greek art, vigorously expressed, as is much in Etruscan art, sometimes more effectively than the more controlled Greek examples of the same period. Early 4th cent. BC. Height 65cm. Florence, Archaeological Museum 1.

400 The bronze 'Ficoroni cista', a bronze box of a type made at Praeneste near Rome, in Etruscan style but, as here, with incised scenes on the body which closely copy the finest Greek narrative drawing. This shows an episode in the Argonaut story (the detail drawing [b] shows heroes disembarking); on the lid, Dionysos (Etruscan Fufluns) and two satyrs. It is inscribed as the work of Novios Plautios, no doubt a freed Greek slave. 4th cent. BC. Height 74cm. Rome, Villa Giulia.

401 Etruscan bronze mirror, the back incised with scenes of Heaven (Hercules [Greek Herakles] received by Zeus) and the Underworld (Greek heroes from Troy; and winged naked death demons) – an extraordinary expression unparalleled in Greek art although totally dependent upon it. Etruscan mirror backs are a rich source of such scenes translating Greek myth and figures. About 300 BC. Paris, Bibliothèque Nationale.

402 Bronze figurines, on their own or attached to furniture, are characteristic of Etruscan art, usually simply standing figures, as here of an offerant, executed in modified Greek Archaic style. From near Prato (near Florence). About 470 BC. Height 17cm. London, British Museum Br 509.

403 The clay group on the lid of a funerary urn from Volterra. This is accomplished realism with honest depiction of rugged, ageing faces, their heads and hands somewhat enlarged for effect, and the whole conveying a poignant moment of life although in a funeral setting, a spirit that, by this time, Greek art had virtually lost. 2nd/1st cent. BC. Volterra, Etruscan Museum.

404 A spectacular early demonstration of architectural techniques, using concrete vaulting and traditional brick and stone; a model of the Sanctuary of Fortuna at Praeneste (south-east of Rome), of the 2nd century BC, which outdoes even the Hellenistic terrace plans for sanctuaries in Greece.

405 The reconstruction in drawing of a row of shops in 2nd-cent. AD Ostia, the port of Rome, presents domestic architecture much like that of the 19th/20th centuries AD.

406 The Pantheon [38] was an example of a building essentially contained within a dome. A later plan for a hall, to influence the form of Christian churches, was the apsidal Basilica, with columned naves and wide vaulting. This is one built of brick and concrete in Rome by Maxentius and Constantine, by AD 313. 100m long.

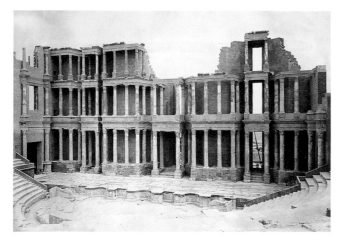

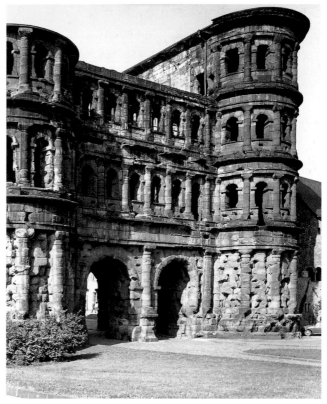

407 The stage building of the theatre at Sabratha in Libya; marble construction of traditional manner, with an all-Corinthian order. The type replaces the Greek hillside theatre, except in Greece itself. 2nd cent. AD.

408 The city gate (Porta Nigra) at Trier in Germany, a capital city for the Empire in the north. 2nd/3rd cent. AD.

409 The amphitheatre at Verona. The seating is built up, over vaults, not dug in. A venue for games, gladiatorial and other, naval battles, parades, and nowadays for opera (that at Arles is now a bullring). 1st cent. AD.

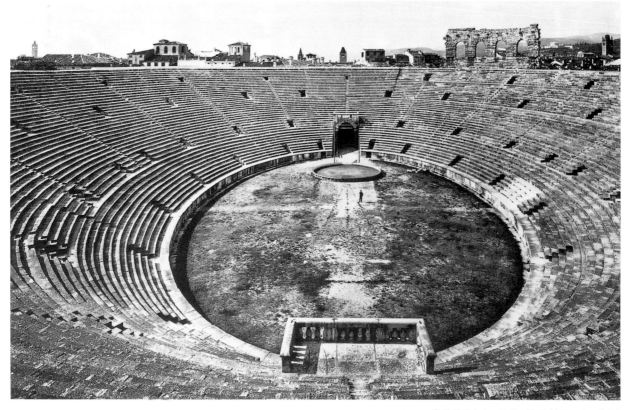

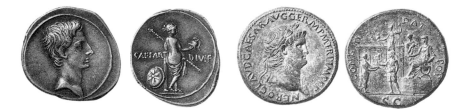

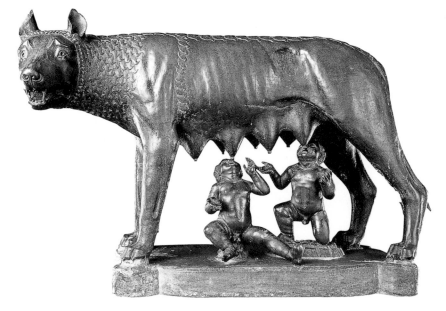

410 A model of the Palace of the Emperor Diocletian at Spalato (Split, on the coast of Croatia). About AD 300. Overall about 180 × 215m. Rome, Museo della Civilta Romano.

411 Art serving dynastic propaganda: (a) a silver coin with the portrait of Octavian, soon to become the first Roman emperor, Augustus. The reverse names him as son of the divine (Julius) Caesar and shows Venus Victrix, the divine ancestor of the Julian family. 31 BC; (b) a bronze coin of Nero, his portrait and titles on one side, on the other he supervises the distribution of food and money to the people, under a statue of Athena (Minerva) and attended by a servant holding a symbol of liberality. AD 64–66.

412 A bronze she-wolf, a study of the animal associated with the early history of Rome who suckled the founders, Romulus and Remus (Pollaiuolo supplied two babies for the creature in the 15th cent. AD); a great display of pattern (the neck mane) and animal strength. Early 5th cent. BC. Height 85cm. Rome, Capitoline Museum.

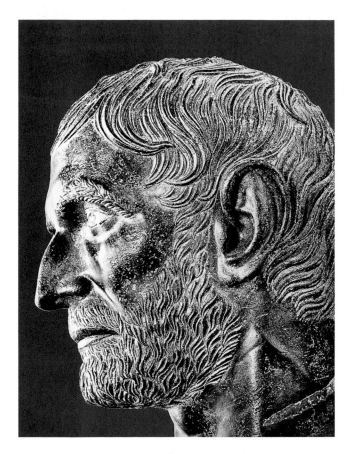

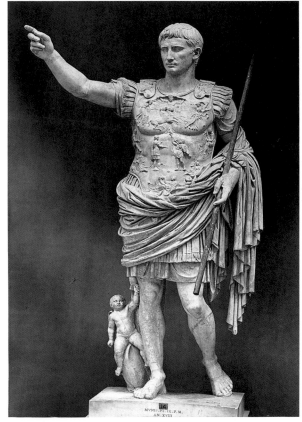

413 An Etruscan or Republican Roman bronze portrait, long popularly identified as Brutus; it has a measure of idealized realism which is not quite Greek. 3rd/2nd cent. BC. Rome, Capitoline Museum.

414 The Prima Porta portrait of Augustus, from the Villa of Livia outside Rome. The young emperor is shown as a general, but bare-footed, and bare-headed although in armour, which could be a heroizing touch. The pose derives from the characteristic Greek Classical for an athlete or hero. The corselet is decorated with symbolic and historical figures. About 20 BC. Height 2.03m. Vatican Museums.

415 A Roman Republican portrait of a man, in marble. This is more ruggedly realistic. About 30 BC. Height 33cm. Providence, Rhode Island School of Design, Museum of Art.

416 *A noblewoman presented as an over-life-size and naked Venus, indicating her near-divine status. Late 1st cent. AD. Rome, Capitoline Museum.*

417 *The 'Ildefonso Group'. A classicizing confection in the Hellenistic manner. Apart from portrait and divine statues, which follow recognized types, there are few original compositions in the round in the art of the early Empire. This nameless pair was designed in the 1st cent. AD for public or more probably private display. Madrid, Prado Museum.*

418 *Portraiture can play its part in funeral iconography. Here the recumbent woman on the sarcophagus lid is from stock, but she holds a real portrait bust of her husband. 1st cent. AD. London, British Museum.*

419 Bust of the Emperor Commodus as Hercules, wearing the hero's lionskin and holding his club and the apples of immortality, supported by symbols of prosperity and power. Late 2nd cent. AD. Height 1.18m. Rome, Capitoline Museum.

420 Bronze portrait of the Emperor Septimius Severus, naked because divine, made for an area of the Empire where Classical nudity was even more acceptable for such figures than it had become in Rome. Early 3rd cent. AD. Height 2.06m. Nicosia, Cyprus Museum.

421 Equestrian and often over-life-size equestrian statues were tours de force for the artisan and stood as a challenge to Renaissance artists. This is the Emperor Marcus Aurelius. AD 164–66. Height 3.5m. Rome, Capitoline Museum.

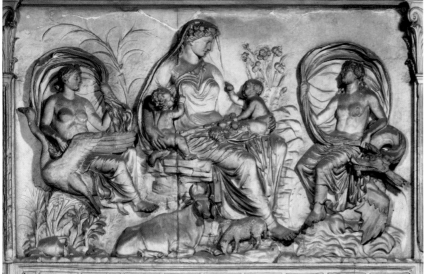

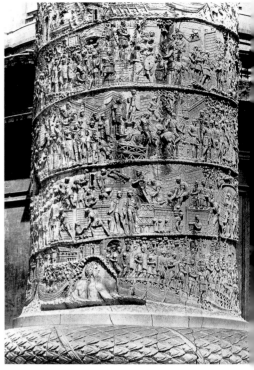

423 A detail of the spiral relief from the lower part of Trajan's column (early 2nd cent. AD), which stood in the Roman Forum. It depicts his Dacian campaigns in a relatively naive narrative style with rudimentary perspective, in a manner not too unlike the Assyrian nearly a millennium earlier. There are 155 scenes, each of which is coherent, without repeated figures, but not physically divorced from its neighbours. The relief, unwound, is about 200m long, the column 38m high. Height of relief bands 91cm – the figures thus roughly one-quarter life-size.

422 Reliefs from the Augustan Altar of Peace (Ara Pacis) in Rome. (a) With Mother Earth (Tellus), children and personifications of prosperity. Other reliefs on the Altar show the imperial family, and the dado (b) is a rich and fanciful display of floral scrolls, such as appear also often in metalwork and for house decoration in stucco or paint. 13–9 BC. Height of relief 1.6m.

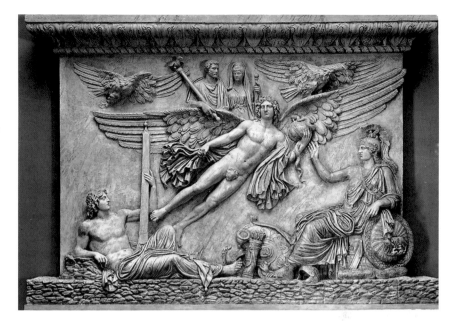

424 *This relief from the base of the column of Antoninus Pius in Rome (highly influential in the decoration of the Arc de Triomphe in Paris) shows the apotheosis of the emperor and his wife Faustina, who stand self-consciously on the back of a flying* genius *with eagles, watched by Roma (a figure deriving from Greek Athena), and the personification of the Campus Martius, where the column stood. He clutches the obelisk from Egypt which stood there too, as the 'hand' of a colossal sundial of Augustan date. AD 161.*

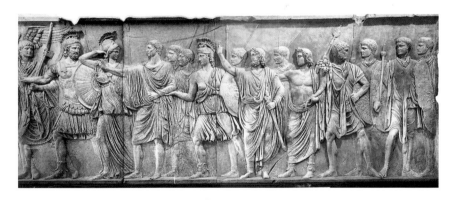

425 *A relief showing the Emperor Domitian setting out in the company of divine and allegorical figures, emphasizing his divinity and Rome's destiny. After he fell from favour, the head on this relief was re-carved to show his successor, Nerva – a practice (*damnatio *in Roman terms) also of the ancient Egyptians, an act of economy as well as substitution by a superior. AD 80–90. Height 2.07m. Vatican Museums.*

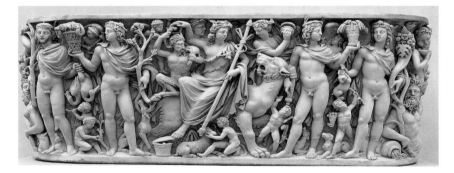

426 *Dionysiac subjects, carrying some intimation of immortality, were especially popular on marble sarcophagi. Here the young god (Dionysos/Bacchus) is seated on a lion, accompanied by Pan, putti and personifications of the Seasons. Early 3rd cent. AD. Length 2.21m. New York, Metropolitan Museum of Art, Purchase, 1955; Joseph Pulitzer Bequest (the 'Badminton Sarcophagus').*

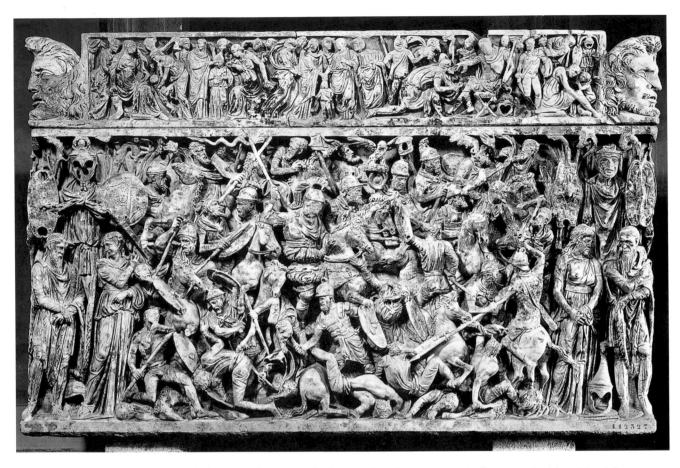

427 A 'Battle Sarcophagus', probably made for a general who served in the campaigns in Germany. At either side of the battle scene between German cavalry and Romans, their general on horseback at the centre, are prisoners and trophies. From Portonaccio, near Rome. Late 2nd cent. AD. Length 2.39m. Rome, Terme Museum.

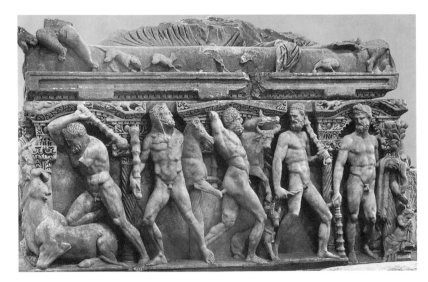

428 Hercules (Greek Herakles), a hero who achieved immortality through his labours, is a popular subject for sarcophagi. Here the labours are shown against an arcade. The groups derive from Greek types devised in the 4th cent. BC. This make of sarcophagus, 'Asiatic', was widely exported in the Empire, made on the marble-rich island of Proconnesus (in the Sea of Marmora). Early 3rd cent. AD. Length 2.5m. Konya, Archaeological Museum.

429 The Nile Mosaic, inspired by Alexandrian art, in the apsidal hall of the Sanctuary of Fortuna at Praeneste [404]: a grandiose riverine landscape with a full display of wild animals, and vignettes of convivial, military and religious life. Rome indulged no little Egyptomania, partly inspired by Cleopatra and her court, partly reflecting the role of Alexandria in Hellenistic art. 1st cent. BC. About 6 × 4.9m. Palestrina Museum.

430 This detail shows a girl baring her back to ritual flagellation, part of a long painted frieze decorating a wall in the Villa of Mysteries at Pompeii and representing a mystery ritual. Much depends in such painting on realistic coloration but the detail shows that draughtsman's hatching still plays a part in depicting light and shade. Late 1st cent. BC.

431 The bedroom of a villa at Boscoreale near Pompeii, as restored in New York; with a mosaic floor and the wall panels painted to show urban and garden vistas. Pompeii was destroyed by the eruption of Vesuvius in AD 79, and the discovery of its paintings in the 18th century AD revolutionized contemporary interior decoration in Europe. Mid-1st cent. BC. New York, Metropolitan Museum of Art, Rogers Fund.

432 An elaborate and fantastic architectural setting, loosely related to stage art and laid out in skilful perspective, is used in this painting from Pompeii to present the Anatolian god Attis, at ease in the central hall, attended by Eros and, at the left, nymphs. 1st cent. AD.

433 Wall painting released the artist's imagination as no other medium. Here is an idyllic rustic landscape from Boscotrecase, Pompeii. 1st cent. AD. Height 65cm. Naples, National Museum 147501.

434 Pompeian walls also display a quite different painting style, sketchier, with elongated figures, depending much on strong highlights and theatrical gesture. Here Trojans labour to pull the fateful Trojan Horse within their walls. 1st cent. AD.

435 Pompeii exemplifies Roman success at comprehensive interior decoration, but this was not confined to walls. This is the ceiling of an underground vaulted building found near the Porta Maggiore in Rome, decorated with low-relief figures in stucco against a painted background. Mid-1st cent. AD.

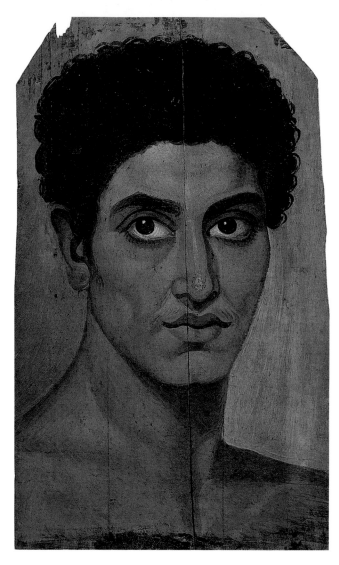

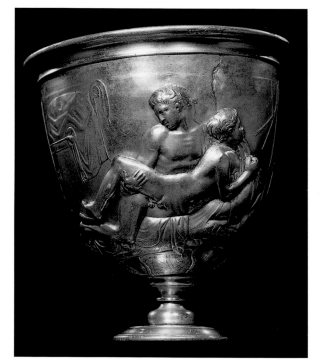

437 *Silver goblets demonstrate high technical proficiency as well as iconographic innovation. These examples offer the range of decoration. On (b) a Roman imperial subject, from Boscoreale, near Pompeii, with the Emperor Augustus, courtiers and soldiers, receiving the submission of defeated barbarians. Paris, Louvre Museum. (a) is more in the spirit of Hellenistic decorative and erotic imagery, with a scene of homosexual love-making in which some have detected portraits of Rome's imperial family. Early 1st cent. AD. London, British Museum GR.*

436 *The old method of burial by mummification persisted in Egypt, but in the Roman period the portrait of the dead, painted in tempera on board or linen and in Classical style, might be enclosed at the head end. There was a big cemetery of these in the Fayyum, some 100km south of Cairo, of the 2nd to 4th cent. AD. This is on wood, from W Hawara. London, British Museum EA 74713.*

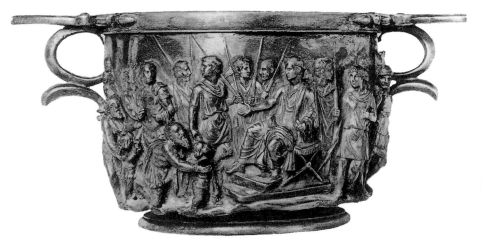

438 The centre part of a silver dish said to be from Mildenhall in Kent (England), in a hoard of silver including some vessels with Christian subjects. A late example of decoration and figures which remain purely Hellenistic in appearance: the head of Ocean surrounded by sea nymphs, and an outer frieze of satyrs and maenads. 4th cent. AD. Diameter 60.5cm. London, British Museum P&RB 1946.10-7.1.

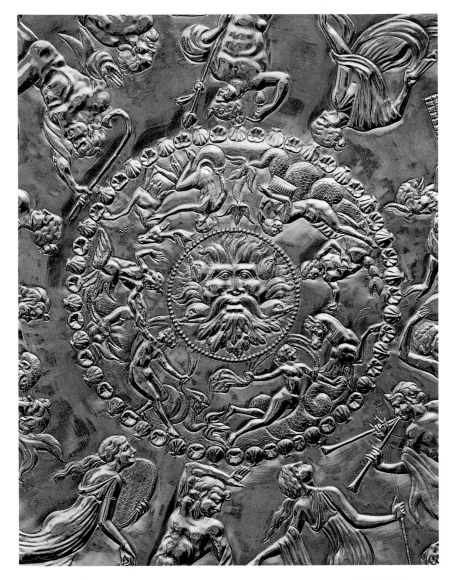

439 Relief plate was copied in finely moulded clay in 'Samian' or 'Arretine' ware, fired with a fine and glossy red slip, and with decorative and figural motifs. There was a brisk trade in such cups through the early Empire, with production also in several of the provinces. This is the mould for one showing erotic scenes in the finest Classical style, with the maker's seal. Late 1st cent. BC. Berlin, Staatliche Museen 1962.35.

440 The 'Portland Vase', a work in 'cameo-glass' with the upper pale layer carved in the technique of stone cameos (which are often copied in glass in this way). This vessel, with its still puzzling mythological and divine figures, inspired Josiah Wedgwood's essays in 'blue jasper ware'. Early 1st cent. AD. Height 24.7cm. London, British Museum.

441 The 'Gemma Augustea', a very large cameo of sardonyx, exploiting the contrasting colours of different layers of the stone. It glorifies imperial rule and success: at the top Augustus is shown as Jupiter with his eagle, being crowned, and the goddess Roma (like Athena) beside him, his zodiacal symbol (Capricorn) in a disc above. Tiberius, his successor, dismounts from a chariot, fresh from his victories in Germany (in AD 12), which are commemorated in the lower register by the erection of a trophy of arms and barbarian prisoners. 19 × 23cm. Vienna, Kunsthistorisches Museum.

442 As in Hellenistic Greece, portraiture became an important subject for gem and signet-ring engraving in Roman Italy. (a) is a rare Republican portrait on a gold finger ring, signed by the Greek artist [Her]akleidas. 38 × 29mm. From Capua. Naples, National Museum 25085. (b) commemorates Greek statuary, prized by the Romans; it is a glass copy of a gem signed by Heius, showing the head of a mid-5th-century statue of the Athenian legendary king Kodros (named in the headband). Heidelberg, Institute of Archaeology. (c) is a portrait on an agate pendant of Augustus' sister Octavia, as Diana (the spear before her); a companion piece shows her brother as Hermes. 1st cent. BC. 56 × 46mm. London, British Museum GR 1954.11-6.1.

443 Most Roman engraved gemstones follow the latest Hellenistic repertory, but more are inscribed, some have wholly Roman subjects, and in the east there is a long series of gems with magic formulae and Egyptian demons [284]. This cornelian is a more sober piece of Greek mythology: Diomedes escaping from Troy with the Palladion, being greeted by Odysseus. It is inscribed with the name (in Greek) of its owner, Calpurnius Severus, and on the altar of its engraver (Felix, probably a freed Greek slave). Early 1st cent. AD. Width 29mm. Oxford, Ashmolean Museum 1966.1808.

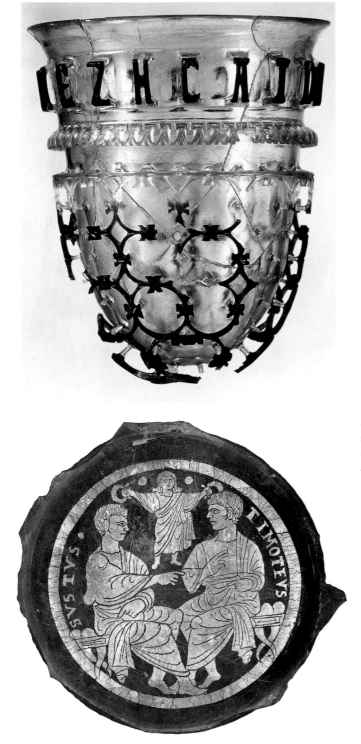

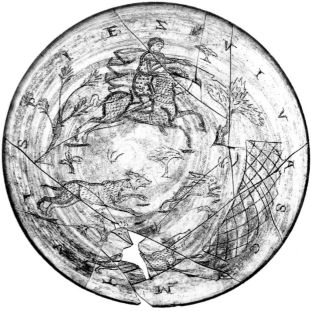

444 Glass 'cage cup', the relief decoration cut, not moulded, with red, green and gold, and a bibulous motto. A virtuoso type of glass which was a speciality of the province of Germany, where this was made. Cologne, Romano-German Museum 60.1.

445 Engraved glass is another innovation of the 3rd/4th century AD. This bowl, from Wint Hill in Somerset (England), is one of the latest Romano-British works made before the Romans withdrew from Britain. It shows a hare hunt and is inscribed in mixed Greek and Latin 'Life to you and yours. Drink and good health to you.' Diameter 21cm. Oxford, Ashmolean Museum 1957.168.

446 The later period offers considerable versatility in the handling of decorative glass, not all of it for luxury use. 'Gold glass' has decorated gold foil sandwiched between glass at the bottom of open cups, and was especially favoured for Christian subjects, often with a figure of Christ crowning saints, emperors or dignitaries. The Xystus here may be the 3rd-century Bishop of Rome. Vatican Museums.

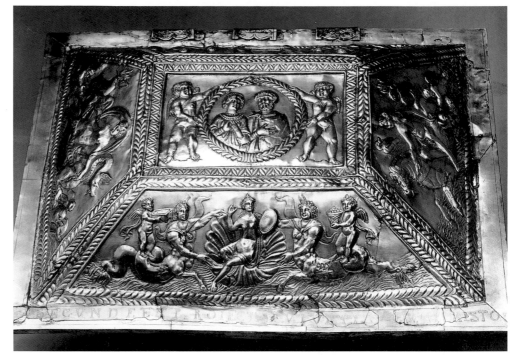

447 Projecta was a Christian lady of Rome: she may have converted her husband to Christianity. He (Secundus) is named with her on this gilt silver casket. It was found on the Esquiline Hill in Rome with other treasures, in AD 1793. It depicts her with her husband on the lid, and in public visiting the Baths, but the other scenes are wholly Classical in subject and style (mythological). Projecta died in AD 363. Length 54.9cm. London, British Museum P&RB 66.12-29.1.

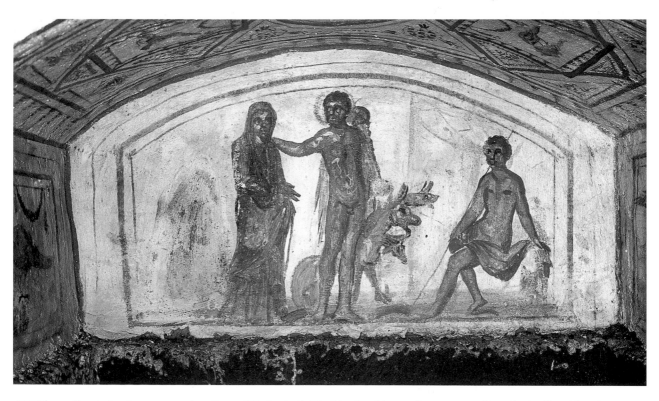

448 The wall painting in a catacomb at Rome (Via Latina). The Greek subject and treatment – Hercules leading Alcestis back from the grave to her husband Admetus, having subdued the hound of Hades, Cerberus (at his side) – is used to demonstrate Christian beliefs in resurrection. The hero is increasingly presented as a saviour rather than simply a monster-slayer. Mid-4th cent. AD. Height 65cm.

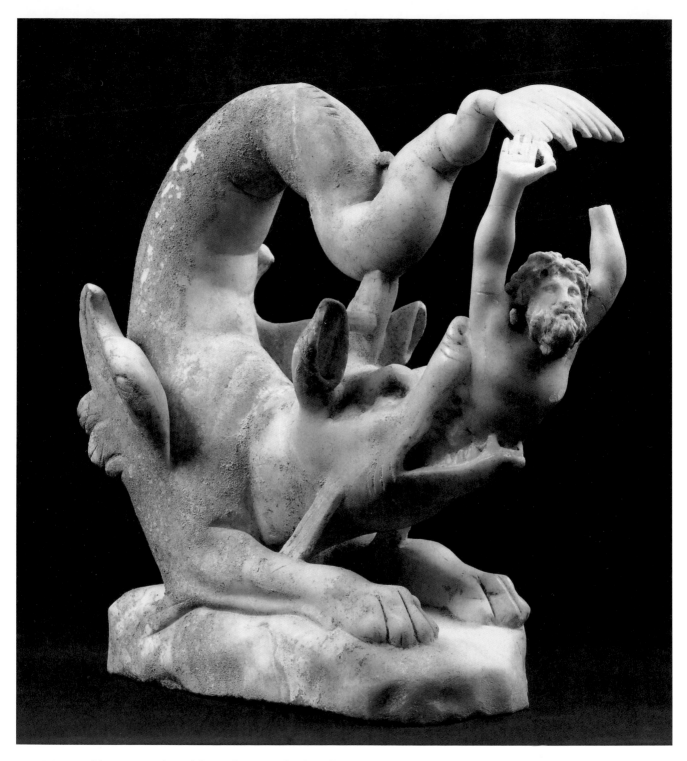

449 *A marble statuette of Jonah being thrown up by the 'whale'. A companion piece shows him being swallowed, and other figures in the group, probably from a funerary deposit in Anatolia, have other Jonah scenes, a Good Shepherd and busts of a man and woman – clearly Christian. The whale takes the form of the Classical sea-monster* ketos *rather than the cetacean; a common use of Classical imagery in the interests of Christian and Biblical iconography. 3rd/4th cent. AD. Height 40.7cm. Cleveland Museum of Art 65.238.*

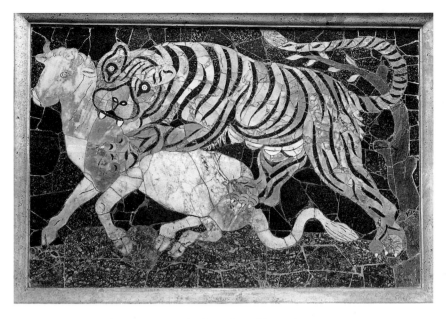

450 Opus sectile *uses pieces of coloured marbles and precious stones to compose figure scenes, and becomes a major style for interior decoration in the late period. There is much from the early 4th-century AD basilica of Junius Bassus in Rome; here we see a panel with a tigress attacking a bull. Rome, Capitoline Museum.*

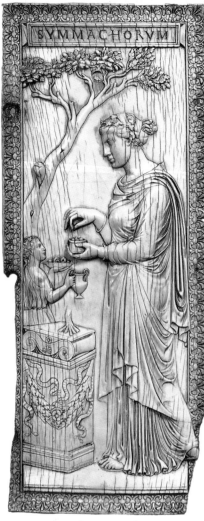

451 *Ivory diptychs (covers for writing tablets) were elaborate official gifts to mark special occasions. This is a leaf of one made for the Symmachi to celebrate an agreement with another family, the Nicomachi. (Nowadays it is pens that are inscribed and exchanged.) The scene is purely Classical, of sacrifice, at a time when pagan ritual was under Christian imperial attack. About AD 400. Height 30cm. London, Victoria and Albert Museum.*

452 *The Arch of Constantine in Rome. Triumphal arches were a Roman invention, a conspicuous way of celebrating victory, and they were erected all over the Empire. This example is unusual in that it incorporates reliefs from earlier imperial monuments. In the detail shown, the roundels had been made for Hadrian (AD 117–38) showing imperial virtues in the hunt and worship; below is a more formal relief showing Constantine (his head missing) distributing gifts. AD 312–15.*

453 The pursuit of Classical art far from the Mediterranean is rewarding both for what it shows in the dispersal of artistic techniques but especially for the ways in which the styles of Mediterranean narrative and display can be adapted to different cultures. Dura Europos is a Greek, then Parthian and Roman site on the River Euphrates, east of Palmyra, destroyed by the Sasanian Persians in AD 256. Among its buildings is a synagogue, lavishly decorated within with painted walls. This panel shows the anointing of King David in a late Roman style which we can see to be developing towards the Byzantine. Damascus, National Museum.

454 The late Empire can still produce realistic portrait sculpture but tends more and more to abstract pattern and unrealistic emphasis, more an expression of power than identity, in many ways prefiguring the Byzantine. This is the bust of an early 4th-century emperor, made and found in Egypt (Benha). Porphyry. Height 75cm. Cairo, Egyptian Museum.

455 While styles of Classical gem-engraving spread widely through the east, even to the Indian subcontinent, the cameo remained the less common form. Here, though, is a splendid Sasanian Persian example of the 4th century AD celebrating their King Shapur I's defeat and capture of the Roman emperor Valerian in AD 260. Sardonyx. Width 10.3cm. Paris, Bibliothèque Nationale.

E. OLD AND NEW WORLDS

Moving from consideration of the arts of the Old World to those of the New takes us into a possibly crucial area for the thesis of this book, and more into its archaeology than its art history. On it depends whether we can justly admit discussion of the arts of the New World on the same footing as that of the arts of the Old. This interlude is designed to introduce environmental and technical concerns which will help us through the following account of New World arts. This may help readers to approach Old and New on the same terms. The contrast with the Roman Empire may be less extreme than it at first sight appears.

Most modern histories of art will admit the existence of the arts of the Central American and Andean states (Maya, Aztec, Inca), usually emphasizing how different they are from the arts of the Old World and remarking that most of them belong to periods which in the Old World are mediaeval (if one chooses to ignore Asia), rather than truly 'ancient'. They make no serious attempt to align the achievements of the early New World with those of the early Old World in a comparable stage of development rather than date, and so in a strictly comparative manner. They also may remark on horrid habits, barely excused by religion, which are in fact no horrider than those of the Old World, although they may there be less prominent in the arts. A Maya pyramid, an Aztec idol and some Inca gold are enough to tell it all, with the observation that this is all basically 'Stone Age' until the Spaniards arrived in the 16th century AD

with their horses and gunpowder and Christianity, and proceeded to massacre the Americans or to kill them with European diseases. World-art histories written in the Old World tend to patronize the New; world-art histories written in the New World are somewhat better; but art histories devoted solely to the New World seem to draw comparisons with the Old sporadically and not in any comprehensive way, any more than do the archaeological histories. Dedicated prehistorians are generally more open-minded in these matters.

The pre-Columbian arts of America are infinitely rich in their variety and in the imaginative skills they display. It will prove more difficult to do justice to them here than with their Old World kin, and not simply because they have been less thoroughly explored, which is only partly true, but because they represent work over a very large area for a greater time span than most

of their Old World comparanda. There is indeed a certain unity of style, but it is expressed with vigour and in a multitude of forms.

It is not just a question of the arts and this section is called for so that there can be some consideration of other aspects of life and technology which might lead us to believe that there is no reason to separate discussions of Old and New. To illustrate the problem, we start with two matters which have caught the attention of many as seeming to distance the New World from the Old in our subject as well as in the history of man. The invention of the wheel takes a prominent role in accounts of Old World civilization, enabling easy carriage of bulk materials and use of chariots. The early New World had no wheel, implying, for the thoughtless, a remarkably unimaginative and backward society. But wheels are only useful for moving heavy loads over hard surfaces, and to do that you need a draught animal to pull the cart. The Old World had horses and oxen, and for carriage camels and yaks; the New World had only dogs in the Arctic north for carriage, while llamas can hardly carry more than a man and are less manageable, though they could serve as mounts. So we find no wheels for transport, but only for toys. As a result perhaps there was a general aversion to rotatory technology – bow-drills, potter's wheels and the like, at best rollers. Again, the progress of Old World civilizations is determined in the minds of most scholars by technology, especially metal technology – with the sequence of Stone/Copper/Bronze/Iron Ages – to the point that much in the development of society and trade is attributed to access to and skills with metals. The New World never properly developed a bronze and iron technology, and so, it may be thought, it has to be judged beside the Stone Age cultures of the Old World and nothing more 'advanced'. But some of the Americans were highly skilled with precious metals for ornament and display. And although they did not find the tin with which to alloy their copper and make bronze, they did nearly as well with *tumbaga*, an alloy of copper and gold, unknown in the Old World, a technology that came late, from beyond Panama (Colombia), and which only came north in the latest period.

Lack of the wheel and of metal technologies did not, however, hamper them in constructing architectural monuments in stone that stand comparison with most in the Old World for both size and finesse of execution, and in building well-planned cities of great extent. Nor did their highly sophisticated social systems depend on control of high technology, but rather on what has always been the main sustaining factor worldwide – a large population devoted to the production of food. Ploughshares are the better for being of iron, and best with animals to pull them, but fire-hardened wood for digging sticks is efficient if the manpower is available. The efficacy of weapons depends on how they are designed and used, and what the opposition has, not what they are made of. Populations dependent on lands rich only in metals will starve unless they exploit their wealth in trade, for food, which is what proved necessary for several Old World states. Old World technologies were not the only way to prosperous societies which sought to express power and their relationships with the divine and mortal through the practice of the arts. All the New World arts are readily paralleled in the Old World, even if not at the same time.

We shall see what the New World achieved in the arts after this interlude, but first a few words are required to help bridge the gap between Old and New in the minds of readers – a temporal, spatial and conceptual gap which exists in the minds of many Old World historians, archaeologists and art historians, who might learn much from the achievements of cultures wholly insulated from the intellectual and technological life of early Eurasia and Egypt.

It might be argued that comparability is impaired by the fact that the Central American civilizations, although unquestionably urban, are not altogether climatically and environmentally temperate. This is only half true and not altogether relevant. Geographically they lie astride the Equator, between the Tropics of Cancer and Capricorn, not mainly to the north, as do those of the Old World. They match more of India and South-east Asia than Africa, but are by no means just desert or rainforest. Much of central Mexico is a high plateau (2400m high, the 'Mexico Basin') and well served with rivers, with a broad central valley and lakes which were

the focus for Aztec power. The Maya to the south are more tropical, lowland in the north, highland in the south, but they met the challenges by skilful waterworks and were encouraged by native crops that ensured rapid population growth, a major factor in urban development in Old and New Worlds. The rainforest proved no bar to progress when other sources for prosperity were available, and it is possible that it was not so extensive in antiquity. Rainforests seem to come and go quite quickly with climatic changes. As for the 'tropical' aspect, major urban civilizations also arose in some tropical areas of the Old World, but only after the period studied in this book (in south India and South-east Asia).

In the south, the Andean environment ranges from a coastal desert, well served by sea-fishing (a major factor for subsistence from an early date), with not very well-watered river valleys, up to the highlands. Prosperity was mainly dictated by the highlands, balancing the resources available from lower territories but able to sustain major urban centres, and with river valleys and a lake (Titicaca) as focuses, but with strong regional differences, reflected in their history and arts. Temperate urban zones are defined as much by what they are not as by what they are.

The problems of earliest history play a more important role in the New World than in the Old, where the very early spread of *homo sapiens* from Africa and subsequent settlement can be roughly charted. We may take it as axiomatic that the New World played no part in this, and that the earliest urban societies of Central and South America developed with no serious knowledge whatever of the Old World. The earliest contact, long before the arrival of Christopher Columbus, was the passage of Palaeolithic man into Alaska over the Bering land bridge, even before the beginning of the last Ice Age 20,000 years ago, and also repeatedly after it ended about 12,000 years ago when the Bering Strait was flooded. DNA research shows that the immigrants were from various areas of China, Siberia and Central Asia, this eastern 'Caucasoid' perhaps contributing most to the native American population (Kennewick man). The northern migration at least brought with it the technology and arts of the day, still relatively unsophisticated. However, a suggested late migration soon after 2000 BC could have brought elements of early Chinese art (Shang Dynasty) which some have tried to trace down the west coast of America. Whether these can account for broad similarities of stylization between the arts of China and those of North and Central America is another matter. Then there was some far-northern and strictly localized exploration by Norsemen in centuries AD.

South America is presumed to have been settled from the north and this must largely have been the case, but DNA has even suggested some very early arrivals from the due west (reversing Kon-Tiki), and stylistic similarities with Chinese art in a period when South America was developing, at last, a metal technology (with the Chavin) might not be totally illusory. The sweet potato reached Polynesia *from* America by AD 1000. Maybe these oceans were not so impassable.

However, none of the arguments supporting any other *influential* contact from across Pacific or Atlantic carries any conviction, and although I suppose some Phoenician sailor might have been carried off from the Straits of Gibraltar or the Morocco coast to the Caribbean by wind and currents, he was unlikely to have had in his crew skilled geographers, architects, mathematicians, artists and scribes, nor need any have followed him – and at any rate the cultures of Central America were already on course long before 1000 BC, while recent finds push yet farther back the apparent development of sophisticated societies. And we can forget myths of a lost continent of Atlantis. Similarities are generally explicable in terms of a common human response to common problems, such as can also be detected in parts of the Old World which seem not to have communicated with each other. Dissimilarities seem to have been the product of, perhaps, genetic history, but certainly of environmental differences: no draught animals so no wheel, no prominent deposits of hard metals so no advanced metal technology, a different range of native fauna and flora, just to hark back to examples already cited.

We may review a few cases of similarity and dissimilarity, taken from the monumental to the trivial, some of them impinging on the arts. I shall not always specify *where* in the New World various features or

practices are attested; in this context it is enough to know that they existed somewhere in the Americas.

Stone masonry was dressed without hard-metal tools, as it was in Egypt (using pounding and abrasion with stone and tools of copper), with no loss of ability to handle massive blocks, to dress them with extreme accuracy and to construct with them walls, ashlar and polygonal, with the very finest joints. The best of this is in Andean buildings **457, 551, 552**; the Maya and Aztecs were generally less ambitious except in sheer size of structure **34**. Working stone on stone was a basic technique but could be helped out with drilling, with solid or tubular drills (of bone), again such as were used from an early date in Egypt, for both masonry and on small objects: a rare example of a rotatory technique though not with a bow-drill, as in Minoan Crete and Egypt, but in the hands. The Old World often used clamps and dowels to bind stone blocks, wooden in Egypt, metal set in lead elsewhere; the New World did not, except in the Andean highlands (copper cramps). Nor did the New develop the technical, then aesthetic refinement of drafted margins to blocks (smooth border, rough centre), locally important in the Old World, though lifting bosses could be left on blocks (as at Machu Picchu in the Andes), possibly for decorative effect.

The New World masons did not discover the arch, but were adept at the use of corbelling to cover parts of all-stone structures **40, 456**. This use of courses of stone overlapping gradually to meet at the top was only closely matched in the Old World in Mycenaean Greece and Sardinia **36, 37, 39**, and superlatively in the round for the construction of the 'beehive' tombs, but the general principle was universal. The Maya seemed to manage the technique using quite small blocks which appear sometimes to defy gravity, but they also discovered how to make a lime mortar and concrete to bind the stones. This was a technique which escaped Old World cultures until the rise of Rome, except for the manufacture of stucco (plaster), in use already in the Neolithic Old World, and which was also used in the New World to face walls and carry painting, and could be modelled over wooden plates or small stones. Circular and apsidal plans are rare in America for major building. They are inspired by reed and thatch, or skins on a wooden frame, rather than rectangular wooden and brick construction, which lies behind most Central American architecture of a monumental character. Domestic architecture, which might also inform the palatial, was not unlike that of much of the Old World in similar conditions of climate and material – sun-dried brick walls and thatch. Fired brick was a very isolated phenomenon, used only where stone was unavailable for building. The patterning of rising walls of major buildings in relief or with painting was commoner in the New World than the Old **456, 466, 468**. Elaborate wall patterns in stucco or clay **548** recall Old World practices in Parthia and later Islam.

From the material to the intellectual: all early peoples are concerned about the passage of time and the seasons. All early urban peoples treat the matter with extreme sophistication and develop higher mathematics to record and predict events of great social, and therefore religious, moment. The Maya were supreme in this but devised counting (including the vital discovery of zero) and calendrical systems quite unlike those of the Old World, and in many ways far more advanced: a 365-day year, a 260-day sequence of twenty-day months, as well as bases for era dates counting from important events or the foundation of dynasties, and a Long Count of days going back to 3113 BC. All this provided data for a strong interest in the historical past. There was the same motivation and intellectual response as in the Old World, but of a different order **459**. Weighing and measuring systems seem to have been no less complex.

There was no need for 'money', although cacao beans could be used in the way that cowry shells were in China. Money, meaning stamped or inscribed, certified metal, came relatively late in the Old World too – 6th-century BC Anatolia, earlier in China. There was no need in the New World either for sealing, for property or documents, which we have seen to be an important function in much of the Old, but there were some small stamp and cylinder 'seals' (*pintaderas*) in clay (Olmec and South American) for decoration of flesh rather than textile or clay, not for identification. But, for identification at a different level, there are some patterned brick stamps (Moche). In Central America writing started from pictographs, as

in the Old World, but the results are visually and linguistically totally different. Mayan was written from left to right and often in two columns read from top to bottom 52. Again, there was the same motivation and invention of a similar process, although it seems in application to have been even more different from those of the Old World scripts than they are from each other. Reduction to an alphabet never happened, as it did eventually for the Old World in the Levant. For books in the latest period something like vellum parchment was used, as in the Old World, and a paper made from figbark was the equivalent of papyrus. South America remained illiterate but Incas had the *quipu*, a device of multiple knotted cords, for record and calculation.

Passing to matters apparently more trivial but more often engaging the artist: spears and knives are weapons any human would devise, and at their simplest they go back to Stone Age use of worked-stone edges and points fitted to wood. A spear can be thrown further and harder with the use of a spear-thrower, like an extra joint to the human arm. Both Old and New World hunters devised them. Longer blades need hard metal, so the New World had no swords, but at best long stone daggers, such as we find also in early China, but they wielded heavy clubs of wood and stone and carried small round shields to parry blows; there was no metal body armour. Bows and arrows seem only to have reached the North American Indians around AD 500, from the north, and no farther south. This seems an odd aberration of non-invention in the New World, although the weapon may in fact also have arrived in Central America very late and from the south, if arrowheads are correctly identified. Stone as hard as jade was worked from an early date, probably cut into slices using a saw of string and abrasives, as in China, and drilled by hand. Jade was as much admired as in China, since the Maya would collect the older Olmec jades and add inscriptions. It came to be valued even above gold ('excrement of the gods' to the Aztecs).

Weaving techniques seem identical in Old and New Worlds, with both hand looms and fixed looms, and as a result some comparable woven patterns suggested by the comparable techniques. The Andean cultures were precocious in tapestry, embroidery and lace-making

523–25, 546, 547. Clay, the ubiquitous and most versatile of media for early man, does not need a potter's wheel to be exploited for pottery, and the New World's aversion from rotatory technology may explain why the wheel was not independently invented and used there. Parts of the Old World moved quickly from the slow to fast potter's wheel, but even there it was not universally adopted. New World pottery was moulded, carved or built up in coils and slabs, but a non-pivoted turntable could be used to help, especially in the decorating. The technique of 'tremolo' or 'rocker' decoration on clay was devised in both Old and New Worlds – impressing a zigzag by 'walking' a shell, serrated edge or chisel across clay (or metal, in the Old World); also the multiple brush, like a comb, for economical vase decoration of parallel lines. Lead could be used to produce a dull glaze in the fired clay (plumbate), but not the true, glassy glazes of the Old World, although there was skilful employment of colour with various pigments and methods of firing. For the plumbate a built kiln was probably required; otherwise firing was 'open' (to 700/800 degrees Centigrade). There was no production of glass or enamel, but plentiful use of coloured stones for inlay, as in the Old World. A Maya potter invented the bayonet-top jar; the Chancay of Peru made as good lace as contemporary Italians.

Metal technology has already been mentioned. In precious metals the New World's control of the material was supreme, though mainly in South America, near the sources. Moreover, both New and Old devised not only the mainly obvious ways of treating gold decoratively – casting it or making foil and the chasing and tracing of sheet gold – but also the abstruse technique of soldering gold to gold, even for granulation and filigree, an ancient technique which baffled modern science for many years. Both Old and New Worlds used the lost-wax technique for casting solid figures in metal but, more remarkably, both also used it for casting hollow figures, although the New World never aspired to the very large castings which bronze allowed. Hammering on to positive or negative matrices was a shared technique. In the New World monumentality was for architects, and for architectural more often than free-standing sculpture.

Technical mastery over the environment was demonstrated in ways barely matched in the Old World. The challenges of the rainforest and drought were overcome by miracles of drainage and irrigation. For food supply there was an advantage over the Old World in possession of the most fecund of all cultivable grasses – maize. Elevated roads are a feature of areas of major irrigation, and later the creation of raised fields set in a network of canals (Aztec *chinampa* farming – 'floating fields'). If we assume that present-day rainforest areas were much the same in antiquity large areas would have to have been cut back for occupation and farming, as they are today in the Amazon forests. But in the Maya lowlands there are signs of a period of relative drought after about AD 100 which would have abetted deforestation. In Peru they cut underground water channels for irrigation, recalling the *qanat* of Central Asia.

At a more personal level, processes of skull deform-ation in babyhood, for aesthetic, religious or practical (carrying loads) purposes, are apparent in the New as in the Old World at various periods. And religious interests are, as in the Old World, directed towards personal and corporate survival, the weather and crops, and against enemies, and served by imaginative explanations common to man everywhere. Care for the ancestor was supreme, by monument or, in places, mummification – the Incas kept and worshipped their mummified kings.

I demonstrated in the Preface my personal discovery that the visual experience of any New World society must have been totally alien to any of the Old. This experience was, nevertheless, dependent on shared principles in the treatment of materials, devised independently and differing only where local conditions, essentially the environment (animal, vegetable, material, geographic and climatic rather than purely social), required different solutions. In the course of the next sections we shall also see what was and was not shared in matters of artistic perception, design and execution, but the principal aim will be simply to present what was achieved by the New World artists.

It must be repeated that we are dealing with an extremely large area, comparable with the whole of the Near East including Mesopotamia and Egypt, and over some three millennia. The political history is complex and still far from clear except for the later

CENTRAL AND SOUTH AMERICAN PHASES AND DATES

BC	Central	South	BC
1500		*Initial Period*	
900	*Early Formative*		
	Olmec		800
600	*Middle Formative*		
		Chavin: *Early Horizon*	
300		Paracas	
BC/AC			BC/AC
	Late Formative		
300	*Early Classic*	Moche: *Early Intermediate*	
	Teotihuacan	Nazca	
600	Maya	Tiwanaku: Wari	550
900	Maya		
	Early Postclassic		
	Huastecs		1000
	Chichen Itza	Lambayeque	
1200	Tula Toltecs	*Late Intermediate*	
	Late Postclassic	Chimu: Chancay	1400
	Mixtec: Aztec: Tenochtitlan	Inca: *Late Horizon*	
1519	Spanish Invasions		

centuries; by reducing discussion to broad concepts like 'the Maya' we may be concealing many local and possibly short-lived achievements that could deserve treatment. That the overall similarities nevertheless transcend the superficial visual differences encourages this broad approach, but this is an area for which far more scholarly time and authentic discovery are required before the record can be treated on quite the same terms as the Old World. Readers with expectations bred by study of the Old World may be dismayed by material that seems so exotic – yet is no more so in fact than the Chinese might seem to a Westerner, and visual differences cannot conceal fundamentally similar intentions and responses to the challenges of survival and the search for prosperity. The search for world peace was not, despite the *pax romana*, much of a concern to the peoples whose arts are studied in this book.

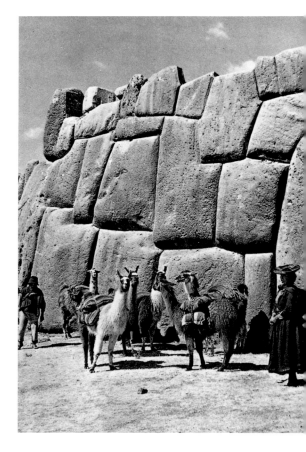

456 A detail of the façade of the 'Governor's Palace' at Uxmal, demonstrating the role of corbelling to span entrances (here narrowed below), combined with the highly decorative horizontal treatment of the rest of the façade.

457 For truly ambitious use of masonry we turn rather to South America and especially the Incas. This shows part of the zigzag rampart wall to a fortress (Saccsaihuaman) above Cuzco. The massive polygonal blocks are carefully fitted, almost seamlessly. 15th cent. AD.

458 Developed scene on a Maya cylindrical clay pot, showing scribes (one of them the Maize God). 8th cent. BC. Private Collection.

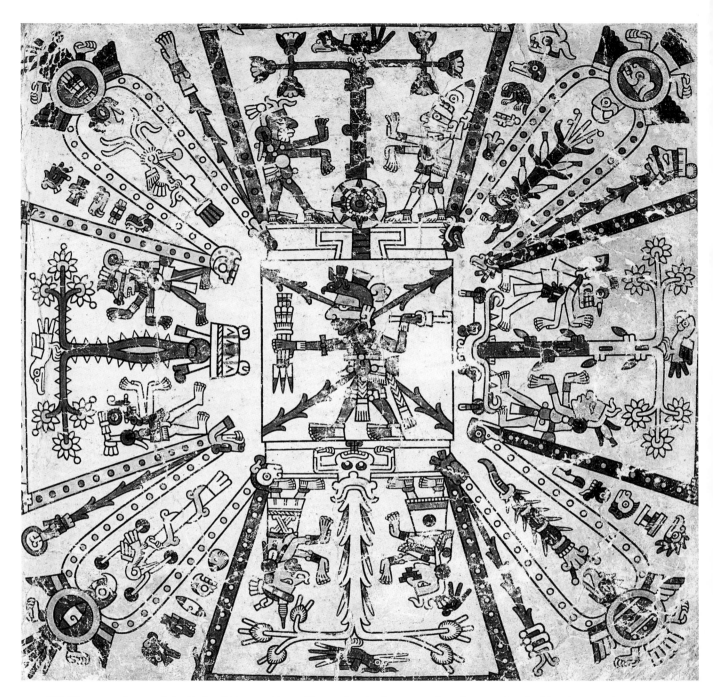

459 *The cover picture of the Codex Féjervary-Mayer illustrating the Aztec cosmic order, associated with colours and animals, set in a Maltese cross with 260 dots on it, signifying the 260-day ritual calendar cycle. Just post-Conquest in date but purely Maya work. Liverpool, National Museums.*

CENTRAL AMERICA (MAYA AND AZTEC) MAP 10

The earliest culture, which distinguishes itself for its monumental architecture and sculpture and which begins to express what we shall recognize as Central American style (the Formative phase), is that of the Olmecs, on the Gulf Coast, over roughly the 1,500 years before Christ. Thereafter, in Central Mexico, the city of Teotihuacan becomes a focus for the Classic phase (AD), at a time when the Maya Empire is flourishing to the south and east, over the following thousand years. The Maya decline around the end of the 1st millennium AD, possibly in part the result of prolonged drought, was followed by the relatively brief (compared with what had gone before) dominance of the Aztecs in Central Mexico from the 12th century AD to the arrival of the Spaniards in the early 16th century. There are many smaller groups of people, with distinctive arts which are sometimes influential in the more dominant centres, but their historical relationships are often obscure, and this has to be a nutshell history of a very complex period whose unity is expressed as much as anything by a certain unity in its arts.

The cities of the major empires could be enormous, sustained by a large population and a well-organized rural economy based on advanced skills in irrigation and early and effective domestication of crops, notably maize (corn) and beans; the Maize God is as important a deity as the Rain God Tlaloc. In central Mexico both Teotihuacan (early AD) and the Aztec capital Tenochtitlan (just pre-Spaniard, buried under Mexico City) may have had populations approaching 200,000. It was perhaps a symptom of the lack of sophisticated weaponry among neighbours that the cities lacked major fortifications with architectural pretensions, like those of Mesopotamia. They are not a feature of city plans, nor are there territorial dividers,

like China's wall. But this is not a token of peaceful interstate behaviour, and the empires which are the best understood were composed of many states, sometimes each with several urban centres, sometimes allied, often at war with each other. Decipherment of inscriptions has shown that states were subject to dynastic rule, and that most cultural divisions which have been discerned were a matter also of dialect differences. Although some nurtured locally significant styles in the arts, there was an overall homogeneity which strikes the eye despite the great range in time and place.

The most conspicuous urban areas at all periods were an assemblage of buildings whose function seems to have had more to do with ritual and burial than administration. 'Palaces' as administrative centres can be identified, while the domestic architecture of the towns and compounds scattered widely around these centres seems to have been nondescript and not even supplied with any regular road systems. Ubiquitous are the mounds or pyramids, hallmarks of Central American urban architecture **22, 461, 463**. Their alignments and grouping seem determined by careful astronomical observation, at which the Americans seem to have been more adept than most early peoples, leading to highly complex calendrical systems **34, 459**. The mounds are crowned by ritual buildings approached by very steep, broad or narrow stairs. Some are solid stone, but most are faced with stone, which may receive a stucco finish for painted decoration, and with time the cores may be built up more economically on a network of corbelled vaults, topped by a tall, slim 'roof-comb' **465**. Some achieved their height by being built one upon another by successive rulers, and some carefully enclose other structures such as tombs, which have remained preserved with all their offerings and decoration intact. Provision of suitable burial for rulers seems to have been the major source of inspiration, making them virtual 'ancestor complexes', and some have thought that even the plazas between the mounds might have been taken as paradigms of the underworld, while human sacrifice clearly played a major role in a ritual designed to secure the state and its future: life was dependent on death. This interest in the past is a concern shared by most urban societies, although not quite in this way.

The Pyramid of the Sun at Teotihuacan **22** was at least 61m high (the tallest Egyptian pyramid is nearly 150m). Sheer height was a major factor, granting access to the heavens, rather than serving any specific or universal civic or religious function. The mounds almost play the role of an architectural mode, like Doric or Gothic, rather than functional architectural units. Other structures seem to depend on the model of wooden building techniques, but using the pillar more commonly than cylindrical column, except with the later Maya in the north. Corbelled stone vaults may lighten walls and, side by side, offer something like breadth of plan, but the original 'Halls of Montezuma' were tall rather than wide. Buildings generally stand independently and, even when grouped around an enclosed court, like the Maya 'Nunnery' at Uxmal, do not observe common plans for each wing. Long low façades are in order, with repeated structural or decorative motifs, which are nonetheless individual to each building, so they do not create anything like an 'order'. All-over wall decoration in relief – stone, stucco or brick – was normal **460, 466, 468, 469**.

Ball courts – large open rectangular areas with side walls, vertical or battered – appear on many sites **470**. This original American Ball Game was played with a heavy rubber ball, propelled by hip or forearm: a strange sport which has survived in a reduced form to the present day in Mexico. The courts' lower walls may be decorated with reliefs; some imply that the penalty for losing was death **477**, and the whole performance was clearly one of ritual rather than pleasure or exercise. This is an unusual example, outside the Classical world, of architecture in the service of sport.

Palaces seem no more than a succession of chambers behind a richly decorated façade, and there are signs of quite sophisticated plumbing in places, even sauna baths. Here and there large corbelled 'arches' **40** lend the only curvilinear feature to otherwise rectilinear elevations. Purposes often remain obscure – palaces, administrative offices, storerooms, even 'observatories'. Royal and priestly functions commonly cohered in antiquity but elsewhere they were usually also given different foci, in palace and temple.

On Maya sites whole staircases (as at Copán) may be covered with inscriptions recording the past history

of the dynasty. Only Egypt, Mesopotamia, Persia and Rome match this for records in monumental form. In most places and periods in Central America there is evidence of the retrieval and respect offered to older monuments, which may have been adjusted for their new role as memorials of a significant past.

Relief decoration overall leaves few bare walls on major buildings. It is mainly geometric but embraces the figural, especially animals and faces (masks 468), the principles of design for which we have yet to address. Again, each system of decoration seems individually devised, even when using common features – masks, skulls, snakes, geometrical devices which seem derived from textile patterns. The universal practice of employing a carved human figure as support is known, but uncommon 33. Low relief figural slabs decorate doors, dados and pillars 467, 474–76, and figural painting on surfaces of dry stucco (not true *fresco*, which is kept damp for painting) could be employed for interiors as well as façades 483, 485, 486, where there may be quite ambitious stucco relief figures also. Figure reliefs are generally shallow with the details incised rather than modelled 479. As elsewhere in antiquity, we easily underestimate how much colour went to inform the visual experience, in exteriors as well as interiors. Major hieroglyph inscriptions can play a conspicuous role, and they kept their pictographic content throughout antiquity without being significantly demoticized or simplified in form.

While the composition of architectural decoration is generally symmetrical, there is little impression, apart from the few pillared façades, of any attempt to create any unity of design or even scale between constituent parts. The result is a near-riot of architectural decoration which can appear almost a design fault; amid it the only dominant physical elements are the great stepped mounds. The requirements of religion seem to have dictated major architecture to a degree more absolute, it may be, than they did even in Egypt.

The desire for lavish carved-stone decoration was in no way diminished by the laborious techniques required, using only stone to abrade or cut, not metal. Man's need to express his experience of the world in the arts of decoration and images was conditioned by the

techniques available to him, but only to a minor degree did they ever inhibit the range of that expression. This is made abundantly clear by Central American arts.

In the figural arts, both for architecture and smaller objects, two principal modes, and compromises between them, can be detected throughout the period we are studying. One is formal, what I call hieratic 475–78, 496, with near-geometrical, angular stylizations of natural forms, usually rendered in outline and sometimes composed in rounded rectangular fields even when they form part of a figure. The head alone, whether real or as a mask, is always important, in art as in ritual. This is the formal mode for major works in stone but it is also apparent in the lesser figural styles, as on painted pottery, where parts of the body are similarly stylized.

With time details are relaxed, and eventually the figure motifs seem to have been 'deconstructed' and the original forms may be obscure. This is what we see in reliefs and paintings of figures and groups, where the profile view was the rule. Frontality was generally for the divine only, and even the frontal figures splay their feet into profile. There are examples, however, of greater realism both in parts and for the whole, where even three-quarter poses are effectively rendered, although not true foreshortening of limbs (as opposed to concealment of limbs 488), and this other major mode shows us artists ready to attempt a degree of realism which only fails to achieve that of the Classical or Chinese because it is generally piecemeal and seldom applied for whole figures or groups 472, 487, 492–99. We see this most often in painting, but even overlapping of figures is generally avoided until the latest period. In effect, the range is much the same as that we saw from China to Egypt, and in Greece down to but not beyond the Archaic period, but with different emphases, and with the dominant geometricization of whole and part lending an altogether different aspect to all the work.

There is a decided *horror vacui*; the available field for decoration must be filled, and there is no feeling for ambient space around figures. This, in figure scenes in relief or on vases, is abetted by the extravagances of dress – feathered clothes and headdresses in the form of animal heads (birds, snakes, jaguars), exploiting the

rich avian life of the region, but creating a rather ragged appearance to eyes more used to arts which concentrate on the essential figure rather than its trappings. It is a characteristic of many Central American figures, more than most others appearing in this book, for the mouth to be shown open; this may have something to do with 'utterance' being an expression of power. As in Egypt, inscriptions may fill the field, and identities are indicated by these inscriptions or attributes, but there is little by way of close stereotyping or establishment of many conventional 'types' for individual deities. The American artists seldom repeated themselves as slavishly as many in the Old World.

Some of the most laboriously executed sculptures are also the earliest – the great Olmec heads of basalt **471**. Their realism is matched in smaller sculptures of figures with high-crowned heads, reflecting the widespread practice in the Americas of skull deformation. Many of the early figures are in jade **473**, one of the hardest of stones to work but rewarding for its deceptively soft appearance and translucency, as the Chinese had discovered. Some figures of flint exploit a technique otherwise required for the making of spearheads or knives **499**, not a genre attempted much by flint-users elsewhere. The Olmec figured reliefs range from altars to thrones, and there are some strange figures of fanged 'were-jaguar-babies'. It was the Olmecs who first explored that stylized, hieratic treatment of figures, in relief, which was to be characteristic of the whole area for centuries to come, rendered in great profusion by the Maya and Aztecs on architectural relief, but no less in painting and the minor arts where there is an engaging range of materials in use, such as feathers **519**. The few pieces of carved wooden sculpture surviving **494**, and the clay, some of which (especially with the later Aztec **510–12**) are of considerable size and attest especial skills in firing, show that the artist was not obsessed by the angularity encouraged by stone-cutting techniques. The paintings tell their own story **483, 485, 486**. With the Maya, the realistic traits are sparse and generally late.

Maya art, from its beginnings in Olmec art to its last phase of Toltec influence, embraced a vast area – eastern Mexico to Guatemala – and lasted for over a millennium. The southern sites decline in the 9th century AD, and the latest phase is exemplified in the Puuc hills of the Yucatan peninsula and at sites such as Chichen Itza (settled by the Itza from the south) and Uxmal. There are local fashions, only discerned where enough of one site has been excavated, but there was an overall unity of design and style no less remarkable and almost as long-lived as the Egyptian, and equally distinctive to our eyes.

The message of the arts depended mainly on complicated statements of religious behaviour or belief rendered by symbolic figures among which the animal world played a prominent part, more so than the floral. The jaguar was the prime feline predator of Central America, answering the lion and tiger in the Old World, so jaguar masks and jaguar-men figure among the divine personnel, with serpents a close second, as threatening powers. Other studies of the animal world, most notably among the Aztecs **513, 514**, show considerable perception of form and behaviour, almost more so than the humanoid where, especially with the Aztecs, the grotesque and even terrifying aspects of humanoid deities were dwelt upon, as were depictions of the more gruesome expressions of religious behaviour – blood-letting (of self and others **475, 491**), flaying **506**, accumulation of human skulls, to name the most conspicuous.

Free-standing figures are relatively rare before the late Maya and Aztec, but the great stelae which stood at many sites have colossal figures cut in relief **476**, and there are the 'Atlantes' pillars as architectural supports **33**. Two-dimensional narrative art was fairly simply composed but not as committed to stereotyped figures and poses as one might expect, and this leads to some difficulty in explaining individual groups or combinations of figures and symbols. The more involved narrative was saved for painting, on pot or wall, and is generally concerned with everyday life and death, warfare, and the behaviour of priests and kings, rather than depiction of any more complicated heroic story-telling. Among the divine the Maize God and his twin Hero Sons **487** are favourites of the Maya beside a multitude of deities with special functions. These belong, however, to no organized 'Olympus' of gods. 'Scribes'

are another favourite subject for painting – to some degree self-portraits, but sometimes shown as 'monkey-scribes', perhaps suggested by their usual squatting posture **55, 458**. This range of subjects corresponds more to that of most of the Old World, although not the Classical, but again there seems no strong stereotyping of scenes, and it cannot just be the thin spread of available evidence, over time and space, that leads one to regard the Maya artists as more than hacks repeating narrative formulae. This embraces subject matter, poses and grouping, which was by no means confined to simple register or frieze compositions. Visual narrative conveyed by juxtaposition of consecutive episodes is rare, but there was an advanced style in book illustration which we can judge from specimens recovered by the Spaniards or made for them in early years of their rule **459, 521, 522**. Landscape settings were summary or generally ignored.

Pottery is as important a source for our knowledge of Maya painting as their walls **487–89**. The potter's wheel was not used, and the firing offered a moderate colour range from slips until the fired vase was covered in a thin stucco layer and then painted. These techniques could produce ambitious polychrome pottery which outdoes most Old World production even after the use of glazes was introduced. The figure decoration, usually showing gods, rulers or action, are, as on the wall paintings, plentifully inscribed, and in one group, from Naranjo, one artist signs his work **489**, while conventional Morellian techniques of stylistic attribution **303** make possible the identification of other individual hands.

The Central American artists clearly had much freedom in treating what were probably predetermined subjects. So it is not surprising that their work, both pottery and sculpture, is occasionally signed. The monuments' intrinsic value as symbols of power meant that they might be stolen in acts of war, hoarded, and even caches of *objets d'art* created. However alien much Maya and Aztec art may seem to modern eyes,

its appeal as an expression of artistic originality, even within well-defined rules of stylization and expression, is immediate and effective. It is an art in which it is not easy to discern development rather than variation on common themes, and for dating we are very much at the mercy of scientific archaeology, inscriptions and judgement about close stylistic similarities. Nor is there real decline, and the terminus cannot be judged one which was the result of any internal decay in society, rather than of invasion, out of the blue.

The last phase, dominated by the Aztecs, has some special qualities, not merely of size and ambition **502–15**. These appear in the aggressively, almost terrifyingly, melodramatic choice and execution of a range of subjects inspired by the more extravagant aspects of Aztec religion, vigorous but also near to giving the impression of a society ripe for extinction. One of its prime activities was war, and the object often perhaps to acquire more victims for sacrifice. Yet there are also in the minor arts realistic studies of animals unrivalled before, and a range in painting, from walls to books, which seem to presage the possibility of a developed style of expression and narrative, which might even have broken the conventions of figural art that bound most early civilizations.

Central American art is never less than exhilarating in its subjects and treatment, and on the whole not more negligent of quieter and humane subjects than some arts of the Old World. But there is rather less of the type of visual satisfaction which our Western training has led us to look for in Old World arts, and which relates mainly to depiction of natural animal and human behaviour, and of landscape.

The pictures for this section are arranged mainly by type for the Maya and related, but the few Olmec are shown together, the Aztec at the end, followed by examples of illustrated books (*codices*), several of them pre-Columbian, which allow a glimpse of an art to which any Old World scholar can immediately relate.

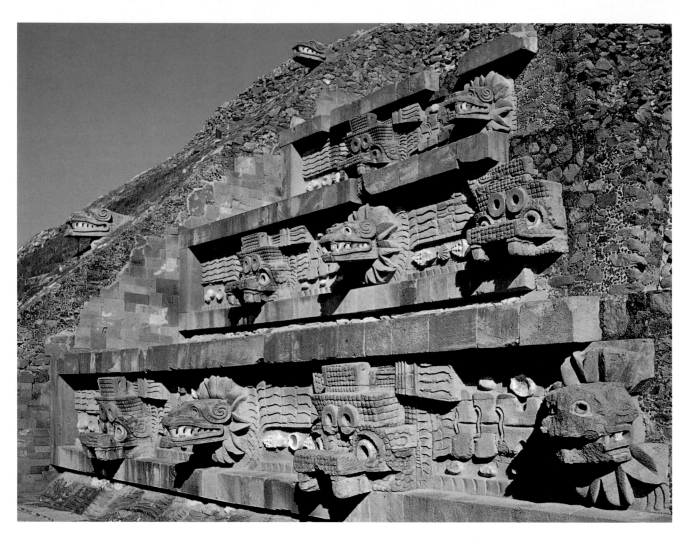

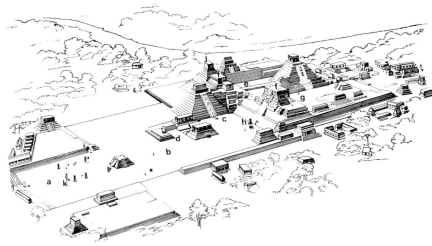

460 *Part of the façade of the Temple of the Feathered Serpent (all such appellations are modern) at Teotihuacan, 3rd cent. AD. Feathered-serpent heads and masks are common sculptural decoration on pyramids or façades or beside stairs.*

461 *Reconstruction drawing by T. Proskouriakoff of the acropolis and plaza at Copán, completed in the 8th cent. AD, showing the layout of pyramids and palaces, and a ball court (centre left; the two parallel blocks).*

462 *The 'Temple of the Warriors' at Chichen Itza, which enclosed a similar earlier structure. The columns at the front are carved with relief figures of warriors and tribute-bearers and there is a broad hall of columns as an approach at the right. About AD 900.*

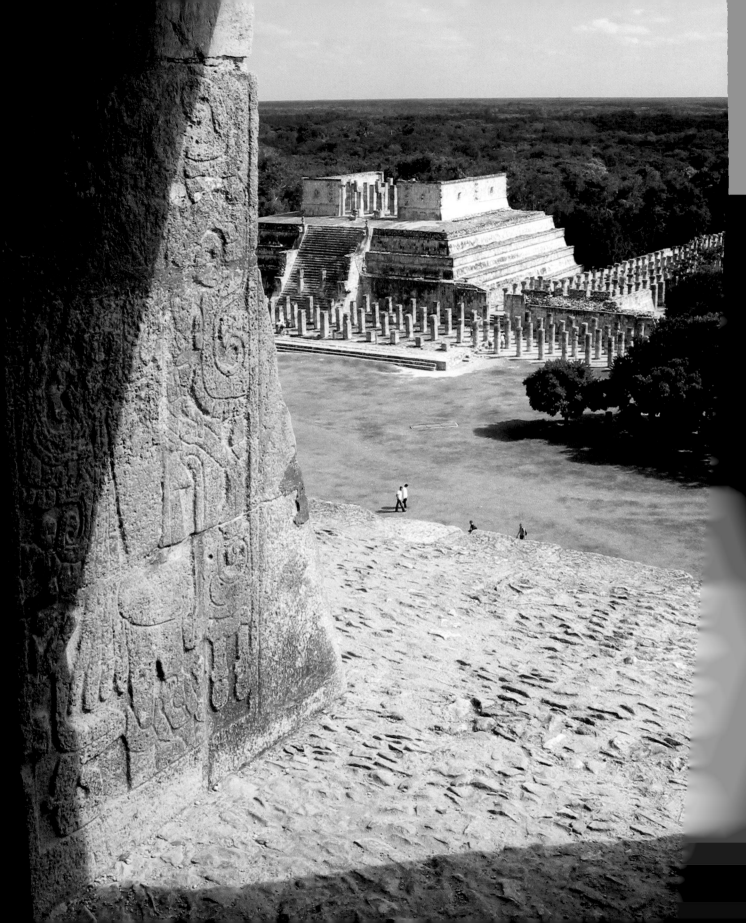

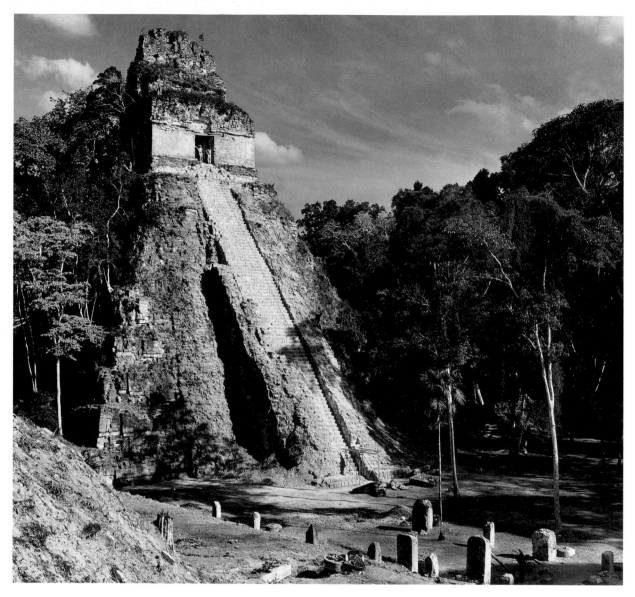

463 Temple I at Tikal (Guatemala), a royal funerary pyramid. About AD 740. Height 69m.

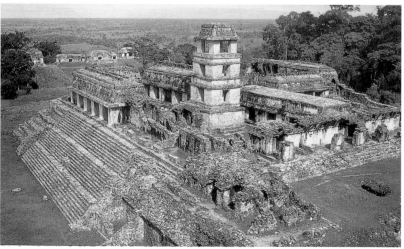

464 The palace complex at Palenque, one of the largest south Maya sites. Set on the usual stepped mound, the series of colonnaded buildings and a tower seem truly residential, for the king and his two sons who built them over a century between AD 650 and 800.

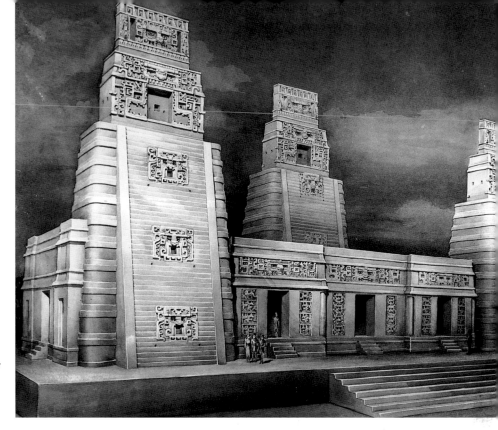

465 *Reconstruction drawing by T. Proskouriakoff of the palace at Xpuhil, showing the 'roof-comb' finials on the three solid, decorative towers. 7th/8th cent. AD. Cambridge, MA, Peabody Museum, Harvard University.*

466 *The hyper-decorated façade of a building (in the 'Nunnery' quadrangle) at Uxmal. About AD 900.*

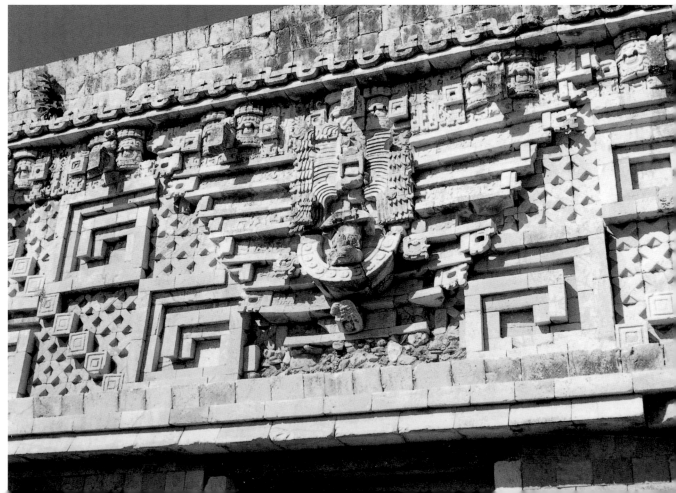

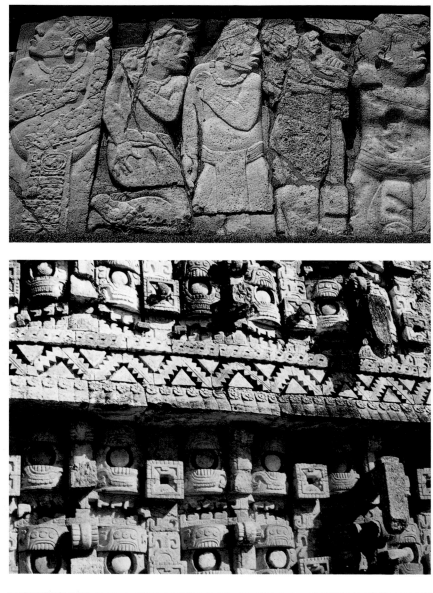

467 The bevelled base of a court wall beside a flight of steps, at Palenque, is decorated with relief figures of captives, carved on separate slabs, possibly removed from another structure. About AD 700.

468 A façade wall composed wholly of masks at Kabah (Codz Pop). 9th cent. AD. Late Maya.

469 Stone mosaic wall decoration at Mitla (Mixtec), copying textile patterns. About AD 1000, or later.

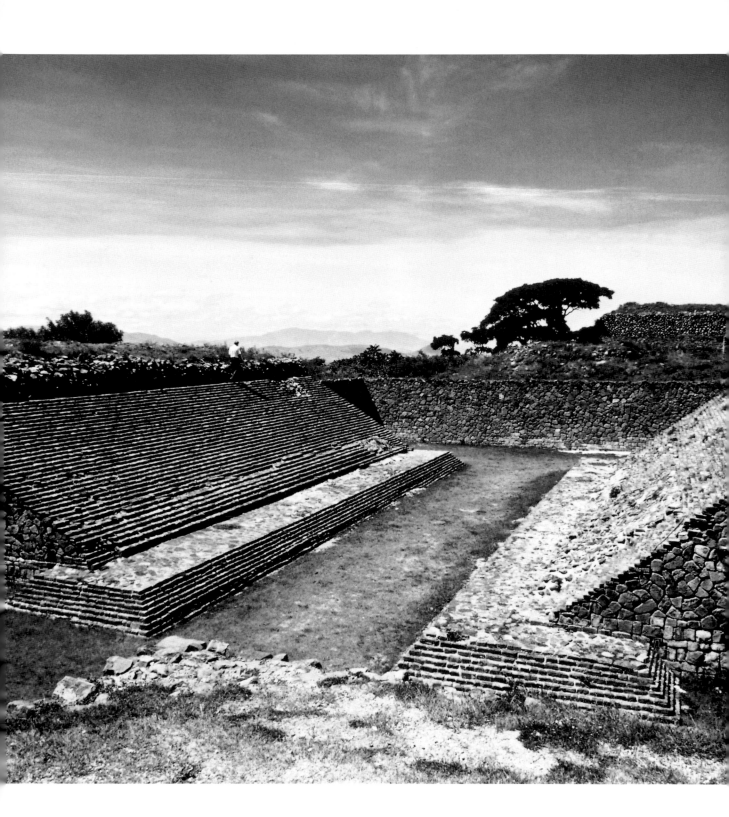

470 *The ball court at Monte Alban. Probably 6th cent. AD.*

471 A colossal Olmec head of basalt. Several of these have been found; this is one of four set around a plaza at La Venta and may represent regal or divine authority. The style is realistic, exaggerating details of eyes, nose and lips in a manner not quite matched to this degree in smaller works of the period. Height about 2.4m. 800–600 BC.

472 A precociously realistic Olmec clay figure of a woman from Xochipala – a further demonstration that realism in the arts is not always the result of evolving style. This is barely matched in Central America for accuracy of anatomy and pose for centuries. Mid-1st mill. BC. Height 23.5cm. Private Collection.

473 An Olmec figure with child, of green jade, showing the distorted skull apparent in much Central American art – and in burials. New York, Brooklyn Museum.

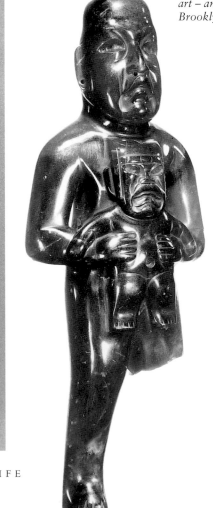

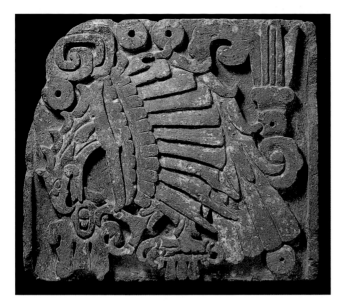

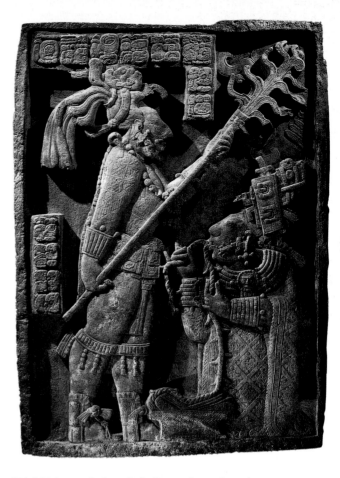

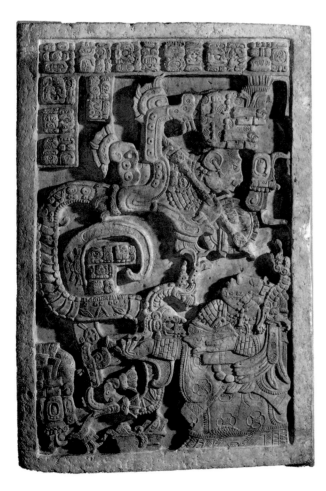

474 *A Toltec andesite relief of an eagle tearing a human heart, a fine combination of realism and decorative stylization. AD 900–1200. Height 69.8cm. New York, Metropolitan Museum of Art 1893,93.27,2.*

475 *Two lintel reliefs (24, 25) from Yaxchilan. (a) The king, Shield Jaguar, before a kneeling queen, Lady Xoc, who is drawing a spiked cord through her tongue to draw blood. On the second lintel (b) she observes a spear-bearing ancestor emerging from a serpent's mouth. There is a mass of linear detail on dress, and finely carved hieroglyphic inscriptions. AD 709. Height 1.1m. London, British Museum.*

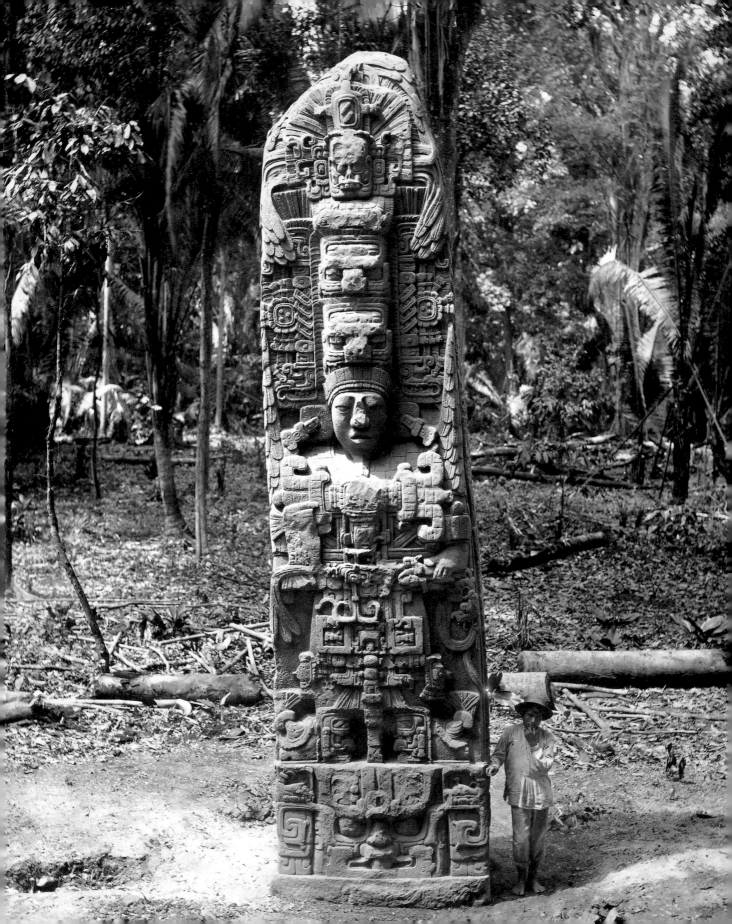

476 (opposite) Tall, free-standing stelae in the Maya plazas carry relief figures of gods or kings with divine attributes and a variety of symbolic items as well as inscriptions. This stood 10.7m high at late Maya Quirigua (Guatemala), erected (so precise are the inscriptions) on 18 Feb., AD 766. A photograph of 1885.

477 A relief from the ball court at Chichen Itza. A player holds the severed head of a loser, whose kneeling body, to the right, sprouts snakes from its neck. The ball between them is decorated with a skull. About AD 900.

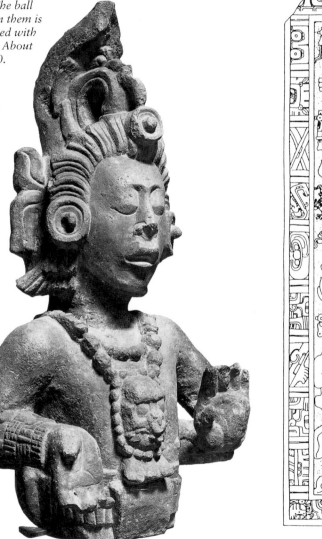

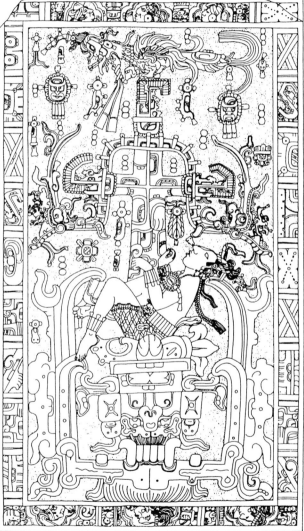

478 One of several similar statues of the Maize God from Copán, a study of beneficence somewhat uncommon in the art of the Mayas, but notice the skull pendant. AD 715. Height 90cm. London, British Museum 1886-321.

479 Shallow carving on the sarcophagus lid of King Hanab Pakal (died AD 683) at Palenque. The expiring king is falling into the jaws of the Underworld, while from him rises a World Tree, or Tree of Life. Drawn by Merle Greene Robertson.

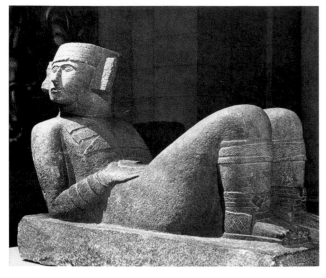

480 'Chacmool' figures of reclining attendants holding a bowl for offerings appear at many late Maya sites; a rare example of a true sculptural type which was often exactly repeated for its specific function. This was found within the Castillo at Chichen Itza [34]. The type was one which Henry Moore found inspirational. 9th cent. AD. Length 1.46m.

481 A Huastec figure of sandstone from Consuelo (Tamuin). The Huastecs lived on the Gulf coast and retained the older custom of building circular mounds and houses. Their artists also favoured free-standing figures. This naked body is covered with hieroglyph inscriptions. He carries an infant on his back. 11th cent. AD. Height 1.3m. Mexico, National Museum.

482 A Huastec statue: the front (a) shows a noble figure, elaborately dressed, but behind (b) he is seen to be carrying a skeletal death figure. 11th cent. AD. Height 1.58m. New York, Brooklyn Museum.

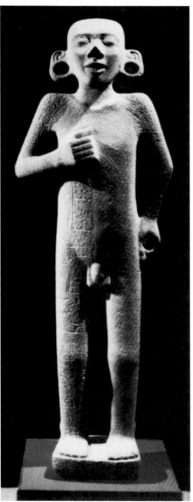

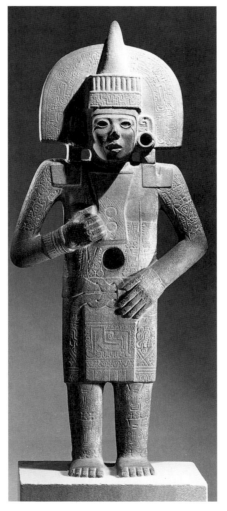

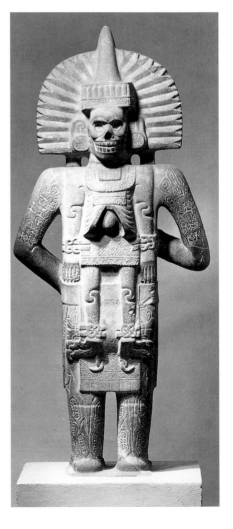

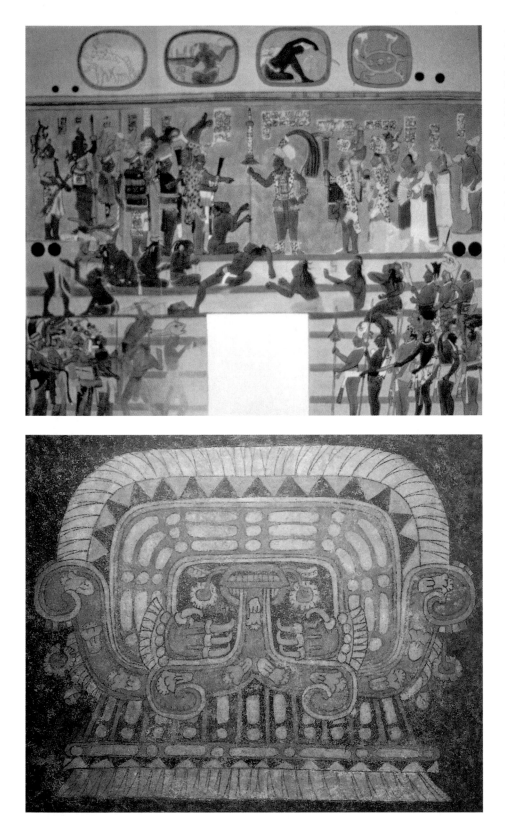

483 The nobles review their troops and various prisoners on steps before them. Painting on a wall at late Maya Bonampak, in rooms which seem to have been designed for the display of a series of such paintings showing battle, celebrations and court domesticity. AD 790/792.

484 A painting of the inverted head of a goddess with clawed hands. Note the mask-like treatment and reduction of the whole stylization into a rectangle. Probably from Techinatitla, near Teotihuacan. About AD 700. 77 × 66cm. San Francisco, Fine Arts Museum.

485 Actors impersonating the Rain God close in on the seated Maize God to decapitate (harvest) him. Reconstruction of a painting at Tancah.

486 Drawing of a painting in the Temple of the Warriors at Chichen Itza. An attack on a town beside a lake, with prisoners led away below. There is no perspective and figures are not allowed to overlap. About AD 900. Washington, DC, Carnegie Institution.

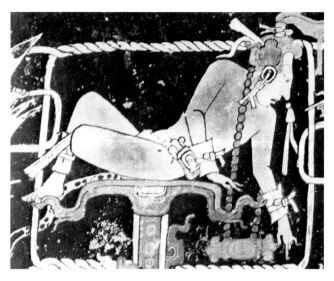

487 A plate from northern Guatemala showing the Maize God freed by his two hero sons, one with a watering pot, from the carapace of a turtle (the earth); signifying crop resurrection. 8th cent. AD.

489 The developed scene on a cylindrical clay vessel (a popular shape for such decoration) of the Maize God dancing with small attendants. Painted by Ah Maxam of Naranjo, a versatile artist identifiable from his signature and his distinctive style. Techniques of painting on pots include also reserved figures on a dark ground, realistically coloured figures on a pale ground, and basic 'script' line-drawing. 8th cent. AD. Chicago, Art Institute.

488 Polychrome painting on pottery is a major source for knowledge of the art since wall paintings are seldom so well preserved. Here, on a black ground recalling Greek red-figure vases, is shown a Maya figure on a column, his twisting body well observed, but without foreshortening of limbs (exactly as on Archaic Greek red figure), which comes only with deliberate observation and copying of life. 7th cent. BC. Boston, Museum of Fine Arts.

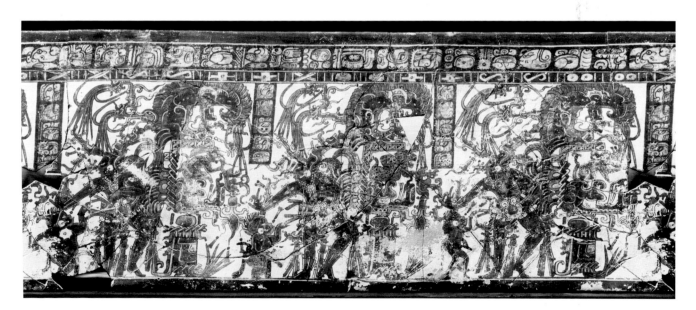

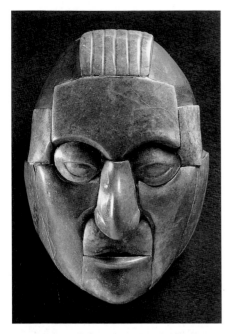

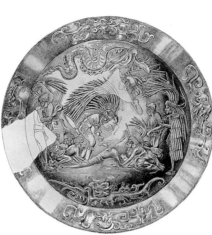

490 The jade mask from the coffin of King Hanab Pakal [479], found in the 'Temple of the Inscriptions' at Palenque. AD 683.

491 A gold disc worked in repoussé, drawn by T. Proskouriakoff. Found in a deep sacred pit (cenote) at Chichen Itza, with several similar. A warrior cuts the heart from a still live victim; a divine warrior emerges from the mouth of a serpent above. The gold disc was probably imported from the south but worked locally by the Maya in an advanced realistic narrative style, shared by the other gold discs. The tendril-like treatment of hieroglyphs and symbols inevitably recalls far earlier Chinese stylization of animal figures and clouds, but was suggested by the basic form of the symbols themselves. About AD 950. Diameter 22cm.

492 A stucco head from the 'Temple of the Inscriptions' at Palenque, buried with King Pakal but taken from some other setting and perhaps portraying him. Ambitious work of this type in plaster is common with the Maya, very rare elsewhere in antiquity, except in Central Asia. 7th cent. AD. Height 39cm. New York, Museum of Natural History.

493 An old man importunes a woman, lifting her skirt, anticipating a popular motif in much later European art. The clay figures seem to have been made in moulds, finished by hand, and must have been coloured. Such intimate studies belong to the people not the rulers, and are rare indeed in Maya art, but their existence is a welcome relief from the otherwise rather forbidding repertory of Maya artists. 8th/9th cent. AD. Height 24.8cm. Detroit, Institute of Fine Art 77.49.

494 (opposite) A rare wooden figure of a kneeling priest, with better modelled features and anatomy than was usually rendered in stone. From the Tabasco area. Early Classic Maya. AD 300–600. Height 35.5cm. New York, Metropolitan Museum of Art.

495 The Veracruz coast, east of Mexico City, was home to some distinctive local styles, such as the smiling figures in clay, from Las Remojadas. 9th cent. AD. New York, Museum of Primitive Art.

496 A clay incense burner from Palenque with tiers of masks, resembling an American Indian totem pole, perhaps not fortuitously. Height 1.14m. Mexico, National Museum 329.

497 A travertine vase decorated with scrolls and masks, with animal handles, typical of the Ulua Valley on the north coast of Honduras, deceptively (?) reminiscent of early Chinese bronze and jade. 9th cent. AD. Height 28cm. London, British Museum.

498 Incised figures on bone from Temple Tomb I at Tikal. Demons and deities, including the Maize God and others in animal form, making what seems to be a conventional gesture of dismay, are paddled through the Underworld.

499 A flint image of figures (?) in silhouette. The material was used worldwide for spearheads and knives, worked by 'pressure-flaking'. The Maya were unique in attempting to use it for ambitious figurative objects such as this. Late Classic. Height 23cm. Dumbarton Oaks Museum PCB.588.

500 Figure vases are a Central American speciality. This is of the Teotihuacan type, and in a popular orange ware. Height 21cm. Mexico, National Museum.

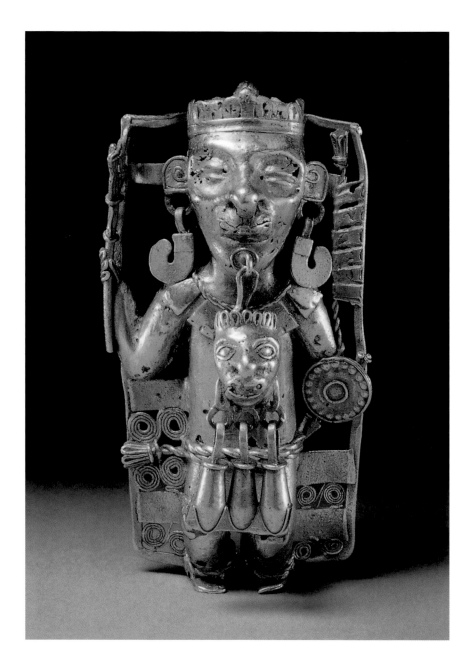

501 A tumbaga *(gold and copper alloy) figure of a Mixtec ruler holding a serpent staff, battle-axe and shield, a mask hanging from his lip-plug. The gold alloy was imported from the south and cast, using the lost-wax technique. Mixtec art was influential through all Maya and Aztec territory. 13th/14th cent. AD. Height about 10cm. London, British Museum Ethno. +7834.*

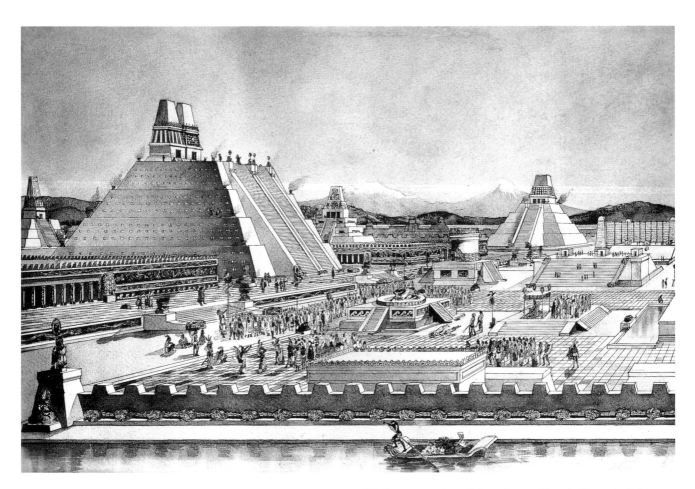

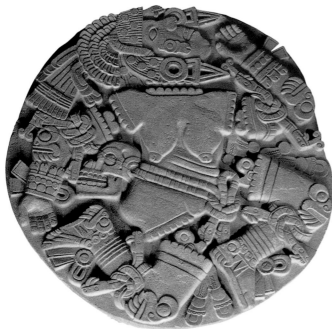

502 Reconstruction of the cult area (Templo Mayor) of the Aztec capital Tenochtitlan, at Mexico City, by Ignacio Marquina.

503 The stone relief disc excavated from the base of the twin pyramid at Tenochtitlan. It shows the dismembered body of the goddess Coyolxauhqui, a victim of divine dissent according to the cosmic myth. 14th/15th cent. AD. Diameter 3m. Mexico, Templo Mayor Museum.

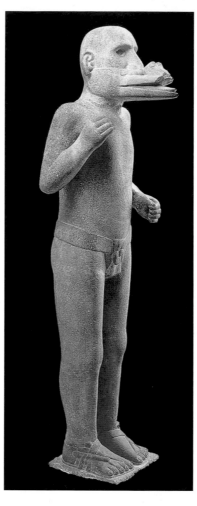

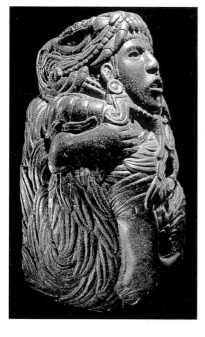

504 Quetzalcoatl, ancestral god of the Toltecs and founder of the city of Tula (destroyed in AD 1170), a site much respected by the Aztecs who explored it and recovered relics. This is a late Aztec (15th-cent.) image in mixed human and animal form, of red porphyry. Height 4cm. Paris, Louvre Museum.

505 Quetzalcoatl wearing a bird-mask. A basalt figure, life-size, in a summary presentation of a human body in near-realistic form. Found in a temple at Calixlahuaca, west of Tenochtitlan. About AD 1500. Height 1.76m. Mexico, Institute of Culture A-36229.

506 A painted lava figure of Xipe Totec, as a man wearing a flayed human skin, cut away at the mouth and wrists, stitched across the chest, a gruesome record of a ritual practice by priests to ensure resurrection (of crops), but deeply expressive of vital energy. 14th/15th cent. AD. Height 46cm. Basel, Culture Museum IVb647.

507 The Aztec goddess of childbirth, a remarkably moving expression of the pain and victory of parturition. Of stone (aplite). 14th/15th cent. AD. Height 20.2cm. Washington, DC. Dumbarton Oaks Research Library and Collection.

508 Coatlicue, *a horrific statue of the goddess, with a pair of snakes for the head, the body almost pyramidal and leaning towards the viewer, hung about with severed hands and hearts, her own hands clawed, a skirt of snakes. The figure was so unnerving that it was several times reburied after discovery. Andesite. 12th-cent. AD. Height 2.57m. Mexico, National Anthropology Museum.*

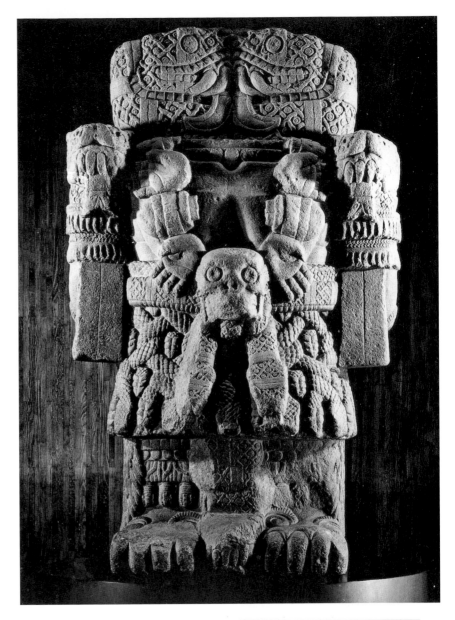

509 *A greenstone head of the goddess of the moon, from the Templo Mayor, Mexico City. She was beheaded by her brother the Sun, as he rose at dawn. The massive form recalls the Olmec heads, which were known to and revered by the Aztecs. About AD 1500. Height 80cm. Mexico, National Anthropology Museum 10-2209118.*

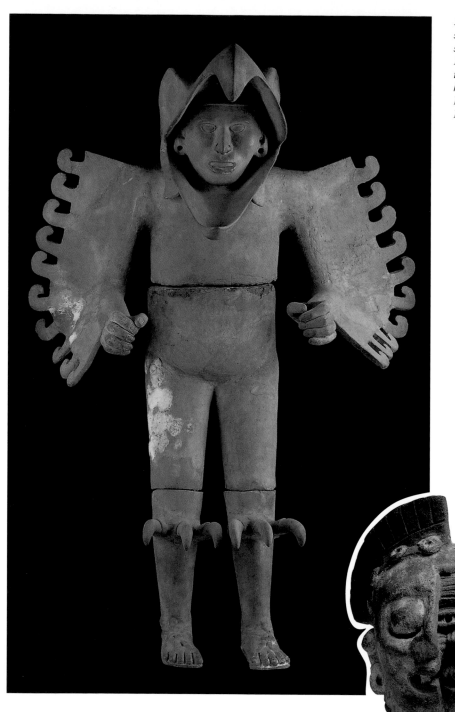

510 A life-size, painted clay and stucco image of an eagle man, a symbolic warrior, from the Templo Mayor, Mexico City. The concept is that of a flayed creature worn by a human figure. Mid-15th cent. AD. Height 1.7m. Mexico, Templo Mayor Museum.

511 Artists in many periods and places have attempted to portray the ages of man, usually in separate figures or heads. Here the artist has also drawn on the ritual flaying practices [506] to devise a head which peels away from a death mask to reveal an old and then a young head within. Of painted clay, perhaps from Teotihuacan, then pre-Aztec, but if so indicating a mode which will be influential with the Aztecs. An earlier version was a head divided vertically, half-real, half-skull. Mid-1st mill. AD? Height 18cm. Mexico, National Anthropology Museum 08-741814.

512 There is more feeling for the *'primitive', rather than the more controlled hieratic modes of Central American art, in this large clay figure of a warrior, in the form of an incense burner. About AD 1500. Height 99cm. Mexico, National Anthropology Museum 10-116586.*

513 *A granite rattlesnake; an appropriately threatening image of a dangerous, therefore sacred, animal. 14th/15th cent. AD. Diameter 53cm. London, British Museum Ethn. 1849.6-29.1.*

514 *A stone figure of a dog; a sympathetic account of man's best friend. About AD 1500. Height 47cm. Puebla, Regional Museum 10-203439.*

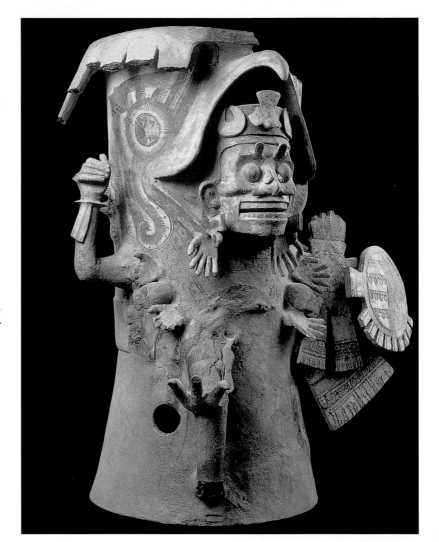

515 A mosaic mask made of jade, turquoise, shell and mother-of-pearl. Latest Aztec. Height 25cm. Rome, Museo Pigorini.

516 A clay cup decorated in a black-figure technique (silhouette with incision) showing a centipede. From Los Otates, on the Gulf coast, a local product. About AD 1400. Mexico, National Anthropology Museum.

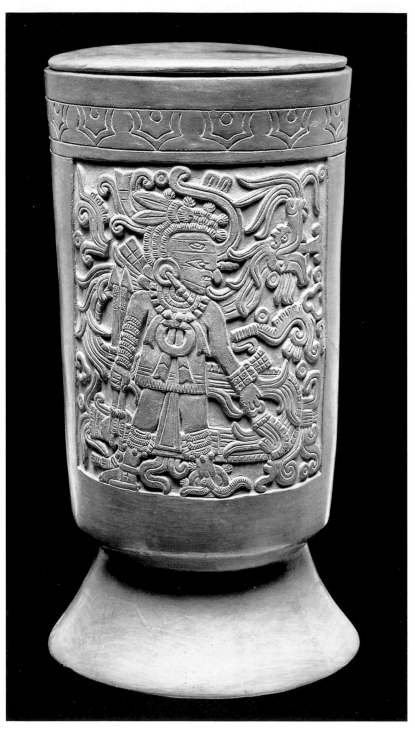

517 An Aztec vase (funeral urn) in orange clay decorated in cut low relief, like the stone reliefs, with a figure of a god in the usual hieratic style. About AD 1470. Height 53cm. Mexico, Templo Mayor Museum.

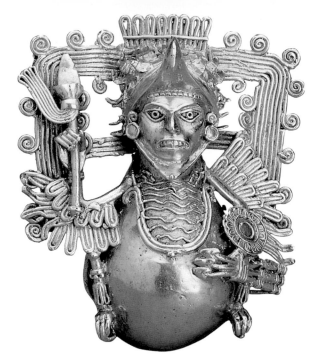

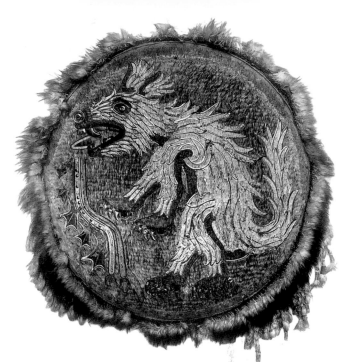

518 A gold bell in the form of the bust of a warrior wearing an eagle helmet. It was cast using the lost-wax process. Detail, as in most such Aztec goldwork, is rendered by gold wire which is soldered on to the cast body. The techniques and style of Aztec goldwork were acquired from the Mixtecs, ultimately from farther south, the source of the gold, in Colombia. About AD 1500. Height 9cm. St Petersburg, Hermitage Museum DM 321.

519 A shield decorated with feathers, with gold sheet and wire, fastened to paper, wicker and vellum. Colourful feathers were prominent in the dress of Central America, as we can judge from reliefs and paintings, but the feather objects are seldom preserved. This shield may be the one taken by stout Cortes as a gift to a Spanish bishop. About AD 1500. Diameter 70cm. Vienna, Museum für Völkerkunde 43.380.

520 A two-headed serpent made of wood with turquoise and shell inlay. About AD 1500. Width 43.3cm. London, British Museum Ethn. 94-634.

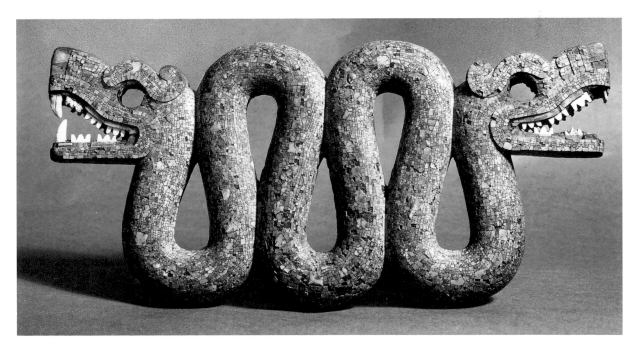

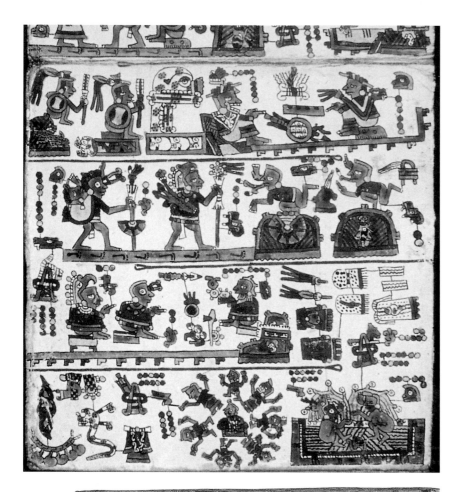

521 A page of the Codex Selden, a pre-Conquest Mixtec book, here with a narrative, read in friezes, from below up, following the small black footsteps (below the second frieze down) which are an engaging Aztec-period convention in such narrative paintings. Oxford, Bodleian Library, Selden A2.

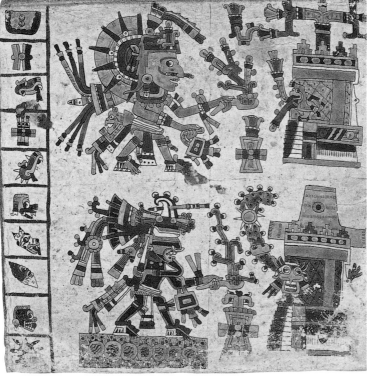

522 Another pre-Conquest Mixtec book, made up like a screenfold, is the Codex Cospi (Borgia Group), mainly devoted to illustrating the ritual calendar. Deities at temples, rendered in the latest mode of the hieratic style. Bologna, University Library Ms. 4093.

The geographical gap between the lands of the Maya and Peru will be accounted for later – Costa Rica and Panama, then notably Colombia, but also Ecuador where ambitious town building has been detected at Real Alto in the 3rd millennium BC, soon with corn-growing and an export trade in oyster shells. It would be wrong to regard the south as seriously backward in its early development vis-à-vis the centre and north of the continent. Its arts share the same general American idiom, but with many original contributions in architecture and the figurative arts. Moreover, its physical world was markedly different.

The urban cultures of the south are determined by the rather odd environmental circumstances which allowed them to prosper by exploiting the varied resources offered by the sea, around the river valleys, and the mountains. In the arts the closest comparisons have to be drawn with Central America, even though the physical evidence of contact is slight for the early period; we know that the Andean population came from the north and was practising sophisticated arts at least as early. Yet there are accounts of Andean art that seem able to ignore the north completely. There are certainly some significant differences, largely concerning materials. Textiles are important in the surviving record – first twined, later loom-made, and their patterns may be woven or painted **524, 525, 547**. Camelids (llamas, vicuña, alpaca and the like) provided the durable raw material, and the textiles carried abstract (determined largely by technique) and figural designs, whose relationships to the hieratic styles of Central America (and nowhere else) are striking. Yet fired pottery does not appear before about 2000 BC.

A particular feature of the area is the objects and iconography deemed to reflect the use of hallucinatory drugs, the effect of which on the arts may perhaps be apparent, though not significantly so to me. The subject matter of the arts is rather less humanoid than to the north, but no less addicted to the mythical, often devised in feline rather than serpentine form, and with no less emphasis on faces and masks and with much the same hieratic figure conventions as in the north. The Moche of north Peru are a very special case, with developed styles of narrative not encountered elsewhere **534, 535**. Sheer realism, usually in head studies **536**, is achieved occasionally and generally more completely than in Central America. In a way there is more here for the student of approaches to the arts worldwide, but again we are dealing with a very large area and over many centuries.

The various pre-Inca cultures are named for their regions, and an overall series of 'Horizons' match the 'Classic' phases of Central America. There are no inscriptions to help us, although a complicated Inca method of recording and counting by knotted cords (*quipu*) shows considerable mathematical ingenuity, and there are Moche brickmakers' and potters' marks, but not names. Urban centres are characterized by high platform structures of ritual intent, not unlike the Central American pyramids but with less emphasis on steps to a built cult place, and sometimes facing a three-sided court **526, 537**. By the time of the Incas we find a skill in the handling of massive masonry unmatched elsewhere in pre-Columbian America **457, 551, 552**. Techniques with mudbrick include some early use of bricks in the shape of cones and cylinders set in clay

mortar to bind the core of an adobe wall, and producing patterned wall surfaces that recall some techniques of early Mesopotamia.

The Chavin culture of the last centuries BC centres on a site at a height of 3,500m in the northern Andes, and offers very conventional figures in the hieratic style on stone revetment slabs and stelae 527, incised rather than shallow-carved and so dependent on colour, with some engaging feline devices; also some colossal humanoid heads that somehow recall the Olmec. Gold-working, probably the earliest in the Americas, is managed by hammering (*repoussé*) and uses solder, largely for the decoration of ritual or state dress.

The Paracas (largely still BC), followed by the Nazca of the Central Andes, take us through at least the first 500 years AD, and are more like developed village cultures than truly urban. With them, as with many tropical cultures, we find far more dense composition in the decorative arts, on textiles and in pottery 524, 525, 530–32. Textiles, the most notable of the Paracas arts, survive thanks to their practice of mummifying bodies 523, dressing them lavishly, and depositing them in sacks and baskets in dry areas where the textiles do not perish easily. Patterns and figure decoration may be embroidered, not just woven, which was the commonest practice in antiquity, while many of the Nazca textiles have painted decoration. Nazca ceramics represent one of the major traditions of the craft in Andean art 530–32. Their polychromy was achieved by use of fired slips, not by painting over stucco as in Central America, and was much reliant for forms on modelling – with no potter's wheel. The architecture of hill temples is complemented by the remarkable 'Nazca lines' 533, outlines of animal figures and patterns made by brushing aside surface rubble to expose pale rock beneath, some of them possibly ritual paths. They cover large acres of ground and one line runs straight for 20km. This application of art to the landscape is not altogether unparalleled elsewhere and was remarked at the start of this Chapter (p. 35).

The Moche culture of the northern coast is contemporary with the Nazca, surviving from the later centuries BC to about AD 600. The sites are distinguished by large brick platform-mounds, and

their cities by defences, otherwise uncommon on any major American site and indicative of the belligerent behaviour of peoples to the south and of locals. The mounds are the largest brick structures of the Americas, the greatest being the cross-shaped 'Pyramid of the Sun' at Moche, which must have stood 50m high originally (using 143 million bricks, allegedly). They were of ritual intent but also concealed monumental tombs, notably those of the rulers of the site at Sipán, rich in gold 540. Two quite dissimilar features of Moche pottery stand out. One is a vivid narrative style of figure decoration, devoted mainly to complicated scenes of cult and offering, often of the bloodthirsty (literally) type familiar from the Maya and Aztecs 534, 535. But the scenes may be repeated by different artists, readily distinguished in a Morellian manner by their drawing, closely following formulaic groups in a way more familiar in Archaic Greek art than in anything seen so far in America. Some scenes are composed in a spiral running up the vase, recalling some Mesopotamian cylinder seals, even Trajan's column in Rome. Many are composed over lightly incised preliminary sketches, another technique shared with the Greek vase and fresco painters.

The other pottery style is of figure vases 536, 538, especially head vases, moulded with a remarkable degree of realism deriving from close observation of models, near-portraiture – another unfamiliar trait for the area and in marked contrast with the hieratic figures of the narrative scenes, which are found also on the polychrome murals. The clay figure vases were made from moulds and so could be mass-produced for wide distribution, another unfamiliar trait for more sophisticated work. In the luxury arts copper, silver, gold, gilding and precious stones (turquoise) make for more colourful assemblages. In this and other ways the Moche artists emerge as a group sharing more of the aspirations and achievements of Old World artists than most in the New World.

The Wari and Tiwanaku of southern and central Peru, with other shorter-lived cultures, are mainly contemporaries of the Moche. They see the beginnings of major projects in monumental masonry, and an interest in stone sculpture and relief ornament,

reminiscent of the contemporary Maya. The Tiwanaku (Tihuanaco, near Lake Titicaca) in particular develop techniques with stone which the Incas will adopt, working rectangular blocks, not always laid as ashlar courses, and intricate assemblages of niched blocks. The finish implies a more effective range of tools, not only lithic, than hitherto. A style of carefully planned stone architecture is created here far beyond anything attempted before in the Old World and inviting comparison with the Egyptian, Classical and Roman, but still lacking anything like an agreed order of decoration, pillars or the like, and still decorated with largely trivial low-relief and incised decoration 541. City planning runs to massive and high walls, as in Huari city (capital of the Wari, with perhaps 70,000 inhabitants, over some 15km sq), enclosing courtyards and packed but regularly planned houses and stores. This too has more of an imperial, Old World feel to it. Raised-field agriculture, as in Mexico, answered some problems of irrigation.

Various Late Intermediate cultures were absorbed by the Incas by about AD 1470. The Chimu and Lambayeque successors to the Moche were busy potters, weavers and metalworkers 542–45. The latter produced some flamboyant goldwork and exploit the technique of hammering over positive matrices, to produce identical forms, rather than only *repoussé* into negative intaglios, or casting. Potters continue the Moche practice of creating shapes from two-piece moulds. The great Chimu capital at Chan Chan was laid out by the Pacific shore in a neat rectangular plan with major rectangular units within high-walled brick enclosures, giving an overall plan not unlike the Old World imperial.

The Spaniards were attracted by the legendary wealth in gold of the Incas, and they effectively removed and melted down most of their treasures, together with many of those of the precedent cultures, which were still accessible. The Inca empire had spread rapidly in the 15th century AD, from Ecuador to Chile, centred more on upland and mountain cities (the capital at Cuzco) than the desert or coastal, to the point even of landscaping mountain vistas by rock-cutting

and terracing. They, like the Aztecs, are as it were the last gasp of independent invention for pre-Columbian Americans. Their rule depended on a road system (40,000km) linking a structure of many dependent centres over a wide variety of terrain, altogether some million square kilometres. Their economic and social system seems to have put the Aztec to shame for its balance and complexity. The major arts appear to have been managed in guilds, in their own communities. For the most part they seem not to have improved on the artistic techniques they had inherited for clay, metal and textiles (notably from silky vicuña hides), and, so far as can be judged, a broadly geometric style of decoration was preferred to elaborate figural scenes. But in architecture they excelled, developing the techniques of the Tiwanaku, and creating walls and terraces of massive blocks, in ashlar courses or polygonal, with the stones most carefully jointed, although they commanded no better techniques for handling stone than their predecessors. A particular feature is the fondness for cushion rather than flat faces for the blocks, giving an air of rustication and emphasizing the stolidity and weight-bearing merit of the construction 457, 551.

The Spanish invasions put an end to the Incas, as they had to the Aztecs. Only the lesser crafts survived, the more sophisticated being encouraged by the new masters, who included scholars. But suddenly the continent was put in touch with the products and techniques (not to mention gunpowder, iron, horses and viruses) of the Old World. We can have no inkling of the culture shock, given that the physical shock was so extreme, but we are in a position to be able, on their behalf, to reflect on their artistic accomplishments, which could match the Old World's, and which in many instances demonstrate comparable answers to the same problems of composition, construction and the abstract and figural arts whatever the differences in absolute chronology, and however much the resultant visual experience of American urban arts may seem alien. The similarities and differences are ones which we can appreciate the better for fuller knowledge of both Worlds and their arts.

523 A Paracas 'mummy bundle' partly unwrapped in its basket. The body is dressed in richly embroidered clothes with a gold nose ring and shell necklace. Late 1st mill. BC. Archivio Museo de America.

524 A detail of a Paracas shroud in the Block Colour style, with repeated demonic figures. Late 1st mill. BC. Figures 10cm high. Boston, Museum of Fine Arts.

525 A painted Nazca textile with harvesting figures. Early 1st mill. AD. Washington, DC, Textile Museum 1964.31.2.

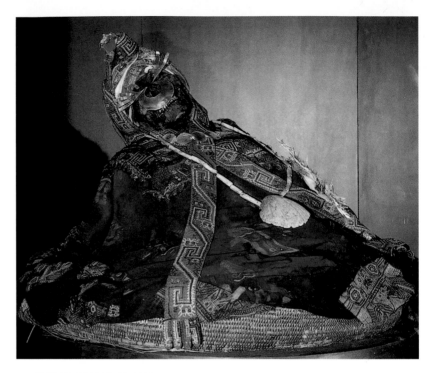

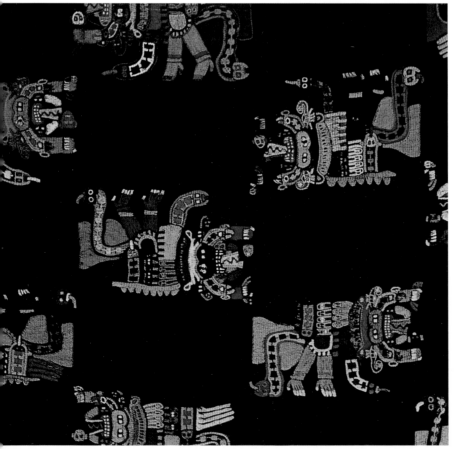

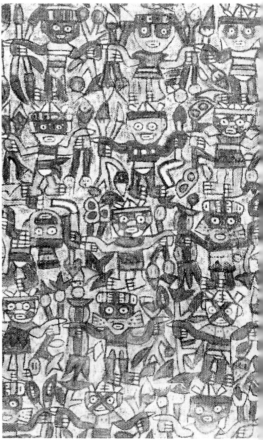

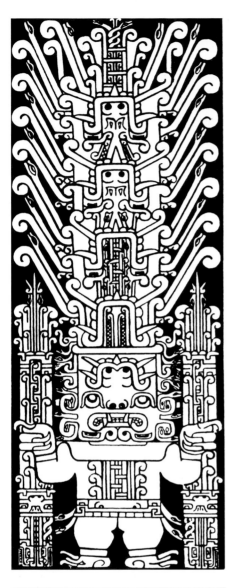

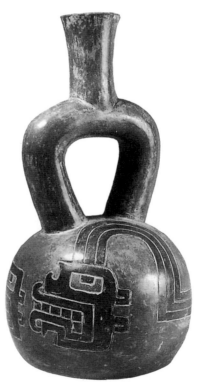

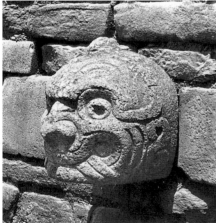

526 Reconstruction (by T.C. Patterson) of a platform and court at Huaca la Florida, Riaca Valley (central Peru), a typical early plan. About 2000 BC.

527 The incised figure on a diorite stela from Chavin (the 'Raimondi Stela'): an animal/humanoid deity with a headdress of what appear to be inverted masks. Another stela like a colossal spear point (the Lanzón) at Chavin may have served as a cult image, 4.5m high. This is shorter, at 1.95m. Before 200 BC.

528 A stone head from the many, animal/humanoid, that decorated the high walls of the temple at Chavin (north Peru). Around 250 BC.

529 Chavin pottery is usually in a red and black ware, well burnished. This 'stirrup jar' has two channels from body to spout, and is a persistent pottery form in the area. Late 1st mill. BC. Height 24.8cm. Atlanta, Carlos Museum, Emory University.

530 An early Nazca twin-spouted vase (a characteristic shape enabling free pouring from a very narrow orifice) with polychrome decoration, wholly abstract, emphasizing the shape. The Nazca commanded a rich range of coloured slips which could be applied before firing. Mid-1st mill. AD. Height 17.5cm. Chicago, Art Institute.

531 A late Nazca polychrome vase
with the more fragmented decoration
typical of the period. About AD 500.
London, British Museum.

532 A late example of decorated
pottery in the Nazca region,
influenced by the styles of Tiwanaku
[541], and associated with the Wari
culture. About AD 600. Lima,
National Museum.

533 'Nazca lines', scraped in the
surface of the plain over an area of
about 1km sq, representing a bird, a
monkey and devious ritual paths.

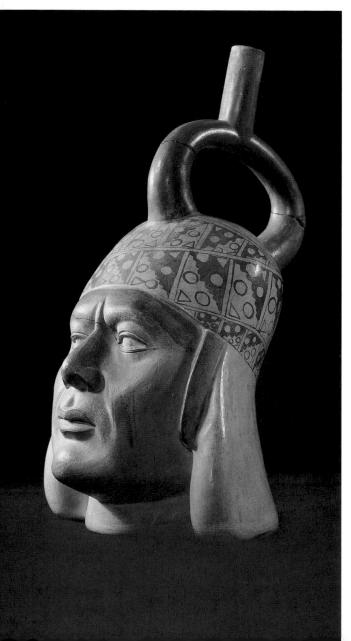

534 Moche fineline scene on a stirrup jar. A complicated battle scene involving more landscape detail than is usual in Andean art, and a semi-spiral composition overall. About AD 600. Private Collection.

535 Moche narrative. Two 'fineline' vase friezes, by different hands, of the same ritual scenes expressed in formulae and groups that each painter repeats with minor personal variations in detail. The figures here are in red and white; there is also a small number of three-colour vases, with added orange. The activities in the scenes shown involve sex and perhaps cannibalism; the same scene is also rendered in relief on another vase, implying something like an accepted and detailed iconographic repertory for artists. About AD 600.

536 Moche stirrup jar as a head vase in a fully realistic style. About AD 500. Height 35.5cm. Chicago, Art Institute, Buckingham Coll. 55.2338.

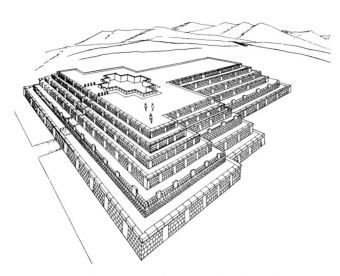

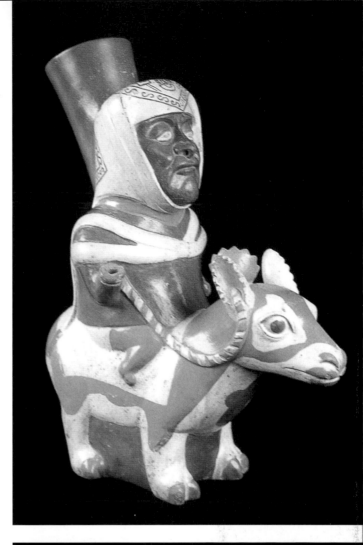

537 The Akapana mound at Tiwanaku (drawn by J. Escalante) of brick, faced with stone ashlars, studded with projecting heads of pumas (the southern predator).

538 Moche figure vase of a man riding a llama. Domestic subjects, animals, musicians and the like, are favoured for these vessels. Private Collection.

539 Pukara, north of Lake Titicaca, was home to a sculptural and architectural style presaging Tiwanaku. This stone fanged man holds a head as trophy.

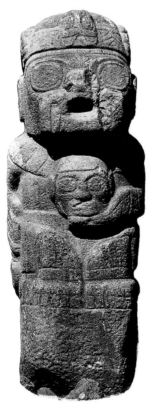

540 An ear-spool of gold with inlaid turquoise, from Tomb 1 at Sipán. Mid-1st mill. AD. Diameter 9.4cm. Los Angeles, Fowler Museum.

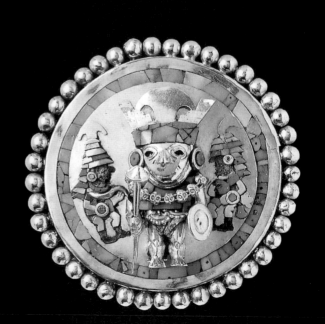

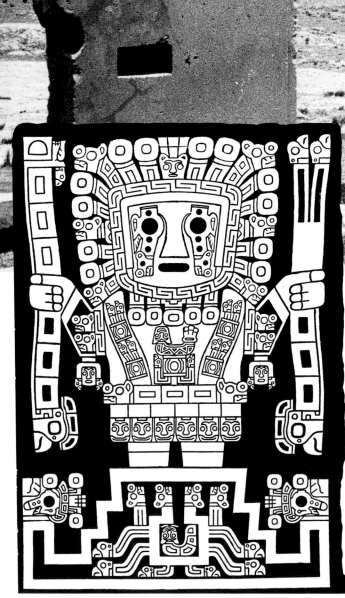

541 Monolithic lintel of a gate at Tiwanaku. The figure styles remain the traditional hieratic, only the subject matter changes, and that but little, except in detail; here the central figure (b) holds weapons and is attended by boxes of winged warriors (see [554]). About AD 600.

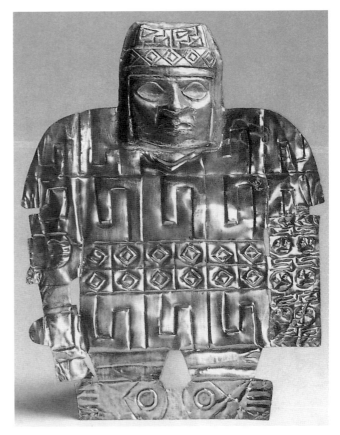

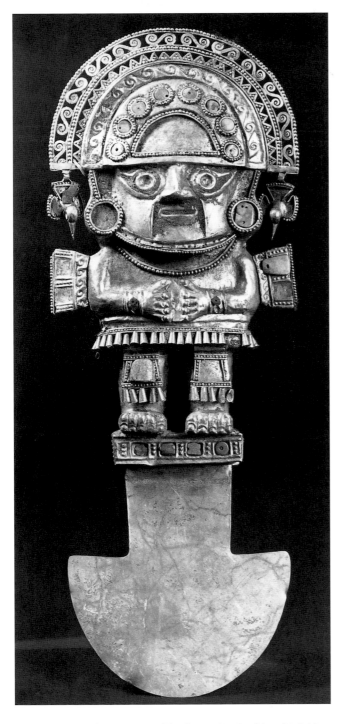

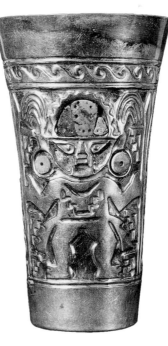

542 A Lambayeque ritual knife (tumi) of gold and inlaid turquoise. A common subject is the figure or head of the Sicán Lord (as on the last image). About 13th cent. AD. Height 43cm. Lima, National Museum.

543 A silver figure (it had a gold counterpart) wearing the typical Wari patterned tunic. About AD 800. Height 26cm. Glassell Collection.

544 A Lambayeque gold beaker, beaten on to a matrix form. About 14th cent. AD. Height 20cm. Lima, Miguel Mujica Gallo Collection.

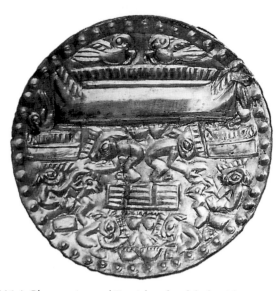

545 A Chimu gold ear-spool showing oyster-catching. The later Andean arts are less devoted to narrative scenes, whether of life or cult, than the earlier, Moche. About 14th cent. AD. Diameter 11cm. Atlanta, Emory University, Carlos Museum 1992.15.261.

546 A Chancay (central Peru) lace headcloth with a pattern incorporating stylized figures of birds. The knotting techniques (suggested by net-making?) are new for America, and only at about this time being developed in the same way in Europe. About 14th cent. AD. 73.7cm sq. Atlanta, Carlos Museum, Emory University.

547 A Chancay weave of brown and white cotton. About 14th cent. AD.

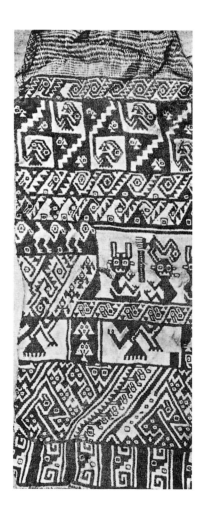

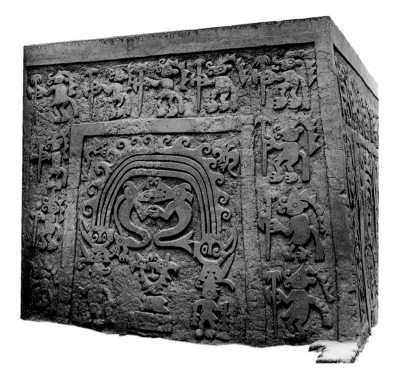

548 Moulded and cut clay relief decoration on walls at Chan Chan (Huaca del Dragón). This is another wall-decoration technique shared with Central America [469]. About 14th cent. AD.

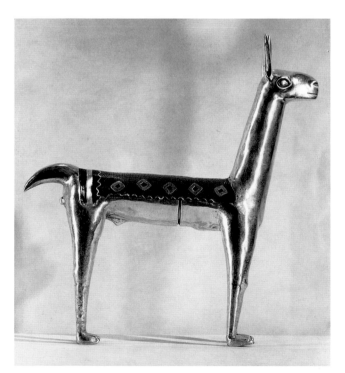

549 An Inca silver figure of a llama with cinnabar inlays on the body. Height 23.2cm. New York, American Museum of Natural History.

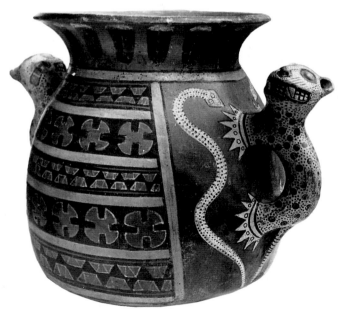

550 An Inca clay jar from near Cuzco, with the jaguar and snake motifs. 15th cent. AD. Cuzco, Archaeological Museum.

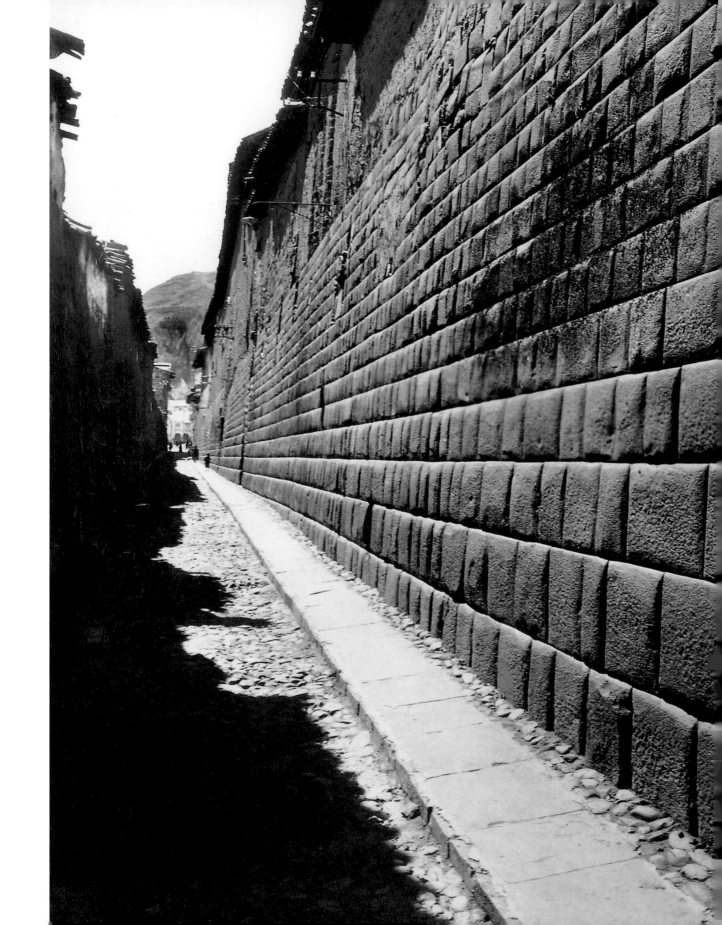

551 An ashlar wall at the Inca capital, Cuzco. See also [457] for polygonal masonry. 15th cent. AD.

552 A typical trapezoidal doorway and niches at Machu Picchu, the Inca site built at a height of over 2,000m in the Andes. 15th cent. AD.

III

THE NORTHERN AND
NOMADIC, AND
INTERFACES

A. THE INTERFACE PHENOMENON

In the last chapter there were various occasions on which we noted an 'interface' between two major artistic styles. These were generally the result of conquest, migration or trade. They could be the product of imposition by the politically dominant, or simply of observation of items of trade, often accompanied by travelling craftsmen, evidence for a peaceful trade war which could become a style war. Often it was a matter of Style A being practised or adjusted to satisfy the expectations of people bred to appreciate and understand Style B, or of the application of a foreign style to native objects and subjects. Virtually every area considered yielded examples, the major source of such phenomena in later periods in the west being Classical Greece and its immediate successors, where the results are readily charted. In the east, from Persia to China, the processes were more complex and seldom resulted in the creation of any independent and distinctive new artistic tradition, except perhaps in Buddhist India. That it could happen at all reflects the fact that everywhere artists were fulfilling much the same functions, and with roughly comparable results on roughly comparable objects, from architecture to the domestic.

Now that we turn to the northern neighbours of the urban civilizations (and, in the next Chapter, to the southern) we observe the same phenomenon, in border zones where the temperate urban agricultural and the northern nomad/pastoral (to put them at their simplest) overlap and interact. However, their artists' roles were usually very different in their different environments and societies and, not surprisingly, the results can sometimes be less than happy, if not bizarre.

There is much more to this which is of interest to the historian of art than the recording of mixed styles and subjects, of misunderstanding and reinterpretation. It raises the question of the degree to which an artistic tradition, ingrained in practitioners and observers, could be adapted to something quite foreign, without losing its essence. At its most basic, in the last Chapter,

this was a question of the degree to which the Classical tradition could in any way survive in the hands of non-Greeks. Generally, it could not, but was converted to new purposes while retaining only the superficial identity of its origins – often no more than a degree of pseudo-realism and some figure and narrative formulae. More pertinent is the question whether artists brought up in a strong tradition, whose visual and so practical experience of it was totally conditioned by its 'style', could ever, by choice or necessity, adapt to a quite different tradition and express it in their work. If they did, we would probably never be able to recognize it unless they left their names and these could be trusted; and were not, for example, simply the adopted names of slaves or hirelings, as often in the Classical world, not indicating truly their ethnic source. We would no doubt accept the probability that we are dealing with migrant artists – like the Greeks making decorated sarcophagi for Phoenicians. But a skilful technician can learn new tricks, and a thoughtful observer can learn to understand much of the intentions and expectations of others. We often think we can do this ourselves when we look at antiquity and try to understand it – and I think we can.

In the arts we are much guided by observation of materials and technique in determining origins. When it comes to an indefinable 'style' it becomes more difficult, particularly if it is being expressed for a society different to that in which it was forged. This raises generally unanswerable questions. The 'ethnicity' of Greco-Persian, or Indo-Greek, or border Chinese, or Central Asian, or classicizing artists at work in Phoenicia or Italy or on the Black Sea coast, is perhaps not particularly important, although it has a certain curiosity value. Most modern studies in ancient 'ethnicity' are the product of contemporary preoccupations of a type virtually never apparent in antiquity. Intentions are more important, and what the product may teach us about both sides of the phenomenon – what it was that was so dominantly characteristic of the source, and what the new milieu in or for which it was being expressed could have expected or tolerated. There are many places where these interface arts are highly revealing and do much to help us also understand interrelationships between peoples brought together through conquest, trade or simply mutual curiosity.

In this Chapter, and to a lesser degree in the following one, noting the interpenetration of artistic styles and expectations is of no less importance than the account of their sources and recipients. There are no general rules to deduce from the study of such phenomena, but there are a few common practices which may be observed and which are the result of the sea change in purpose and understanding which the arts had undergone.

Misunderstanding of a subject or motif in an environment to which it is foreign is commonplace, but forgetfulness and sheer habit can operate in the same manner at home, where there may be a natural development of a familiar motif into something more and more stylized, but still recognizable. But, even in a single cultural milieu, it is also possible for a subject that may start as an explicit statement of a recognizable form to degenerate with time, or be deconstructed, into something whose origins can only be discerned by the historian, and which had possibly been forgotten by its makers and viewers **554**. Both a lapse of time and a change of locale can effect such degeneration. The early masks of Chinese art **87**, highly stylized from the beginning, change over the centuries into forms which never clearly advertise their origins. The same happens to the mask stylizations of early Central American art. Something similar happens to early pictographs everywhere on their way to becoming scripts. Part representing the whole (*pars pro toto*) can produce analogous effects. The realistic subjects of Greek coinage, copied outside the Greek world over the years, because the coinage was important rather than the subjects, translated portrait heads, gods and chariots into patterns of arcs, lines and dots, with remarkably similar end-products from the Celtic world to Central Asia **553**. The phenomenon is not confined to the interfaces but is most common there. Within the arts of the main cultures we find the same thing happening, generally prompted by technical short cuts – as with the 'talismanic' seals of Crete **232c** or the *a globolo* seals of Babylonia and Etruria, where a technique of simply

cut lines, ovals and circles created by a bow-driven cutting wheel determined the style or even the motif.

Re-interpretation is a more revealing process: the adoption of a Greek divine image for the Buddha 148, Herakles becoming Vajrapani 156, his club turning to a thunderbolt, Egyptian Isis becoming Artemis or the Virgin Mary, Classical Zeus as the Almighty (*Pantokrator*), the re-working of monster images (dragon, griffin, chimaera) for a different climate of mythology and folklore. But it is very seldom that the borrowed image also carries a borrowed story or function, and although art as an instrument of propaganda may be attested, it operated through objects, which might or might not prove influential with other artists, rather than through any deliberate instructions to the artists' quarters. At any rate, subjects are easier to copy than styles – I have seen a fine carpet in a wholly traditional factory at Khotan (Central Asia), decorated with motifs from the Bayeux Tapestry, and several in the Carpet Museum in Teheran decorated with travesties of Classical figure subjects: the European mediaeval is easier to copy than the Classical realistic.

I have kept consideration of the interfaces separate within each section in this Chapter, although to a lesser degree in the next. Some of them have a certain identity of their own, although they may be short-lived; others determine in a significant way the later history of an important style, such as the Celtic, even over centuries.

553 *Greek coin devices translated for use in Central Asia and in the European Celtic world. (a) A silver coin from Bokhara, Central Asia, with devices derived from a classicizing Parthian portrait head, and a seated Apollo (a common subject on Hellenistic coins). (b) A Celtic silver coin with versions of a Greek head of Apollo and a chariot.*

554 *Translation rather than degeneration of a figure motif, demonstrated by the 'complete' figure of a bird-headed demon, as shown on the gateway at Tiwanaku in South America [541] at the left, and progressively stylized versions executed on textiles. Late 1st mill. AD.*

B. THE NORTHERN AND NOMADIC

The sweep of land from Mongolia and eastern Siberia across to the Atlantic has some variety of environment and climate, but not so much as to deny a broadly common way of life for its inhabitants in early days, and one in which a nomadic or semi-nomadic existence often recommended itself, and was indeed inevitable. Mongolia, south into the Gobi desert, and areas south-west into the Tarim Basin, and beyond that on to the Caspian Sea, offer grassland giving way to desert, but even in much of the desert, especially in the foothills of the mountain ranges (the Tienshan and north of Tibet, the Tarim Basin, on west to the Hindu Kush), and in some river valleys, such as that of the Oxus, it provides land suitable for either a pastoral or agricultural livelihood, or both, and so parts have figured in our last Chapter.

To the north, in Siberia, and to the west of the Urals on to Scandinavia, much is more forested, while south of this across south Russia and Europe, there is (or was) a mixture of sweeping grasslands and forest, again suitable for a pastoral and agricultural life. North America offered much the same range of grasslands, with forests mainly to west and east, associated with the broad mountainous areas of the Rockies in the west and lesser ranges like the Appalachians in the east. Everywhere, to the north of the forests and grasslands in the Old and New Worlds, the tundra gave way soon to the Arctic, with conditions for human subsistence which were wholly determined by the native wildlife – fish, seals, reindeer.

For the most part this was a sweep of land that in early days had encouraged mobility. This might sometimes be over long distances, following herds of wild animals, or looking for fresh grazing, sometimes not far distant, leading domesticated beasts to and from the local uplands (transhumance). It was dictated wholly by the seasons and brought them, over long periods of time, to some very distant movements of population, while the mobility of the warlike among them led sometimes deep into alien, urban territory to the south. Although the exploitation of mineral resources and global politics have changed the habits of life for most to a more settled, even industrialized, mode today, for many in

the east the general way of life has not much altered. Living off cultivated land is hard work; harder than living off domesticated and wild animals. The former may, however, lead to a rapidly expanding population, the creation of cities and what is regarded as a higher form of civilization, but it also makes the rich very rich and the teeming poor very poor indeed, slaves to their means of livelihood and, in many places, also virtual or actual slaves to the rich and powerful. We have seen the effects of this on the arts in the last Chapter, mainly in the way in which it could lead to the realization of major architectural projects and luxury products. The importance of metallurgy may seem diminished in nomad contexts, but this was not true of Central Asia, where apparently nomad peoples also commanded metal resources and techniques of some complexity (thus, the Bronze Age Andronovo culture of the northern and central steppes), nor was it at all true in Europe.

The nomads and forest-dwellers shared a common way of life for centuries. They were not builders of cities, except where they were inspired by an accumulation of wealth, usually from raids on more settled neighbours – or not even on neighbours, since the Mongols later penetrated far west into the Near East and Europe, under Genghis Khan and Tamerlane, and their nomad predecessors (Scythians and Sarmatians) went nearly as far. Such wealth could lead a Kubla Khan to build himself an imperial city in his homeland. Otherwise it was only close commercial contact with southerners (as of Scythians with Greeks), and the rich grasslands, that encouraged a more settled life and promoted the creation of substantial towns by nomad peoples. Generally, however, they kept themselves to themselves and maintained a certain exclusivity in their chosen arts. Mobility had not always been the rule on the northern steppes, and we have already observed the Bronze and Iron Age oasis and river fortress-cities of Margiana in western Central Asia (p. 92). Near the Urals folk built townships on a circular plan; and in the east the Hsiung-nu were building quite substantial towns and fortresses in Mongolia and to the south by the 3rd century BC.

In the more forested west there was somewhat less movement, except in the north. Much in the pattern of life was set by local conditions rather than pressure from or observation of the south; it was thus in the European Bronze and Iron Age hill forts, but later with different objectives of life and defence in the fortified towns in and beyond the Roman provinces. Less obviously characteristic in very early days were the remarkable 'big-stone' Megalithic achievements in the west, remarked in Chapter One, but not themselves a product of the creators of city civilizations but rather of pastoralists and farmers, and localized, although including a Mediterranean component.

Social structures among the northerners tended to be tribal, with loyalties to kings and dynasties, but with little strong feeling for territoriality – 'this is my own, my native land'. Alliances were readily made, and broken, but could lead sometimes to major concentrations of power and wealth. There are generally no slaves, except for the spoils of war, and the role of women is respected. Matriarchy is not uncommon, and women might fight beside their men – the original Amazons were invented by Greeks from knowledge of Central Asian behaviour, although I doubt whether they ever had to fight any until they settled there. Trade is mainly a matter of exchange, but hand-to-hand it can be over long distances. We think of the caravans on the Silk Roads from China to Syria and Europe, and Chinese mirrors being copied in the Balkans, or of Baltic amber and Asian lapis lazuli carried to the Mediterranean world, and, later, the distribution of precious stones from India and Ceylon. But caravan routes served cities rather than nomads.

For a long while neither formally acceptable 'money' nor writing or sealing were needed, beyond the obvious value of branding horses and cattle to signify ownership; nor complicated systems of mensuration except for travel. Religious life is much involved with the seasons and the animal kingdom rather than hierarchies of gods, since the latter are usually modelled on the more structured classes of settled communities. The spirit world that ruled all the essential features of life and survival was more sedulously courted by a

secular priesthood (the shamans), and this did not generate any complex heroic mythology or genealogies that we can trace nor, as a result, any accompanying narrative in the arts. There is a strong sense of continuity, of the recurring seasons, but not of historical details of the past, nor probably much regard for anything beyond the immediate future. Ancestors may be important but their burial places were never an influential presence in ordinary and mobile life. The grandest tombs are log cabins buried under sometimes enormous earth tumuli for protection as much as display, from Siberia to the Mississippi, and the burials may be richly furnished, not so much with equipment for some afterlife, as with the gear, and sometimes relatives, slaves and animals, which signified the former status of the dead. It is against this way of life that we must judge their art.

The cultures we shall be visiting are, broadly, the eastern nomads, from near Mongolia to the Scythians (a catch-all term in this context) who broke through from Asia into the Near East and south Russia in the 7th century BC, and their later kin. Not that many of these peoples may not themselves originally have hailed from the west, Indo-European and Indo-Iranian – a thorny historical and linguistic problem we shall not face here. In the west the central Europeans of the Bronze Age have less to offer than their successors, the Celts (another catch-all term here), whose well-established arts bring us deep into years AD. In the New World are the native Americans of the Great Plains and seaboards. Seafarers have a slight role, mainly later – the Norsemen. This is a world in which the camel, ox and horse, as draught animals and mounts, are of paramount importance, beside the animals kept or sought for food. This shows in the arts. With no native draught animals in North America, and so no wheeled vehicles, man was the carrier or at best his dog, until Europeans introduced the horse and cattle in the 18th century AD. You cannot tame a bison.

This is not, then, a story of monumental architecture but of the decoration of small objects for domestic use, harness, carts or fighting, or to display status, the subject matter deriving from the animal world or pure pattern rather than human behaviour. Conspicuous expenditure in the arts is generally prompted by infiltration of or from more settled neighbours to the south, but exceptional skills, of technique and design, were lavished on even minor decorative objects and utensils. The strongest inspiration was, broadly, spiritual. Here is a Chapter where the monumental and man as a subject for his own art have to take second place or are indeed invisible.

C. ASIA MAPS 1, 2

We have now to look more closely at the arts of these peoples, starting in the east. Among the true nomads some domestic architecture seems at first to have been wooden, so rectangular, but was soon largely a matter of the portable tent (*yurt* or *ger*), something which could be folded up or carried on a cart. But there were covered wagons too, and tents can be huge, supported by a forest of posts which will, in time and elsewhere, inspire more formal pillared 'hypostyle' halls; or they have broad open entrances, like the later *bit-hilani* halls of Mesopotamia and Syria **28**. The mound structure of the grand tumulus graves was both a demonstration of physical resources and designed to protect the treasures they held. Although there can be clusters of tombs, the nature of nomad life in truly open country meant that major burial areas were but rarely – at best annually – visited, and so needed extra physical protection from robbers and the elements. Otherwise, slab-covered graves served the populace near the main, even if temporary, centres of occupation.

In the figurative arts there are one or two major common factors. Scale is small, most artefacts are portable, and the commonest fields for decoration are on small objects – instruments, weapons or articles of harness for men (belt buckles), animals or carts. Work in stone is known, east and west, but is not truly monumental rather than the trivial magnified, at best a matter of roughly anthropomorphic tomb markers, possibly inspired by the practices of neighbours. Felt (compacted fur) is at least as important a medium as woven cloth. The subject matter for the arts is almost wholly animal, very seldom demonstrably divine or daemonic, except for some monsters which are adaptations of familiar animals (stags, wolves, horses, tigers), and seldom vegetable; so 'Animal Style' is a sensible overall term to be applied to this phenomenon, at least in the central and western steppes, although it is rather decried nowadays. It is important to regard it as distinct from styles of the eastern steppes on China's borders, and of south Central Asia, which are loosely

related. It is a style which served peoples who had nothing in common with the major settled cultures, and who could move about beside and even within them without surrendering anything important in their way of life and art; not unlike many Romanies in 20th-century urban Europe.

The shapes of the objects chosen for decoration in the Animal Style determined the field to be covered. These were therefore generally not the rectangle or frieze affected in arts designed for architectural or more substantial furniture settings; belt buckles and diadems are exceptions, their regularity determined by their functions. Nor is pure decorative pattern much in evidence. This can make for formless but sweeping and dramatic compositions of animal subjects, usually of no more than two figures at once.

The animal figures are conceptually as brilliant as those of the cave painters, but more curvilinear and often somewhat more removed from nature in both detail and pose **555-64**. A common feature, practised from south Russia to the borders of Mongolia, is the reduplication of animal forms or parts, and often their attachment to other animal figures in place of real limbs or horns **555, 561, 564**. Some later animal studies, however, can be more realistic and less stylized, vividly suggesting rest or movement **560, 563**. Animals contorted so that their hind parts are inverted **563** are found throughout Animal Style arts (and, indeed, Bronze Age Greece). The motif may hint at least at a partial view of the creature or group from above. In Mongolia itself and on the borders of China to the south there is a closely related style **567-70** which is reserved for discussion below (p. 331).

Naming and dating the nomad peoples and their immediate neighbours who occupied the lands between China and the Caspian in the 1st millennium BC are not easy matters – Scythians, Cimmerians, Sarmatians, Hsiung-nu, Wu-sun, Yueh-chi, while 'Saka' seems to have become a catch-all term for different tribal units or confederations, rather as 'Scythian' was to the Greeks, and many of those travelling the vastnesses of Siberia own no recorded names. Different names given by different peoples may in fact belong to single groups, and we virtually never know for sure what the various

peoples called themselves since they did not write. There seems to have been general movement north to south, or clockwise past Mongolia into the Tarim Basin, then on into lower Central Asia, India and the west. Mobility and a general tendency to shift west or south towards sources of foreign wealth, and away from pressure from the Chinese, who for a while penetrated west even farther than has modern China, lent a degree of homogeneity to style in art, in the broad terms that are accepted here, and the pictures tell their own story. The caravan system that could span almost the whole width of Eurasia served the urban and oasis settlements en route rather than the extremities.

One major source has been the frozen tombs of the Altai, where conditions of burial have preserved not just metal but wood, cloth, felt and tattooed human skin **556**, although the arts there are mixed in origins (nomad, Persian **352**, Chinese), and the tombs in the Minussinsk Basin to the north. More recent discoveries closer to the Caspian and to its north fill out the picture without making it much more intelligible, and these are related to more settled folk, while for the earliest period the identification of Caucasoid people (the 'Tarim mummies') suggests that very early intrusion could have been from the west.

Nomads in their wheeled carts had reached even south of the Caucasus in the 2nd millennium BC, but the most famous, the Scythians, arrived on the south Russian plains in the 7th century BC, and their rich tombs have proved the source for some of the most spectacular finds that now grace the Hermitage Museum in St Petersburg, from a time when archaeology was the sport of princes and emperors. Beside them is Peter the Great's Siberian collection, a record from the more easterly area. Now we meet another revealing interface, with the Classical arts of Greek colonists on the shores of the Black Sea; indeed, a major part of the 'Scythian' finds of any artistic merit in this area from the 6th century BC on are infected to varying degrees by the arts of the south, and pose questions broached already about nationality and training of artists. Generally, it can be seen that we are dealing with objects of Scythian type decorated by Greek artists, in their nearby colonies or among the Scythians themselves. These are in a Greek

style and sometimes with purely Greek subjects, or at best an approximation to the Scythian. But the Animal Style also travels well, attested in Mesopotamia as the result of southerly Scythian raids and occupation, although it had been nomads who had earlier passed south of the Caspian and influenced if not helped create the early arts of Media and Persia; and later into central Europe, with the Sarmatians at the turn of the era.

The Animal Style seems almost timeless and defies ready classification and dating. It does not take long, looking at the arts of the northern areas of the Old World, to recognize their profound difference from the urban arts to the south, and to understand both their overall similarity and the way they immediately proclaim their dependence on the way of life imposed on their makers by their environment.

555 A gold belt buckle from the Lake Baikal area (east Siberia). A beaked stag, its own neck and body decorated with beaked heads, one holding an animal head, and its tail ending in yet another, as does each of the tines of its antlers. It is being attacked by a smaller beast. These beaked heads are characteristic of steppe art and are applied to birds and animals, predators or not, and often appear on their own or as finials. 5th/4th cent. BC. Height 7.3. St Petersburg, Hermitage Museum.

556 Tattoos from the body in a burial among the frozen tombs of the Altai, at Pazyryk. They extended over arms and legs, the unclothed parts. 3rd cent. BC.

557 Felt decoration on a saddlecloth from the Altai tombs. A griffin of Greek type attacks a contorted ibex. 3rd cent. BC. St Petersburg, Hermitage Museum.

558 A wooden stag, gilded and on a silvered stand. One of at least five that stood at the entrance to a tomb at Filippovka, each about 50cm high. 4th cent. BC. Ufa Museum.

559 A wooden (larch) ornament for a bridle composed of a predator head and two of the familiar beaked heads (see [555]), from Tuekta, the Altai region. 6th/5th cent. BC. Height 14.2cm. St Petersburg, Hermitage Museum GE 2179/149.

560 A bronze plaque showing two camels fighting, from a tomb at Filippovka, north of the Caspian. The pattern is at once fluid, strictly symmetrical and realistic. This was probably a harness ornament. 4th cent. BC. Width 17.3. Ufa Museum.

561 *The gold blazon from an iron shield, from the Kostromskaya kurgan, in the Kuban (east of Crimea). A stag with multiple antler. 6th cent BC. Width 31.7cm. St Petersburg, Hermitage Museum 2498/1.*

562 *A bronze bridle plaque, from the Kulakovsky Kurgan, Crimea. The coiled body of a wolf, decorated with figures of a recumbent goat and a bird's head, its paws stylized as beaked heads. 6th/5th cent. BC. Width 10.5. St Petersburg, Hermitage Museum Kr 1895 10/2.*

563 *A gold plaque (one of a pair) with a winged, horned lion attacking a horse. This displays the contortion of the Animal Style but not the assemblage of animal parts and is to some degree affected by realistic arts of the west and the iconography of Persian beasts. 4th cent. BC. Width 19.3cm. St Petersburg, Hermitage Museum Si 1727 1/6.*

564 *A bronze bridle ornament; stags' heads with their antlers stylized as bird heads (eye and beak). Incised openwork plaques of this type are a long-lived class, well into centuries AD (e.g., at Perm [575]). Length 17.5cm. St Petersburg, Hermitage Museum 2507/2.*

ASIA: THE INTERFACE

Nomads move, and belligerent or hungry nomads move with some purpose. All the more settled areas to the east and south of the steppes felt their threat and were penetrated. In the arts the nomad styles were alien but evocative. Near China important and independent styles developed but their debt to the Animal Style may have been superficial only: in Central Asia and India they become almost imperceptible. Persia, on the routes south of the Caspian, had always been open to the peoples of the steppes – they and their successors (after the Macedonians), the Parthians, started there. And to the west, around the Black Sea, the interface culture was not indigenous, but colonial Greek.

We start with a distinctive group of metal objects from the eastern steppes which can be associated with the Hsiung-nu (probably related to the later Huns), who dominated the area for centuries BC and were a sore threat to China, eventually tamed. And there are related peoples of the Ordos plateau, in the north-western loop of the Yellow River, but still on the wrong side of the Great Wall. Their arts are related to those of the eastern steppes but in their way far more orderly and almost mathematically intricate, perhaps a Chinese trait. Many of the decorated objects are openwork belt buckles or the like, in bronze or gold, in a rectangular frame, as well as various other items of equipment. They were made mainly in the 1st millennium BC, generally its second half, and many are late in it, at a time when relations with China were close and mutual appeasement meant the traffic of a lot of precious gifts to and fro between generals and emperors, and intermarriage of royalty.

The works from this region are certainly related to the Animal Style, as it is met over vast ranges of land to the west, but they are best not lumped together with those of their westerly neighbours. They admit many more human figure compositions than we shall see elsewhere in this Chapter, with domestic and hunting scenes ('anecdotal' genre **569**) rather than heroic or religious, which may reflect the fact that their owners were not strictly nomad in their behaviour, but had settled in small townships by the time the bronzes were made: an 'interface' people whose arts may be seen to influence and be influenced by the city dwellers of China to the east. Moreover, these genre scenes are repeated with only minor variation, implying some sort of definable iconographic repertory which is far less apparent in nomad art. But the animal compositions also differ from the usual Animal Style in being composed often in symmetrical groups **567, 568, 570** and, however distorted some individual creatures may seem to be, there is a formal logic to these groups which reminds us of the arts of more settled peoples, and may owe something to the proximity of the more mannered and controlled arts of the Chinese, themselves shortly to be affected by western styles. In China itself there are some incredibly complex symmetrical compositions of fighting animals, many of them on objects which must have been made for nomad neighbours. In which direction the interface reaction passed is not always too easy to judge. China may have picked up from it some Animal Style art, notably some inspiration for its fluent images of animals and monsters, which contrasts strongly yet manages to blend with the stylized decoration of early Chinese bronzes. But in some respects what seems to be Chinese production for

nomad neighbours, observing the latter's preferences and some of their iconography but imposing Chinese style, can be equated with that of the Greeks for the Scythians, far to the west.

Farther afield, the eventual movement of the Hsiung-nu and others to the south and then far to the west brought this more controlled style into areas closer to typical Animal Style arts 572. By the beginning of our era it is probably the source of manners in Bactria and among the Sarmatians (around the Caspian and moving west), at a time when the old Animal Style was on the wane, and when the arts of the Bactrian Greeks had become well embedded in the local repertory, however much transmuted 571, 576. Luxury products are by now characterized by a degree of colour lent by inlaid stones, notably the locally procured turquoise, but also cornelian, garnet and chalcedony, a technique of some antiquity by then but never before so extravagantly practised 566, 571, 572, 576.

The Greek interface with the Asian nomads had developed via their Hellenistic kingdom in Bactria. It was slight, but enough to work east again and to put Hellenistic florals and figure styles on to textiles in northern Mongolia (Noin-Ula), and to leave a strong legacy even along the Oxus into the first century AD 145, while we have already observed the effect on early Buddhist arts in India (pp. 93–95).

There was a more dramatic confrontation of the arts farther west. Greeks started to found colonies around the Black Sea in the second half of the 7th century BC, and busily thereafter, developing strong trade links for the products of the south Russian grasslands, the fish stocks of Black Sea waters, and no doubt remoter sources of gold. The people they met were the Scythians, some still nomad, some already settled, and these had for long enjoyed sources of the precious metal. For Greeks this had led to myths about the heroic voyages of the Argonauts and of the Golden Fleece in Colchis (modern Georgia). The Greeks settled at or near the mouths of the great rivers – the Danube, the Dneistr (Odessa), the Dniepr/Bug (Olbia), the Crimean approach to the Sea of Azov (Panticapaeum) and the Don/Tanais, and the Phasis in Colchis. The Greeks did well out of the rich northerners, and their artists served them well, in the Greek cities and probably among the Scythians too. They made objects of precious metal using forms familiar to their customers, but decorated in styles dictated by the fashions of Archaic and Classical Greek art 577, 579–83. Much is determined too by the Greek styles of Anatolia and eventually Persia, once the Achaemenids had moved west to occupy Anatolia and parts of Thrace and Colchis.

The products were splendid, sometimes showy, among the very best in the Greek world, and quite alien to the Animal Style and the Scythians' native taste, although they were clearly welcomed and treasured by them. In the Greek manner, they betray close observation of the everyday and of human activities other than just hunting and fighting 577, 580, 583. They did nothing to persuade the Scythian artist seriously to change his style or subjects, although there are some attempts at relief sculpture in styles far from both the Classical and the Scythian in the mixed Scytho-Greek communities that prospered in and near the Greek colonies. At best Greek art helped provide a model for some daemonic figures of as much nomad as Greek identity 581. Rarely did the Greeks attempt to provide decoration in the Scythian manner, and never in the striking figure-distorting/combining manner of the best Animal Style which is so alien to Classicism. For the most part they offered works to which various animal figures were applied, but never properly incorporated in the overall design in the Scythian manner 582, and rendered in orientalizing, then Classical forms. This was a prolific interface between almost irreconcilable art forms, and continued into centuries AD with the Sarmatians, kin to the Scythians, who had also moved west from beyond the Caspian. It was never wholly lost in the arts of the 'barbarians' who were to pass on to vex the Roman Empire and its successors in Europe, nor in remoter corners 575 of what was to become the new, Orthodox Christian Russia.

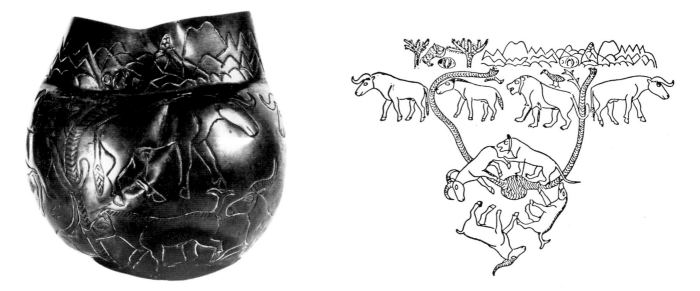

565 A 3rd-mill. BC culture (the Maikop) north-east of the Black Sea gives us a first and in many ways uncharacteristic view of the northern steppes. A silver bowl decorated with animals, disposed among streams, forests and mountains (b) to give a unique if naive landscape, exploiting shape – the top frieze for the distant mountains, and geometry – the placing of rivers and lake at the base. The ponies are the old Asian type (Przhvalski). The people lived in small fortified villages, their arts showing awareness of both Mesopotamia and Central Asia. St Petersburg, Hermitage Museum.

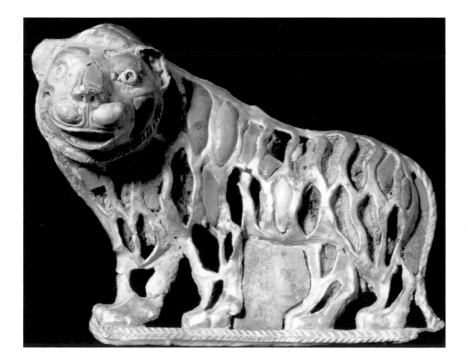

566 This gold tiger is probably to be related to the Bronze Age Central Asian objects of [120–24] but is shown here as an early example of the polychrome technique with stone inlays (cornelian, turquoise, with lapis lazuli background) so common in later centuries (the following pictures). The distinctive creature relates in style to Mesopotamian and Elamite arts of the 2nd/1st mill. BC, and appears also in silver over chlorite and as a chlorite statuette. Length 7.6cm. Once Halphen Collection.

567 A gilt bronze plaque from the Ordos region. A predator attacks an antelope (its head appears over the back of its attacker). Wolves, lions and tigers may contribute to the appearance of the predators in this eastern art, but the upturned snouts are distinctive. The drop-shaped treatment of claws, hair and joints is characteristic of nomad art, often inlaid with precious stones. Mid-1st mill. BC. London, British Museum OA.

568 A gold buckle from Mongolia. Symmetry, characteristic of the eastern nomad arts, dictates this composition of two lions attacking horses. There are turquoise inlays. 3rd/2nd cent. BC. Height 7.9cm. New York, Metropolitan Museum of Art 17.190.1672.

569 One of a pair of gold reliefs making a Siberian belt buckle. A man lies sleeping in the lap of a woman, his bowcase hanging in the tree, while an attendant holds the horses. Late 1st mill. BC. St Petersburg, Hermitage Museum.

570 A gold belt plaque from Siberia showing a tiger attacking a Bactrian camel, beside a tree. There is much here to recall work towards the east – the tree setting and the striations on the tiger's body. 5th cent. BC. Height 5.4 cm. St Petersburg, Hermitage Museum Si 1727 1/15.

571 A necklet in gold from near Rostov-on-Don (Kobyakovo cemetery), in a Sarmatian grave but perhaps made farther east. A seated Asian chieftain with a cup and a sword in his lap; at either side dragon-like creatures are attacked or played with by animal-headed men (compare the next and [54]), inlaid with stone and enamel. 1st/2nd cent. AD. Diameter 21cm.

572 Part of a gold diadem, with turquoise and garnet inlays, from a woman's grave in Kargaly Valley (near Almaty in south-eastern Kazakhstan). There is much of China here – notably a purely Han Chinese dragon [54] and the swirling background in openwork, but with local wildlife attended by humanoid figures, not unlike similar figures in Chinese art (some so-called 'immortals'), with monkey heads and hairy bodies. 2nd/1st cent. BC. Height 5cm. Kazakhstan State Museum.

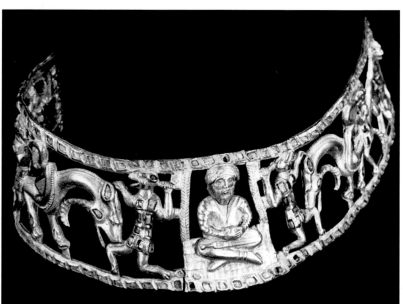

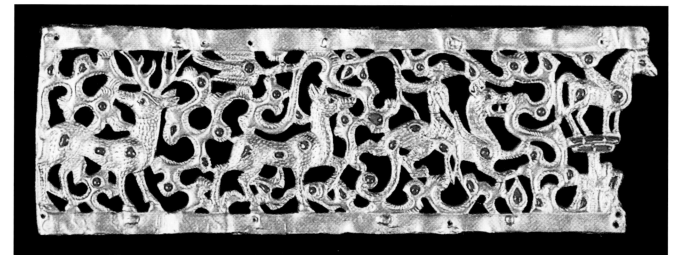

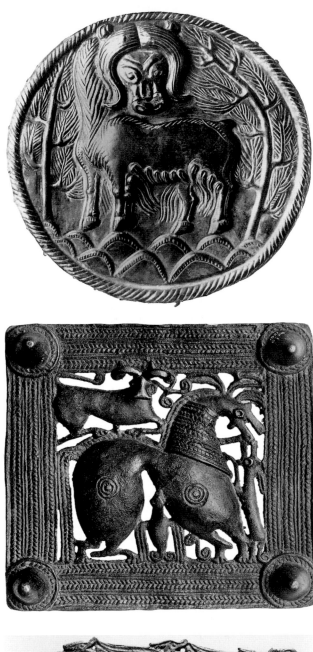

573 Silver disc from Noin Ula in Mongolia, with a yak among trees and rocks; a distant relative of the steppe Animal Style. 1st/2nd cent. AD? Diameter 14cm. St Petersburg, Hermitage Museum.

574 Other late relatives of the Animal Style are seen in belt clasps made in the Caucasus area (Georgia) in the 1st/2nd cent. AD, which seem not a little also affected by both Parthian and European styles. Here a horse is attacked by a small dog, a bird below, a goat above. Height 13.5cm. London, British Museum.

575 A possible and far later parallel to the rare humanoids seen on the Kargaly diadem [54, 572] are the figures on small bronzes from the far north (around Perm, 1,000km north of the Caspian), which are some six centuries later in date, but in the old nomad technique – bronze openwork plaques with incised detail (compare [564]). Generally the steppe artists avoided such depiction of a humanoid spirit world, but it was clearly of great importance in their religion. Perm was a centre for metallurgy and in this late period was occupied by Ugrian tribes. This has a demon riding a fish-filled monster, and various animal heads; from Sarapul District, Udmurtia. 6th/8th cent. AD. Width 18.2cm. Moscow, Historical Museum.

576 Gold plaque with turquoise inlays from a grave at Tillya Tepe, a site just south of the River Oxus. An oriental deity, with slant eyes and 'caste mark' on the forehead (a sign of divine status), wearing a kaftan but turning into acanthus leaves below the waist – a common feature for various demons in the east but deriving from the west (see [581]). He holds two divine horses, maned, horned and winged. This may recall the Chinese mission for the 'divine' horses of Ferghana in Central Asia, with which they could beat the Hsiung-nu on their ponies. The symmetrical composition is that of many 'master of animals' groups, west and east, but not in Animal Style art. From the same studio probably came the Hellenized subject of [145], in the same find. Early 1st cent. AD. Height of figure 6cm. Kabul Museum.

577 The handle of a gold comb from a burial at Solokha (near the River Dniepr). The style is pure Classical Greek, executed for a Scythian nobleman, and shows in the Greek manner a fight between a cavalryman and two men wearing a combination of Greek and local armour. Late 5th cent. BC. Width 10.2cm. St Petersburg, Hermitage Museum Dn 1913 1/1.

578 Scythians were notable metalsmiths, and not only of gold. This is a typical Scythian bronze cauldron, as found in Asia and Europe, but here decorated with a Greek palmette pattern below a Greek frieze of alternate bulls' heads and dishes. From Raskopana Mogila (near the River Dniepr). Height 47cm. St Petersburg, Hermitage Museum Dn 1897 2/14.

579 A detail of the gold phiale from the same source as [577] (Solokha barrow). The Persian shape was occasionally copied by the Greeks. Here the overall decoration is in the Scythian spirit rather than Greek, but resolves itself into separate realistic groups of lions attacking stags and horses, hammered from matrices, then finished on the surface. Around 400 BC. St Petersburg, Hermitage Museum Dn 1913 1/48.

581 A gold plaque showing a goddess attended by horned griffins, holding a severed human head, and becoming a mix of florals and monster foreparts below the waist, rather like a Greek Skylla; thus, a version of a Greek goddess, perhaps an Artemis, in a setting which makes her significant for a Scythian. From a burial at Kul-Oba (Crimea). 4th cent. BC. Height 3.3cm. St Petersburg, Hermitage Museum K-O 70.

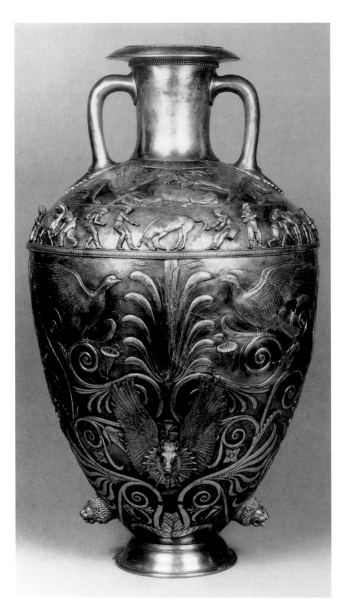

580 A gilt silver vessel from Chertomlyk (near the River Dniepr). The shape is superficially Greek but its purpose, with strainers and three lion-head spouts, was to deal with fermented mares' milk (kumiss), for Scythians. The floral decoration with wildlife is Greek, as is the workmanship and the style of the shoulder friezes, which show fighting animals and scenes from the life of the nomads. Late 4th cent. BC. Height 70cm. St Petersburg, Hermitage Museum Dn 1863 1/166.

582 A gold shield blazon (?) in the form of a fish, found with other Scythian armour at Vettersfelde (Witaszkovo, Poland), probably relics of a nomad raid to the west. The device is Scythian but a Greek artist has answered the Animal Style by simply applying in relief figures of an eagle, animals and a Greek Triton with fish; only the ram's-head tails are incorporated in the creature in something resembling the Scythian manner but also long known in Greek treatment of such extremities. Late 6th cent. BC. Length 41cm. Berlin, Stattliche Museen Misc. 7839.

583 A gilt silver cup of Scythian shape from a Scythian burial at Gaimonova Mogila (Ukraine). The scene of Scythian warriors at ease is rendered as a Greek artist viewed the subject, almost as a domestic rather than a military theme, and was certainly made by a Greek artist in this fully realistic style. 4th cent. BC. Height 9.7cm. Kiev Museum A3C-2358.

D. EUROPE MAPS 2, 6

We now turn west of the Russian plains, and through the Upper Balkans into central and north-western Europe. Significant elements of the Asian Animal Style had also affected some areas of European art in the early Iron Age, but we are not here dealing with mere diffusion, and we have also to consider the indigenous, independent fashions of the west. Mobility was still a factor, but not in all areas, and never on the scale of that farther east, except when the east invaded, but the hunting/gathering/pastoral way of life remained the norm, and agriculture was for long of secondary importance. The construction of small fortified towns is, however, a feature of the Copper/Bronze Age, of folk who used flower-pot 'beakers' and were to bury their cremated dead in 'urnfields'.

In the earlier period of loghouses, and 'causewayed' encampments surrounded by a ditch (like Maiden Castle in Britain), there is the strange Megalithic culture of the west, lasting into the Bronze Age at Stonehenge **15**. The more monumental remains of this were discussed in Chapter One. The humbler remnants, which have more to do with what follows, are illustrated here. In the Neolithic, when pottery had become a major field for decoration, there were odd echoes of patterns on pots of the Upper Balkans **584** which even recall the Neolithic of China (Yangshao **76**): big swirling motifs, like the clouds or waves which may have inspired them at either end of the land mass, and are major features of the observed natural world, whether threatening or beneficial. Spirals too, long popular in Europe, are natural shapes inspired by rolls, coils of rope, even snakes. We cannot here explore many of the links east-west, and a number of the similarities of design were as likely a product of independent but similar response to shared experience, as of borrowing.

In the later, more settled European stone-built forts the defences determined space for life which competed with space for animals. Expressions of the new command of metallurgy did not lead to much by way of new styles in art and decoration; indeed, in other media we might still be in the Stone Age. Much decoration on ordinary objects was still unformed and geometric in patterning, derived from craft usage in

weaving or wicker, but there were notable decorative objects – razors, knives and harness – with mainly geometricized figures and patterns, and heavily stylized figurines of clay and bronze **585–90** not so unlike those of some Mediterranean countries of the early Iron Age, but not derived from them.

Our main quarry here is the Celts, including the creators of the La Tène style, which is named for a site in Switzerland and covers 'Celtic' centuries BC, and to some degree their 'Hallstatt' predecessors (since 1200 BC). No one knows for sure where they came from, or when, or whether they had been there all the time. Here 'Celtic' can serve us as another catch-all name for the arts of the inhabitants of south-central and western Europe from around the 7th century BC on, and most familiar in later centuries, within our era, even applied to the Anglo-Saxon of the English **600**, although not essentially different from the 'Celtic' of the rest of the British Isles.

By the 7th century BC some eastern nomads had moved and begun to live close to central Europe, and interesting interfaces were developing in the Balkans, but the genesis of Celtic art is not necessarily to be sought here, despite the features that it may seem to have in common with arts to the east **591, 595**. Yet the Celts were 'the westernmost outpost of the vast Eurasian belt, stretching East to China, where there was no anthropomorphic art, where beast and mask were all and everything, where the tale of mythology was told in zoomorphic terms'.

Animals remain a favourite subject: 'an art of movement, masks, and beasts, without the image of Man'. But there comes to be more humanity and the humanoid too **589, 592, 594, 599**, especially human heads (which may have something to do with Celtic religious practices); also the world of vegetation and trees. There is virtually no monumentality in figure work or architecture until Mediterranean practices were observed, and implements, vessels and weapons, rather than harnesses, provide the most promising fields for artisan display. Metal-working was highly developed and much of the best work is seen on bronze vessels, in time often with colourful inlays or enamelling **605**.

As in the east, the rectilinear is avoided. Curvilinear and interlace patterns based on spirals, or on latticework of leather or reed, are more prominent than in the east **597–99**, and some are geometric miracles of compass composition **60**. They are, however, as in the east, diversified with a variety of natural and geometric forms, and in many ways they seem the most characteristic and original of the Celtic contributions to the arts of man. The blending of animal parts, often with the floral, strikes a chord after looking at the eastern Animal Style. The way in which this finds subtle and satisfying solutions for finials as well as overall decoration keeps it apart from what is happening to the south, where such features are far more formal. However, by the time of the main production of Celtic art, southern modes are so overpowering that we have to admit that the 'interface' is already at work, although intentions and results remain very different. But in essence the Celtic still has more in common with styles east than with styles south, and this remains true for centuries. Even the Celtic Knot, now a much-favoured decorative motif, has its distant relative in the patterns of Han China. One shared characteristic is the tenacity of forms and compositions: 'rational and irrational; dark and uncanny. Yet it is a real style.' (Quotations above are from the work of Paul Jacobsthal, a classicist who also made the closest study of early Celtic art.)

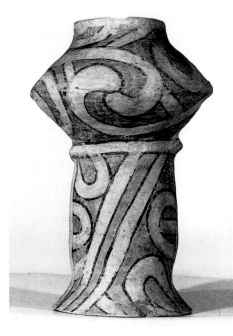

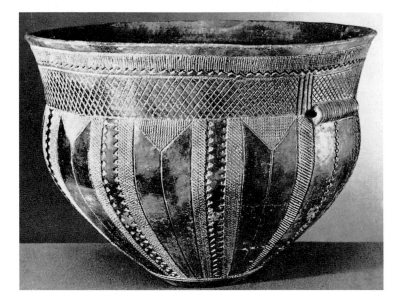

584 Pot of the Cucuteni, a culture in Romania, late 4th mill. BC. It carries the spiraliforn patterns which seem characteristic of much early Neolithic decoration, east and west. From Trusesti. Height 37cm. Bucharest, National Museum.

585 Clay bowl from Skarpsalling (Denmark). Of delicate make with incised decoration clearly inspired by weaving and stitching. 3rd mill. BC. Height 17cm. Copenhagen, National Museum.

586 Clay figure from Pristina (Kosovo). SE Europe seems to have become a centre for busy ceramic design in pottery and figurines in the later Neolithic period, in 'Skarpean' styles no little affected by those of Anatolia and the steppes. The distinctive treatment of the head here is echoed in other works from the same area but there was little unity of style for such figures in eastern Europe. 4th mill. BC. Height 18.5cm. Kosovo, Pristina Museum.

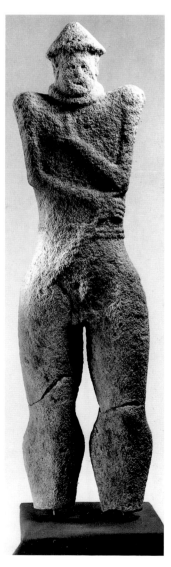

587 Bronze razor from Skivum (Denmark). The main subject incised is a ship with stylized prow and stern (in reality, animal heads). 8th/7th cent. BC. Copenhagen, National Museum.

588 Clay figure from Cirna (Romania) with a bell-shaped skirt, incised decoration and cursory representation of head and arms. 2nd mill. BC. Bucharest, National Museum.

589 The life-size stone figure of a warrior who stood atop a burial barrow at Hirschlanden (SW Germany). Forms remain geometric but material and scale are influenced by knowledge of Mediterranean practice and this is rare monumentality for the early Celtic world. 6th cent. BC. Height 1.5m. Stuttgart, Württembergisches Landesmuseum.

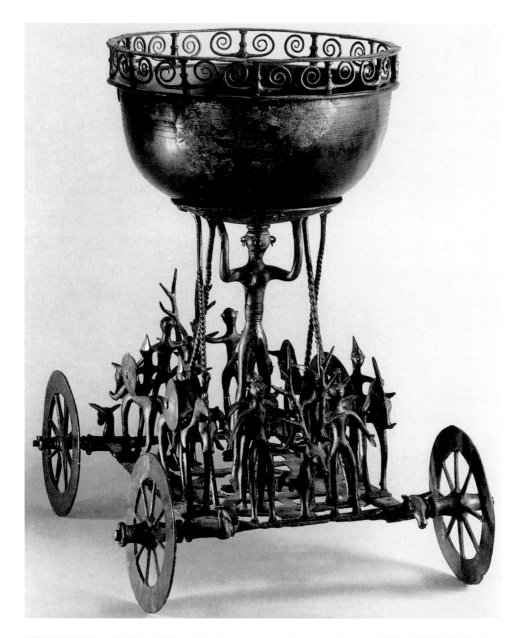

590 The bronze cult wagon from Strettweg (Austria). The individual figures – warriors, horsemen, stags – attend a naked female figure supporting an offering dish. The figures recall but do not derive from Greek Geometric art, here in the service of European cult. 6th cent. BC. Height of woman 22.6cm. Graz, Landesmuseum Johanneum.

591 A bone ornament including a bird's head of Animal Style, eastern type, with a fan tail, from Dürrnberg (near Salzburg, Austria). 5th cent. BC. Salzburg, Museum Carolino Augusteum.

592 The stone head from Msecke Zehrovice (Czech Republic). Heads are important elements in Celtic art and religion; this is a 'portrait' of a mustachioed chief, wearing a heavy neck-ring. 2nd cent. BC. Prague, National Museum.

593 Gold neck-rings from Erstfeld (Switzerland). The openwork pattern of animals is strongly reminiscent of Animal Style arts of the east. 5th/4th cent. BC. Diameters 13.6, 14.8cm.

594 *An animal-hoofed figure, like a Celtic Pan, of cast and sheet bronze, from Bouray (Essonne, France). 1st cent. BC/AD. Height 42cm. St-Germain-en-Laye, Museum des Antiquités Nationales.*

595 *Recalling the wooden carvings from Central Asia (Altai), a large wooden stag from Fellbach-Schmiden (SW Germany). 2nd cent. BC. Height 77cm. Stuttgart, Württembergisches Landesmuseum.*

596 *A bronze dancer – a Classical pose rendered in Celtic style. From Neuvy-en-Sullias (Loiret, France). 1st cent. BC. Height 14cm.*

597 *(opposite) A bronze shield found in the River Thames at Battersea (London). Early 1st cent. AD. Length 77.5cm. London, British Museum.*

598 A bronze mirror from Desborough
(Northamptonshire, England). The spiraliform design is
subtly composed from carefully composed compass
patterns (compare [61]). 1st cent. BC. London, British
Museum.

599 An iron harness ring from Mezek (Bulgaria). A spiral
tree is transformed by barely marked nostrils into a facing
head; a visual pun. 3rd cent. BC. Width 7.5cm. Sofia,
National History Museum.

600 The Celtic style in ornament survives long in the West, to the Book of Kells and beyond. This is a purse lid, framed in
gold, with plaques inlaid with garnets and multi-coloured glass, found in the Sutton Hoo (Suffolk, England) ship burial of
about AD 625. The interlaces, animal groups and detail (the hooked beaks) take one straight back to the arts of the steppes
of eastern Europe and Asia a millennium earlier. Length 19cm. London, British Museum 1939.10-10.2.

EUROPE: THE INTERFACE

One area in the Balkans (Thrace: now south Romania–Bulgaria–north-east Greece) had achieved some notable metalwork in the late Bronze Age. This was not altogether unlike the Animal Style arts of the east, but with stronger treatment of the human figure. The arrival of Greek colonists in the later 7th century BC on the western shores of the Black Sea and at the mouth of the Danube had a similar effect on the arts to that it had exercised to the north and east. Thrace extended down to the north Aegean coast and its closer proximity to these Greek seas guaranteed more direct Greek intervention from this time on, and even some Persian **348, 349**, since the Achaemenid empire dipped into Europe here, across the Dardanelles. The products betray their homeland only in their shapes and some idiosyncrasy of iconography; some, locally produced **601, 602**, look more like truly provincial Greek work than much on the other shores of the inland sea which we have already looked at. There seems to have been no shortage of precious metals.

Farther west the Alps were no barrier to access from and to the south, and in the 7th/6th centuries BC there is the engaging so-called Situla Art (named for the bucket shape on which the art often appears) with a figure style which carries something of the European late Bronze Age with no little of Etruscan/Greek **603**. Until Etruria fell under the spell of Phoenicians and Greeks in the 7th century BC, most of northern Italy had been essentially more European than Mediterranean in outlook.

Greek and Etruscan goods penetrated far into France and Germany: mainly luxury gifts, then wine, from Provence to beyond the Rhine, at first from the south of France, then over the Alps. A site near Munich (Heuneburg) learned about Mediterranean mudbrick, not a natural technique for the area. When a Greek bronze cauldron which travelled north lost one of its orientalizing lion attachments, its local replacement mutely attests the difference in outlook of the two cultures **604**. The biggest object in the grave of a Celtic princess at Vix near the River Seine was a Greek bronze cauldron, man-high, a show piece such as was seldom seen in the Greek world, and indeed of a size that has allowed doubts to be entertained about whether it could have been filled without bursting. This was a status symbol *par excellence*, not evidence for the adoption of Greek drinking habits. A few of the more formal Greek floral motifs were embraced by Celtic art – hardly more, while there was no serious return traffic in our terms. Only in Spain does a 'Celtiberian' art offer an interesting blend of Celtic and Greek **606**, not without a little of the Phoenicians, who had also been busy in Spain from around 700 BC on. The riddle of the Gundestrup bowl **607**, found in a Danish bog and an excellent example of a prime object whose assured findplace offers no clues whatever to where or when it was made, or by whom, raises questions far more complicated than any in Celtic art, and in its way presents a puzzling amalgam of styles and subjects that most Celtic art managed to avoid.

601 Two gilt silver plaques from Letnitsa (Bulgaria). The style is local, deriving from rich earlier decorative gold work, but the subject matter is derivative. The heavily armoured bear-hunter (the faces on the knee caps of his greaves are a local feature) presents an older eastern motif (a); the woman by the sea monster (b) misunderstands rather than re-interprets a Greek subject, where she would be riding the monster, as a sea goddess. 4th cent. BC. Heights 5.0cm. Lovech, Museum of History.

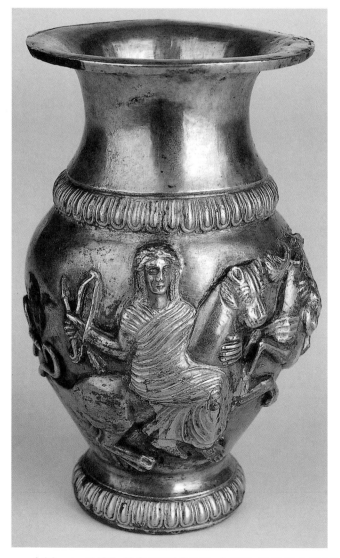

602 A gilt silver jug from Rogozen (Bulgaria). A goddess holding a bow rides a lion; she is a local deity, rendered in a provincial Greek style and probably assimilated to the Greek Artemis, or at least inspired by images of her. Height 13.5cm. Sofia, National History Museum 22455.

603 'Situla Art' is a central European/Italian product of the northern Adriatic area, mainly of hammered bronze vessels with subjects of local significance but admitting several motifs from southern arts and adjusted Classical floral motifs. This part of a bronze bucket from Bologna (N Italy) has warriors with European oval shields and southern round ones, the carriage of liquids, a feast (seated on an Etruscan sofa with accompanying Pan pipes and lyre) and orientalizing animals like those on Etruscan vases. About 500 BC. Bologna, Civic Museum.

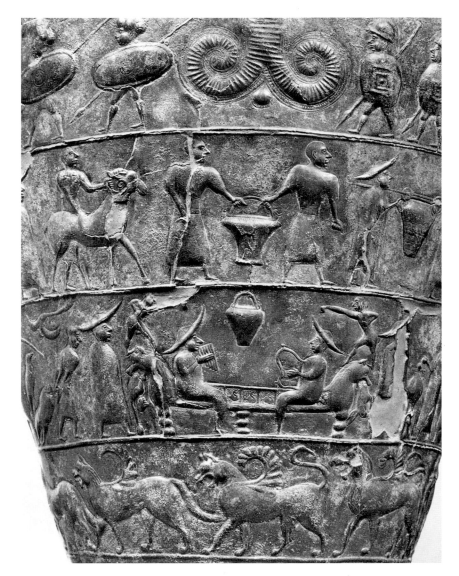

604 Two bronze lions (out of three) from the shoulder of a Greek bronze cauldron found at Hochdorf (Württemberg, SW Germany): (a) is an original Greek; (b) was locally made to replace one that was missing, with no attempt to copy the style of the original. 6th cent. BC. Stuttgart, Württembergisches Landesmuseum.

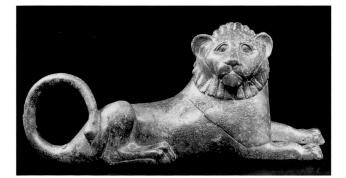

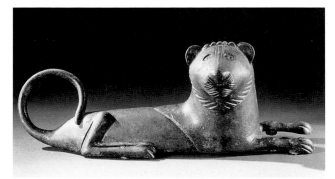

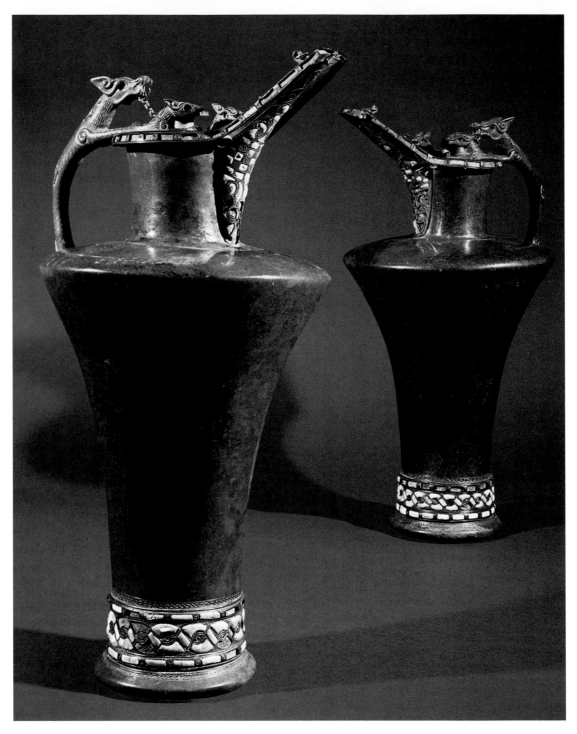

605 *The flagons from Basse-Yutz (on the Moselle, NE France), copying an Etruscan shape and found with imported Etruscan bronze vessels, but decorated with coral inlays and enamel, with an animal handle of eastern or Mediterranean inspiration. About 400 BC. Height 38.7cm. London, British Museum.*

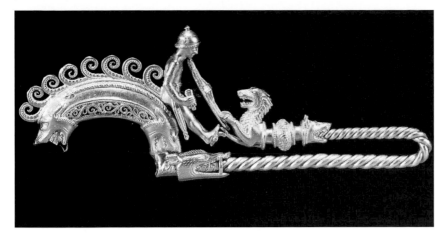

606 A Celtic (Celtiberian?) gold fibula (safety-pin). Over the pin clasp a Celtic warrior faces a very orientalizing lion, but the arc of the brooch carries monster heads and a Greek spiral with leaves, and the twisted pin is held by the heads of a sea monster and a wolf. The technique is excellent and has given rise to the thought that it was made by a Greek, but the warrior looks un-Classical in physique, and the animal heads are very stylized. Length 14.1cm. London, British Museum G&R.

607 The gilt silver bowl found in a peat bog at Gundestrup in Denmark is the most lavishly figure-decorated work of the Celtic world – yet its purpose, the reason for its deposition, its place of manufacture and date remain matters for debate. Much of the imagery is European – horned deities, warriors with Celtic shields and trumpets; but there are elephants too (Hannibal had passed through Europe with his in the 3rd cent. BC) and griffin-like creatures as well as versions of Greek sea monsters. This was probably made somewhere in eastern Europe, possibly Thrace, and perhaps in the 2nd/1st cent. BC. Diameter 69cm. Copenhagen, National Museum.

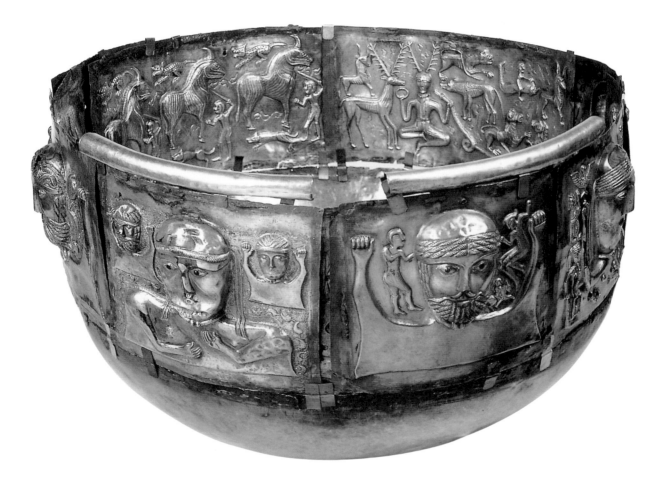

The arts of the early hunter-gatherers of the New World are more elusive, and familiarity with what was observed by the first European immigrants can be deceptive. Identifying and dating local cultures and their arts has been made the easier through modern archaeological methods, but it is nonetheless even more difficult to observe coherence and transmission of styles here than it was in Eurasia.

Humans first entered North America (the Yukon) from Siberia before the last Ice Age, but got no further, thanks to the ice cap. The next intrusion from Asia anticipated by more than fifteen millennia the Russian colonization of Alaska and the seaboard down to California, stifled and bought out by the United States in AD 1867. (See also above, p. 263.)

In the cold north a limited immigration from Siberia of the 2nd millennium BC seems to have brought, as well as the bow and arrow, arts like those of the Asian Animal Style. These are to be glimpsed in the animal motifs on carved walrus ivory and bone, and presage centuries of production of comparable small objects **608, 609, 611** down to the modern Eskimo (Inuit).

Wood, hides and clay were the major media in North America and the products of artisans were generally small and portable, decorated implements, religious objects or the like, the subjects usually animal, as in the Old World. What we see is mainly very late, close to the date of European arrival if not after it. Dwellers in the North American plains did not have horses to ride – a novelty that transformed their society and behaviour – until the 18th century AD, not even perhaps the bow and arrow (from the north) until about AD 500. As in the last Chapter, our view of the early arts of North America must carry us centuries later than any of the Old World, and for the same reasons.

Rock paintings of around 2000 BC (Lower Pecos) offer animal and human subjects, but lack the occasional flashes of realism found in the Old World. They are more like the 'primitive art' of many different places and periods; comparisons are with the Stone Age in the Old World. Rock paintings go on being made for centuries **615**, as they were in Australia. Much pottery decoration of an abstract character betrays its origin in woven patterns. Metalwork is rare, and the animal world remains the inspiration for work in native sheet copper for the Hopewell culture (about 200 BC–AD 400), which was also productive of art in other traditional materials **610, 613, 614**. It is hard to say

whether there was any real narrative art. The familiar so-called totem poles of the west, of late date, are composed of superimposed images of animals and daemons or divinities, which can sometimes be translated, at least for the modern visitor, as *aides-mémoire* to a story, but might be no more than an accumulation of images that reflect the power or influence of deities or a chieftain, like a coat of arms. The antiquity of the form remains uncertain, but see the end of this Chapter.

Burials in wooden chambers beneath high tumuli of earth recall the Eurasian practice, and burial mounds are a feature from a very early date, especially near farming communities which grew up in the south-east. Later, however, in the centuries before the Europeans came, the more ambitious and regular mound structures of religious intent and the accompanying settlements [612], [623] indicate a more settled urban life which cannot have been unaffected by the cultures of Mexico to the south, and are best considered as an interface phenomenon. In the Chaco Canyon of New Mexico, however, pueblos with 'great houses' (9th–12th centuries AD) of fine masonry up to five storeys high and over two acres in area attest local architectural enterprise [617], perhaps only remotely affected by the south. For earlier centuries there is too little to enable us to make more than the broadest comparisons with Eurasia, and some of these, in the north, may in effect even derive from Eurasia. The village arts in pottery and textiles changed little over centuries [616], [618], [619].

608 The bone figure of a walrus from NW Alaska (the Ipiutak culture) of the early centuries AD. New York, American Museum of Natural History.

609 Ipiutak culture, a walrus-ivory pointed utensil from the Seward peninsula, Alaska, in openwork incorporating animal heads. About AD 500. Length 26cm.

610 A raven or crow cut in copper sheet, a familiar subject and material for the Hopewell culture, of the centuries BC/AD, from Ohio. About AD 400. Chicago, Field Museum of Natural History.

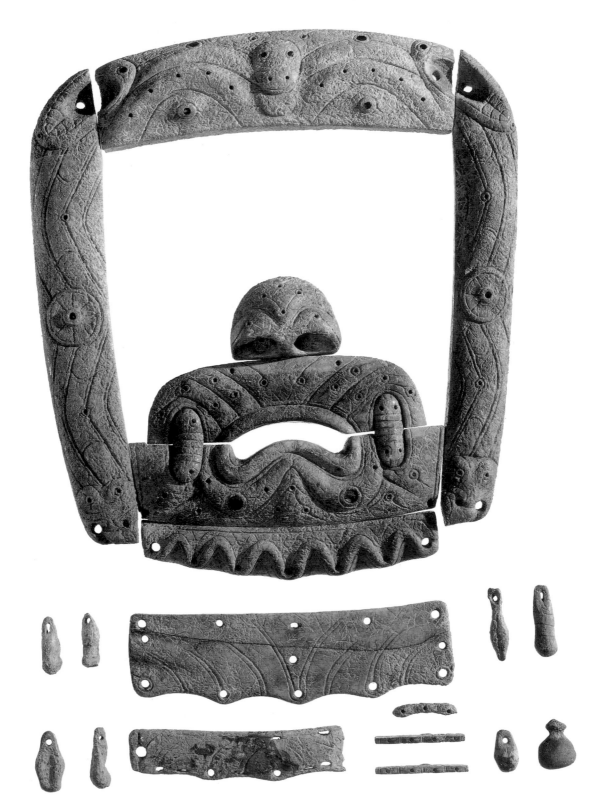

611 *An Ipiutak walrus-ivory funeral mask. About AD 500. Width 24cm. New York, American Museum of Natural History.*

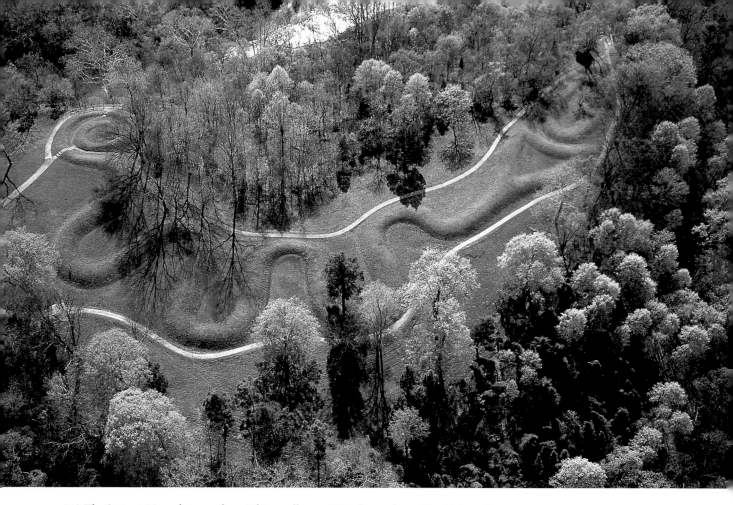

612 *The Serpent Mound, in southern Ohio, well over 400m long, about 15m high, and with no major settlement at hand. Of the Hopewell culture, of the centuries BC/AD, and an uncommon instance of art in the landscape (see p. 35).*

613 *A stone pipe of the Hopewell culture, decorated with the figure of a frog. Pipe-smoking long remained an important element of North American 'Indian' culture. About AD 400. Length 10.5cm. Ohio State Museum.*

614 *Figurine in fossil mammoth ivory, of the Hopewell culture. Height 8cm. Field Museum of Natural History.*

615 Fremont culture rock paintings from the Great Gallery, Barrier Canyon, Utah. The texture and patterns of dress are more important than body forms. Late 1st mill. AD.

616 Detail from a painted bowl of the Hohokam culture (in the south-western desert). Dancers, rendered in what might be regarded as a universal geometricized style. About AD 900. Arizona State Museum.

617 Part of the Cliff Palace, one of several Pueblo settlements in the Mesa Verde (Colorado), masonry buildings generally placed in the protection of cliff overhangs, for a settled, farming community. Early 1st mill. AD.

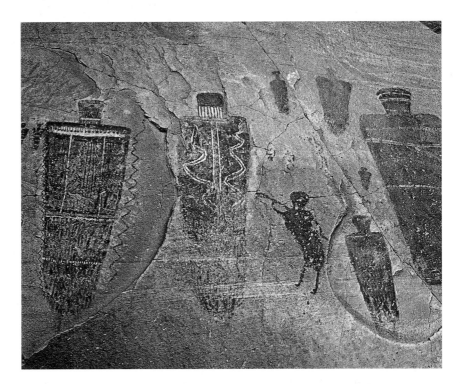

618 A Pueblo bowl from Mesa Verde, with textile patterns. About AD 1300. AD. Diameter 25.4cm. London, British Museum.

619 A Mimbres-style clay dish, with a turtle, from Mimbres Valley, SW New Mexico. A characteristically uncluttered style of pottery decoration, with geometric ornament. A grave offering 'cancelled' for mortal use by the hole in the centre. Early 1st mill. AD. Diameter 27cm. Harvard, Peabody Museum.

620 A deer mask of wood and leather, the details treated with considerable attention to realistic detail. From Key Marco, Florida. Early 1st mill. AD. Length 27.5cm. Philadelphia, University Museum.

621 Clay duck vase from a mound burial at Kolomoki in Georgia, of the Mississippian tradition. Mid-1st mill. AD.

NORTH AMERICA: THE INTERFACE

The big burial mounds and earthworks of the Adena and Hopewell cultures in the centuries around the start of our era lead to what has been called the Mississippi Climax in the 1st millennium AD. Cahokia, on the river opposite St Louis, presents a settlement of perhaps up to 30,000 people. A central plaza is dominated by Monk's Mound, 35m tall, used not for burial but for cult purposes, and the town boasts many more such platform mounds **623**. Other sites (Hohokam) have what seem to be ball courts in shallow ground depressions, so the Ball Game seems to have been as ubiquitous a North American activity then as it is today. It is impossible not to draw comparisons with the Maya and Aztec cities of Mexico, and their plazas and platform mounds, and to deduce that the inspiration came from the south, although scholars of North American archaeology are often loath to admit the link. Such close similarity, with the geography, surely attests something other than independent invention. It would not be the first time in the history of world art that there was geographically a strong reverse trend in influence. Cahokia and the Mexican towns are more like each other than any other works of man at this or any other date. The figurative arts associated with this culture and others towards the south also bear unmistakable traces of Mexican styles in pattern and the stylized portrayal of the human figure **622, 624**, although not exercised on any monumental scale.

One cautionary note needs to be sounded, if only to demonstrate how little we really know and how profoundly new archaeological discoveries might affect our view of ancient arts. In the Preface I remarked that I had noticed no points for comparison between Old and New World arts, except for stylizations of figures and masks in Central America and early China. Others, I found, had already remarked this in a more professional, documented manner, and had added the superficial (or more?) similarity of vertical compositions of heads and masks in early Chinese jades and bronzes to those on the 'totem poles' of western North America, at least as they are known from far later periods. And the assumed later migration across the Bering Straits came at around the time the relevant styles were current in China (Shang Dynasty). Could such a view of the arts have travelled along the western seaboard, to Central America, there to be expressed in such similar yet culturally different ways at such an early date? Do some aspects of the interface I have just sketched reveal rather a trace of yet older styles in the north, introduced from Asia, rather than new ones from the south? The questions must remain unanswered, but similar ones have also been broached for South America, as we have seen (p. 263).

622 The stone figure of a man for a pipe, from Adena Mound (Ohio) of the Adena culture. The open-mouthed figure bears unmistakable kinship with Central American figures. 1st cent. BC/AD? Height 20cm. Columbus, Ohio Historical Society.

623 Mississippian shell disc with a kneeling figure carrying a human head and a mace; the kneeling posture denotes running, a common convention in narrative art, here abetted by the shape of the field. The style is essentially that of Mexico in this period. About AD 1000. Diameter 10cm. New York, National Museum of the American Indian.

624 Reconstruction painting (by William R. Iseminger) of the Mounds site at Cahokia, a site of some 15 acres. The 'Monk's Mound', 35m high, is the largest in prehistoric North America. Near the Mississippi (St Louis area). About 1000 AD.

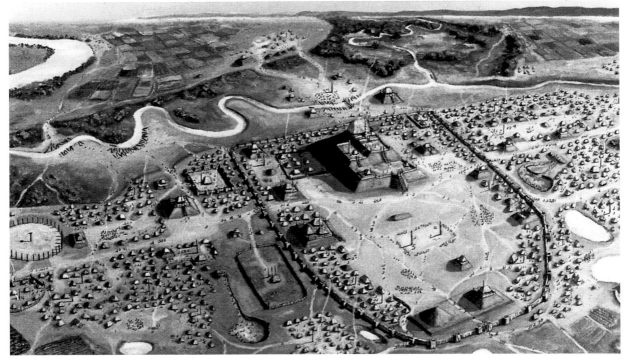

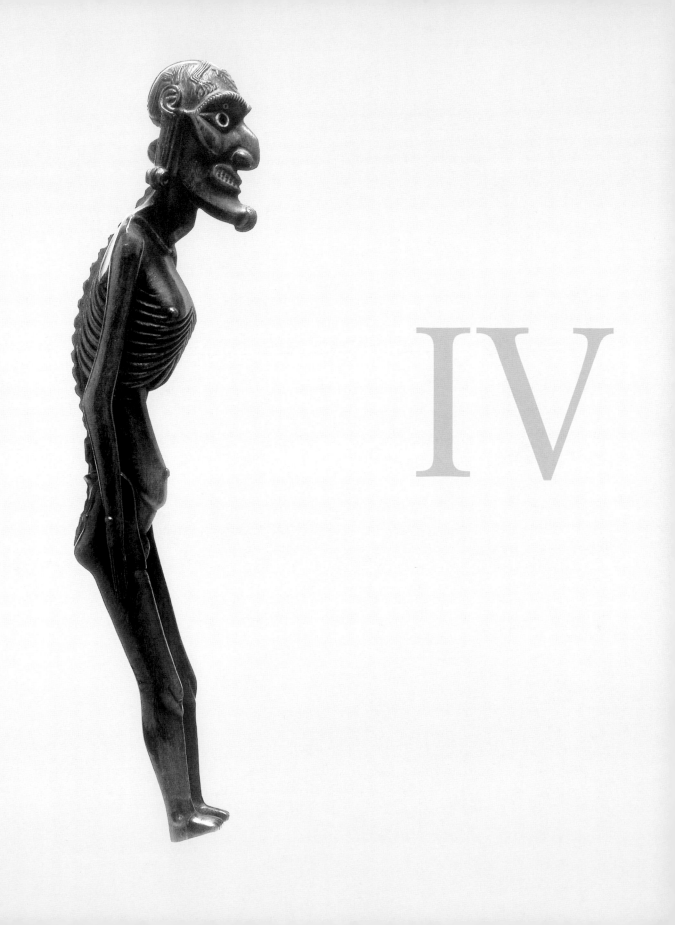

IV

THE TROPICAL ARTS

The arts surveyed in this chapter present a rather special case, and discussion of them will have to be very summary in comparison with the last two Chapters. This is largely because their qualification as 'ancient' has, except for much in South America, to be accepted without direct proof, and rests on the assumption that African and Oceanic arts had changed little over centuries, down to the periods in which they are most fully documented, which means virtually the 19th century on. The alternative would have been to exclude them altogether from this book, but that would deny the reader some interesting contrasts with what had happened in the north, as well as some interesting interfaces with urban cultures and a further demonstration of an environment:society: art equation.

Within the tropical arts there is a certain unity from continent to continent. Styles are highly sophisticated in terms of execution and design, although not generally in terms of technology, and they serve broadly similar ways of life. These were dictated by Nature, the universal provider, with produce which was sometimes vigorously sought out by man, but which for the most part he did not try or need seriously to tame and domesticate, and with which he was always ready to compromise. Agriculture is mainly opportunist, pastoralism rather restricted by the animal life available for domestication despite the provision here and there of large areas of savannah, potential grazing land. For the most part we are dealing with the hunter-gatherer. Where life began to resemble that of the temperate societies it can generally be seen to have been developed from or by them. Lack of communication, and perhaps the fact that the environment did not provide the conditions for the rapid population growth that promoted urban cultures, may be a part of the answer. This, again, is an oversimplification but may go some way to explain any unity of response to the tropical way of life that we may detect. That there is a unity is unquestionable, more apparent between Africa and Australasia than in South America.

The major arts, with their overall similarities in appearance, all patently acknowledge the spirit world more than the ruling class. They are relatively free from those preoccupations with the assertion of an individual person, family, race or god that dictated much of what we have seen in the urban belt, except to the extent that ancestors are the natural repositories of spiritual power and a current ruler needs to be seen to be dominant. Flashes of realism in the arts are rare and uncharacteristic, or again promoted by the outsider, yet the eye can sometimes detect what seems to be effective though unrealistic, perhaps instinctive, portraiture in many of the wooden figures, especially in Africa. Narrative art is as remote a conception as it was in the northern cultures we looked at in the last Chapter. We have arts devoted to the embodiment rather than portrayal of mainly ancestral spirit entities,

and more engaged with the human figure than the animal – the reverse of the situation in the north.

Chronology is a dire problem everywhere and our 'ancient' has often to be illustrated by the almost modern. This is done with good reason and not too many qualms, however. Almost all the materials are perishable, rarely even of fired clay which can be dated and is sophisticated enough to be informative. In America only Colombia/Ecuador had a serious interface with the urban cultures of Central and South America, largely because of the metal resources (gold) the area enjoyed and the techniques of working it that had been mastered. Here chronology is more real. In Africa, parts of which had been a major source of materials for Egypt and the Levant, there was the possibility of more contact between the sub-Sahara, central Africa and the urban north, but never to the degree that the arts of the peoples of the tropics were seriously affected, and this despite the local intrusion of Egyptians, Muslim Arabs, eventually Europeans. It leaves thus a certain unity and even purity of style which is 'ancient' in our terms but persists in places as a live style, not just nostalgic, to the present day. Much the same is true of Australasia, indeed even more so, since the nearby ancient cultures of China and India did not penetrate far or perceptibly in their developed forms, and Europe did not intrude before the 18th century AD. But it does mean that we have to accept that much of the art of the last few centuries, which is almost all we have, is a fair indication of precedent styles, a fair assumption supported by the few pieces for which some antiquity can be proved. In both Africa and Australasia rock paintings can seem almost a separate genre, sharing much with the Palaeolithic elsewhere as a result of common aims and materials, and not too much with surviving local artefacts in the round, of wood or stone.

In this Chapter there are not many significant interfaces which produced distinctive art forms, so they are treated in passing, and illustration is little more than token except in the chronologically better-defined areas.

The geography is complicated – mainly tropical and, for present purposes, excluding only the Andean west where city civilizations developed. In the north, especially Amazonia, much is and was rainforest, but capable of clearance. Farther south was savannah and increasing cold.

Modern Colombia in the north, beside the land bridge to the home of the Maya (in fact quite distant – over a thousand difficult kilometres but well populated) was the home of a distinctive culture and of advanced metallurgy, but not to the point of comparison in terms of social organization with the less metal-conscious city cultures of the New World. It rather presented an assemblage of small towns and villages, with changing fortunes over a very long period, principally AD, until the arrival of the Spaniards. Availability of gold and copper led to the invention of the hard alloy *tumbaga* and development of distinctive but very varied styles in elaborate goldwork. All necessary techniques – hammering, wire, foil, granulation, soldering, lost-wax casting – were discovered, as they had been, independently, in the Old World. The objects could also be enhanced by a rich gilt surface ('depletion gilding') which is a Colombian speciality. While some of the products bear an unmistakable American stamp, many do not, but they exhibit a treatment of animal and human subjects in an original manner not all that unlike that of other tropical arts in the world **625, 626, 629, 630**. The material, but not the style, was introduced very late in Central America (for the Mixtecs and others **491, 501, 518**), although it had arrived by about AD 800.

The San Agustin culture in the south offers some stone sculpture for graves and shrines **627**, probably inspired by the Andean (Chavin in Peru), and here too there were quite elaborate rock-cut tombs with pattern-painted interiors. Cylindrical and barrel-shaped clay burial urns in human form **628** are a feature shared with an Amazon delta culture to the south (Marajó), where the figures are seated **635**; some uncannily recall the more primitive Egyptian and Philistine Iron Age clay coffins of the Old World.

The Amazon basin housed, as it does today, a large number of separate, relatively small cultures. There was, it seems, little intercommunication, given the size and nature of an area which could easily support a hunter-gatherer society. The population was not always as sparse as one might imagine. There are mounds, but unlike those of Central America, being either platforms for villages or burial grounds, when not shell mounds of debris from meals. There was, and is, even limited agriculture – maize and manioc. Some areas can be seen to have developed traditions in the arts, most apparent in their pottery, and the richest areas for early art are towards the estuary, on the Equator.

Elsewhere, along the land bridge to Mexico, the arts shared as much of the north as of the south **631, 632**, while the rest of South America could reflect the urban styles to their west in varying degrees **634, 636**.

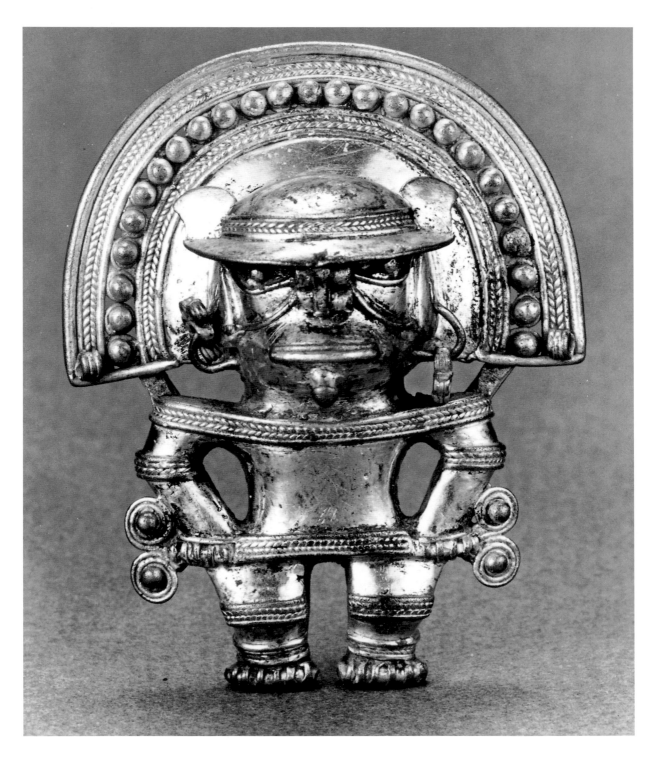

625 *A cast* tumbaga *pendant from the Tairona region, Colombia. Early 2nd mill. AD. Height 6.4cm. Bogotá, Museo del Oro.*

626 *The gold (tumbaga) head of a sceptre in the form of a toucan. From the Sinu area, Colombia. There is a strong feeling for the animal form, apparent in little of the other Colombian gold. Length 16.2cm. Once in the collection of the sculptor Jacob Epstein, now of George Ortiz, Vandoevres.*

627 *The stone figures of the San Agustin culture, south Colombia, are generally frontal, about one metre high, often with jaguar faces in which the eyes and nose are prominent, with fanged jaws, or they are human attacked by a jaguar. Here, a jaguar-man is holding a club and shield. Mid-1st mill. AD. Height 95cm. London, British Museum Q.78.*

628 *Clay burial urns from Tamalameque, north Colombia. They contained the de-fleshed bones of the dead. Human-figure vases for general use are also a feature of early Colombia. About AD 1000. Heights 39–87cm. Bogotá, Museo del Oro.*

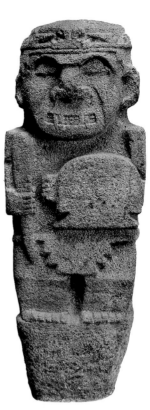

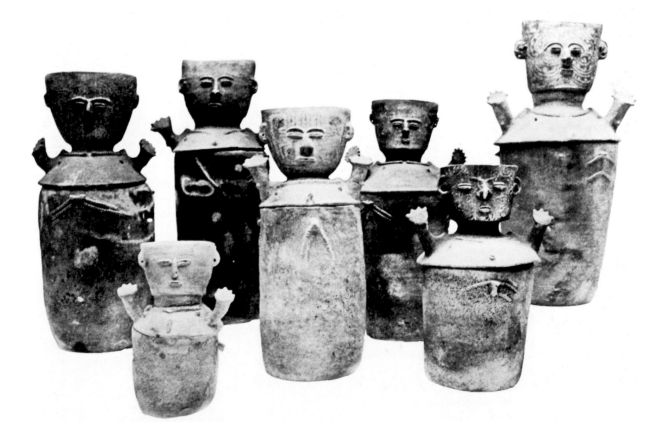

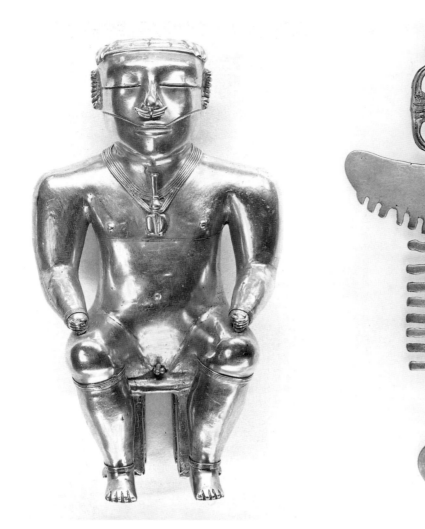

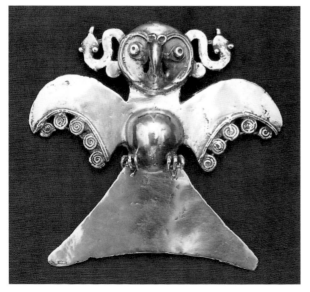

629 A cast tumbaga *figure of a man: a container for lime powder which is taken with chewed coca leaves. From the Quimbaya Treasure, Cauca valley, Colombia. Late 1st mill. AD. Madrid, Museum of America.*

630 A cast tumbaga *knife in the Tolima style, Colombia. It takes the form of a displayed semi-human monster. Early 1st mill. AD. Height 17.7cm. Bogotá, Museo del Oro.*

631 A gold cast pendant from Panama (Veraguas). *Colombian styles with gold and the material were adopted by various local cultures en route to Central America. Height 10.2cm. Cambridge, Fitzwilliam Museum.*

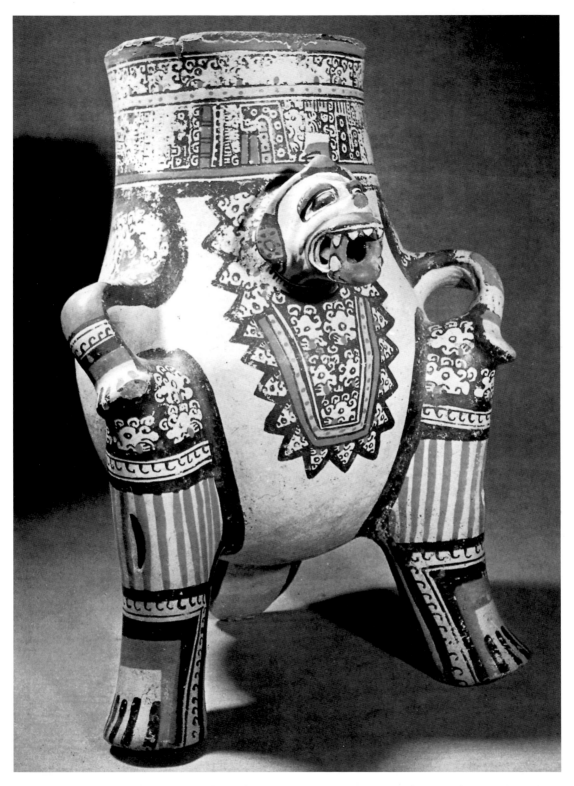

632 A vase (Nicoya Polychrome) in the form of a squatting jaguar, from the Pacific coast of Costa Rica; a distinctive local product, much influenced by the styles of Central America. Height 30cm. San José, National Museum.

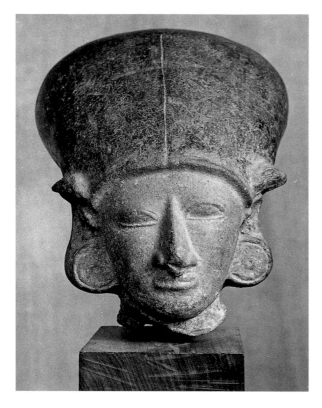

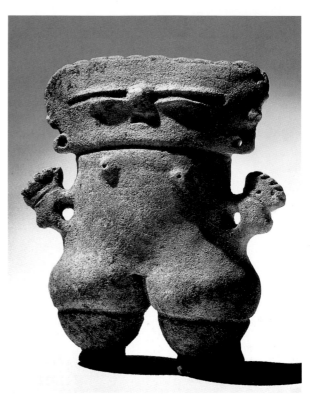

633 A woman's clay head from Esmeraldas, Ecuador, an area also noted for metalworking, and even later for platinum. Early 1st mill. AD (Bahia phase). London, British Museum.

634 A clay figurine tyical of Venezuela (Trujillo), just pre-Conquest. Caracas, Department of Anthropology.

635 A clay burial urn in the form of a seated figure, from Marajó island in the Amazon delta. Pre-Conquest. Height 67cm. Belem, Museum Goeldi.

636 A cast copper plaque from NW Argentina (Aguada culture). It shows a human figure between spotted felines, in a style deriving from that of Tiwanaku to the west. Late 1st mill. AD. Height 16cm. Cambridge, University Museum of Archaeology and Ethnology.

It is perhaps impertinent to take into one section all central and southern Africa, the cradle of mankind, but in terms of the history of art it makes some sense despite some disparity of environment and the enormous area involved. The south Sahara used to be damper than it is today and its grasslands were the home of pastoralists and even some farmers by the 4th millennium BC, but later the herding of sheep, goats and cattle was the staple, without domestication of draught animals or even use of the plough and potter's wheel. In and south of the equatorial forests, in savannah and grasslands, the hunter-gatherer was long to reign, and both farming and metalworking began to spread only in centuries AD.

It was in the northern area, notably Nigeria with its major river (Niger) and delta, that an Iron Age of sorts developed, and spread south with the Bantu-speaking peoples. The technology was learned from the north (there was no real Bronze Age), as well as some sophisticated use of fired clay which has guaranteed the survival of earlier works of art (other than rock carving and painting) than are available from the south, where the artists' materials were all perishable. Thus, in Nigeria the clay figures from Nok **638, 643** give the first intimation of styles in figure art that are to be echoed throughout the continent to the south, while in the 1st millennium AD lost-wax bronze casting, eventually the famous Benin bronzes and ivories **642**, offer the most sophisticated of the later African arts, apart from the urban record of the Nile valley and the Romanized north.

The Saharan and many other southerly rock engravings and paintings **9, 637** are demonstrably very early because some depict animals now extinct in those areas. For the later period, virtually to the present, the major art is wood sculpture **640, 641**. Fired pottery seems not a major medium but we can be sure that, as elsewhere, the patterns of weaving, wicker and plaited grasses played their part in the decorative and symbolic arts of their day, and they are apparent in the subsidiary decoration of the woodwork. The fired-clay heads of the Nok **638, 643** attest, from their style, the wood-carving of the late centuries BC, since they betray little of the natural clay modelling techniques of adding material to build up forms, rather than cutting back and carving.

Cast metal sculptures are, for the early period (but how early?), a feature again of Nigeria, notably at Ife (nearer the coast than Nok). They are only certainly of centuries AD, using copper alloys. There are few and small stone sculptures **639**, also apparently AD.

For subject matter the African sculptures are almost exclusively humanoid, only occasionally animal. Compositions are usually frontal and symmetrical. Heads are prominent – as they tend to be in most arts and places, for obvious reasons. Squatting figures, or standing with legs bent **640**, are characteristic, as they are also in Australasia. Masks played an important part in ritual, and the creation of masks for wearing, defining and exaggerating natural human features, would have influenced the treatment of heads on their own and on whole figures **641**. Sometimes the figures form parts of practical objects – weapons, bowls, stands or furniture – but presumably exercising the same spiritual functions as the free-standing figures or masks.

It is impossible to characterize their style succinctly, yet even the untrained eye has no difficulty in distinguishing the arts of this Chapter from those of the last, let alone the urban of Chapter Two: 'primitive' in terms of modern perceptions simply means totally unlike anything European or Classical. Several heads and even figures approach normal, realistic proportions, also in treatment of detail, but for the most part effect is achieved through distortion of scale, although not uniformly – very small eyes can be as telling as very large ones, and sexual characteristics are often prominent. Colour is important, though bodies are commonly left in the natural wood colour; beads and feathers are used, sometimes flamboyantly. Action groups are almost unknown, if we except mother and child. These are statements of spiritual power rather than demonstrations or narratives of that power in action, which might be acted by masked dancers. As such, they remain effective even to modern eyes, perhaps more effective than the attempts to achieve the same response made by many allegedly higher cultures in their arts. The range of different styles is largely accounted for by regional preferences and traditions, developed and changing probably over centuries without us being able to define them very closely, and mainly distinguishable to the connoisseur anthropologist rather than the art historian.

Interfaces with the north are hard to define. The busy southern shores of the Mediterranean were not so remote from the Saharan lands as not to influence the area technologically, although not in the arts. In Nubia (Sudan) the lessons of Egypt to the north were learned and they contributed to a distinctive but mainly derivative culture, building on an essentially rich south Saharan pastoral base, and with a distinguished record in the arts and architecture throughout the period of Dynastic Egypt and well into the Roman period. Nubia and the kingdom of Kush contributed much to the north in terms of trade in slaves, gold and ivory, and even supplied a Nubian Dynasty in Egypt in the 8th/7th century BC. They lent a perceptible essence to the civilization of the Nile valley, though without in any way justifying the view that Egyptian civilization was a product of Black Africa, rather than a local African culture quickened by an exceptional environment (the Nile) and by contact with other urban civilizations: a quite exceptional interface, if you will. Later, the Meroitic kingdom of the Sudan and Ethiopian highlands derived from South Arabia, with its arts, and may have introduced iron-working to Africa.

From early days Greeks and Phoenicians explored the African coasts west and east, even to beyond the Equator. Anything like major urban architecture in Sahara and central Africa is the direct result of trade with the north and the ensuing concentrations of wealth and power, as at Zimbabwe (12th–14th centuries AD). Yet in many ways the stone architecture of Zimbabwe and the brick mosques of Timbuktu remain prime expressions of 'ancient' architectural technology.

The most sophisticated and best-known products of the African artist are probably the Benin bronzes, starting in the 16th century AD. Some betray the same stylistic traits as the wooden sculpture, but they are generally far more realistic, and the many reliefs and groups which depict action and assemblies are very obviously inspired by the interests, behaviour and even arts of the Europeans, at first the Portuguese, from the 15th century on. I find it difficult to regard them as in any way 'ancient' in the terms of this book and so I illustrate just one ivory head **642**.

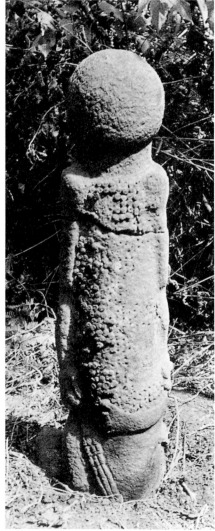

637 The Tassili Massif in southern Algeria is the source of rock paintings, many of which are demonstrably early (at least pre-1000 BC). Here, a woman dancer with a horned headdress, set over various smaller fighting and dancing figures. Paris, Museum de l'Homme.

638 This clay head from Nok is more plastic and 'African' in appearance. Lagos Museum.

639 An unusual and large (over 1m) figure of stone, from NE Yorubaland (W Nigeria). The formless body is studded with iron nails. Probably 14th cent. AD or later.

641 A wooden mask made by the Fang (Gabon), a piece which was owned by Vlaminck, then Derain, an example of the 'primitive' art so influential in Paris in the early 1900s. Height 47.5cm. Paris, Museum de l'Homme.

640 A wooden figure of the Baule (S Nigeria) detailing an elaborate hairstyle and tattooing (scarified) on head and body, with a highly polished surface. Height 52cm. London, British Museum.

642 An ivory mask pendant from Benin, the most sophisticated expression of the style more familiar in the 'Benin bronzes'. 16th cent. AD. Height 19cm. London, British Museum.

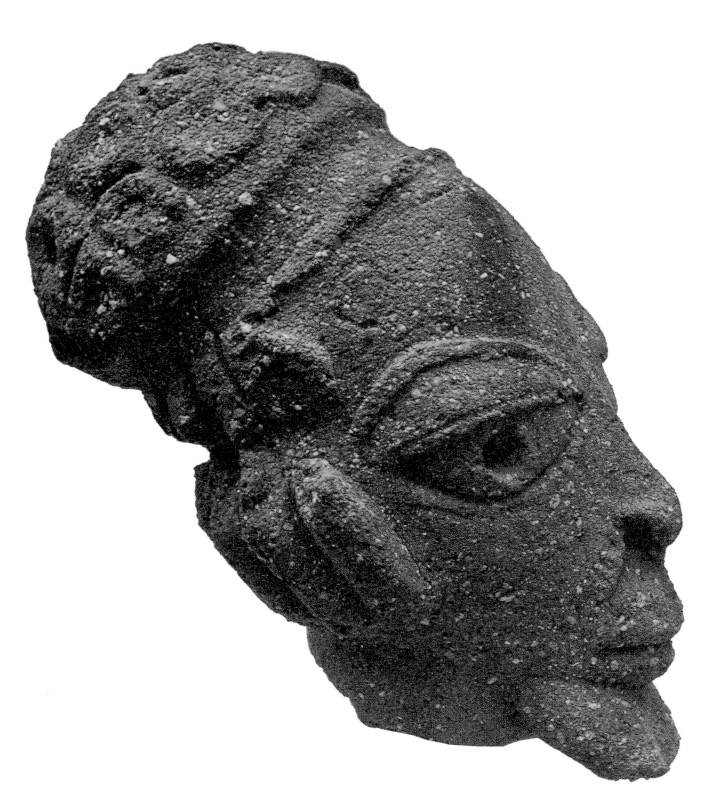

643 A clay head from Nok (Nigeria), with elaborate hairstyle. At 21cm it is approaching life-size, and its lean forms suggest derivation from wood-carving techniques rather than plastic. 1st cent. BC. Jos Museum.

C. AUSTRALASIA MAP 12

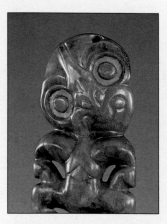

This includes Australia and Oceania, which is Melanesia (New Guinea, etc), Micronesia and Polynesia to the east, and New Zealand. These are areas in which arts not so unlike those of Africa developed, seemingly with little change over millennia; not, therefore, unlike the Americas, except that there was the possibility of influence from China, South-east Asia and India, before the intrusion of spice-traders from Europe in the 17th century AD, followed by the 18th-century voyages by westerners which promoted real colonization. The climate is tropical but capable of some variation, with Tasmania and New Zealand farther south even than Cape Town in Africa, but both with rainforests. Australia and the larger islands offered a wide variety of animal and vegetable life for sustenance, albeit without the common subsistence crops available elsewhere: wheat and rice are not for the low-lying tropics.

The smaller islands depended more on the produce of the sea and incredible skills in open-sea navigation. Here for the first time we encounter early man's dependence on the sea (except to a lesser degree in coastal Peru or the Arctic) and, as in America, general indifference to metal technology. With little by way of animal life to domesticate except pigs and the dingo (an import to Australia), this is the home of the hunter-gatherer *par excellence*, on land and sea.

Man reached Australia late, by about 40,000 BC, and New Zealand (Maori) perhaps not much before AD 1000. The early rock paintings of Australia reveal a way of life, hunting with spears and boomerangs, not to change significantly for millennia. The island complexes were settled by around 3000 BC, from the west mainland, betraying something of the arts of South-east Asia and of China beyond, spreading with the 'Lapita culture' of Melanesia (down to at least AD 200), and sharing an 'Austronesian' language. The Lapita complex is distinguished by its elaborately decorated pottery, red-slipped and with impressed patterns of the type suggested by the technique (using the edge of a shell, no doubt) met in many other parts of the world,

including the Mediterranean. The people also sought and used obsidian. They were bold voyagers, creating an economy which made the most of the restricted animal (notably fish, chicken and pigs) and vegetable (mainly roots and squashes) resources available, but remaining essentially a Neolithic culture. The islands offered even less than Australia beyond the opportunities offered by the seas around and the challenge of seafaring.

For the arts, we are much dependent on relatively recent products, making the same assumptions as in Africa about the earlier history of 'style' and without the help offered by the early Nigerian figures of fired clay. Rock paintings, mainly in Australia **645**, are not that unlike the African and many must be as early, but there is no direct connection. To the untutored eye, indeed to anyone not intimately aware of the regional differences in style, it is well nigh impossible to distinguish the African wooden sculptures from much of the Oceanic **644, 646, 647**. This can only in part be the result of using comparable materials – wood with colour, feathers, skins – and so comparable techniques. And since the results are equally unlike any from the rest of the world we are entitled to judge that the same effect was sought because it served much the same function, in a very similar environment using the same materials. Hunter-gatherers of the tropics of the eastern hemisphere all sought to figure their world in much the same way. This we must judge to be an instinctive human response to a need to portray and embody the spirit world of ancestors, in an environment and society without the elaborate religious hierarchies of the urban, or the very different everyday preoccupations of the dedicated pastoralist. It is not even much like the arts of Palaeolithic man elsewhere, yet it emerges from the Palaeolithic of the region.

It is, however, among the Vanuatu of the South Pacific that we meet a method by which art can recall the past in an unexpected manner, subtler even than pictographic writing. An old man can draw in the sand an intricate labyrinthine pattern that can recall to him and his listeners their whole corpus of myth, history and cosmogony. This may well be a manner of recollection more subtle even than the *quipu* of Peru,

or a rosary, or the alleged associations of some Aboriginal paintings, or a knotted handkerchief. It was perhaps much practised elsewhere in antiquity in what we dismiss as abstract patterns, but examples would be difficult to recognize and impossible to interpret; it seems a higher form of the symbolic use of pattern and patterns than that we meet elsewhere, especially in religious art.

Easter Island presents a unique phenomenon for the area; settled late, and from about AD 1000 to 1500 peopled by a profusion of massive stone figures of ancestors (*moai*) **649**. This is a genre which seems mainly foreign to the rest of the history of the arts in the islands, with a very few exceptions, and in a style barely matched elsewhere: Polynesian stone-working for figures seems almost casual and did not develop any strong tradition. But the other, wooden arts here are more in keeping with the record of the rest of the island world **647**. For the stone figures no little was determined by the material, a softish volcanic tufa, and the problems of working it with basalt hammers. Here we have man in virtual isolation from his immediate ancestors devising art forms necessary to his view of the past and present, yet bearing a certain slight relationship to the product of his former kin in other islands: an object lesson in originality in artistic invention, but one whose possible future foundered in civil war and mismanagement of the rural ecomomy (deforestation) long before European ships appeared on the horizon.

Traces of interface with neighbours, even distant, is not entirely lacking in the South Pacific. The Bronze Age arts of China, as practised in Yunnan and Vietnam (Dong-son), may have introduced new patterning (scrolls and the like) for Lapita pottery, but not metallurgy. Generally, the early arts of South-east Asia lay in the shadow of China, later India. New Zealand's essays in jade **648** may seem to echo China but, except in technique, really reflect the general Oceanic attitude to live forms. There is even the possibility of contact with South America (AD) without conclusively definable results (see p. 263), although monumental stone work is alleged – not the most likely product of such distant influence, I would think.

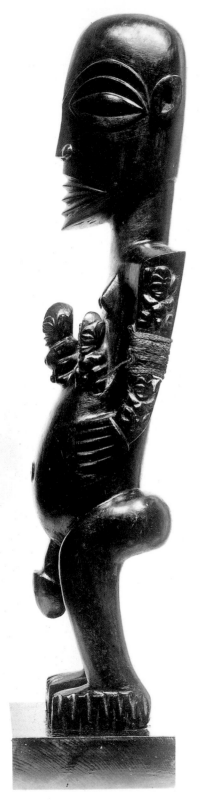

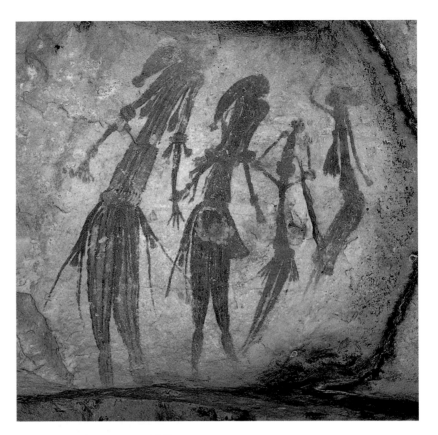

644 *A wooden figure from the Cook Islands, representing a god and his three sons. Height 70cm. London, British Museum.*

645 *A rock painting from the Kimberley (Gwion Gwion), NW Australia, probably of about 1000 BC.*

646 *The wooden prow of a boat from the Solomon islands, with mother-of-pearl inlay. Styling ships' prows as human or animal and monster heads, even if no more than a pair of eyes, is a readily intelligible device worldwide. 19th cent. AD. Height 18cm. Munich, Museum für Völkerkunde.*

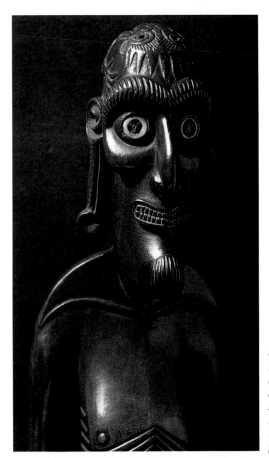

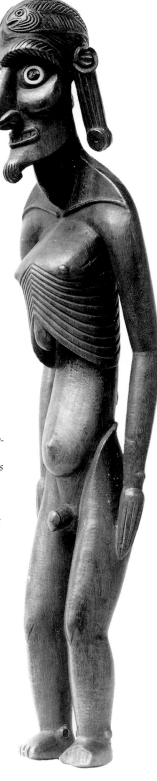

647 A wooden figure from Easter Island with inlay of obsidian and bone. A strictly local type, with exaggerated attention paid to the skeletal anatomy. 18th cent. AD. Height 43.6cm. Brussels, Musées Royaux. (b) is a detail of a similar figure in London, British Museum.

648 A Maori jade (nephrite) chest pendant (hei tiki) inlaid with mother-of-pearl. These may owe something to what was known of Asian jades as well as island styles, but they are a distinctive local type of a regular pattern, possibly suggesting an embryo. 15th/18th cent. AD. Height 21.5cm. London, British Museum.

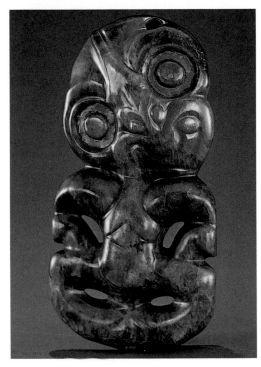

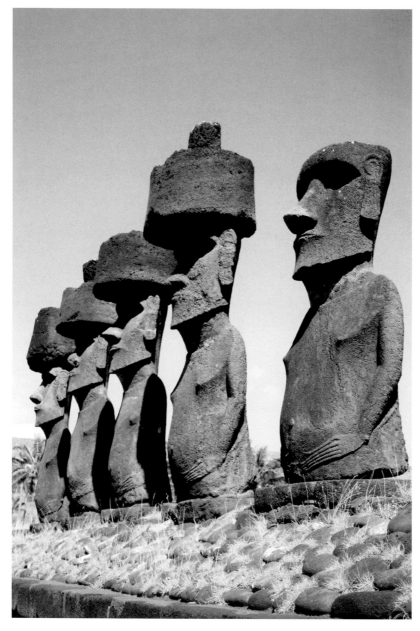

649 *There may have been as many as a thousand* moai *on Easter Island: stone figures standing up to 10m high, weighing some 82 tons, and generally set on platforms which also served as burial places for the ancestors whom the images are thought to represent. Their headdresses are of red stone, their eyes were inset with white coral, and their backs are often carved in relief. They were hauled over kilometres from the quarries where there are some 400 left unfinished; made in the first centuries of the second mill. AD. The back view (b) is of a figure in London, British Museum.*

EPILOGUE

Man tried to control his world and one of the ways in which he demonstrated his place in it and his relationship to his fellow-men was through art, depicting that world and decorating the utensils of his life, from buildings to dress to pots.

We are told, on evidence that is very hard for most of us to judge, that early man shared something like a common language, which spread, along with the technology associated with human rather than animal life, as man himself travelled through the continents. What we can judge, however, is that with time differentiation of languages was such that verbal intercommunication between neighbouring cultures could become a matter of intuitive skills in ordinary dealings between humans rather than common forms of speech. Both vocabulary and language structure changed in different ways in different places over long periods of time. Only where there is some commonality of vocabulary or structure can we begin to hope to perceive origins and the process of diffusion. The obvious example is that of the Indo-European languages which seem the common heritage of a once pastoral society, but the extreme difficulties still found by scholars in demonstrating kinship, origins and movement are not encouraging for anyone who hopes by this means to trace back the details of man's migrations and cultural development. Genetic kinship, shown by DNA, might prove a more rewarding approach, but need not imply any cultural succession also.

Is 'art' a like case? It is a form of communication much dependent for its structure on materials and needs, and is designed by and for the human eye and brain. Most uniformity worldwide is perceptible mainly at its simplest and earliest, when needs and responses were much the same everywhere. Further differentiation is determined by geography, as it was with language, and the reason why the differentiation took the form it did, making Chinese art so unlike Mesopotamian art, might be a related phenomenon, even though the reason remains quite obscure to us, or seems to depend on almost fortuitous exploitation of one means of visual expression rather than another. At the interfaces we can see that it could be even more difficult to blend these different arts, once developed, than it is to be truly bilingual. Yet world literature has common themes and functions determined by human experience, but presented in different languages: world art is surely just as much a commonwealth despite its different styles.

In the Preface I laboured the point that ancient (in my terms) art was functional. It should then be judged with understanding of what its function was, and in the light of any evidence we might have that it succeeded –

even if this means no more than observing that a certain style or form or image became established because it long remained acceptable. Much of this can be perceived in many arts and over centuries. In many respects the Athenian state's (effectively, no doubt, Pericles') decision to commission Pheidias to oversee the sculptural decoration of the Parthenon in Athens can be judged in much the same terms as Pope Julius II's commissioning of Michelangelo to paint the ceiling of the Sistine Chapel in Rome. Both projects were undertaken within the established conventions of the political/religious art of their day, and both were executed with an originality of expression which we may attribute to the artists' ability as much as to the expectations and demands of the sponsor. Since the Renaissance the artist has acquired a different status and competes for commissions from state or individual on the strength of a personal style, by which he is judged. Thus, when Spence, Epstein, Sutherland and Britten were invited to contribute to the project of the rebuilding and rededication of Coventry Cathedral after World War II, the choice was dictated by considerations of their very individual styles, little conditioned by traditional expectations. For a Pheidias or Michelangelo there would have been alternatives available whose work would probably not have been seriously different.

In antiquity a degree of innocence in such matters was lost when rich Romans began to collect and commission Greek art. This was done in part through the allure of the names of famous Classical artists, a Pheidias or Praxiteles, in part through the attractions of subject and style, since they were also buying a stake in a culture which they admired and at a time when credit accrued to collectors who displayed the admired Hellenic taste. Rome took the lead here for the west, but in the rest of the world, notably China, the arts of the past could also be cherished, and the cult of the artist was also to begin to dictate appearances and commissions for work. At this point our criteria for perceived success change accordingly, at least for the higher arts.

Judging ancient art in the manner proposed in this book brings out its functions and, I hope, says something about the common aspirations of men as artists worldwide and over millennia. We are enabled to do this because, over the last 300 years at least, man has devoted much time and money to recovering ancient art and much thought and ingenuity to explaining it. It is a process that has been practised in parallel with concerns about world history: parallel lines of research which have not always met. We depend on what has been collected in museums and on what has been disseminated through books, drawings and photographs, and described and explained by archaeologists and art historians. It all seems suddenly more familiar but not necessarily more intelligible: antiquity remains very much a foreign land.

The years of collecting, research and study have also resulted in changing attitudes to the evidence. This has sometimes been conditioned by the circumstances of discovery, although too much can be made of alleged imperialist interpretation of material which may have been acquired as a by-product of colonization. Nowadays it is possible for anything from nihilist philosophy to Politically Correct attitudes to affect the teaching of art history. However, the intentions of scholars have generally been far more altruistic, and generally the better for comment from practising artists who think about their work and its place in society. But by now ancient art has become as much a commodity as most post-antique art. It is sad that it can still be sought out unscrupulously from ancient sites whence it is torn in a destructive manner – destructive of material as well as of information – but this does not in itself negate the instinctive and scholarly desire to collect and display, and much collecting in the past, as now, was done to conserve and inform, not for profit. Nor does the professional archaeologist often show much sympathy for those who wish to admire his finds (and who have financed him), being prone to hide away and often never even publish what he has robbed from antiquity, albeit robbed in what at the time passes as a scientific manner and for scholarly ends. A thirst for knowledge can be self-defeating.

Some two hundred years ago Henry Layard carried off from Nimrud (in modern Iraq) many Assyrian sculptures, disdained by the then occupants of the land who did not regard them as their 'heritage'. Many came to London where they now form a spectacular and

much-visited display in the British Museum. Others went to Layard's patron who made a special building to house them. This became part of a school which, after World War II, sold them; they travelled overseas and are now displayed for the public in New York. However, a substantial fragment was overlooked; this was sold recently and taken to a museum devoted largely to Near Eastern antiquities in Japan. What has since been collected and found in Iraq is housed in a modern museum in Baghdad, but subject to the possibility of looting in times of trouble. The experience with the Nimrud reliefs may seem less than perfect, but the result is more effective than any attempt (surely doomed) might have been to preserve them all on site, remote from all but the hardiest tourist or most dedicated archaeologist. At Beziklik in Central Asia it was sad to see that the centre part of an early Buddhist wall painting had been cut out and carried away, though it might easily have happened, as it has done often elsewhere, that nothing of the painting would have survived to the present day. And in the United States, coming upon an Asian painted wall fragment, acquired in the same way, I was torn between memory of the rape at Beziklik (which could easily be repaired, but has not been) and satisfaction at being reminded in an otherwise very evocative and varied collection, of a certain style and subject, by an original example. In a way we destroy the past as we attempt to read it, whether through excavation or in collecting.

This leads to consideration of another crux – authenticity. Study of ancient art by facsimile – photograph or cast – is as much as many can afford; there are also appalling parodies of antiquity marketed as if for the true connoisseur. But the real will always be more appealing than the virtual, and the many small collections in public and some private hands worldwide, however acquired, give an immediate access to works of ancient art to many who deeply appreciate their authenticity. The almost necrophiliac instincts of some scholars and even collections is self-defeating and defies the reasons for our interest in man's past. But with the value set on authenticity goes the problem of the fake. There have been notable examples in the last 200 years, some of which (those detected!) have been influential. Science and an

informed eye for style can detect most. Faking and copying for profit is a criminal activity requiring more than usual skills in both production and detection. But antiquities that were themselves mass-produced from moulds can be reproduced today with the same method, like prints from a block, yet remain non-authentic to our eyes. In antiquity faking was often a matter of adding a false signature, or conscious archaizing to recall the styles of an admired past (thus in Greece, Egypt and China, perhaps Mexico). We are probably as much at risk today from computer-adjusted images (of which there are many in this book) and some of the effects of 'scientific' conservation, and do well never wholly to trust our eyes.

Today ancient art may be admired and collected for much the same reason as it was by the Romans, so that we can share the visual and spiritual experience of members of an admired culture, and to illuminate history. But, for the Romans, the Greek was also still a live culture. Today man's cultural heritage is commonly defined as national heritage. It may be claimed even by people (usually nationalist governments) whose genetic descent from the makers, whose spiritual values they do not share and may even despise, may be shaky if not imaginary, and whose sympathy for the role and function of 'their' ancient art is wholly an affectation inspired by the profits promised by tourism. Far more real and worthy of respect is the attitude also shared by many ancient peoples, that their past was in some form a guarantee of their future, and that their destiny might be read in it. Almost the only ancient culture whose art has enjoyed a continuous if changing tradition, to at least the late modern age, is that of China (and, to some degree, Japan and India). All others were interrupted, usually by the onset of intruders motivated by an unsympathetic religion (usually Christianity or Islam). Revivals, like that of the Renaissance in Europe, have been exceptional. In China, down to the 18th century at least, emperors and nobles would cheerfully copy and rework ancient bronzes and jades in the 'modern' style, supplying new inscriptions if need be. Even in the 19th century damaged Classical marbles could be given to a sculptor to complete (Thorwaldsen for the Aegina Marbles in Munich; Canova refused to do the same for

the Parthenon Marbles in London). 'East Asians are perhaps also more conscious than Westerners are that the past is not simply a burden but is also a treasure' (Toynbee).

The museums and galleries created in the late 18th and early 19th century have offered the general public what had been the preserve of the private collector – a share in man's past. And not just to satisfy a local interest but to explore and cherish the achievement of man the artist worldwide, regardless of creed or race, to recall ages in which the image was more important than the word, as it can still be today for an increasingly illiterate society, and in which craftsmanship and valuable materials were admired. The museums were the result of the age of Enlightenment: and 'Enlightenment Museums' they have been called. They are European (notably London, Paris, Berlin, St Petersburg) because it was Europe that was obliged to rediscover its lost heritage, and then sought out that of its colonies worldwide. They are also well stocked with the spoils of deliberate exploration of the world's oldest civilizations, in Mesopotamia, Egypt, the east, now displayed for the education of a public ready to look beyond the borders of its own nationality and religion. Most later, comparable museums elsewhere are effectively European colonial creations. Only recently have China and Japan, where there was no serious break in artistic tradition, begun to copy the west in forming museums of ancient national art, even of international ancient art (notably Japan). To oppose or hamper such global education in the arts of all periods and places is surely perverse. These are not 'dead arts' and they bear witness to the ambitions of ancestors whose aspirations and achievements were no less worthy than our own.

650 The frontispiece of Description de l'Égypte, *compiled for Napoleon in 1809, the academic fruit of his three-year occupation of the country ten years earlier. The frame celebrates empire – the Egyptian winged disc above; over the main scene, his fleet at the left corner, a neo-Classical Alexander/Napoleon in a chariot defeating the barbarians, with a Classical figure of the River Nile at the corner; at the sides are trophies; below, subject princes approach the Napoleonic 'N'. The main scene is a panorama of ancient Egypt, its architecture and sculpture, along the Nile from the Mediterranean to Philae (near Aswan).*

651 *The architectural styles and 'orders' of antiquity have attracted artists even more than the sculptural. This is an imaginary confection of 19 different styles, from primitive to Gothic, in a watercolour by Joseph Michael Gandy, exhibited in 1836. London, Sir John Soane's Museum.*

FURTHER READING

The books selected here will offer the reader more information and pictures. The most useful are often those produced in the 1960s and 1970s (especially if updated in later editions), for their range and documentation: notably the Pelican/Yale handbooks; many in the Thames & Hudson (hereafter T&H) *Ancient Peoples and Places* and *World of Art* series, and the translations of the *Arts of Mankind* series; as well as some large compendia. Later works are more up-to-date and well illustrated but often more cursory when it comes to detail, history, techniques, etc, or they take the easy option of discussion by theme rather than history. Latterly, glossy but detailed exhibition catalogues are proving a major resource, their commentary ranging from the detailed to the cursory, but there is much to learn also from the historical (discovery) approach of authors in the small-format *Découvertes Gallimard* series (many translated by T&H, as *New Horizons*). There are several detailed and well-illustrated relevant *Propyläean Kunstgeschichte* volumes (Berlin). Everyman, Phaidon/Elsevier (*The Making of the Past*), Phaidon and Oxford University Press have also issued series of world-art volumes, and there are many British Museum regional and subject handbooks, quite detailed. In Britain, the best concentrated and open ancient art library is in the British Museum Reading Room.

The main headings below do not exactly correspond with those in the chapters, and there are some subdivisions within them, proceeding from general to particular or by area, self-explanatory. I have surely omitted several most worthy titles.

GENERAL

For the detailed historical background, *Cambridge Ancient History* for the Classical world, Egypt and the Near East, and the accompanying Plates Volumes; *Cambridge History of Iran, ... of Central Asia, ... of India, ... of Ancient China* (to 221 BC), *... of the Native Peoples of the Americas* (North, Mesoamerica, South), *... of the Pacific Islanders*.

A. Toynbee, *Mankind and Mother Earth* (Oxford 1976)

J.M. Roberts, *Ancient History* (London 2004)

S. Schama, *Landscape and Memory* (London 1996)

Atlas of World Art (ed. J. Onians; London 2004)

Atlas of World Archaeology (ed. P.G. Bahn; Andromeda, Oxford 2000)

Archaeology. Theory, Methods and Practice (ed. C. Renfrew, P. Bahn; T&H 2004)

M.K. O'Riley, *Art Beyond the West* (London 2001)

J. Boardman, *The Diffusion of Classical Art in Antiquity* (T&H 1994)

N. Penny, *The Materials of Sculpture* (Yale 1993)

D. Diringer, *Writing* (T&H, 1962)

P.T. Daniels and W. Bright (eds), *The World's Writing Systems* (Oxford/NY 1996)

J. Mack, *Masks. The Art of Expression* (British Museum 1994)

E.J.W. Barber, *Prehistoric Textiles* (Princeton 1990)

B. Sentance, *Basketry* (T&H 2001)

V. Ebin, *The Body Decorated* (T&H 1979) – tattoos etc.

M. Carroll, *Earthly Paradises. Ancient Gardens in History and Archaeology* (British Museum 2003)

P.D.A. Harvey, *The History of Topographical Maps* (T&H 1980)

O.A.W. Dilke, *Greek and Roman Maps* (T&H 1985)

EARLY

The Oxford Companion to Archaeology (ed. B.M. Fagan; Oxford/NY 1996) for many aspects, except the purely art-historical

The Penguin Archaeology Guide (ed. P.G. Bahn 2001) useful for names and dates

A. Lommel, *Prehistoric and Primitive Man* (Hamlyn 1966)

L. Pericot-Garcia et al., *Prehistoric and Primitive Art* (T&H 1969)

P.G. Bahn, *Prehistoric Art* (Cambridge 1998)

J. Maringer, *The Gods of Prehistoric Man* (London 2002)

M. Ruspoli, *The Cave of Lascaux* (T&H 1987)

J.-M. Chauvet et al., *Chauvet Cave*

(T&H 1996)

A. Sieveking, *The Cave Artists* (T&H 1979)

P.R.S. Moorey (ed.), *The Origins of Civilization* (Oxford 1979)

M.J. Mellink and J. Filip (eds), *Frühe Stufen der Kunst* (Propyläen Kunstgeschichte, Berlin 1974)

CHINA

C. Debaine-Francfort, *The Search for Ancient China* (Gallimard/T&H 1999); especially for the early period and quoting the ancient description of the mausoleum of Emperor Qin (pp.134–5)

W. Willetts, *Chinese Art* (Penguin 2 vols. 1958; abridged but fully illustrated reprint, T&H 1965); dated, but good on history, materials and techniques

W. Watson, *Style in the Arts of China* (Penguin 1974)

W. Watson, *The Arts of China to AD 900* (Pelican/Yale 1995)

M. Sullivan, *The Arts of China* (1973, but later edns fuller)

J. Rawson (ed.), *The British Museum Book of Chinese Art* (British Museum 1992)

J. Rawson, *Chinese Bronzes* (British Museum 1987)

P. FitzGerald, *Ancient China* (1978)

M. Tregear, *Chinese Art* (T&H 1997)

S. Little et al., *Taoism and the Arts of China* (Chicago 2000)

Wen Fong (ed.), *The Bronze Age Arts of China* (New York exhib. 1980)

P. Swann, *The Art of China, Korea and Japan* (T&H 1963)

E. Capon and W. Macquitty, *Princes of Jade* (1973)

G. Liu, *Chinese Architecture* (London 1989)

Fu Xinian et al., *Chinese Architecture* (Yale 2002)

J. Portal, *Korean Art and Archaeology* (British Museum 2000)

The Chinese Bronzes of Yunnan (foreword J. Rawson; 1983)

CENTRAL ASIA AND INDIA

F.T. Hiebert, *Origins of the Bronze Age Oasis Civilisations in Central Asia* (Harvard 1994)

D Christian, *History of Russia, Central Asia and Mongolia* I (Blackwell 1998)

UNESCO History of the Civilizations of Central Asia

V.I. Sarianidi, *Die Kunst des alten Afghanistans* (Leipzig 1986)

V.I. Sarianidi, *Margiana and Protozoroastrianism* (Athens, Kapon 1998)

V.I. Sarianidi, *Bactrian Gold* (St Petersburg 1985) on Tillya Tepe

Treasures of Ancient Bactria (Miho Museum, 2002)

F.R. Allchin, *The Archaeology of Early Historic South Asia* (Cambridge 1995)

R.C. Craven, *Indian Art* (T&H 1997)

B. Rowland, *The Art and Architecture of India* (Pelican 1953, editions to 1970) – this is fuller on early India than the more up-to-date:

J.C. Harle, *The Art and Architecture of the Indian Subcontinent* (Pelican/Yale 1994)

P. Brown, *Indian Architecture* (Bombay 1976)

M. Hallade, *The Gandhara Style* (T&H 1968)

L. Nehru, *Origins of the Gandhara Style* (Oxford/Delhi 1989)

B.K. Behl, *The Ajanta Caves* (T&H 1998)

MESOPOTAMIA

E. Strommenger/M. Hirmer, *The Art of Mesopotamia* (T&H 1964)

W. Orthmann (ed.), *Der alte Orient* (Propyläen Kunstgeschichte, Berlin 1975)

H. Frankfort, *The Art and Architecture of the Ancient Orient* Pelican/Yale 1996)

N. Postgate, *The First Empires* (Phaidon 1977)

D. & J. Oates, *The Rise of Civilization* (Phaidon 1976)

R. Whitehouse, *The First Cities* (Phaidon 1977)

A. Parrot, *Sumer* (T&H 1960)

C. Burney, *From City to Empire* (Phaidon 1977)

H. Crawford, *Sumer and the Sumerians* (Cambridge 1991)

J. Oates, *Babylon* (T&H 1979)

J.E. Reade, *Assyrian Sculpture* (British Museum 1998)

D. Collon, *Ancient Near Eastern Art* (British Museum 1995)

ANATOLIA

Orthmann, Frankfort (see Mesopotamia)

O.R. Gurney, *The Hittites* (Penguin 1990)

J.G. Macqueen, *The Hittites* (T&H 1996)

E. Akurgal, *The Art of the Hittites* (T&H 1962)

E. Akurgal, *Phrygische Kunst* (Ankara Univerity 1955)

BRONZE AGE GREECE

S. Marinatos, *Crete and Mycenae* (T&H 1960)

S. Hood, *The Minoans* (T&H 1971)

S. Hood, *The Arts in Prehistoric Greece* (Pelican/Yale 1994)

R.A. Higgins, *Minoan and Mycenaean Art* (T&H 1997)

J. Boardman, *Pre-Classical* (Pelican 1967); also for Archaic Greece

EGYPT

W. Stevenson Smith, *The Art and Architecture of Ancient Egypt* (Pelican/Yale 1998)

H. Schäfer, *Principles of Egyptian Art* (trans. J. Baines, Oxford 1974)

J. Malek, *Egyptian Art* (Phaidon 2003)

J. Ruffle, *Heritage of the Pharaohs*

(Phaidon 1977)

D. Arnold, *Building in Egypt* (Oxford/NY 1991)

G. Robins, *Proportion and Style in Ancient Egyptian Art* (Austin 1994)

C. Andrews, *Ancient Egyptian Jewellery* (British Museum 1990)

P. du Bourguet, *Coptic Art* (Macmillan 1971)

CLASSICAL GREECE AND ROME

Oxford History of Classical Art (ed. J. Boardman; Oxford 1993)

J. Boardman, *Greek Art* (T&H 1996)

J. Boardman, Handbooks to Greek Sculpture and Vase Painting (T&H 1974–98)

M. Robertson, *A History of Greek Art* (Cambridge 1975)

J.J. Pollitt, *Art and Experience in Classical Greece* (Cambridge 1972)

A. Stewart, *Greek Sculpture* (Yale 1990)

C. Rolley, *Greek Bronzes* (Sotheby's/Chesterman 1986)

D.E. Strong, *Greek and Roman Gold and Silver Plate* (Methuen 1966)

R.A. Higgins, *Greek Terracottas* (Methuen 1967)

R.A. Higgins, *Greek and Roman Jewellery* (Methuen 1980)

J. Boardman, *Greek Gems and Finger Rings* (T&H 2001)

J. Boardman, *The History of Greek Vases* (T&H 2001)

V.J. Bruno, *Form and Colour in Greek Painting* (T&H 1977)

C.M. Kraay/M. Hirmer, *Greek Coins* (T&H 1966)

A.W. Lawrence, *Greek Architecture* (Pelican/Yale revised 1996)

J.J. Coulton, *Greek Architects at Work* (London 1977)

J.J. Pollitt, *The Ancient View of Greek Art* (Yale 1974)

J.J. Pollitt, *Art in the Hellenistic Age* (Cambridge 1986)

R.R.R. Smith, *Hellenistic Sculpture* (T&H 1991)

M. Bieber, *The Sculpture of the Hellenistic Age* (New York 1961)

B.S. Ridgway, *Hellenistic Sculpture* (Wisconsin 1990, 2000, 2002)

R.A. Higgins, *Tanagra and the Figurines* (Princeton 1986)

K.M.D. Dunbabin, *Mosaics of the Greek and Roman World* (Cambridge 1999)

R. Ling (ed.), *Making Classical Art* (Tempus 2000) on techniques

M. Colledge, *Parthian Art* (London 1977)

N.H. and A. Ramage, *Roman Art* (Cambridge 1991)

M. Henig (ed.), *A Handbook of Roman Art* (Phaidon 1983)

E. Simon, *Augustus* (Hirmer 1986)

A. Boethius, *Etruscan and Early Roman Architecture* (Penguin 1978)

J.B. Ward-Perkins, *Roman Imperial Architecture* (Pelican/Yale 1994)

J.R. Clarke, *The Houses of Roman Italy* (Berkeley 1991)

J.R. Clarke, *Art in the Lives of Ordinary Romans* (Berkeley 2003)

D. Kleiner, *Roman Sculpture* (Yale 1992)

K.M.D. Dunbabin, *The Mosaics of Roman North Africa* (Oxford 1978)

R. Ling, *Roman Painting* (Cambridge 1991)

G.M.A. Richter, *The Engraved Gems of the Romans* (Phaidon 1971)

E. Doxiadis. *The Mysterious Fayum Portraits* (T&H 1995)

K. Weitzmann (ed.), *The Age of Spirituality* (New York 1979)

W.F. Volbach, *Early Christian Art* (T&H 1961)

R. Bianchi Bandinelli, *Rome, the Late Empire* (1971)

THE LEVANT

Orthmann, Frankfort (see Mesopotamia)

N.K. Sandars, *The Sea Peoples* (T&H 1985)

D.B. Harden, *The Phoenicians* (T&H 1962)

W. Culican, *The First Merchant Venturers* (T&H 1966)

S. Moscati, *The World of the Phoenicians* (Weidenfeld & Nicolson 1968)

F. Briquel-Chatonnet and E. Gubel, *Les Phéniciens. Aux origines du Liban* (Gallimard 1998)

St John Simpson (ed.), *Queen of Sheba* (British Museum 2002)

ACHAEMENID PERSIA

Orthmann, Frankfort (see Mesopotamia)

J. Wiesehöfer, *Ancient Persia* (Tauris 2001)

J.M. Cook, *The Persian Empire* (Dent 1983)

E. Porada, *The Art of Ancient Iran* (Methuen 1965)

M.C. Root, *The King and Kingship in Achaemenid Art* (1979)

J. Boardman, *Persia and the West* (2000)

SARDINIA/ETRURIA

Kunst unde Kultur Sardiniens. Ausstellung (Karlsruhe 1980)

M. Guido, *Sardinia* (T&H 1963)

O. Brendel, *Etruscan Art* (Pelican updated 1996)

S. Haynes, *Etruscan Sculpture* (British Museum 1971)

S. Haynes, *Etruscan Bronzes* (London, Sotheby's 1985)

S. Haynes, *Etruscan Civilization* (British Museum 2000)

M. Martelli, *La Ceramica degli Etruschi* (1987)

LATER EURASIA

B. Piotrovsky et al., *Scythian Art* (Phaidon 1987)

K. Jettmar, *Art of the Steppes* (Methuen 1967)

E. Jacobson, *The Art of the Scythians* (Leiden 1995), mainly for interface cultures

T. Talbot Rice, *Ancient Arts of Central Asia* (T&H 1965)

V. Schiltz, *Les Scythes et les nomades des steppes* (Gallimard 1994)

V. Sarianidi, *Bactrian Gold* (Leningrad 1985) for Tillya Tepe

Various catalogues of Scythian exhibitions, often in different editions according to locale, notably:

L'Or des Scythes (Brussels 1991)

The Golden Deer of Eurasia (New York 2000)

Scythian Gold (ed. E.D. Reeder; New York 1999)

Nomad Arts of the Eastern Eurasian Steppes (ed. E.C. Bunker; New York 2002)

Or des Sarmates (ed. V. Schiltz; Daoulas 1995)

EUROPE

N.K. Sandars, *Prehistoric Art in Europe* (Pelican/Yale 1995)

D.W. Harding, *Prehistoric Europe* (Elsevier/Phaidon 1978)

R. and V. Megaw, *Celtic Art* (T&H, 1989, 2001)

The Celts (ed. S. Moscati et al., Milan 1991)

Ancient Gold. The Wealth of the Thracians (ed. I. Marazov, New York 1998)

O.-H. Frey, *Die Entstehung der Situlenkunst* (1969)

THE AMERICAS

G. Kubler, *The Art and Architecture of Ancient America* (Pelican, 1962, 1990 with extra bibliography)

W.M. Bray et al., *The Ancient Americas* (2nd edn, 1989)

R. Stone-Miller, *Seeing with New Eyes* (Michael C. Carlos Museum, Atlanta 2002) – museum objects Central and South

G.H.S. Bushnell, *Ancient Arts of the Americas* (T&H 1965)

B.M. Fagan, *Ancient North America* (T&H 1995)

D. Snow, *The American Indian* (T&H 1976)

G.R. Milner, *The Mound Builders* (T&H 2004)

M.E. Miller, *The Art of Mesoamerica* (T&H 1996)

M.E. Miller, *Maya Art and Architecture* (T&H 1999)

M. Miller and S. Martin, *Courtly Art of the Ancient Maya* (T&H 2004)

J.E. Clark and M.E. Pye (eds), *Olmec Art and Archaeology* (Washington 2000)

R.A. Diehl, *The Olmecs* (T&H 2004)

M.D. Coe, *The Maya* (T&H 1993)

N.D.C. Hammond, *Ancient Maya Civilization* (Cambridge 1982)

Olmec Art of Ancient America (eds. E.P. Benson, B. de la Fuente; Washington 1996)

R.F. Townsend, *The Aztecs* (T&H 1992)

M.E. Smith, *The Aztecs* (Blackwell 1996)

E.M. Moctezuma, F.S. Olguin et al., *Aztecs* (Royal Academy exhibition 2002)

W. Bray, *The Gold of El Dorado* (Royal Academy exhibition 1978)

C. McEwan (ed.), *Pre-Columbian Gold* (British Museum 2000)

C. McEwan et al. (eds), *Unknown Amazon* (British Museum 2001)

R. Stone-Miller, *Art of the Andes* (T&H 2002)

F. Anton, *The Art of Ancient Peru* (T&H 1972)

R.L. Burger, *Chavin* (T&H 1992)

C.B. Donnan and D. McClelland, *Moche Fineline Painting* (Los Angeles 1999)

C.B. Donnan, *Moche Art of Peru* (Los Angeles 1978)

J. Pillsbury (ed.), *Moche: Art and Archaeology* (Washington 2001)

R.L. Burger, *Chavin and the Origins of Andean Civilization* (T&H 1992)

M.E Moseley, *The Incas and their Ancestors* (T&H 2001)

TROPICAL AFRICA/ AUSTRALASIA/OCEANIA

O'Riley (see General); Lommel (see Early)

F. Willett, *Ife* (T&H 1967)

F. Willett, *African Art* (T&H 1971)

P. Garlake, *The Kingdoms of Africa* (Elsevier/Phaidon 1978)

J. Guiart, *The Arts of the South Pacific* (T&H 1963)

A.J.P. Meyer, *Oceanic Art* (Könemann 1995)

A. D'Alleva, *The Art of the Pacific* (Everyman 1998)

V.A. Van Tilbury, *Easter Island* (British Museum 1994)

W. Carmana, *Aboriginal Art* (T&H 2003)

MAPS

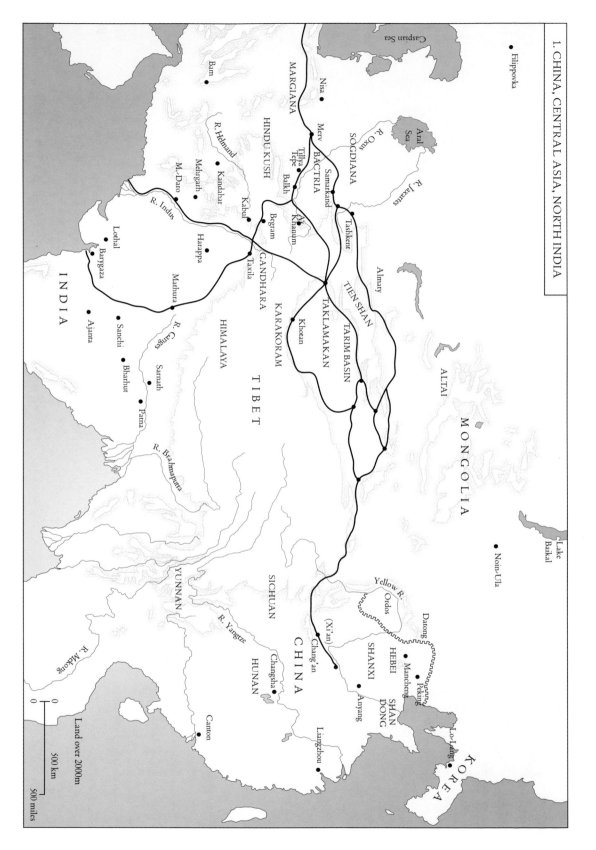

1. CHINA, CENTRAL ASIA, NORTH INDIA

Caspian Sea

Aral Sea

R. Oxus

R. Jaxartes

Filippovka

Bam

Nisa

MARGIANA

Merv

HINDU KUSH

R. Helmand

Tillya Tepe

BACTRIA

Balkh

Ai Khanum

SOGDIANA

Samarkand

Tashkent

Almaty

Mehrgarh

Kandahar

M.-Daro

Kabul

Begram

Lothal

Harappa

GANDHARA

Taxila

R. Indus

Barygaza

Mathura

KARAKORAM

Khotan

TAKLAMAKAN

TIEN SHAN

TARIM BASIN

ALTAI

INDIA

R. Ganges

HIMALAYA

TIBET

MONGOLIA

Ajanta

Sanchi

Bharhut

Sarnath

Patna

R. Brahmaputra

Lake Baikal

Noin-Ula

YUNNAN

SICHUAN

R. Yangtze

R. Mekong

Yellow R.

Ordos

Datong

HEBEI

(Xi'an)

Chang'an

CHINA

SHANXI

Mancheng

Peking

Changsha

HUNAN

SHAN DONG

Anyang

Lo-Lang

KOREA

Canton

Liangzhou

Land over 2000m

0 500 km

0 500 miles

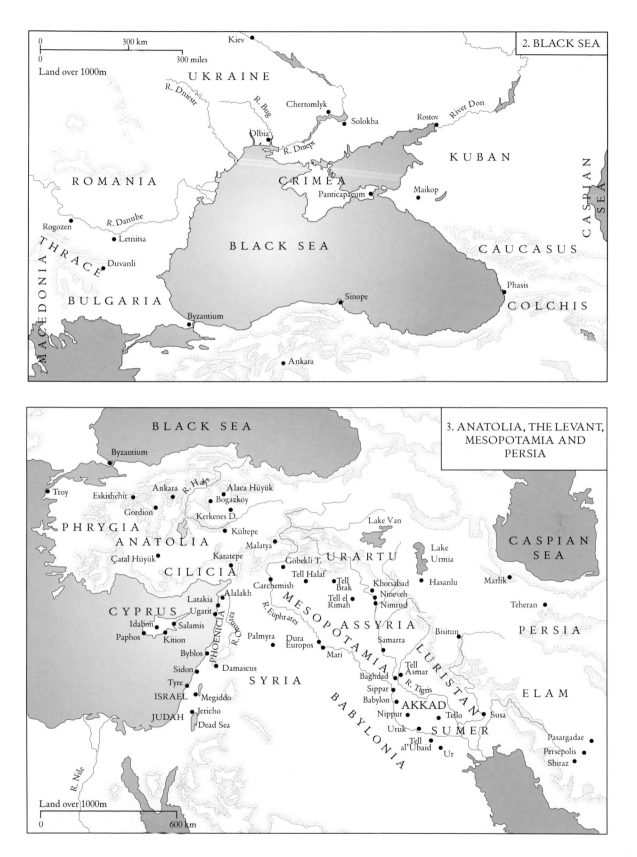

2. BLACK SEA

0 300 km
0 300 miles
Land over 1000m

Kiev

UKRAINE

R. Dniestr

R. Bug

Chertomlyk

Solokha

Rostov

River Don

Olbia

R. Dniepr

KUBAN

ROMANIA

CRIMEA

Panticapaeum

Maikop

R. Danube

Rogozen

Letnitsa

BLACK SEA

CAUCASUS

CASPIAN SEA

THRACE

Duvanli

MACEDONIA

BULGARIA

Byzantium

Sinope

Phasis

COLCHIS

Ankara

3. ANATOLIA, THE LEVANT, MESOPOTAMIA AND PERSIA

BLACK SEA

Byzantium

Troy

Eskishehir

Ankara

R. Halys

Alaca Hüyük

Bogazköy

Kerkenes D.

Lake Van

CASPIAN SEA

PHRYGIA

Gordion

Kültepe

ANATOLIA

Malatya

Göbekli T.

URARTU

Lake Urmia

Marlik

Çatal Hüyük

Karatepe

Tell Halaf

Khorsabad

Hasanlu

CILICIA

Carchemish

Tell Brak

Nineveh

Teheran

Latakia

Alalakh

Tell el Rimah

Nimrud

PERSIA

CYPRUS

Ugarit

R. Orontes

MESOPOTAMIA

ASSYRIA

Bisitun

Idalion

Salamis

R. Euphrates

Palmyra

Dura Europos

Samarra

LURISTAN

Paphos

Kition

Byblos

PHOENICIA

Mari

Tell Asmar

ELAM

Sidon

Damascus

Baghdad

R. Tigris

Tyre

SYRIA

Sippar

Susa

ISRAEL

Megiddo

Babylon

AKKAD

Pasargadae

JUDAH

Jericho

Nippur

Tello

Persepolis

Dead Sea

BABYLONIA

Uruk

SUMER

Shiraz

R. Nile

Tell al'Ubaid

Ur

Land over 1000m

0 600 km

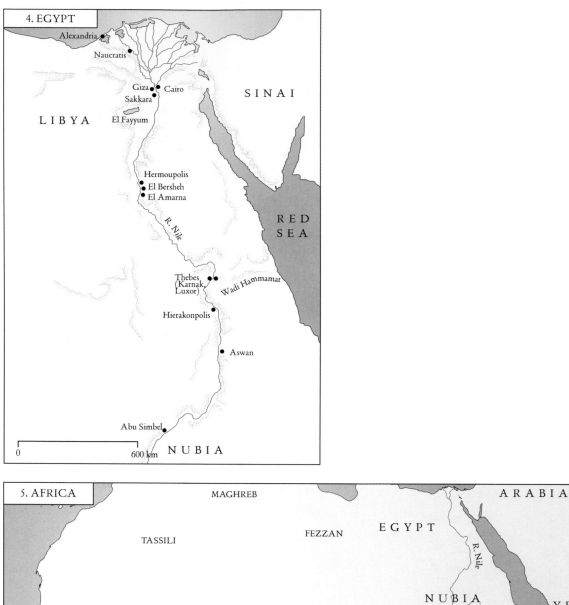

Alexandria
Naucratis

SINAI

Giza
Cairo
Sakkara
El Fayyum

LIBYA

Hermoupolis
El Bersheh
El Amarna

R. Nile

RED
SEA

Thebes
(Karnak,
Luxor)
Wadi Hammamat

Hierakonpolis

Aswan

Abu Simbel

0 600 km NUBIA

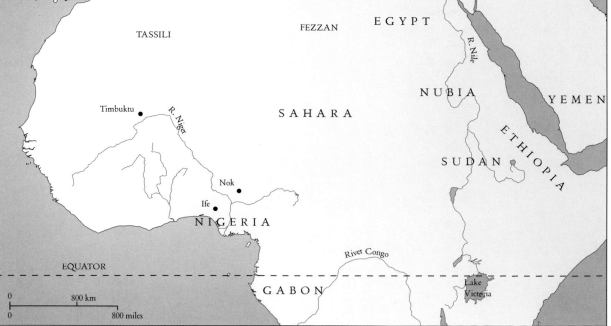

MAGHREB

ARABIA

TASSILI

FEZZAN

EGYPT

Timbuktu

R. Niger

SAHARA

R. Nile

NUBIA

YEMEN

ETHIOPIA

Nok

SUDAN

Ife

NIGERIA

River Congo

EQUATOR

GABON

Lake
Victoria

0 800 km
0 800 miles

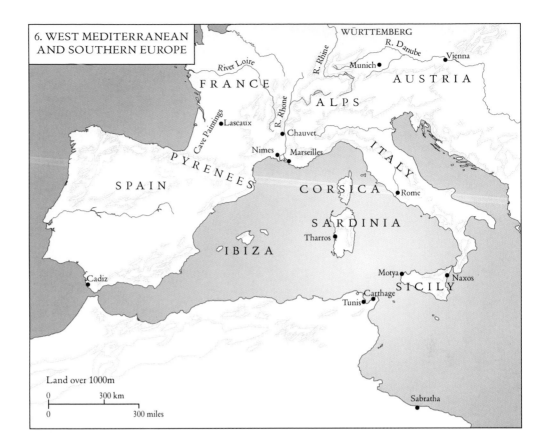

6. WEST MEDITERRANEAN AND SOUTHERN EUROPE

WÜRTTEMBERG

River Loire

R. Rhine

R. Danube

Munich ●

● Vienna

FRANCE

A U S T R I A

A L P S

R. Rhône

● Chauvet

Cave Paintings

● Lascaux

P Y R E N E E S

Nimes ●

● Marseilles

I T A L Y

S P A I N

C O R S I C A

● Rome

S A R D I N I A

● Tharros

I B I Z A

Motya ●

● Naxos

S I C I L Y

Tunis ●

Carthage ●

● Cadiz

Sabratha ●

Land over 1000m

0 300 km

0 300 miles

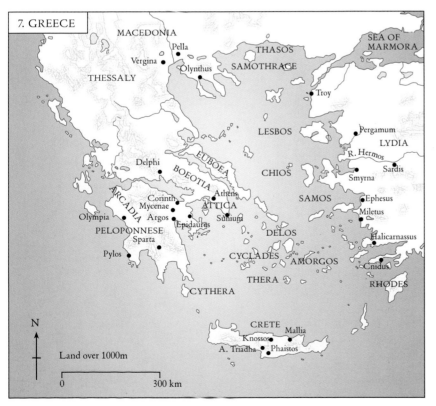

7. GREECE

MACEDONIA

SEA OF MARMORA

● Pella

THASOS

Vergina ●

● Olynthus

SAMOTHRACE

THESSALY

● Troy

LESBOS

Pergamum ●

LYDIA

R. Hermos

Delphi ●

EUBOEA

CHIOS

Smyrna ●

● Sardis

BOEOTIA

Athens

SAMOS

● Ephesus

ARCADIA

Corinth ●

ATTICA

● Miletus

Mycenae ●

Sunium

Olympia ●

Argos ●

Epidauros ●

DELOS

Halicarnassus ●

PELOPONNESE

Sparta ●

CYCLADES

AMORGOS

● Cnidus

Pylos ●

THERA

RHODES

CYTHERA

N

CRETE

● Mallia

Knossos ●

Land over 1000m

A. Triadha ●

● Phaistos

0 300 km

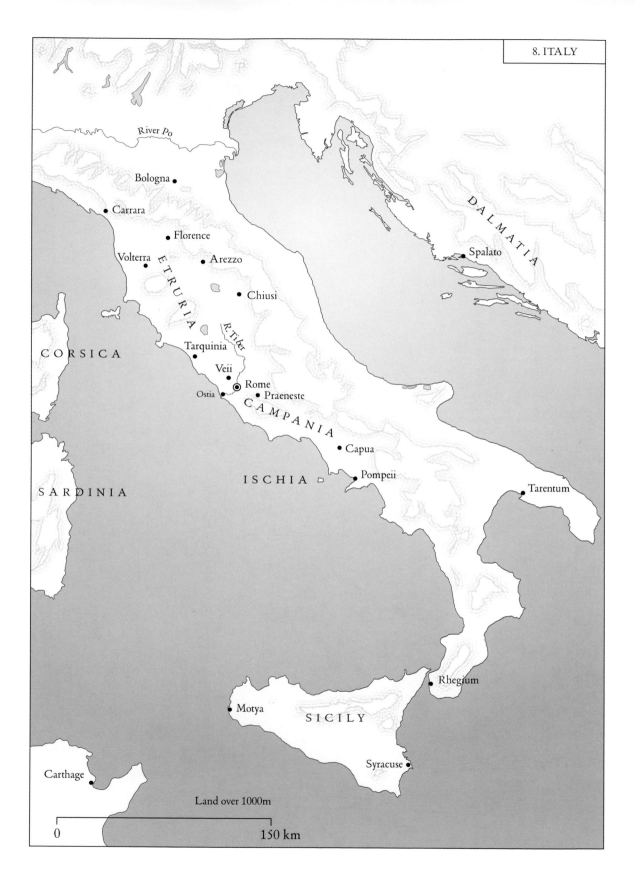

River Po

Bologna

Carrara

Florence

Volterra
ETRURIA

Arezzo

Chiusi

DALMATIA

Spalato

CORSICA

Tarquinia

R. Tiber

Veii

Rome

Ostia

Praeneste

CAMPANIA

Capua

ISCHIA

Pompeii

Tarentum

SARDINIA

Rhegium

Motya

SICILY

Syracuse

Carthage

Land over 1000m

0

150 km

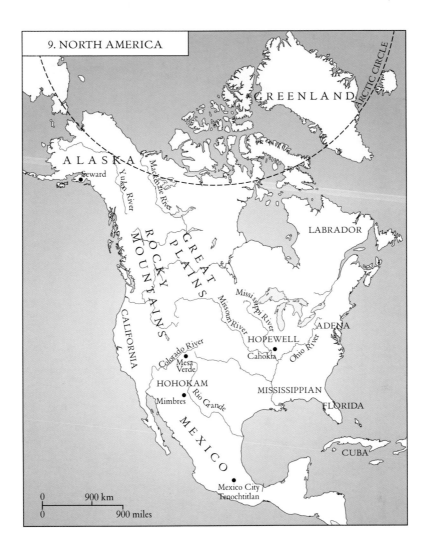

9. NORTH AMERICA

GREENLAND

ARCTIC CIRCLE

ALASKA

Seward

Yukon River

Mackenzie River

ROCKY MOUNTAINS

GREAT PLAINS

LABRADOR

CALIFORNIA

Mississippi River

Missouri River

ADENA

HOPEWELL

Colorado River

Mesa Verde

Cahokia

Ohio River

HOHOKAM

Mimbres

Rio Grande

MISSISSIPPIAN

FLORIDA

MEXICO

CUBA

Mexico City
Tenochtitlan

| 0 | 900 km |
| 0 | 900 miles |

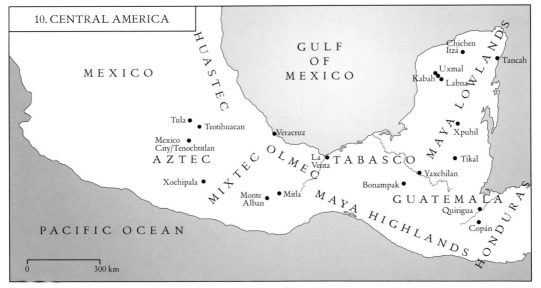

10. CENTRAL AMERICA

HUASTEC

GULF
OF
MEXICO

Chichen
Itzá

Tancah

MEXICO

Uxmal

Kabah Labna

MAYA LOWLANDS

Tula Teotihuacan

Veracruz

Xpuhil

Mexico
City/Tenochtitlan

La
Venta

TABASCO

Tikal

AZTEC

MIXTEC OLMEC

Yaxchilan

Xochipala

Bonampak

GUATEMALA

Monte
Alban Mitla

MAYA HIGHLANDS

Quirigua

HONDURAS

PACIFIC OCEAN

Copán

| 0 | 300 km |

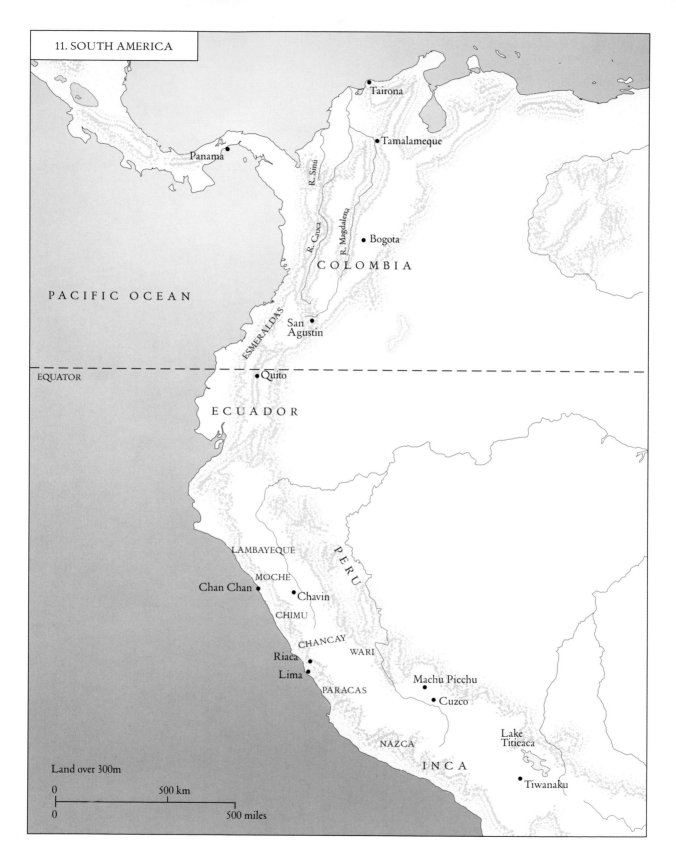

11. SOUTH AMERICA

Tairona

Tamalameque

R. Sinú

R. Cauca

R. Magdalena

Bogota

COLOMBIA

PACIFIC OCEAN

ESMERALDAS

San
Agustin

EQUATOR

Quito

ECUADOR

PERU

LAMBAYEQUE

MOCHE

Chan Chan

Chavin

CHIMU

CHANCAY

WARI

Riaca

Lima

Machu Picchu

PARACAS

Cuzco

Lake
Titicaca

NAZCA

INCA

Tiwanaku

Panama

Land over 300m

0 500 km

0 500 miles

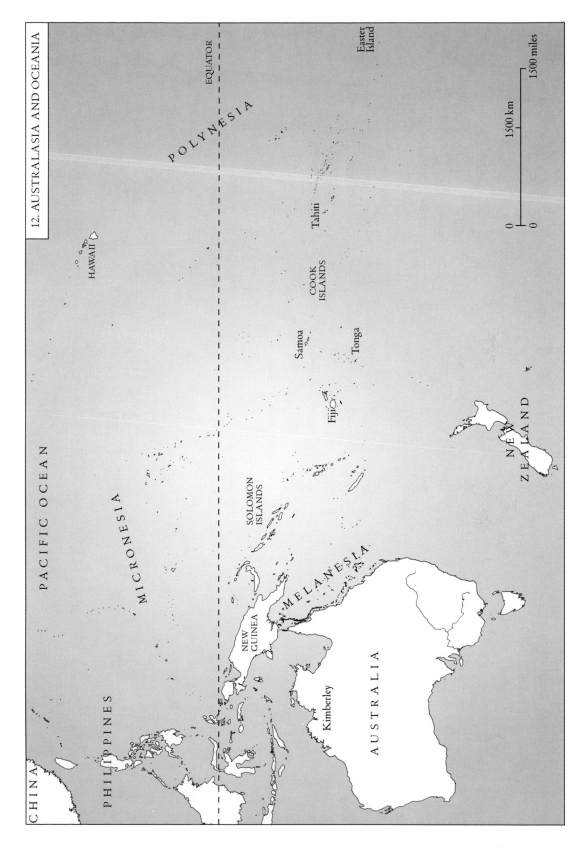

12. AUSTRALASIA AND OCEANIA

CHINA

PHILIPPINES

PACIFIC OCEAN

MICRONESIA

POLYNESIA

EQUATOR

HAWAII

Tahiti

Easter
Island

COOK
ISLANDS

Samoa

Tonga

Fiji

SOLOMON
ISLANDS

NEW
GUINEA

MELANESIA

NEW
ZEALAND

Kimberley

AUSTRALIA

1500 km

1500 miles

0

0

GENERAL INDEX

References to illustrations are given in *italics*.

Adena culture 362; *622*
Africa 23, 366, 373–74; *637–43*
Aguada culture *636*
Ahiram *327*
Ahuramazda *339, 341, 345, 350*
Akhnaten (Amenophis IV) 156; *261–62*
Akkadian *see* Mesopotamia
Alcaeus 135
Alexander 14, 35, 91, 93, 157, 178, 200–01, 210; *328, 369, 374b, 650*
amber 46, 322; *224*
Amlash *197*
Andean *see* Inca
Andronovo culture 322
Animal Style 43, 44, 74, 324–26, 331–32; *see* Central Asia
animals in art 19, 20, 30, 35, 43, 76, 92, 114, 115, 272–73, 325, 331, 341
annals 40, 130; *47, 180*
Antiochos I *382*
Antoninus Pius *424*
arches/vaults/domes 35, 73, 112, 144, 230; *35, 38, 230, 310, 404, 409, 435, 452*
architecture 32–37; orders 34, 94, 136, 155, 175, 200, 211, 230; *24–26, 59, 294, 295, 339, 355, 390, 651*; plans 47: *23, 63–68, 194*; techniques 45, 154, 264; *see* arches/vaults/domes, corbelling
Arcimbaldo 43
Aristotle 47
Arretine *439*
artists 9, 12, 33, 48–50, 95, 172, 201, 229, 272, 273, 302, 319, 320, 325–26; *51, 70–73, 358, 303, 395, 400*
Aryan 92
Asoka 40, 93, 94
Assurbanipal *188–90, 193*
Assyria *see* Mesopotamia
Astarte *332*
astronomy 36, 155, 270; *15, 32*

Atlantes *272; 33*
Atlantis 263
Augustus *411, 414, 441*
Australasia 23, 366, 374, 378–79; *644–49*
Aztec 39, 50, 262–6, 269–73, 302, 362; *459, 502–20*

Babel, Tower of 21
Babylonian *see* Mesopotamia
Bactria/Bactrian art 91–95, 210, 332
ball court 36, 270, 362; *461, 470, 477*
Banpo 75
Bayeux Tapestry 320
beaker culture 340
bi 82
bit-hilani 324; *28*
body, treatment of 37, 46, 155, 266, 302
Bonaparte 153, 154; *650*
bone *see* ivory
Book of the Dead *274*
books 265, 273; *459, 521, 522*
bow and arrow 265, 354; *97*
Braudel, F. 12
brick 35, 46, 49, 73, 92, 93, 112, 113, 135, 201, 230, 239, 264, 301–02, 349, 370, 374; *35, 38, 108, 166, 195, 343, 404, 406, 537*
Bronze Age 22, 74, 92, 134–37, 154, 173, 192, 262, 332, 333, 340, 349, 373, 379
bronze-working 22, 74, 114, 176, 229, 373–74
Brutus *413*
bucchero 398
Buddha, Buddhism 11, 13, 42, 73, 75, 76, 91, 93–95, 176–77, 320; *62, 89, 146–48, 151*; *see* stupa
Byzantium (Constantinople)/ Byzantine art 95, 178, 229, 230, 232, 260; *453, 454*

calendars *see* mathematics
cameo 178, 211, 231, 232; *374, 378, 440–41, 455*
Canova 285
Caryatid 34, 135; *28, 29, 33*

cave painting 19–21, 23, 24; *1, 2, 4, 135*
Celtiberian 349; *606*
Celtic art 319, 340–41, 349; *60, 553, 589, 592–600, 605–07*
cemeteries/burials 3, 6–7, 36, 37–49, 75, 135, 211, 228, 231, 252, 270, 323–24, 355, 367
Central Asia, Central Asian art 91–95, 319, 322, 332; *18, 54, 120–24, 138–41, 144–86, 151, 156–58, 174, 205, 351–53, 555–73, 575–76*
chacmool 480
chaitya 130
Chancay culture 265; *546–47*
Chavin culture 263, 302, 367; *527–29*
Cheops, King *253*
Chephren, King *253*
Childe, G. 22
Chimu culture 303: *545*
China/Chinese art 13, 36, 39, 44, 72–76, 263, 325, 331–32, 341, 362, 379; *42, 65, 75–109, 497, 572, 576*
Chlorite 92; *123–24, 174, 566*
Christianity, Christian art 11, 13, 157, 178, 229–30, 232, 261, 320, 332; *286, 406, 446–49*
Cicero 212, 229
cire perdue 46, 114; *175*
city plans 34
'civilization' 12
Classical art 14, 36, 40, 42–44, 48, 49, 93–95, 157, 172–79, 319, 332
Cleopatra 157
Coatlicue *508*
codex *459, 521–22*
coinage *see* money
collecting/collectors 50, 229, 232, 273, 384–85
Colosseum 230
Colossus of Rhodes 211
colour 18, 20, 22, 39, 112, 113, 136, 154–55, 175, 177, 200, 211, 212, 219, 228, 231, 234, 265, 271, 273, 308, 332, 374
Columbus 263
Commodus *419*
compasses 46, 47; *59, 60*
Confucius 13

Constantine 230; *406, 452*
contrapposto 176; *301*
Coptic 178; *286*
corbelling 35, 73, 137, 155, 227, 270; *36, 37, 39, 40, 384, 456*
'cultural heritage' 385–86
Cycladic art 116; *226*

Dai, Lady *100*
Darius, King *344–45*
Daunian culture 389
diffusion 10–11, 18, 21, 50, 172, 340, 383
Diocletian's edict 48
Dionysos/Dionysiac 93; *142, 145, 153, 158, 300, 372, 376, 379, 400, 426*
Domitian *425*
Dong-Son culture 379
Douwan, princess *94, 102*
dragons 41, 75, 76, 320; *54, 82, 93, 96, 99, 100, 104, 111, 195, 284, 571, 572*
dreams 19
drills 45, 74, 262, 264, 265, 320

Eden, Garden of 21
Egypt/Egyptian art 153–57, 192–93, 210, 230, 374; *23, 24, 32, 43, 53, 61, 63, 68, 70, 73, 219, 248–86, 322, 324, 329, 338, 344, 345 361, 429, 436*
ekphraseis 232
Elam/Elamite art 112, 114, 115; *123, 161–63, 180, 192, 339, 343, 566*
enamel 45, 201, 211; *240, 314, 350, 351, 571, 605*
epic poems 43
Eskimo (Inuit) 354
Etruria/Etruscan art 193, 227, 228, 349; *386–403*
Eucratides, King *141*

fakes 385
feathers *519*
Fernández-Armesto, F. 12
Fremont culture *615*

Gandharan art 94; *149–51, 154, 155*
Gandy, J.M. *651*
gardens 36, 44, 113, 211, 229, 230; *23, 63, 168, 431*
gemstones and sources 39, 45, 46, 49, 211 see also seals

Pliny 49, 212
Pollaiuolo *412*
Polykleitos *301*
portraiture 42, 155, 156, 178, 211, 229, 231; *257, 261–64, 312, 365, 373, 403, 411, 413–16, 418–21, 442a, 459*
potting techniques 45, 46, 265, 273, 373; *71, 117*
Praxiteles *306*
'primitive' 23, 44, 374
Projecta *447*
Pueblo culture *617, 618*
puns, visual 43; *53, 55, 57, 58*

qanat 92, 266
Qin empire *101*
Quetzalcoatl 13; *504, 505*
quipu 265, 301, 379

rainforest 32, 263, 266, 357, 378
Ramesses II *254*; III *282, 283*; VI *279*
realism 156, 175–78, 211, 216, 229, 271, 280, 301, 302, 366
relics 50, 74, 94, 114, 265, 271; *30, 504*
religion 12, 23, 38, 42, 154, 155, 302, 303, 341, 344, 345, 366, 374, 379 see Ahuramazda, Buddhism, Christianity, Hindu, Jain, shaman, Taoism, Zoroaster
'reserve' head *257*
rhyton 73, *139, 142, 207, 229, 377*
roads 36, 47, 201, 266, 270, 303
Rome/Roman art 36, 173, 174, 178, 228–32; *41, 69, 147, 152, 284, 405–54*
Ruskin, J. 45

San Agustin culture 367; *627*
Sappho 135
sarcophagi 193, 211, 231, 319; *235, 327, 328, 329, 418, 426–28, 479*
Sargon II *186, 187*
Sarmatians/Sarmatian art 76, 332; *571*
Sasanians/Sasanian art 91, 201; *158, 453, 455*
Scythians/Scythian art 322–26, 332; *350, 577–83*
Sea Peoples *282, 283*
seals and engraved gems 40, 92, 114, 115, 134, 136, 157, 178, 201, 211, 228, 232, 264, 265, 319, 320, 322; *46, 58, 116, 121, 215, 232, 233, 243, 288, 313, 334. 345, 346.374, 442, 443*
Seneb *258*
Septimius Severus *420*
shaman 13, 19, 323; *322, 323*
shell 18, 21, 74, 265, 301, 367, 378; *12, 164, 172, 173, 176–78, 515, 520–23, 624*
Shunga dynasty 94
silk 75; *65, 99, 100*
Situla art 349; *603*
skeuomorph 38
Socrates 13; *312*
sport 36, 41 see ball court
Stephanoff, J. frontispiece
stoa 36, 210; *354, 355*
stupa 35, 73, 94; *30, 131–33, 153*
'style' 10, 12, 33, 319
Sumeria see Mesopotamia
sundial 230, 231
Symmachi family *451*
synagogue *453*

Syria/Syrian art 174, 192, 193; *28, 202, 214, 216–19, 225, 291, 318–20, 323, 381, 382*

Taoism 13, 48
taotie 43; *87*
tattoos 19, 38, 46; *556, 640*
technomorph 41
temples 21, 35, 50, 94, 134, 155, 173–75, 200, 211, 228, 230, 235, 236, 240
textiles 22, 46, 49, 114, 265, 301–03, 373; *229, 380, 523–25, 546, 547, 557, 585*
theatre 36, 38, 42, 93, 174, 175, 210, 230; *21, 310, 354, 407, 409*
Thetha *277*
tholos 137; *36*
Thorwaldsen *385*
Thrace/Thracian art 135, 210, 332; *349, 601, 602, 607*
Tiberius *359, 441*
Tiwanaku culture 302, 303; *537, 539, 541*
Tlaloc *269*
Toltec culture 272; *33, 474*
totem pole 355, 362; *496*
Toynbee, A. 11–13
Trajan *423*
tremolo technique 265
tumbaga 262; *501, 625, 626, 628, 630*
Tutankhamun 154; *269–72*
Tuthmosis 156
Tuthmosis III *268*

Urartu/Urartian art 112, 115; *199, 200*

Vajrapani 320; *156*
Valerian *455*
Vanuatu 379
Vedic hymns 92

viaducts 230; *41*
Virgil 229
Virgin Mary 230, 320
Vishnu *157*
Vitruvius 46; *59*

Wari culture 302, 303; *543*
weights and measures 40
Wen, Emperor *111, 112*
wicker 22, 41, 341, 373; *98, 159, 519*
women 42, 49, 201, 231, 322
wood 45, 46, 73, 75, 94, 175, 200, 264, 270, 272, 324, 355, 366, 373, 374, 379; *25, 27, 77, 127, 130, 176, 177, 204a, 222, 227, 267, 269, 278, 494, 520, 558, 559, 595, 620, 640, 641, 643, 644, 646, 647*
writing 39, 49, 74, 75, 92, 114, 134, 136, 137, 174, 264, 265, 270–73, 301; *42–52, 56, 68–70, 116, 182, 184, 214, 268–70, 274, 278–80, 284, 292, 297, 344–46, 443–46, 458, 474–76, 479, 481, 489*

X-ray drawing 20; *8*
Xipe Totec *506*
Xoc, Lady *475*

yakshi 129, 137
Yang-shao culture 76
yu 84
Yunnan *110, 113*

Zeus 230, 320; *305, 354, 356, 374b, 401*
ziggurat 35, 92, 113, 134; *19, 31*
zong 80
Zoroaster 13, 93

INDEX OF PLACES

References to illustrations are given in *italics*. For culture areas see General Index.

'Ain Ghazal *14*
Africa 18, 22, 153, 173, 366, 373, 374; *637–43*

Agade 112
Aï Khanoum 93
Ajanta 94; *135*
Al Mina 135
Al'Ubaid 175
Alaca Hüyük 134; *205, 213*
Alalakh 134; *214*

Alaska 354; *608, 609*
Alexandria (eastern) 93, 211
Alexandria (Egypt) 95, 210, 211; *231*
Altai 325; *352, 556, 557, 559*
Amaravati 94
Amarna 42, 156; *63*
Amazon, R. 32, 266, 367; *262–266*
Amlash *197*

Amorgos *226b*
An-yang 73; *42*
Ankara 206
Anping *77b*
Antinoopolis 286
Antioch 210
Arabia 95, 112, 193, 374; *316, 335*
Aral Sea 91
Arcadia 135
Argentina *636*